ART AND HISTORY OF
PARIS
AND VERSAILLES

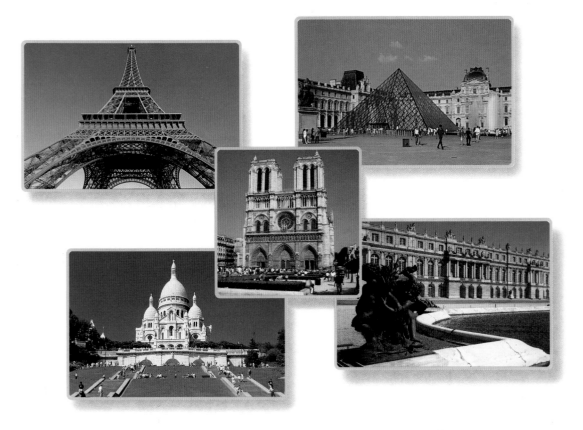

W9-BZY-339

BONECHI

Authors

HISTORICAL AND ARTISTICAL INTRODUCTION
Georges Poisson

PARIS
Giovanna Magi - Rita Bianucci

LOUVRE and MUSEE D'ORSAY
Hubert Bressonneau - Giovanna Magi

MUSEE CARNAVALET
Rita Bianucci

VERSAILLES
Jean-Georges d'Hoste

ART AND HISTORY
OF PARIS AND VERSAILLES
Project and editorial conception: EDITPROJET
Publication Manager: Monica Bonechi
Picture research and graphic design: Serena de Leonardis
Cover and video layout: Laura Settesoldi
Translation: Studio Comunicare, Florence
Editing: Rita Bianucci
Drawings : Stefano Benini

© Copyright by CASA EDITRICE BONECHI - Firenze - Italia
© Copyright by EDITPROJET - Paris - France

E-mail: bonechi@bonechi.it - Internet: www.bonechi.it

Photographs from the archives of Casa Editrice Bonechi taken by
G. Dagli Orti, L. Di Giovine, U. Falugi, P. Giambone, J. C. Pinheira, A. Pistolesi
with the exception of the following:

*pages 4 bottom, 5 bottom, 7, 21, 41 top, 48 top, 50 top, 89, 92 bottom, 102 top, 157 top,
158, 159, 160, 161, 162, 163, 169 top left: by* G. Dagli Orti;
pages 112 top and 113: by V. Gauvreau;
*pages 15, 17, 19, 54, 55, 60, 61, 62, 63, 65, 66, 67, 68, 69, 70, 71, 73, 74, 75, 76, 77, 78, 79, 81, 124, 125, 128, 129, 130, 131,
132, 133, 135, 136, 137, 138, 139, 140, 141, 186 bottom, 197 bottom:* © Photos Réunion des Musées Nationaux.
The publisher thanks Disneyland® Paris for the photos on page 177 bottom.

ISBN 88-8029-651-5

* * *

Paris in History

*I*n the beginning what was eventually to become Paris was located on the banks of a river with a scattering of islands forming a natural ford. Recent excavations have brought to light a habitat dating to many thousands of years before the birth of Christ.

Although this nucleus may not have been continuously inhabited, around the 3rd century B.C. a Celtic peoples, the Parisii, lived here in a village known as Lucoticia, or Lutetia. Although the famous gold staters bear witness to their economic prosperity, there were other more powerful tribes in Gaul. Even so the fact that they were able to send eight thousand men to Vercingetorix when the land rose up against the invading Romans, leads us to believe that the settlement numbered around fifty thousand inhabitants and perhaps even more. Not enough to hold out against the Roman legions, and Labienus, Caesar's lieutenant, defeated the Parisii and their chief Camulogen in the year 52, probably on the plain of Grenelle. For the next four centuries Lutetia was an integral part of the Roman world, and the monuments and countless vestiges conserved in the territory bear witness to its increasing prosperity. While it was not one of the greater cities of Roman Gaul, the fact that it was situated at the crossroads of a route which joined north and south and a water way, represented by the Seine, was not to be underestimated. These two great natural highways became increasingly important during the period of rebellions and disorders and it was in Lutetia, in all likelihood on the Ile de la Cité, that Julian was proclaimed Roman emperor in the year 360. With St. Denis and St. Marcel, Christianity was already deeply rooted in the city which was beginning to be called Paris.

The Barbarian invasions of the 4th century forced numerous inhabitants of the left bank to seek refuge on the Ile de la Cité, around which ramparts were built. Of the various invasions in the centuries to follow mention must be made of that of the Huns, brought to a halt by St. Geneviève who instilled courage in the hearts of the inhabitants. Troubled times continued until the arrival of Clovis, who chose Paris as the capital of his kingdom. It was here that he founded the abbey of Sainte-Geneviève and here that he died in the year 511. His successors safeguarded the supremacy of the city, excluding it from the dynastic partitions and building churches. But with the Carolingians the city began its decline, hastened by the Norman invasions in the 9th century. The left bank was definitively abandoned and the inhabitants took refuge on the island, where they remained till the end of the century when they ventured forth anew, to settle this time on the right bank.

When Hughes Capet, count of Paris, mounted the throne of France, the destiny of the city and that of the kingdom became one and the same. The great highways of trade and communication which flowed together on the right banks favored the development of mercantile activities. In the 12th century Louis VI transferred the general markets (the Halles) to the area known as Champeaux, where they were to remain for more than eight hundred years. Churches were either built anew or enlarged on the heights overlooking the swamplands which were gradually reclaimed and tilled, while the Ile de la Cité, densely populated, became the center of regal and ecclesiastic authority. Fortified bridges guaranteed passage to the right bank, center for trade and activity, as well as the left bank, which had been practically abandoned for a long time and which now returned to life thanks to the presence of students. After numerous disputes between the king and the bishop, in 1209 the students finally succeeded in collecting the various teaching centers together under the name of University, and for a long period this also indicated the entire left bank.

King Philip II Augustus, one of the great builders of Paris, had the quarters of both banks circled by defensive walls, of which vestiges still remain. He had the streets paved, created the first fountains and had the tower of the Louvre, symbol of royal power, built. Development was also favored by the international fame of Saint Louis. Since the king almost always resided in the city, the aristocracy built their mansions here while the houses of the middle classes and artisans also grew apace. Generally timber frame structures, with the gable facing onto the street and shops on the ground floor, these houses were built one next to the other along the narrow streets, on the bridges and on the banks, often blocking the view of the river.

In the 14th century, the capital counted about 200,000 inhabitants and the city continued its political, financial and commercial growth, in particular on the right bank, which meant that as early as 1356 a new city wall had to be built to accommodate the urban expansion northwards.

But the defeats inflicted during the Hundred Years War, the captivity of John the Good and the weak-

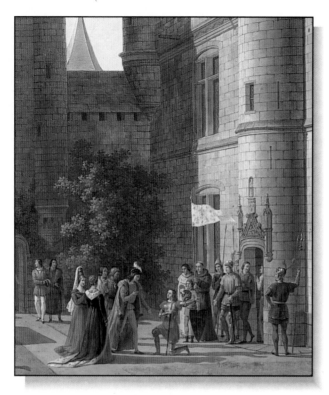

Joan of Arc meets Charles VII at Loches.

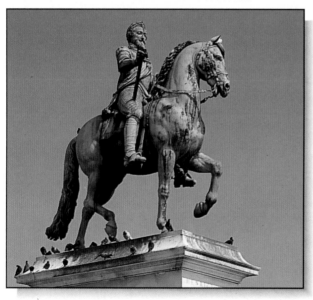

Henry IV; Paris and the Seine in the seventeenth century.

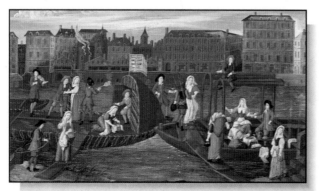

ness of the Dauphin were the causes behind the first Paris revolution headed by the merchants' provost Etienne Marcel, who was however unsuccessful and lost his life when he allied himself with the English. Restored to his position, the Dauphin, now king as Charles V, attempted to make amends, but he no longer felt safe in the city and chose to live in his residences to the east: Saint-Paul, Tournelles and the castle of Vincennes. This was however all to the advantage of the quarter of Marais which for three centuries was preferred by the aristocracy. When hostilities with the English once more flared up, events again became dramatic with the capital occupied by the enemy forces, Charles VI and his attacks of insanity, the civil war between Armagnacs and Burgundians, the defeat of Joan of Arc at the gate of Saint-Honoré. Recovery was slow and upon his return to the city in 1436, Charles VII left almost immediately for the Loire valley where the kings and the court were to reside for over a century.

Even so, the Valois had definitively set up the organs of central government in Paris: the Chamber of the Exchequer, the Treasury, the Archives, the Mint. The system of a twofold State-City authority, which was to govern the capital for a period of eight centuries, was installed in the time of Saint Louis..

On his return from captivity in 1528, king Francis I established his residence in the region around Paris and found a city that enjoyed an immense intellectual fame, and which had risen to be a capital of the arts, of literature and, shortly thereafter, of a new humanism with the founding of the Collège de France. King Henry II, still involved in war, had the city fortifications strengthened, but he died in the course of a tournament held outside the royal residence of Tournelles. As the war against external enemies was losing force, the newly born Reformation degenerated into a dispute of religious nature and then openly broke out in a war. The massacre of the Eve of Saint Bartholomew (1512) left the population of Paris in the hands of the hard-line Catholics, and resulted in the creation of the Holy League, which initially opposed Henry III and instigated his death, and then Henry IV who, after his conversion, found himself governing an exhausted city.

His first task was to improve conditions by opening numerous building yards which aimed, on the one hand, at reducing the number of jobless, and on the other at embellishing the city and exalting the prestige of the crown. The works involved were not limited to architecture but included town planning, and the idea was to provide incentives for the economy: the creation of squares, streets, the building of the Hospital Saint-Louis, the founding of a royal tapestry factory, the installation of a pump called La Samaritaine to furnish water for the fountains, the publication of the first town planning norms. Other projects were still under study when the king was assassinated on May 11, 1610 when traffic was blocked in Rue de la Ferronnerie.

While the king was still alive and after his death, urban expansion was entrusted to private promoters, who created the new quarters of Pré-aux-Clercs and Ile Saint-Louis. The construction fever, documented by the rise of countless aristocratic and middle class dwellings in the Marais and north of the Louvre, went hand in hand with the creation of convents, the fruit of the Catholic renewal after the Counter-Reforma-

tion, in the quarter of Marais, in Faubourg Saint-Honoré, but above all in Faubourg Saint-Jacques, the point of departure for pilgrims to Compostella, where a sort of holy city was created thanks to the interest demonstrated by the queens, Marie de'Medicis and Anne of Austria. The complex of Val-de-Grâce is the finest example of this type of devotional architecture. Religious life was also distinguished by the creation of seminaries and beneficial institutions: Paris, where an archbishopric was instituted in 1622, rose to the rank of religious capital of France.

New uprisings broke out with la Fronde in 1648-49 and the diffidence of the king towards the capital once more rose to the surface, engendering an economical crisis which further aggravated the general poverty. Throughout the reign of Louis XIV the number of deaths continued to be greater than the births and the rise in population was due solely to the constant immigration from the provinces. The increase of the needy led to the creation in 1656 of the Hôpital Général, which resembled a penitentiary more than a welfare center. To guarantee the maintenance of public order, in 1667 Colbert instituted a new magistrature headed by the Lieutenant de police, who was administrator, questor and judge, all at the same time. But Louis XV's reign was also a great period of construction enterprises aimed at exalting the monarchy (palace of the Louvre), the greatness of the city (triumphal gates), arts and crafts (the Gobelins manufactory), scientific studies (observatory), assistence to civilians (hospital of the Salpétrière) and the military (the Invalides), the state of the roads (Pont Royal), urban reorganization (boulevards along the Seine, fountains) and even real estate speculation (Place des Victoires, Place Vendôme). Private citizens, nobles or middle class, for a brief period continued to settle in the Marais, which had its last moments of glory, and above all in the suburbs situated along the road leading to Versailles, Faubourg Saint-Honoré and Faubourg Saint-Germain. At the death of Louis XIV, Paris had about 25,000 houses and a population of circa 500,000.

Intellectual life in the capital and the urban development of the early 18th century ran along independently of that of the monarchy. The philosophers and encyclopedists met in countless salons and escogitated a variety of ways of avoiding royal censure in making their ideas known to the public. At the same time initiatives in the field of building passed into private hands and as the economy expanded so did the population which in turn stimulated the development of private building. The numerous palaces of the period and the first tenement houses are distinguished by a search for comfort, above all in service facilities.

Around the middle of the century, during Louis XV's reign, private initiative in Paris witnessed the rise of new interests. Like some of his predecessors who had embellished the capital with building works, the king began a few imposing undertakings: Place Louis XIV (later renamed Place de la Concorde), the military school (École Militaire), the Academie de Chirurgie, the Abbey of Sainte-Geneviève (now the Panthéon) and the Mint. These "great workyards" changed the aspect of several districts and sanctioned the triumph of the new classicism.

On the other hand, this is also when an awareness of urban building and the role played by monuments, considered not so much for their formal aspect as for

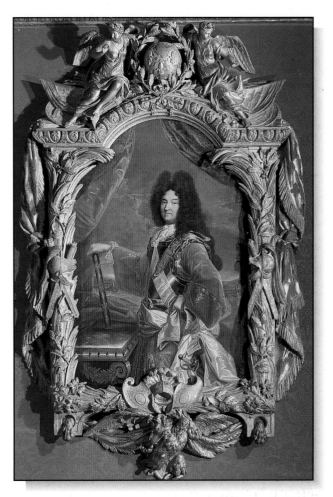

Louis XIV; The Taking of the Bastille.

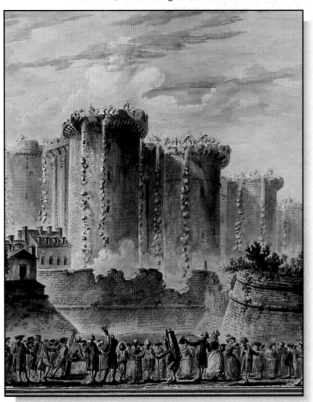

5

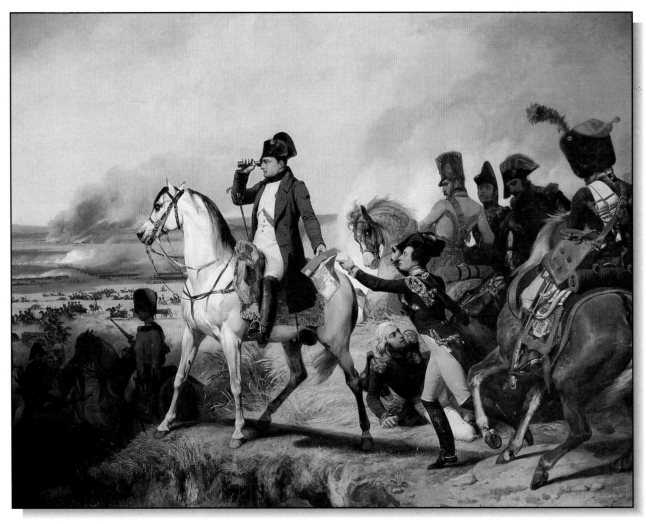

Napoleon at the Battle of Wagram, July 6, 1809.

their function and meaning on the social level, began to make itself felt. At the end of Louis XV's reign and during that of Louis XVI studies in town planning and in the regulation of works of public interest, such as markets, fountains and theaters, as well as private building multiplied. In 1783 the height of the houses with respect to the width of the roads which they lined was established. Works inspired by criteria of public interest and health include the Mont de piété, the Théatre Français (now the Odéon), the Pont Louis XVI (now de la Concorde), various fountains, and the suppression of parish cemeteries.

The Revolution broke out in a city which was in full intellectual evolution but where expansion was held back by the economic crisis. The desire of the majority for reforms and a reduction of existing inequalities was manifested, on the one hand, by a surge of trust in the monarchy, and on the other by a disorderly proliferation of ideas which were broadcast through the journals and political clubs, intoxicated by the liberty so suddenly acquired and diffident with respect to the monarchy. Louis XVI was unable to keep this movement under control and guarantee order, with the result that on July 14th some of the revolutionaries had no trouble attacking the Bastille, that decadent symbol

of royal absolutism, and getting it to surrender and not, as is generally affirmed, to storm it. The king refused to act against the crimes committed in that occasion even though he could have counted on the support of an overwhelming majority of the population, and humbled himself by going to Paris where he was received by Bailly, the first mayor of the city. On the contrary, the more avant-garde political clubs, the Jacobins and the Cordeliers, who had set up headquarters in the old convents from which they had taken their names, succeeded in galvanizing their supporters and organized the bloody expedition of October 5th and 6th which was the cause of the transfer of the royal family from Versailles to the Tuileries, where they gradually became prisoners of the Revolution, without any sign of resistence or attempt at temporizing on the part of the king. The Assembly, following the king, set up headquarters next to the palace, but neither of the two buildings has survived the vicissitudes of history. The fête of the Federation, at the Champ de Mars on July 14, 1790, for a moment seemed the beginning of a new era, but it was nothing but a manifestation without a future.

In 1356, 1589 and 1649, the sovereigns had simply left the city when the Paris revolutions broke out.

Louis XVI was the first to bungle his chance and on June 23, 1791 the royal family in flight was ignominiously brought back from Varennes. But monarchic feelings were so deep-rooted that the king was reinstated and the new constitution was modified so that some of his powers would be returned to him. The meeting of the Legislative Assembly (October 1, 1791) seemed momentarily to prelude to the installation of a new "acceptable" regime of the constitutional monarchy, but the inexperience of the deputies, the indecision of the king and his duplicity were unable to hold out against the revolutionary republican determination of some of the Jacobins. On August 10, 1792, an insurrection against the legitimate government swept away the monarchy and the royal family was shut up in the tower of the Temple to await the guillotine.

The situation the revolutionaries who had risen to power thanks to the new Convention, first with Danton, then with Robespierre, were faced with was direful: war against foreign powers, an economical crisis, a confusion of ideas and lastly civil war with the insurrection of the Vendée. They attempted to safeguard their absolute and contested power by using terror, first clandestinely (the prison massacres of September 1792), then in official form with the terrible condemnations to the guillotine by the revolutionary Tribunal, which marked the period of the Great Terror (September 1793-July 1794). Robespierre was unable to bring this dramatic regime to an end in time, and on July 27, 1794 (9 Thermidor), overcome by fear and fatigue, the Convention gave way.

In the five years that followed, Paris was the seat of governments born of compromises and fluctuations of opinion, with the Convention of Thermidor followed by the Directory, in a scene of economic decadence and corruption. The regime was on the verge of exhaustion when on 18 Brumaire it succumbed to the coup d'etat of General Bonaparte.

Afer Philip Augustus, Charles V, Henry IV, Louis XIV, Louis XV, Napoleon was one of the few great sovereigns to show interest in Paris. He found a city which had been bled white and was going to rack and ruin, ravaged by an economical crisis and in the throes of an institutional anarchy. It was necessary to create new structures such as the Prefecture of the Seine, the Prefecture of Police, reestablish the system for the acquisition and distribution of provisions, reinstitute the collection of taxes, an immense task which was carried out in very little time.

Moreover the Emperor hoped to open various great new arteries and embellish the city with new monuments: the most important are the two triumphal arches. Only a few of his projects were realized or finished because of the brevity of his government and the various wars continuously in progress and a certain weakness of the finances, but also because he was becoming more interested in works of urban order such as the reorganization of the river banks, the bridges, the numbering of the houses, markets, fountains, slaughter houses, the water supply, the sewage system, cemeteries. The result is outstanding although, obviously, today practically everything has been renewed.

Occupied by enemy troops for two years in a row, in 1814 and 1815, Paris twice saw the old king Louis XVIII resume his throne, succeeded by his brother Charles X. They were unable to reconcile the Parisians to the hereditary monarchy nor did they attempt to radically change the appearance of the city. After fifteen years, thanks to the imprudence and lack of responsibility of Charles X, the inhabitants of Paris rose up for three days, known as the "Trois glorieuses", and overthrew the old monarchy.

The city continued to stagnate under Louis Philip, when only one important artery was laid out, Rue Rambuteau. Even though the citizen-king was interested in building, the conservative attitude he had adopted when he rose to the throne led him to pay little attention to the difficult conditions in which most of the people of Paris lived. "There are a thousand inhabitants per hectare in the Grève, in Saint-Merri, in the Cité. In these quarters where alcoholism, tuberculosis, prostitution and crime are rampant, virulent epidemics break out: the cholera of 1832 reaped 44,000 victims. In 1848, 65% of the population is too poor to pay taxes and 80% of the dead are thrown in the common grave." (J.P. Babelon). On the other hand the indifference of the king was shared by the financial upper middle classes, from whence came that privileged world described by Balzac.

Two noteworthy undertakings saw the light in Paris during his reign: the building of a ring of fortifications around Paris and the construction of the railroad stations, which were so far apart that it became obvious that Paris had no intention of becoming simply a place of passage.

A chance economic crisis and a slight political agitation followed by a pacific revolution were enough to make the July monarchy fall, in February of 1848.

Napoleon III and Baron Haussmann.

The Second Republic left two pages of history in Paris: one social, with the questionable experience of state-owned workshops (Ateliers nationaux), the other, stained with blood, of the days of June. Subsequently the sovereign who was to transform the capital as none of his predecessors had done finally arrived.

Napoleon III proposed to radically renew the city which was still medieval in various aspects, giving it air, light, ease of transportation, public works, economical structures and social housing, and at the same time furnishing the organs of power with the means required to suffocate any possible revolt. In putting through this policy he found a remarkable administrator, Eugène Haussmann, who in a period of sixteen years, realized outstanding works: the opening of great communications routes, a water and sewage system, sidewalks, green spaces, administrative and religious buildings. In 1860 the towns located inside the fortification walls were annexed.

The opening of new streets went hand in hand with the construction on a vast scale of new buildings, with a clean cut segregation on a social level as a result. The period of the cohabitation of all classes under the same roof had come to a close; the families of the laborers were pushed into the peripheral areas and this was to be significant during the future class struggles. The new buildings were reserved for the bourgeois classes, also divided into categories which, whether out of envy or indifference, divided up the floors of the buildings, from the bottom up, according to their social standing and income.

Unfortunately the emperor was not well acquainted with the city and neither he, nor the prefect, had a developed aesthetic sense. As impressive as the achievements of these two figures may be on the level of actual accomplishments, they are sadly lacking regarding the monumental aspect, which could have been helped by a greater sensitivity, above all on the Ile de Cité. But at the same time Paris, intellectual and artistic center, had never appeared as full of life and prosperity as then. The economic development favored the well-to-do classes rather than the working classes and the life of Paris, symbolized by theaters, festivals, orchestras, parades, the waltz, irradiated a splendor which attracted foreign visitors, in particular during the period of the first universal expositions, in 1855 and 1867.

The inconsistency of the French government, which fell into the Prussian trap in 1870, led to the sudden downfall of this brilliant structure. "The terrible year" was felt above all in Paris, first with the siege, during which the courage of the population was poorly exploited by the mediocre military chiefs, and subsequently with the Commune, a real class struggle which bloodied the city and set fire to its monuments. The economic growth of Paris was brought to a halt for several years, as well as its political supremacy over the rest of France.

By now power in the capital was in the hands of a provincial electoral class, often from the South, and a great deal of time was required before they could acquire the necessary skills.

Even so, the universal expositions of 1878, 1889 and 1900 brilliantly marked the stages of the rebirth and economic renewal of France and Paris and at the same time publicized the technical inventions which were to revolutionize the urban layout and daily life, in particular building in metal and electricity.

The third of these expositions concided with what is called, with a certain liberty, the Belle Epoque, which was beautiful only for the richer classes. The only works of a social nature realized in that period regarded the collective institutions such as schools and hospitals, while in 1900 the underground transportation system was inaugurated, and it has continued to grow ever since in a spectacular way.

In Paris the nineteen hundreds was the century of wars, of disorders, of uncertainties. After the early years, violently troubled by the Dreyfus case, by Boulangisme (a political movement of the opposition led by General Boulanger), the Panama question, anarchism, the war of 1914 arrived and for four years the capital made the best of the threat of enemy forces which arrived near the city not once but twice, bombing Saint-Gervais on Easter Friday. The victory of November 11th set off an exhibition of joy in the streets of Paris such as the city had never known.

The enthusiasm of the mad Twenties rapidly died down and the financial, political and social problems fuelled an unease which broke out in the insurrection of February 6th in Place de la Concorde. Despite this, Paris did all it could to appear serene on the occasion of the Exposition of Decorative Arts in 1925, the Colonial Exposition of 1931 and the International Exposition of 1937, but various problems made the uncertainty of the times rise to the surface.

War soon broke out again, accompanied by four years of particularly brutal enemy occupation, marked by the struggle against the Resistance carried out in terms of imprisonment, torture and convictions. The prisons of Rue des Saussaies and Rue Lauriston, Mont-Valérien bear witness to this tragedy.

In August of 1944 many Parisians rose up against the enemy which was at this point on the run, launching violent attacks with whatever weapons they might have until the arrival of the tanks of Leclerc's division. On August 25th General von Choltitz surrendered at the station of Montparnasse and on the following day General de Gaulle paraded along the Champs-Elysées.

Almost fifty years have passed since then and Paris, aware of drama as it is of fashions, prone to enthusiasm, or to be moved, ready to rebel on one front or another (as happened in May-June 1968), has remained the seat of national power, made manifest here, in particular, with the great public works. But the city has also achieved full municipal autonomy which has allowed it, in various respects, to change or embellish its aspect. Thus, as Charles de Gaulle said, it remains "faithful to itself and to France".

Architecture and Town Planning

For over two thousand years buildings have been going up and coming down on the same site, flanking each other, replacing each other, as the city evolved, and as dictated by the life and work of its inhabitants. As it grew, the town devoured itself, destroying part of its artistic heritage, but even so each period has left its share of monuments which constitute a manual of the history of architecture from Gallo-Roman times to the dynamic present.

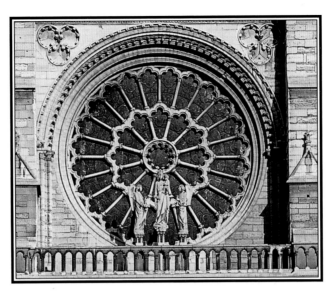

On the site of a Gallo-Roman temple, in a place where people had prayed for over a thousand years, the bishop Maurice de Sully, and then his successor Eudes, oversaw the construction of this new sanctuary.

The last of the early Gothic cathedrals, the first of the great classic cathedrals, Notre-Dame is the turning point for the evolution of Gothic, and an equilibrium was achieved in the concept: six-partite vaulting, springing however from uniform piers; five aisles but only three portals on the facade; tribunes to house the greatest number of worshippers, and a quest, still insufficient, for light. It was inevitable that Notre-Dame should influence architecture throughout the bishopric. But a few steps away, in Paris itself, the church of **Saint-Julien-le-Pauvre** was built, which has preserved two marvelous capitals. Remains of the kitchens and refectory, and the bell tower of the original church of the **Abbey of Sainte-Geneviève** have been incorporated into the Licée Henri IV.

The town was small and to defend these religious structures the king Philip Augustus enclosed them in a defensive wall two meters thick and flanked by towers. Important elements can still be seen in the Rue des Jardins-Saint-Paul. At the most vulnerable point, a keep, the great tower of the Louvre, was built, the base of which has been brought to light in recent years.

At the time of Saint Louis, this early Gothic art in Paris, sober and still a bit heavy, became more aerial, bolder and more elegant in style, as witnessed best by the **Sainte-Chapelle**.

Built in two stories, one for the royal family and one for the servants, despite its relatively small size, the virtuosity of the architecture, with its elegant solutions of the distribution of forces through the ribbing and buttressing, and its use of light make it an example of truly inspired architecture. The architect may have been Pierre de Montreuil, who was also active in Notre Dame, when the transepts were enlarged, with the addition of new richly decorated facades in the second half of the 13th century. The architect appears once again in the two great convents which at the time were located near Paris, **Saint- Germain-des-Prés** and Saint-Martin-des-Champs. For the former he rebuilt the monastic structures of which only the refectory gable and fragments of the admirable **chapel of the Virgin** are still extant. The chapel portal is now in the museum of Cluny. In Saint-Martin-des-Champs we still have the lovely **refectory** with two aisles, and the lectern.

The Gallo-Roman period

In the early centuries of our era Lutetia was nothing but a provincial market town on the banks of the Seine, and its monuments could hardly be compared to those of the great cities of antiquity. Even so two characteristic buildings of Roman life have been preserved: the **arena**, which could hold 16,000 spectators, and the **Baths of Cluny**. The remains suffice to demonstrate what the Roman genius in the provinces was capable of in terms of construction techniques.

After this, Paris passed into the night. The next monument of note dates to seven hundred years later, the bell tower of the monastery of **Saint-Germain-des-Prés**. Built around the year 1000, it is the symbol of Romanesque art in Paris, a period which, apart from the nave of the same church, greatly altered, has left little else.

Paris and its splendid medieval period

If Paris has only a few modest remains to represent the art which created Cluny and Vézelay, demolition and reconstruction are largely to blame, but it must also be kept in mind that the Ile de France, the cradle of Gothic art, was the first region to reject the Romanesque formulas in its quest for a more ambitious architecture. As early as 1130-35, ogival vaulting appeared in the choir of Saint-Martin-des-Champs.

The characteristics of the style were soon defined and the crossing in **Saint-Pierre-de-Montmartre**, dated to 1147, is already elegant, vigorous, and worthy in all aspects of the name of Gothic. The new technique was used in the construction of the choir of **Saint-Germain-des-Prés**, with its fine ambulatory. And, on April 21, 1163, Pope Alexander III consecrated this apse and laid the cornerstone of the cathedral of **Notre-Dame**.

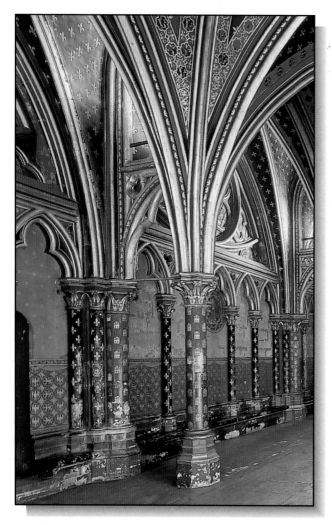

Examples of Gothic and Flamboyant Gothic.

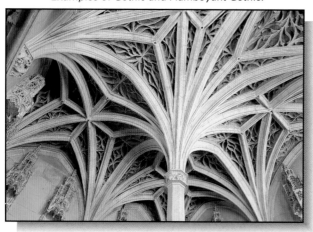

The Gallery of the Kings in Notre-Dame.

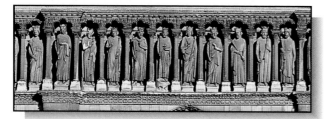

The fourteen hundreds marked a pause: architecture, perfect master of its means, lost some of its inventiveness and freshness of inspiration. **Saint-Leu-Saint-Gilles** and the **Chapel of Saint-Jean-de-Beauvais** maintain the slightly cold character of this impeccable style. But the **refectory of the Bernardines**, an example of the austere elegance of Cistercian architecture, must be cited.

So far no mention has been made of civil architecture. Nothing remains of the early medieval dwellings and any houses that have survived go back no further than the 14th century.

A fine low vaulted hall remains from the Parisian town house of the abbot d'Ourscamp (46 Rue François Miron), while the postern of the **Hôtel de Clisson** (around 1380) with its two overhanging towers survives as an example of a house of the feudal aristocracy. The **royal palace** at the time was still on the Citè. Philip the Fair had the mansion rebuilt, preserving the **Sainte-Chapelle**. Still extant today is the majestic and austere **Conciergerie**, where the rigor of the lines is softened by the elegance of the sculpture. But the palace was gradually taken over by the magistrates and Charles V commissioned Raymond du Temple with transforming the **Louvre**, of which the lower part has recently been brought back to light.

It was in fifteenth-century Paris that flamboyant Gothic came into its own, with a multitude of churches. As the town spread and the population grew, new sanctuaries had to be built, and those which were too small were reconstructed or enlarged. The many still standing include: **Saint-Laurent**, **Saint-Médard**, **Saint-Germain-de-Charonne**, **Saint-Nicolas-des-Champs**, **Saint-Germain-l'Auxerrois**, **Saint-Séverin**, not to mention the later churches which will be discussed further on and where we will see tradition holding out against more modern tendencies. In Paris, Gothic lasted five centuries.

Compared to the churches of the great Gothic period, these buildings display a certain simplification with less stress on height and on the horizontal and vertical divisions, and more attention paid to the circulation, light, and above all the decoration, which is no longer solely didactic, a Bible in pictures, but ornamentation for its own sake, anecdotal and almost secular.

This flamboyant architecture continued throughout the century. The **Tour Saint-Jacques** went up between 1509 and 1523 and remained as refractory to Renaissance art as did the church of **Saint-Merri**, rebuilt between 1520 and 1552. In the latter, the complicated vaulting of the transept crossing, the window tracery, the sculptures of the portals demonstrate the persistence of Gothic.

But the most astonishing example of this survival of a style beyond its time is the church of **Saint-Gervais**, built between 1494 and 1657. While the facade will be dealt with later on, the building itself is pure Gothic, and even more strictly so than the buildings which preceded it: the flamboyant style seems to have fallen fom favor with a return to a purely classical Gothic.

This period has also left us a **cloister**, that of the **Billettes**, with its four galleries of six bays where the vaulting rests on ribbing with ornamental keystone bosses and the **refectory** of the Monastery of the **Cordeliers**.

The civil constructions of the 15th century were as numerous as the religious buildings. Even though much has been destroyed, outstanding examples of both

aristocratic mansions and more modest dwellings are still extant. Three great aristocratic residences, known as hôtels, preserved entirely or in part are the **Hôtel de Bourgogne**, the **Hôtel de Sens** and the **Hôtel de Cluny**. Jean sans Peur (John the Fearless) added a square tower to the building north of the Halles that belonged to the dukes of Burgundy. Inside, on the top floor, the newel of the spiral staircase branches out into oak branches which form the ribbing of the vault. These Gothic elements gradually lost their original purpose and were employed solely as ornamental motifs as dictated by the fantasy of the decorators.

Of the various prelates who had dwellings fit for great lords built in Paris, one was the archbishop of Sens. Construction of the Hôtel de Sens began in 1475. Unfortunately in the 19th and 20th centuries it was subject to excessive restoration and nothing of the original building remains except the silhouette, still picturesque with its gables, conical tower turrets and large dormer windows.

The best preserved of the Gothic dwellings in Paris is the hôtel built between 1485 and 1498 for the abbots of Cluny, of which the ensemble of buildings and the chapel still exist. Basically a comfortable town house, the Hôtel de Cluny affirms the importance of comfort, set as it is between court and garden, with wide windows, service areas, a large number of chimneys.

While the great lords and prelates lived in these more or less isolated mansions, the middle classes, artisans and shopkeepers lived in narrow houses, which we know were of stone at ground level, frequently with shops open to the street, and with overhanging upper stories in timber work, generally unplastered till the later Middle Ages. A triangular gable, symbol of economic well being, as stated in the French proverb (avoir pignon sur rue, meaning to have a house or business of one's own), rose up at the top, but was later prohibited by the municipal authorities who required the roofs to be parallel to the street. These houses were crowded together along narrow roads and the only squares in Paris were to be found at the crossings or in front of the churches. Renaissance architecture dedicated much of its efforts to a quest for space and light.

The quest for a new spirit

Without overly stresssing the aspects that characterized the artistic revolution known as Renaissance (influence of antiquity, individualism, prevalence of secular art) it should be noted that they arrived late, in particular in religious architecture, which continued to flourish. Churches were being built in Paris throughout the 16th century. Some, as previously mentioned, were purely Gothic in style while in others the new ideas gradually made headway. With the exception of the facade, the church of **Saint-Etienne-du-Mont** was built between 1492 and 1585. In plan and elevation, it is still a flamboyant Gothic structure, but various details herald the new style such as the passageways around the nave which communicate with the "jubé" or rood screen extended across the aisles, the last example of its kind preserved in Paris. Perhaps still odder is the case of **Saint-Eustache**, built between 1532 and 1640. There too the plan and elevation are traditionally Gothic, but the piers and small

columns have been replaced by antique columns and pilasters; a Gothic body clothed in Renaissance detail. In civil architecture the new style made its debut in the **Hôtel Carnavalet**, which adopted the layout of the Hôtel de Cluny, set between a court and garden. Low wings enclosed the court, with the one along the street serving both as isolation and defense for the mansion. At the same time work was going on in an exceptional construction yard, that of the **Louvre**. Francis I decided to rebuild the four-sided structure, entrusting the work to Pierre Lescot and Jean Goujon. In the end the work, completed by their successors, was four times the area of the medieval court.

Strength and splendor of the seventeenth century

When after ten years of civil war, Henry IV once more began building activities, the spirit of the times had changed. Antiquity was no longer fashionable, the elegance of the sculpture was thought superfluous. Architecture now depended more on the choice and contrast of materials, the cut of the stone, rather than the fantasy of the decorator.

The king wanted public squares and the finest was built in the Marais, establishing the canon for those that were to follow. *Place Royale*, at present **Place des Vosges**, is geometrical in plan with a series of uniform buildings set around the statue of the king. **Place Dauphine** dates to the same period. Triangular in shape, its access is flanked by two houses whose slate roofs, porticoes and moldings in stone, emphasize the red of the brick facades. The **Hôpital Saint-Louis** is also a sort of square, an austere quadrilateral with four corner buildings.

Henry IV's taste for the monumental is what characterizes the new works on the Louvre, which was joined to the Palais des Tuileries by a gallery along the Seine, the work of the architect Androuet Du Cercau, in a composite style which appears somewhat heavy, a sign that Renaissance architecture was dead. But the majestic equilibrium of the neoclassical period was yet to come.

The change in style took place with Jacques Le Mercier, commissioned by Louis XIII to continue work on the **Cour Carrée**, as well as building the **Pavillon de l'Horloge**, an elegant four-story structure topped by a dome. He was succeeded by Louis Le Vau, who completed the four-sided court, but without building the upper floor, so that the wings of the palace were nothing but empty boxes until the advent of Napoleon.

In the meanwhile, Salomon de Brosse had built the **Palais de Luxembourg** for Marie de' Medicis, with an entrance that consisted of a domed pavilion which led to the courtyard.

The affirmation of power in Paris coincided with the building of **palaces**: after the one built for **Marie de' Medicis**, comes the palace of **Cardinal Richelieu** and that of **Cardinal Mazarin**, which, after various transformations, now houses the **Bibliotèque Nationale**. After acquiring the **Hôtel de Chevry**, which is still extant, Cardinal Mazarin entrusted it to François Mansart for restructuring. Mansart added two superposed galleries, and as a result the gallery became an integral part of the great aristocratic mansions of Paris.

Any number of aristocrats and magistrates followed the example of the two cardinals and ministers. Vari-

ous members of the nobility had their houses built in Rue Saint-Antoine: the **Hôtel de Mayenne**, which suffered considerable alteration in the last century, the **Hôtel Sully**, by Jean Androuet Du Cerceau, which has maintained its original aspect intact, with its entrance portico, court, main body and orangerie.

The finest houses were built in the Marais, which had become the residential quarter of the aristocracy. The **Hôtel de Chalon-Luxembourg** has an outstanding portal with a lion head above a coat of arms; the **Hôtel de Saint-Aignan**, the work of Le Muet, is articulated by majestic Corinthian pilasters and also has an outstanding stairwell inside. In building the **Hôtel de Beauvais**, Lepautre exploited a sloping piece of ground to create a theatrical type of building with a great flight of stairs decorated by Desjardins.

But the loveliest town houses in the Marais of the first half of the seventeenth century are the **Hôtel Aubert de Fontenay** (at present housing the **Picasso Museum**), built in 1656 for the tax collector and known better as Hôtel Salé with reference to the taxes on salt of the time, with a facade flanked by sphinxes and crowned by a curved pediment, while inside is what may be the finest staircase in Paris, and the **Hôtel Amelot de Bisseuil**, known as *des Ambassadeurs de Hollande*, built around two courtyards and characterized by a decoration of small angels.

The works of François Mansart merit separate mention. These include the **Hôtel Guenegaud**, the **Hôtel Poulletier**, now unfortunately occupied by a fire station, the enlargement of the **Hôtel Carnavalet**, with the addition of the upper story on the low wing surrounding the court, and the **Hôtel d'Aumont**, in which Mansart succeeded Le Vau, with an elegant decoration of garlands and heads on the facades overlooking the court.

Other buildings went up on the Ile Saint-Louis, particularly for members of the Paris Parliament and the nouveaux riches. The two most important of the many that lined the banks of the Seine were by Le Vaux: the **Hôtel Lambert** and the **Hôtel Lauzun**.

Religious architecture seemed reluctant to abandon the Gothic prototypes, and the new style that eventually developed was the result of an adaptation of Italian models to French taste. It took three centuries before this French "baroque" was fully accepted and appreciated, for despite its harmounious proportions and wealth of decoration it was often scorned.

Various churches were either remodelled or continued in line with this new aesthetic canon. The church of **Saint-Gervais**, for example, with a facade built between 1616 and 1620, is a clear example of this break in style. The concept underlying the facade where the upsurge of the columns was counterbalanced by an affirmation of the horizontal lines contrasts sharply with the Gothic body of the church.

Religious architecture is characterized also by the appearance of the dome, as in the Carmelite church (**Carmes**) and in the churches of **Saint-Paul-Saint-Louis**, in that of the **Visitation**, the **Sorbonne** and the **Val-de-Grâce** with a particularly elegant dome which rises above the majestic facade of the monastery.

Louis XIV and Paris

Even though Louis XIV did not trust this unpredictable city, he was one of the kings who by his own will and through his ministers had the greatest impact on the urban landscape of Paris.

Once more work began with the **Louvre**, with the opening of the workyards for the construction of the **Galerie d'Apollon**. For the first time in Paris, all the artisans of the various branches of the decorative arts worked under the direction of a single man, Charles Le Brun. The sovereign wished to provide the **Cour Carrée** with a monumental facade on the entrance side, to the east. After an attempt by Bernini failed, Charles Perrault's **colonnade** was built, thus marking the affirmation of the French style.

In the same period, in 1663, Le Vau had undertaken the construction of the **Collège des Quatre Nations** on the other bank of the Seine. On the side overlooking the river, the building had a dome which crowned the chapel, flanked by two wings curved in quarter circles, while the buildings on the back developed around three courts.

It is thanks to the king himself that the building defined as the finest of the time went up in Paris. Up to then the veterans had been leading extremely meager lives and in 1670 Louis XIV decided to have a hospice built for them, commissioning the work from Libéral Bruant. The architect designed a building which united the idea of barracks and convent, with a large porticoed court at the back of which there was to be a chapel and a long facade with a triumphal portal. But this building was not considered sufficiently grandeloquent to celebrate the greatness of the monarch. At this point Jules Hardouin Mansart, grandnephew of François Mansart, was called in and outdid himself in this construction. After building the soldiers' church, he added another Greek-cross church on the south side, with a dome which, unlike those of the Sorbonne and the Val-de-Grâce, harmonized with the ensemble and crowned the south facade and which also fit in marvelously with Bruant's facade.

Counterpoint to the famous complex of the Invalides is the **hospital of the Salpétrière**, which originated as a clinic and a place of reclusion. Le Vau, and after him Libéral Bruant, built the structures in sober lines and with eight aisles in the chapel which rayed out to separate the various categories of pensioners.

The astronomers were provided with headquarters in the elegant **Observatory**, the work of Charles Perrault, who paid more attention to the proportions and decoration than he did to the use of the building. The times were not yet ripe for functional architecture: architecture was still meant to be evocative and impressive, as can be noted in the **Porte Saint-Denis** and the **Porte Saint-Martin** which harked back to Antiquity and were built in the form of triumphal arches.

Jules Hardouin Mansart was also responsible for the two royal squares, **Place des Victoires** and **Place Vendôme**, masterpieces of well balanced grandeur.

In plan and layout, private buildings greatly resemble those of the first half of the century, with a courtyard and a garden, the entrance door flanked by domestic premises, reception rooms and private quarters. New palaces were built in the Marais, which continued to be the residential quarter par excellence: the **Hôtel du Grand Veneur** (intendent of hunting of the crown), the **Hôtel Le Peletier de Saint-Fargeau**, **Hotel Presty**, and the **Hôtel Mansart de Sagonne** which was a symbol of the social and economic prestige of Jules Hardouin Mansart. But the new residences also tended to move westwards, around the quarter of the **Halles** (tenant apartment houses in Rue de la Fer-

ronnerie) or in the vicinity of **Place Vendôme** (house of Lulli in Rue Sainte-Anne). The **Hôtel de Laffémas** and the fine residence of the Le Brun family, by Boffrand, went up on the left bank of the Seine.

As the city grew, new parish churches were built and those no longer large enough were reconstructed, some of which remained unfinished: **Saint-Roch, Saint-Sulpice, Saint-Louis-en-l'Ile, Saint-Nicolas-du-Chardonnet**. On their part, the religious orders built the churches of **Saint-Jacques-du-Haut-Pas** and **Saint-Thomas d'Aquin**.

The eighteenth century - euphoria to austerity

Louis XIV died on September 1, 1715. His death co-incided with an evolution of style that had begun around a decade earlier. The architectural orders of antiquity were abandoned and the curve took over in the universe of the straight line. Examples of this rococo style, known as rocaille, are various mansions, the **Hôtels Chenizot, de Brienne, de Charolais, d'Estrées**, all to be found in the quarter of Saint-Germain, along the road that led to Versailles. But the **Hôtel de Soubise** and **Hôtel de Rohan**, characterized by the structural and decorative innovations of the first half of the century, are also in the Marais.

But another quarter, the **Faubourg Saint-Honoré**, was taking form at the same time. The finest mansion built there was the one we now know as the **Palais de l'Elysée**, at present the residence of the President of the Republic. Moving towards the center, one encounters the town **houses of Place Vendôme**, most of which date to the eighteenth century, with facades designed by Mansart.

This brief list makes it seem that the members of the aristocracy and the upper middle classes each had their own mansion, but actually many of these buildings were subdivided inside, and behind a prestigious address there was often nothing but a tiny attic apartment. Rented lodgings became widespread in this period, with separate apartments on different floors. Among the oldest examples are the houses in the area around the church of Saint-Gervais, in Rue François Miron.

In the field of religious architecture, the period of Louis XV, considered dissolute, witnessed the building of various churches: **Notre-Dame des Victoires, Saint-Thomas d'Aquin, Saint-Louis en l'Ile** were terminated in line with the original designs, but with a decoration more in keeping with the times.

Two churches stand out for their innovations. The original plan of **Saint-Roch** was transformed, and became more intricate. A series of chapels was added to the ambulatory: the **chapel of the Virgin**, the **chapel of the Communion** and the **chapel of Calvary**, with a scenographic effect of breaking up the internal space as if they were small apartments so in vogue at the time. In the church of **Saint-Sulpice**, Oppenordt took up work in line with the designs of the preceding century, but everything changed when the construction of the facade was commissioned from Servandoni, who added a large pediment, flanked by two baroque bell towers, which rose up over two superposed porticoes. But lightning destroyed the pediment and the two bell towers were replaced.

The clergy set about modernizing the Gothic churches, in particular **Saint-Merri**, where Michel-Ange Slodtz faced the choir with a decoration of marble and stucco. New convents were built, such as the one near the old **abbey of Sainte-Geneviève**, of which the imposing stairwell crowned by a dome supported by palms still remains. The building which houses the Ministry of Veterans has retained the magnificent external architectural order of the **convent of Pentemont**, in Rue de Bellechasse.

Neoclassicism

The style long known as "Louis XVI" had actually appeared way before the death of Louis XV. In Paris this artistic phenomenon appeared precociously, as witnessed by the **fountain of the Four Seasons** (fontaine des Quatre-Saisons) of 1734, based on new concepts, while many town houses continued to be constructed in line with the dictates of rococo. The new style is symbolized in Paris by two monumental works, both by Jacques-Ange Gabriel, the best known architect of Louis XV's reign: the military school (**Ecole militaire**) and the reorganization of the **Concorde**.

While his great grandfather Louis XIV had seen to the old soldiers, Louis XV wanted to help the future army officers and for the building in mind he also chose a piece of land with gardens on the left bank of the Seine. A fine view of the military school, with the central dome and flanked by two wings at right angles, can be had from the Place Fontenoy.

Place Louis XV, later **Place de la Concorde**, was conceived of as a royal square, with a geometrical plan, architectural uniformity and a statue of the king. Gabriel may be the first in the history of Parisian town planning to interest himself in the environmental impact and he built only on the northern part. But hoping to give the square a geometrical shape, he had perimetral ditches traced, which were later filled in.

The Mint (**Hôtel des Monnaies**) was built by Antoine according to the new architectural canons characterized by balanced masses, symmetry, the alternation of solids and voids. Antoine also worked on the Palace of Justice (**Palais de Justice**), where the facade at the top of a majestic staircase is surmounted by a dome and flanked by two lower wings set at right angles so as to leave the adjacent Sainte-Chapelle free.

The Doric order, highly fashionable at the time, appeared in the **Theater of the Odéon**, by Peyre and Nailly, but only in the peristyle, while in the remaining part the architects were more interested in the aspects related to the use of the building, such as circulation, communication passageways, fields of vision and acoustics.

The most important undertaking relative to the new artistic style is the transformation of the **Palais-Royal**, residence of the duke of Orléans. He commissioned the architect Louis to build tenant apartments around the garden, on a horseshoe plan with the portico articulated by pilasters in a colossal order.

This type of building continued to develop and many apartment buildings of this sort still exist. Construction however also continued in the field of aristocratic town houses which were characterized by an attempt to reconcile the magnificence of the reception rooms with the requirements of comfort and privacy. Living at the time was sweet. Among these mention

may be made of the **Hôtel du Chatelet**, the **Hôtel de Rochechouart** and those built by Brongniart in the zone overlooking the Boulevard des Invalides. One of the last great residences in the quarter of Saint-Germain, by Rousseau, was built in Rue de Lille for the prince of **Salm**: the entrance court, access to which is through a portal in the form of a triumphal arch, contrasts with the elegant back facade which overlooks the Seine.

As the Marais was abandoned, new quarters rose north of the great boulevards, characterized by small dwellings, refined both in their proportions and in their decorations, such as for example the **Hôtel Gouthiere** and the **Hôtel Botterel-Quintin**.

A typical construction of this period is the so-called folie, an elegant country house of small size, of which an outstanding example is the Folie of **Bagatelle**, built in sixty-three days by Bélanger.

Only one parish church was built in that period, **Saint-Philippe du Roule**, by Chalgrin, basic in the evolution of the basilican style which was to continue up to the middle of the nineteenth century.

As far as convent architecture is concerned, the most noteworthy event of the time was the reconstruction of the abbey church of **Sainte-Geneviève**, at present **Pantheon**, entrusted to Soufflot, who intended to unite "the lightness of the Gothic buildings with the purity of Greek architecture". Although subsequent modification altered the initial project, the building has retained an exceptional feeling for space and balance.

In the last years of the Ancien Régime, a purely functional work was commissioned from the visionary Ledoux: new city walls for Paris articulated with pavilions at the various points of entrance. He realized forty-five monumental structures, each different from the other, of which only four have survived.

Napoleonic Paris

Apart from works of a functional nature, which will be dealt with elsewhere, the Emperor wanted to furnish the capital with prestigious monuments. Vignon erected the **Temple of Glory**, which then became the church of the **Madeleine**, finally finished in the period of Louis Philip. Symmetrical with this, Poyet built the new facade of the Chamber of Deputies (**Chambre des Députés**) and, paradoxically, Brongniart made the new building of the **Stock Exchange** look like an ancient temple.

Napoleon moreover wanted to terminate the complex of the **Louvre** and the **Tuileries**. He succeeded only in having a triumphal entrance built for the Palais des Tuileries, the **Arc du Carrousel**, and the wing of the Louvre overlooking Rue de Rivoli.

Today, by Arch of Triumph, one means in particular the Arc de Triomphe de l'**Etoile**, built by Chalgrin for Napoleon, on the top of the hill of the Etoile, in a perspective line with the Tuileries, characterized by a single central passageway in its mass.

Hereditary monarchy and bourgeois monarchy

The Bourbons summed up their two basic concepts of monarchy and religion in their Paris structures, with the erection of new royal statues and new churches, including **Saint-Vincent de Paul**, by Lepère and Hittor, and the **Expiatory Chapel**, with all its memories.

Louis Philip's monumental policy was aimed at reconciling the various tendencies of thought of the period. In deference to the Republicans, he had the **column of the Bastille** erected while to reconcile the Bonapartists he finished the monuments begun by Napoleon, in honor of whom he had the grandiose **tomb of the Invalides** built. A rebirth of the taste for Gothic art led to imitations, of which the church of **Sainte-Clotilde** is an outstanding example, and to works of restoration, bound to the name of Viollet-le-Duc, who worked at Notre-Dame for twenty years.

Even so there were also architects who sought out original solutions, such as Labrouste, entrusted with the construction of the **Library of Sainte-Geneviève**, where construction materials such as iron, stone and glass were rationally used.

The glory of the Second Empire

In less than two decades, Napoleon III and Haussmann were responsible for an enormous transformation of the city, positive in many ways, which will be dealt with elsewhere. The laying out of streets and the tearing down of buildings accompanied the construction of countless public buildings, all in the service of a political idea. Churches built for the conservatives and traditionalists were marked by a mixture of styles where the innovative tendencies, such as in **Saint-Eugène** and **Saint-Augustin**, characterized by a generous use of elements in iron and cast iron, in part dissimulated, were of note.

The **Louvre-Tuileries** complex was also completed in this period, three and a half centuries after Henry IV's interventions. Lefuel, in line with Visconti's plan, built two imposing wings on either side of the central space which were solid and harmonious although slightly overloaded.

The merit for offering Paris the privilege of an exceptional monument in this period however goes to Charles Garnier, with his theater of the **Opéra**. The validity of the design, with a mass rigorously articulated by the spaces, is associated to an astounding anthology of decorative elements as symbol of a joyful and at the same time irresponsible society.

Other buildings of the time, both in classical taste (**Palace of Justice**) and modernistic (**Gare du Nord**), testify to the importance of building well and to the taste for monumentality.

Paris of the Expositions

A trend for innovation was affirmed in the Expositions of 1878 and 1889, a sign of the rebirth of France. The most typical example is the **Eiffel Tower**, a masterpiece of engineering. The Exposition of 1900, where the decorative effect was of greater importance, left us buildings characterized by innovative techniques, which employed metal elements, skilfully hidden by stone, as in the **Grand Palais**, the **Gare d'Orsay** or, at least in the case of the **Pont Alexandre III**, faced with a copious decoration. At the same time, while public

buildings such as the **Hôtel de Ville** (Town Hall), the church of the **Sacré Cœur** and the **Sorbonne** were invaded by a wave of eclectism or expressed the last gasps of a dying academicism, private building experimented new formulas, both in the large Department Stores and in the apartment houses where the **Art Nouveau** of Guimard and Lavirotte flourished. This new naturalistically inspired type of "baroque" decoration scandalized our grandparents, amused our parents and fascinates us today.

While iron gives an idea of lightness and delicacy, concrete imposes rigor and exalts the straight line. This new building material, "launched" by A. de Baudot in the church of **Saint-Jean de Montmartre**, was then used by A. Perret in the **building in Rue Franklin** and subsequently in the **Theater of the Champs-Elysées**, built in 1912 but which looks twenty years younger.

The uncertainty of the first postwar period

The hesitation and negligence which characterized French politics between 1918 and 1939 are also evident in the architecture. A few **museums** can be cited as examples: the **Musée des Colonies**, built for the 1931 Exposition and the museums of the new **Palace of Chaillot**. The **Museum of Modern Art** is of elegant aspect with two bodies united by a colonnade, but the distribution of space is disastrous. The only museum worthy of the name is the **Musée des Travaux Publics**, begun by A. Perret, but which was never finished and was therefore dismantled. Perret however managed to complete the building of the **Mobilier National**, where the furnishings of the state owned public buildings are kept.

Better results were obtained in the field of school and university architecture. Airy, brightly colored and decorated schools were built, while in the **Cité Universitaire** Le Corbusier designed a Swiss Pavilion (**Pavillon suisse**) which is a true manifesto of architecture and exerted great influence.

Architecture in Paris of this period between the two great wars can be defined as a permanent conflict between the innovatory architects Perret, Le Corbusier, Sauvage (**stepped building in the Rue Vavin**), searching for a new ethic and new materials, and the traditionalists, such as Roux-Spitz, who tended to reassure the patron conferring a "modern" appearance on buildings which were still basically rooted to a classicist mentality.

An architecture for our times

Parisian architecture, in the half century that has passed since the end of the war, is characterized by two periods. The first, from about 1950 to 1970, witnessed the rise of uniform barrack buildings, in an attempt to handle the deterioration of the aging city buildings and the crisis in living quarters, and towers such as the **Tour Montparnasse** and the complex known as *Front de Seine*, now under attack, as well as large public buildings, some of which marked our epoch: the **Unesco** building (architects Breuer, Nervi, Zehrfuss, 1958), the **Maison de la Radio** (Bernard,

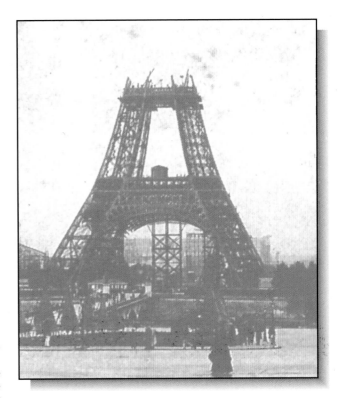

The Eiffel Tower in construction.

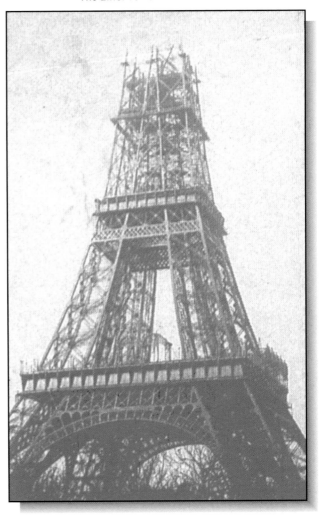

15

1963), the **Convention Palace** (Palais des Congrès, Gillet, 1972), the **seat of the Communist Party** (Niemeyer, 1972), the **stadium of the Parc des Princes** (Taillibert, 1972).

The second period, corresponding to the last two decades, has generated a type of town planning that is more human, more aware of the environment, with a more refined architecture, in contrast to some of the monumental structures which are often aggressive: **Centre Beaubourg** (architects Piano and Rogers, 1977), the **Cité des Sciences et des Techniques** at La Villette (Chaix, Morel, Fainsilber, 1985-86), the **Institute of the Arab World** (Nouvel, 1987), the **Palais des Sports de Bercy** (Andrault and Parat, 1984), the new **Ministery of Finances** (Chemetov, 1989), the **Pyramid of the Louvre** (Pei, 1989), the **Opéra de la Bastille** (Ott, 1989), the **Bibliothèque de France** (French Library), still under construction (Perrault) and the **Charles de Gaulle Bridge** (Arretche).

After two thousand years, Parisian architecture still continues to manifest its vitality and its first concern, that of best providing shelter for all of man's activities.

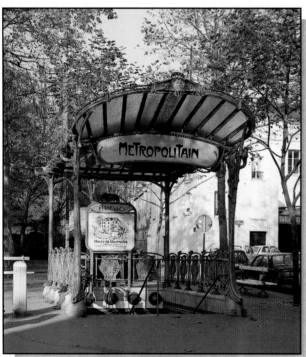

Nineteenth-century urban decoration...
...and early twentieth-century Art Nouveau.

The Artists of Paris

For two centuries art has centered on Paris, the city of their choice for artists, and although in various periods there were minor provincial centers, the story of French art was written above all in the capital. In particular, the development of painting in Paris encompasses practically all French painting, while Le Brun, Fragonard, Renoir, Picasso are part of the history of French art in general, without a specific localization. Their work and their influence therefore lie outside the limits of our theme.

On the other hand, Paris entrusted the decoration of its monuments to specific artists, who decorated them respecting the design, the mass and the use for which they were destined, with a style that had generally been assimilated in the Parisian workshops. In the arc of a thousand years Parisian artists in all fields have contributed to enhancing not only the beauty of the buildings but also their meaning.

The work of the medieval artists has for the most part disappeared. Nothing remains from the Romanesque period but the early capitals of Saint-Germain-des-Prés. Their theatrical almost aggressive realism make us regret all the more the disappearance of other works of the time.

In Notre-Dame, a sort of great orchestra in which each artist had his part to play, little has remained of the monumental decoration. Painted decoration has completely disappeared, the works of the goldsmiths have almost all been destroyed while sculpture suffered incredibly in the period of the Revolution. Notwithstanding, in the field of sculpture the decoration of the gables remains as a book of mystical images, while the heads of the statues in the gallery of kings miraculously returned to light not so many years ago. This early Gothic sculpture appears in the representations of harpies in the choir of Saint-Julien-le-Pauvre or on a capital in Saint-Germain-de-Charonne decorated with vine leaves, ferns and clover, directly inspired by the plants which grew around the village of the time.

Of the 13th-century windows of the cathedral, the three rose windows on the west, north and south have survived; the north rose window, the best preserved, depicts figures of the Old Testament, judges, kings and prophets.

Art in the time of Saint Louis reached its high point in the Sainte-Chapelle, with the capitals which illustrate the flora of the Ile de France, the region of Paris, while the statues of the apostles are set elegantly against the columns. But it is above all the stained glass which triumphs in its incredible wealth of colors to begin with the *Nativity* up to the Vision of *Saint Louis holding the crown of thorns*. The portal of the refectory of Saint-Martin-des-Champs dates to the same period. Here the flowers and ivy and grape leaves carved in the soft stone are the last remembrance of the green of the countryside which at the time surrounded the abbey.

In the 14th century the decorative arts, above all sculpture, attempted to free themselves of architecture and take on a life of their own. After the figure of the Madonna on the door of the cloister of Notre-Dame, an inseparable part of the architecture, come the statues in Saint-Germain-des-Prés and in the cathedral itself: individual figures, in the typical S-curve posture, sometimes smiling, and with a life of their own. Again in Notre-Dame, the bas reliefs of the choir enclosure depict religious scenes that in their narrative quality betray the influence of the dramatic representations of the time.

The tendency to realism and the picturesque is intensified in the subsequent period, in the decorations in flamboyant Gothic style. Among the outstanding examples are the external frieze on the apse with radiating chapels of Saint-Laurent, a sort of comic strip with animals and picturesque figures, the decorated pendants of Saint-Germain-de-Charonne, the old wings of the door of Saint-Nicolas-des-Champs, the porch of Saint-Germain-l'Auxerrois with its sculptured keystones and its famous statue of *Saint Mary of Egypt* carrying the three loaves of bread which were to nourish her in the desert, and in the same church, a series of anecdotal sculptures scattered over the spires and the gargoyle water spouts, where parables are shown in the guise of fables. Lastly other sculpture, richly ornamented water-spout gargoyles and baldachins appear in Saint-Séverin.

Fortunately a considerable number of stained-glass windows of the late 15th and early 16th century have been preserved, evidence of the successful development of this art towards a pictorial technique of a more secular inspiration and glorying in color. The churches of Saint-Séverin, Saint-Merri, Saint-Gervais, Saint-Germain-l'Auxerrois preserve these great luminous pages, less mystical than those of the Sainte-Chapelle, but still extremely fascinating.

Sculpture also appears on civil structures, as witnessed by those still extant. The sculptural decoration with secular motifs that were often imaginative of the Hôtel de Cluny stresses the role assigned to the building, with its amenities, comforts, moments of splendor and its feeling of protection.

The Renaissance imposed a decoration of a secular nature, inspired by antique models, on all the new buildings. Superficial elegance and proportions were more important than deeper meanings. This tendency also comes to the fore in religious buildings, such as for example the "jubé" or rood screen between the choir and the nave of Saint-Etienne-du-Mont, where the two depictions of *Fame* on the cornerstones, with free-flowing hair and uncovered breasts, for the first time in Paris introduce the Renaissance spirit into a medieval religious environment.

The great sculptor of the period is Jean Goujon, known for his free-flowing drapery and poses which testify to his mastery of drawing and the chisel. For the jubé of Saint-Germain-l'Auxerrois, no longer extant, he made elegant bas reliefs, now in the Louvre, while those of the Hôtel Carnavalet are still in situ. The large figures of the *Seasons*, which may not be by his hand, are particularly famous. But the elegant nymphs of the fountain of the Innocents which symbolize the fluidity which the fountain lacks are also by Jean Goujon. With this small monument, the taste for antiquity, the new secular and almost sensuous art was publicly affirmed. We encounter Jean Goujon again as collaborator of Pierre Lescot who was entrusted with restructuring the Louvre, and where his elegant, slender figures, in an almost imperceptible relief in the lower floors, more distinct and scenographic in the attic, are so perfectly integrated with the monumental structure that the question arises as to just what is to be attributed to the architect and what to the sculptor, so perfect is the collaboration between the two.

Another ornamental motif of Italian inspiration, to be found in some of the French châteaux of the time, appears in the Gobelins quarter, in the town house known as that of Scipion Sardini, where who the personages depicted in the terracotta medallions are still remains a mystery, despite all attempts at research.

Other late 16th-century stained-glass windows worthy of note, fill the five upper windows of the choir of Saint-Etienne-du-Mont, representing the *Apparitions of Christ*, where a love of detail fuses with the concept of monumentality.

As far as civil architecture is concerned, the interior decorations of the Louvre have been preserved only in a fine ceiling by Scibec de Carpi and not until the seventeenth century can a few more complete examples of interior decoration of royal or aristocratic palaces and residences, be found: with gold-ground decorative woodwork and picturesque or fantastic motifs as in the Luxembourg palace, the Arsenal or, later, the Hôtel Lauzun.

Although sculptors and decorative painters of the period were generally Parisians, the temporary void that was created in the school of French painting left no choice but to turn to foreign artists. The best known example regards Rubens, called in to decorate a gallery in the Luxembourg Palace with monumental theatrical canvasses, but other Flemish artists decorated the ceilings of Luxembourg and of the chapels of the Carmes, while the Italian Romanelli collaborated with the sculptor Anguier in the decoration of the ceilings of the apartments of Anne of Austria in the Louvre and in Mazarin's town house, at present seat of the Bibliothèque Nationale.

Parisian decorators, the painters and sculptors, were quick to take over the market, ready to set to work on the new town houses in the Marais. While many of these buildings have lost their decoration, a few examples are still left, such as, for example, the gallery of the Hôtel des Ambassadeurs de Hollande, frescoed by Michel Corneille and, in particular on the Ile Saint-Louis, the decoration of the Hôtel Lambert and the Hôtel Lauzun. The former, although it has lost the paintings of the famous cabinet of the Muses, still has the gallery decorated with paintings and sculpture, where Le Brun and Van Opstal narrated the Stories of Hercules with a pomp that recalls that of the château of Vaux-le-Vicomte and the palace of Versailles. The Hôtel Lauzun has no galleries but a series of rooms which bear witness to the perfection achieved by interior decoration in the first half of the century. The gilded decorative woodwork framing intarsia landscapes, the sculptured decorations over the doors, the painted ceilings constitute a glittering, at times slightly heavy, ensemble, lacking in balance and proportions, but full of fantasy and highly inventive. This type of decoration, often painted on wood, appears in some of the private chapels attached to churches (Saint-Gervais).

The art of stained glass had for some time been emitting its last gleams with a topical and showy style taken over from painting. The stained-glass windows of the porticoed gallery behind the choir of the church of Saint-Etienne-du-Mont might be taken as an example, full of highly colored and picturesque images which lend a rather esoteric air to religion, as in the case of the *Mystical Press*.

The Louis XIV period turned to decoration in a grandiose and triumphalistic sense, with saints and angels in the dome of the church of the Val-de-Grâce, by Mignard, and in the perfectly composed pictorical and sculptural complex of the dome of the Invalides, while mythological divinities decorate the painted ceilings of the Hôtel de Sagonne. The ability of the decorator is in being able to skilfully distribute the figures over a surface without attracting attention to one particular detail.

And it is the decorators who appear as executors in transforming the medieval churches at the behest of the clergy. For a long time these transformations were judged negatively but now it sometimes seems regrettable that they are no longer there. The choir of the church of Saint-Merri has retained the stuccoes and polychrome marbles, but the uncompromising theories of Viollet-le-Duc, who was entrusted with restoration in the nineteenth century, have deprived us of the decoration of the choir of Notre-Dame, carried out between 1699 and 1714 by Jules Hardouin Mansart and Robert de Cotte. Only part of the choir stalls, masterworks of early eighteenth-century wood sculpture, have been preserved, in addition to the famous statues by Coysevox and Coustou.

At the time decorative woodwork played an important role in the decoration of religious buildings. Worthy of mention are the stalls and churchwardens' pews in the churches of Saint-Gervais, Saint-Germain-l'Auxerrois, Notre-Dame-des-Victoires, the sculptured panels which accompany the great canvasses of Van Loo, rare examples of religious painting still in situ.

An entire chapter should be dedicated to funerary sculpture of the period. It is curious that in the century in which the habit of erecting monumental tombs for deceased sovereigns in Saint-Denis fell into disuse, countless fine tombs were erected in the churches of Paris to commemorate the dead: nobles, military chiefs, ministers, prelates and simple bourgeouis citi-

zens. The tombs of numerous personages can be discovered in visits to Saint-Germain-des-Prés (king Casimir, the Castellan brothers), Saint-Nicolas-du Chardonnet (Le Brun's mother), the Invalides (Turenne), the Sorbonne (Richelieu), the Istitut (Mazarin), Saint-Eustache (Colbert), Sainte-Marguerite (Girardon's wife) and lastly Saint-Roch, a real museum of funerary sculpture of the seventeenth and eighteenth centuries. Little by little the visitor, apart from the vistas of new streets and automobiles, can reconstruct the appearance of this city in the times of the Ancien Régime, observant of the political and religious order, conventional and extravagant, which concealed the misery of a great part of the population behind a splendid facade, and which long succeeded in having it forgotten or go unrecognized.

In the subsequent century, this religious decoration was subject to an extravagant, at times disorderly and spectacular, development. An interesting example is the pulpit in rococo style of the church of the Blancs-Manteaux, or, in Saint-Sulpice, the tomb of the parish priest Languet de Gergy, disputed by death and the angel of the Resurrection, both extremely rhetorical in style.

In the meanwhile decoration of private houses had developed in line with the fashions of the time, fleeting as they might be. On the facades of the town houses the stone was turned over to the sculptors whose task was to enliven and complete them. In the Hôtel de Rohan, one among many, the building overlooking the court-

yard of the stables, elegant in proportions and in the silhouette of the roof, the bas-relief of the Steeds of the Sun glows like a jewel, highly theatrical in its effect, a work by Robert Le Lorrain, a brilliant note in the subdued harmony of the latter part of the reign of Louis XIV.

Wainscoting, a fundamental element in the furnishings of the eighteenth-century palaces, predominates in the interiors. While originally it was a simple facing meant to offer protection from the cold and humidity, subsequently it became a showy ornamental element, on which the wood carver, with the precision of an engraver, executed intricate moldings in soft woods to frame motifs of various types, often asymmetrical in the Regency, subtle reliefs enriched and embellished by the application of gold leaf, at times in various hues.

The panels in the salon of the Ambassadors in the palace of the Elysée merit mention. The work of Lange and Hardouin, they are decorated with trophies which evoke the booty of a battle fought with golden weapons. The masterpiece of Parisian decorative woodwork however is undoubtedly the apartment of the princess of Soubise, with the splendid decorative cycle that was realized between 1730 and about 1740, at its best in the oval Salon, in which Natoire, narrating the *Story of Psyche* framed by stuccoes and gilded panels, reached what may be called the zenith of what decoration could achieve before becoming bombastic and redundant.

Of the interior decoration of the Hotel de Rohan, the

In his painting Atelier aux Batignolles Henri Fantin-Latour portrays Manet, Monet, Bazille, Renoir, Scholderer, and some of Manet's friends.

Room of the Monkeys is still extant in addition to the staircase. The former was painted by Huet between 1749 and 1752 and in these panels the sculptor left the field to the painter, charged with manifesting in a joyous decoration the interest of the period for exotica, travel and adventure.

The neoclassic period preferred a different type of decoration, more sober, orderly, with more space reserved for sculpture. In this context the fountains of the dining room of the Hôtel du Chatelet are justly famous. But decorative painting retaliated in the chapel of the Souls in Purgatory in the church of Sainte-Marguerite, where Brunetti created an illusionistic decoration using the *trompe l'œil* technique, and in the interiors of the mansions in the quarter known as *Nouvelle France*.

Outstanding decorative cycles have also been preserved from the early nineteenth century, no less significant from a political and social point of view: the staircase and the Murat salon in the Elysée, the interiors of the Hôtel Bourrienne and the Hôtel de Beauharnais, the Egyptian Gallery of the Louvre, the decorations in the churches of the period of the Restoration, in which painting begins to prevail.

It was, to all effects, the beginning of a golden period for decorative painting and in those fifty years the churches of Paris were furnished with paintings of a religious nature which are only now beginning to be discovered. They were painted by some of the leading artists of the time. Flandrin painted the rows of serene and majestic saints in Saint-Germain-des-Prés, Chassériau created sumptuous orientalizing figures in Saint-Philippe-du-Roule but they were all outclassed by Eugène Delacroix in the church of Saint-Denis-du-Saint-Sacrement, whose *Lament over the Dead Christ* is a highly colored tragedy. But works for civil buildings were also commissioned, such as the central decoration of the Galerie d'Apollon in the Louvre, where the artist successfully succeeded in integrating his work with Le Brun's composition which dated to two centuries earlier, the two cupolas of the library of Luxembourg and, in particular, the outstanding pictorial cycle in the library of the Palais Bourbon, considered the French Sistine Chapel. Delacroix concluded his career in the chapel of the Angels in the church of Saint-Sulpice, where his *Jacob wrestling with the angel* seems to symbolize his own inner conflicts.

At the same time Ingres, his old rival, designed the stained glass for the chapel of Notre-Dame-de-la-Compassion in commemoration of the death of the duke of Orléans.

The sculptures of the Arch of Triumph represent another great moment for the decorative arts, perfectly in harmony with the spirit of the monument that made them famous. One of the major works of French sculpture - the *Marseillaise* by Rude - presents itself to all those who pass by, much like the majestic pediment of the Pantheon, by David d'Anger.

In these same years Viollet-le-Duc was restoring Notre-Dame and taking on the difficult task of renewing the sculpture that had disappeared during the Revolution. A whole team of stone cutters set to work under his authoritative direction and produced acceptable imitations, letting their imagination run free in recreating the fantastic chimaerical figures which decorated the cathedral towers at their base.

The Second Empire generously opened the doors to artists of all fields, who brought show, life, the joy of living and color to the Louvre which had been newly renovated, and the facades were decorated and sometimes rather weighed down by sculpture, which has today been rediscovered, to the theater of the Opéra, where Carpeaux's sculptural group of the *Dance* rises as a symbol of this joyous art to which the whole building is dedicated, and in the hôtel of the marquis of Païva. An ideal example of interior decoration commissioned by power for power might be the conference hall of the Luxembourg palace, which probably contains the most complete decorative cycle of the period, of a rather gaudy sumptuosity. But in the salons of the Rivoli wing of the Louvre or those of the *Maison Opéra* that same feeling of prescribed sumptuosity and technical virtuosity prevails.

The dramas of the Commune of Paris made it necessary to open new construction yards, such as for example for the reconstruction of the Hôtel de Ville (Town Hall), where the interior and exterior decoration are in a sense a manifesto of the official art of the times. Long looked at askance or ridiculed, this architectural complex today appears well balanced, homogeneous, and perfectly suitable to its role of public building.

In the period of Haussmann, real estate was built along particularly rigid rules and left little room on the facade for decoration. But the building norms were liberalized in 1884 and in 1902 and as a result an entire sculptural repertory of plant motifs and human figures appeared on the facades. In particular, a motif that had been forgotten since the 17th century once more came back into vogue: the caryatid. They were used in pairs, at times gesticulating, at times impassible, joyous or serene, to frame portals, support cornices or balconies, conferring an animation and a liveliness to the streets of Paris which forced its way into the attentions of the passers-by.

And the taste for ornament, for an ornament strictly tied to and integrated with architecture, reappeared in the early years of the twentieth century in the form of the artistic expression known as *Art Nouveau*. Iron, ceramics, glass, sculptured stone became subject to the curve and to color with an authentic lyricism, as for example in the facades of the buildings by Lavirotte, or the métro entrances designed by Guimard, to enhance the gestures of normal everyday life. This floral exuberance naturally led to a reaction in the sense of a return to a neoclassic rigor, as can be noted in the Theater of the Champs-Élysées, where Bourdelle successfully integrated hieratic personages into an architecture characterized by large bas-reliefs.

Subsequently this will for integration seems to have disappeared. The sculpture of the Palais de Chaillot, dating to 1937, well made and an exemplary example of the rather cold classicism of Rodin's successors, look more like a later addition than an integral part of the building. The works of art created for the UNESCO headquarters in the Fifties are independent and practically extraneous to the building. The stained-glass windows designed by Bazain for the church of Saint-Séverin (1966-68) have at one and the same time been the object of praise and of scandal, like the columns installed by Buren in the court of the Palais-Royal in 1986. But the door remains open to new ideas, for the greater glory of the new Parisian artists.

Georges Poisson
Conservateur Général du Patrimoine

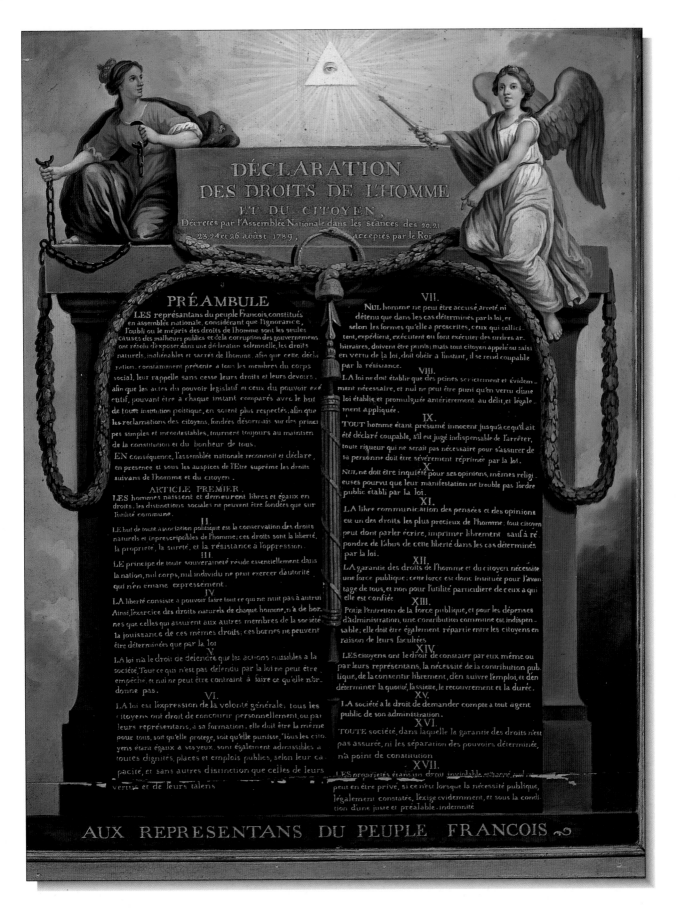

The Declaration of the Rights of Man.

Ile de la Cité

Notre-Dame -
Conciergerie -
Palace of Justice -
Sainte-Chapelle -
Ile Saint-Louis

The Pont-Neuf
◆◆ 36

The Sainte-Chapelle
◆◆ 32

The large building,
headquarters of the
Police Prefecture, stands
on the west side of Place
du Parvis Notre-Dame,
across from the cathedral

The statue of
Charlemagne,
crowned emperor
of the Holy Roman
empire in the year
800, stands on the
south side of Place
du Parvis Notre-
Dame

The statue of Henry IV
◆◆ 36

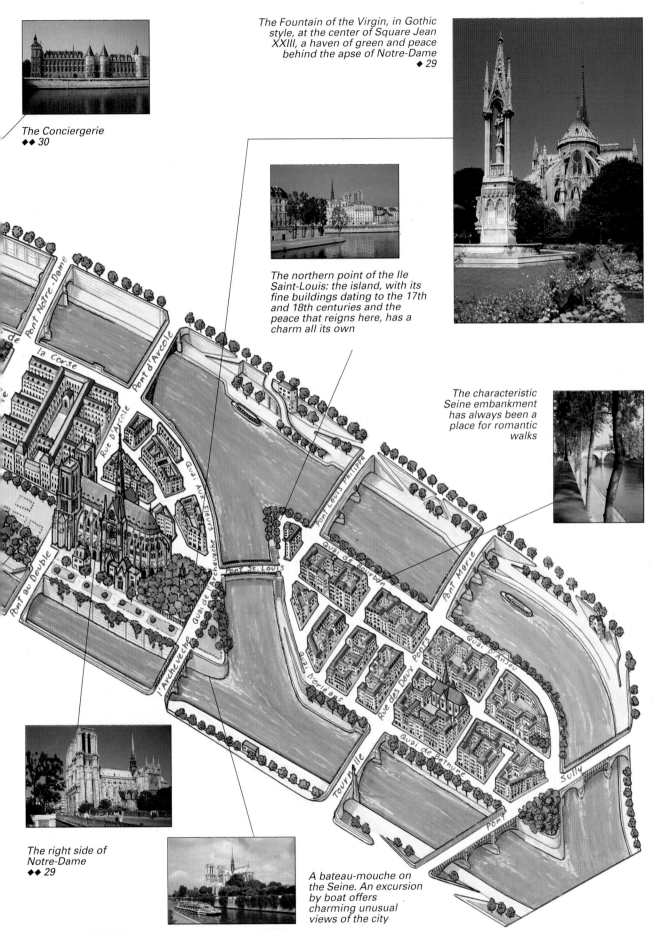

The Conciergerie
◆◆ *30*

The Fountain of the Virgin, in Gothic style, at the center of Square Jean XXIII, a haven of green and peace behind the apse of Notre-Dame
◆ *29*

The northern point of the Ile Saint-Louis: the island, with its fine buildings dating to the 17th and 18th centuries and the peace that reigns here, has a charm all its own

The characteristic Seine embankment has always been a place for romantic walks

The right side of Notre-Dame
◆◆ *29*

A bateau-mouche on the Seine. An excursion by boat offers charming unusual views of the city

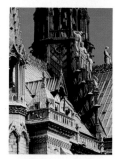

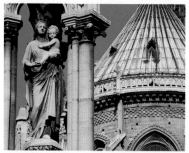

NOTRE-DAME

Built on the site of a Christian basilica which had been occupied previously by a temple dating from Roman times, the church was begun in 1163 under Bishop Maurice de Sully, work commencing from the choir. As time passed the nave and aisles followed, and finally the facade was completed in about 1200 by Bishop Eudes de Sully, though the towers were not finished until 1245. The builders then turned to the construction of the chapels in the aisles and in the choir, under the direction of the architect Jean de Chelles. In about 1250 another facade, that of the north arm of the transept, was completed, while the facade on the south arm was begun some eight years later. The church could be said to be finished in 1345. With the ravages of time and damages caused by men and by numerous tragic wars, the church's original appearance changed over the centuries, especially during the Revolution: in fact, in 1793 it ran the risk of being demolished. Notre-Dame at that point was dedicated to the Goddess of Reason, when Robespierre introduced this cult. But it was reconsecrated in 1802, in time for the pomp and ceremony of the coronation of Napoleon I by Pope Pius VII in 1804. It underwent a definitive restoration by Viollet-le-Duc between 1844 and 1864, and it was threat-

Details of the cathedral of Notre-Dame and a fascinating view at night.

The majestic and imposing facade of Notre-Dame. The remains of dwellings 2000 years old were found under the parvis.

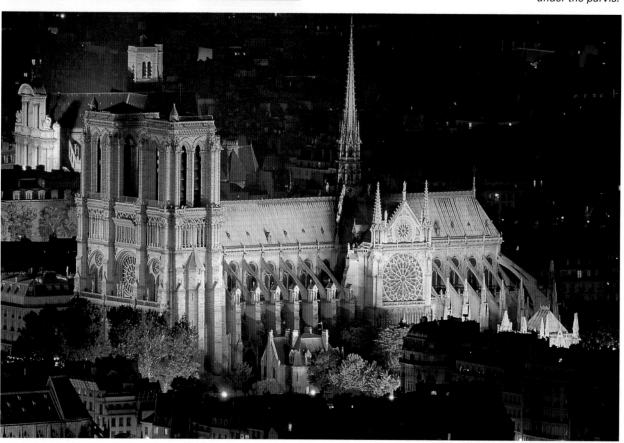

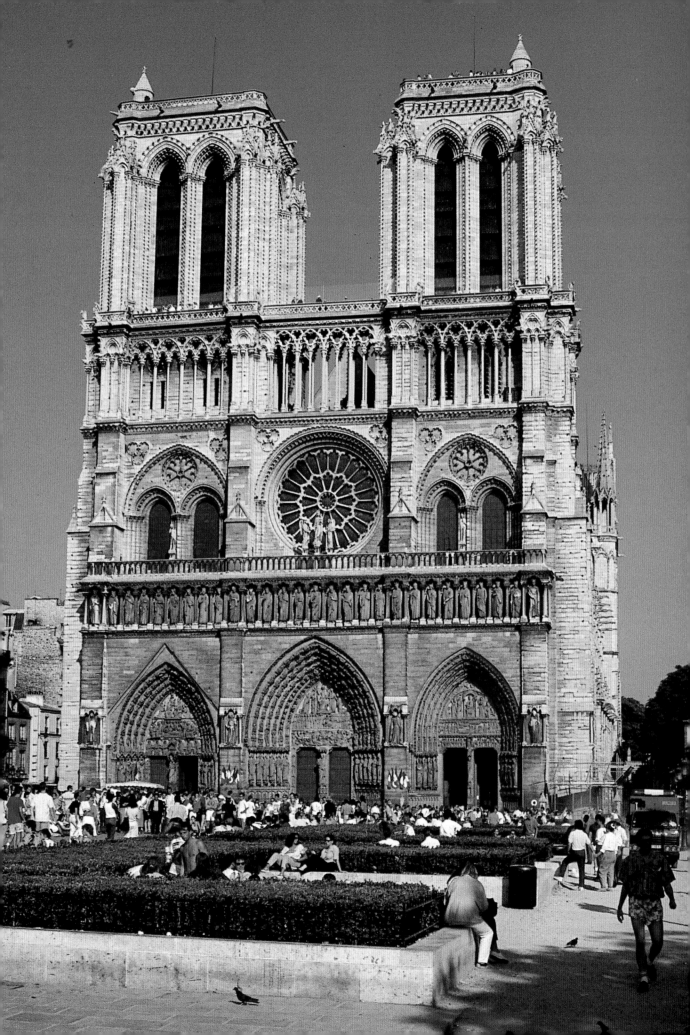

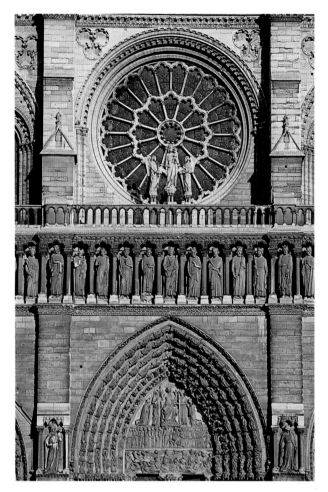

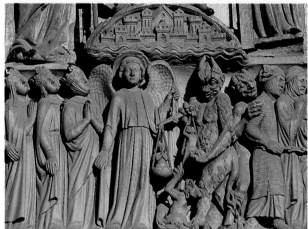

Above and on the facing page. Details of the facade, with the magnificent rose-window with the gallery of 28 statues of the kings of Israel and Judaea below, and the imposing portals, richly sculptured in the lunettes and in the embrasures.

ened with destruction by fire in 1871. Imposing and majestic in its stylistic and formal consistency, the facade of Notre-Dame is divided vertically by pilasters into three parts and also divided horizontally by galleries into three sections, the lowest of which has three deep portals. Above this is the so-called Gallery of the Kings, with twenty-eight statues representing the kings of Israel and of Judaea. The Parisian people, who saw in them images of the hated French kings, pulled down the statues in 1793, but during the works of restoration at a later stage they were put back in their original place. The central section has two grandiose mullioned windows, on each side of the rose-window, which dates from 1220-1225 and is nearly 33 feet in diameter. This central section is also adorned by statues of the Madonna and Child and angels in the centre and of Adam and Eve at the sides. Above this runs a gallery of narrow, intertwined arch motifs, linking the two towers at the sides which were never completed but which, even without their spires, have a picturesque and fascinating quality with their tall mullioned windows. Here Viollet-le-Duc gave free rein to his imagination: he created an unreal world of demons who look down with ironic or pensive expressions on the distant city

below, of birds with fantastic and imaginary forms, of the grotesque figures of leering monsters, emerging from the most disparate and unlikely points of the cathedral. Crouching on a Gothic pinnacle, half-hidden by a spire or hanging from the extension of a wall, these petrified figures seem to have been here for centuries, immobile, meditating on the destiny of the human race which swarms below them.

Detail of the portal. The Gothic style of these portals (dating from about 1220) is characterised by a softer and more direct way of looking at and interpreting nature, whereby the material is used to create more delicate forms and the space between one figure and another is more freely distributed. On the central portal is the subject perhaps best loved by the Gothic artists, that is, the Last Judgment. On the pilaster which divides it in two is the figure of Christ, while on the embrasures are panels with personifications of the vices and virtues and statues of the Apostles. Figures depicting the celestial court, Paradise and Hell are sculpted with great skill around the curve of the arch. The lunette with the Last Judgment is divided into three sections and is dominated by the figure of Christ, at whose sides are the Madonna, St. John and angels with symbols of the Passion. Beneath this on

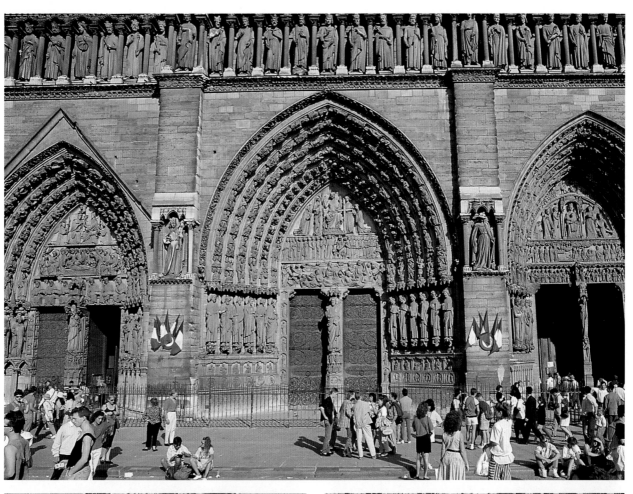

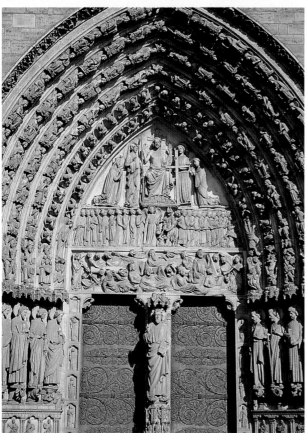

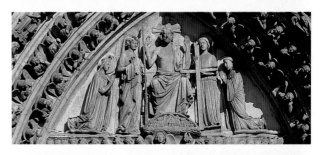

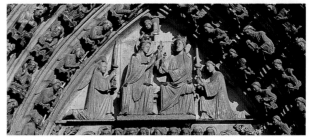

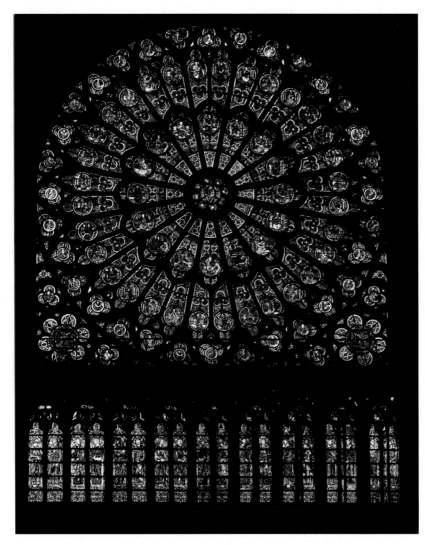

The south rose-window, about thirteen meters in diameter, and the statue of Our Lady of Paris (Notre-Dame-de-Paris) set against a pier to the right of the transept.

one side are the blessed who have merited salvation, and on the other side the damned being dragged towards their final punishment. In the lower strip is the Resurrection. The right-hand portal, called the Portal of St. Anne and built between 1160 and 1170, has reliefs dating from the 12th and 13th centuries, with a statue of St. Marcel, bishop of Paris in the 5th century, on the pilaster which divides it. In the lunette Our Lady is depicted between two angels and on the two sides are Bishop Maurice de Sully and King Louis VII. The third portal, the one on the left, is called the Portal of the Virgin and is perhaps the finest of the three because of its epic tone and the solemn grandeur of its sculpture. On the dividing pilaster is a Madonna and Child, a modern work. In the lunette above are the subjects dear to the iconography of the life of the Virgin, including her death, glorification and assumption. At the sides of the portal are figures depicting the months of the year, while in the embrasures are figures of saints and angels.

Interior. Entering the interior of the cathedral, one is immediately struck above all by its dimensions: no less than 130 m. (426 ft.) long, 50 m. (164 ft.) wide and 35 m. (115 ft.) high, it can accommodate as many as 9000 persons. Cylindrical piers 16 feet in diameter divide the church into five aisles, and there is a double ambulatory around the transept and choir. A gallery with double openings runs around the apse above the arcades, surmounted in turn by the ample windows from which a tranquil light enters the church. Chapels rich in art-works from the 17th and 18th centuries line the aisles up to the transverse arm of the transept. At each end of the transept are rose-windows containing splendid stained-glass pieces dating from the 13th century; particularly outstanding is the stained-glass window of the north arm, dating from about 1250, with scenes from the Old Testament and a Madonna and Child in the center, justly celebrated for the marvellous blue tones which it radiates. From the transept one passes into the choir, at the entrance to which are two piers; the pier on the north has the famous statue of Notre-Dame-de-Paris, dating from the 14th century and brought here from the Chapel of St. Aignan. An 18th-century carved

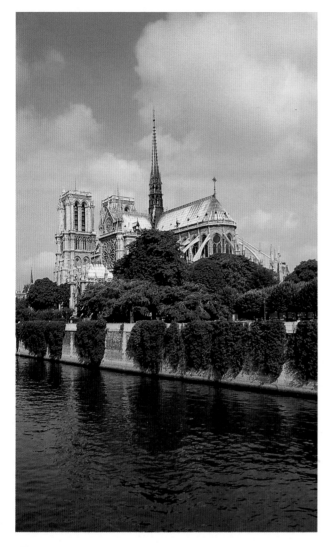

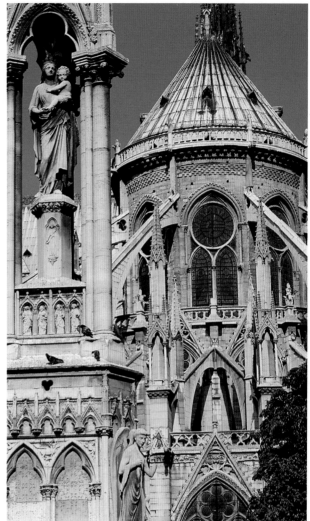

The right side of the cathedral and the apse which acts as backdrop to the fountain of the Virgin which stands in Square Jean XXIII.

wooden choir surrounds half of the presbytery, and on the high altar is a statue of the Pietà by Nicolas Coustou; at the sides of this are two more statues, one representing Louis XIII by Giullaume Cousteau and the other Louis XIV by Coysevox. Finally there is the ambulatory with radial chapels which contain numerous tombs. On the right, between the Chapelle Saint-Denis and the Chapelle Sainte-Madeleine, is the entrance to the Treasury, in which can be seen relics and sacred silverware. Among the most important relics are a fragment of the True Cross, the Crown of Thorns and the Sacred Nail. At this point, having reached the end of the church, if one turns towards the main entrance one cannot help being struck by the great rose-window above the 18th-century organ.

Interior: south rose-window. A work of the 13th century, but restored in the 18th century, it depicts Christ in the act of benediction surrounded by apostles and the wise virgins and foolish virgins. The richness and luminosity of the colours and the precise placing of the glass tesserae combine to give almost the impression that a single, intensely bright star is bursting, throwing its splendid rays of light in every direction.

Right side of the Cathedral. An evocative view of the right side of the cathedral can be had from the colourful quay of Montebello, one of those streets along the Seine always so full of animated life. The "bouquinistes", the famous sellers of prints old and new where rare and curious books can also be found, give this street its peculiar flavour and typical Parisian spirit.

Apse. From the bridge called Pont de la Tournelle, constructed in 1370 but rebuilt many times, one can see the vast curve of the apse of Nôtre-Dame. In other churches, the part centering on the apse usually aims at gathering together, as if in an embrace, all the lines of force and the rhythmic and spatial values of the interior. But here the apse creates its own rhythm, serving as a terminal point but also creating a new sense of movement which extends to every structural element, from the rampant arches to the ribbing. The rampant arches, which here reach a radius of nearly 50 feet, are the work of Jean Ravy.

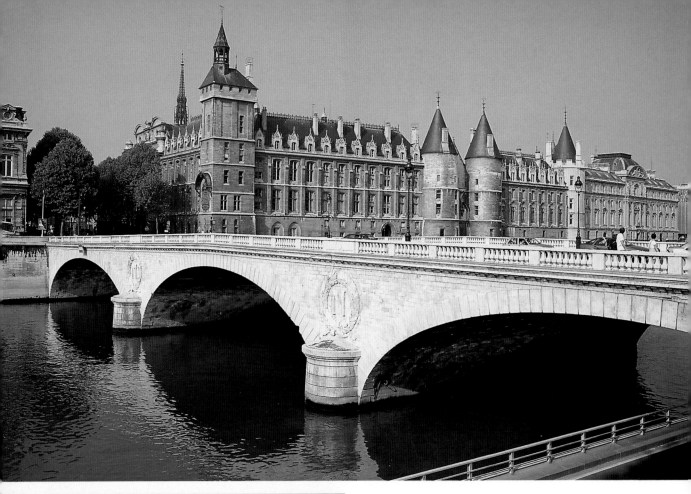

The Conciergerie, with its twin towers flanking the entrance to the oldest prison in Paris, and the square 14th-century Clock tower. The great clock, the first public clock in the city, dates to 1370, while the relief decoration dates to the 17th century.

CONCIERGERIE

This severe and imposing building on the banks of the Seine dates from the time of Philip the Fair, that is between the end of the 13th and the beginning of the 14th centuries. Its name derives from "concierge", name of the royal governor who was in charge of the building. Today it constitutes a wing of the Palais de Justice. A visit to the castle is of considerable interest, since it is full of memories and takes the visitor back to distant and troubled times of conspiracy and revolution. In fact, from the 16th century on it served as a state prison. Then, during the Revolution, its cells were occupied by thousands of citizens who lived out their last hours here before climbing the steps to the guillotine. On the ground floor is the Hall of the Guards, with powerful piers supporting Gothic vaults, and the large Hall of the Men-at-Arms. The latter room, which has four aisles and is no less than 68 m. (224 ft.) long, 27 m. (88 feet) wide and 8 m. (26 ft.) high, was once the dining-hall of the king. From the nearby kitchens the expert cooks of the royal house were capable of preparing meals for at least a thousand guests. To speak of the Conciergerie, however, takes us above all back to the time of the Revolution; visiting the cells and learning the segrets of the building we are following the last footsteps of those con-

demned to death, many of whose names are only too well known. In a large room on the ground floor, with cruciform vaults, the prisoners could have, for a certain fee, a straw pallet on which to sleep; in another area, with the tragically ironic name of Rue de Paris, the poor prisoners were quartered. The cell of Marie Antoinette, converted into a chapel in 1816 by the only remaining daughter of Louis XVI, the Duchess of Angoulême, is perhaps the most evocative of all: here the royal prisoner, scornfully called the "Austrian woman", lived from 2 August 1793 until 16 October; on this Wednesday morning, at 7 o'clock, after cutting her own hair, she too climbed on the cart to be taken to the scaffold where nine months before her husband had died.

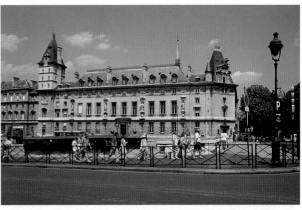

PALACE OF JUSTICE

The western sector of the Ile de la Cité is occupied by the Palais de Justice or Palace of Justice, a complex of buildings dating to various periods, including the Conciergerie, the Sainte-Chapelle and the Palace of Justice itself. The principal facade of the latter faces

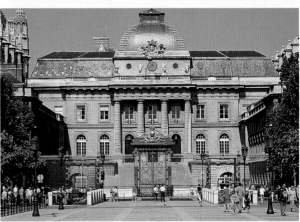

The south elevation of the Palace of Justice on the Quai des Orfèvres; at n. 36, near the Judicial Police, was the office of the famous Commissioner Maigret, protagonist of the detective stories of Georges Simenon.

The monumental facade on Boulevard du Palais. Beyond the court, on the left, stands the Sainte-Chapelle.

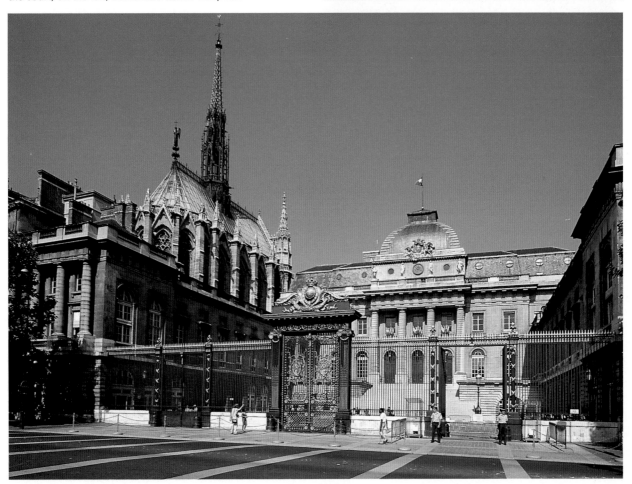

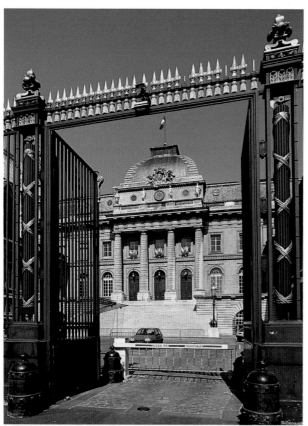

out on the Boulevard du Palais, preceded by the scenic Cour de Mai with its elegant wrought iron railing. At the back of the Cour de Mai, to the right of the staircase, was the door of the Conciergerie through which the wagons with their 2600 prisoners condemned to the guillotine during the period of the Terror passed.

SAINTE-CHAPELLE

From the courtyard of the Palais de Justice, through a vaulted passageway, one reaches that masterpiece of Gothic architecture which is the Sainte-Chapelle. It was built for Louis IX (Louis the Blessed) to contain the relic of the crown of thorns which the king had bought in Venice in 1239; the relic had been brought to Venice from Constantinople. The architect who planned the chapel was probably Pierre de Montreuil, the architect of Saint-Germain-des-Prés; here he actually designed two chapels, standing one above the other, and they were consecrated in 1248. The lower church acts as a high base for the overall structure, above it being large windows crowned with

The entrance to the Cour de Mai and details of the splendid gate of honor, crowned by the coat of arms with the fleur-de-lys of France, at the center of the splendid wrought iron railings.

Sainte-Chapelle, a true gem of Gothic French art, its slender spire rising skywards.

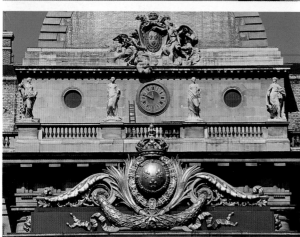

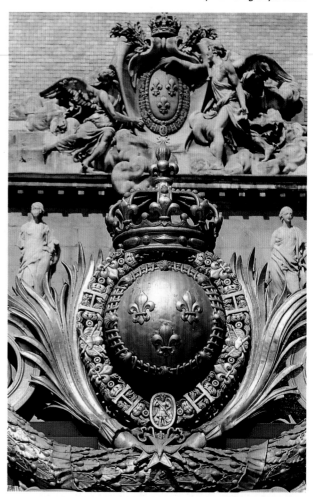

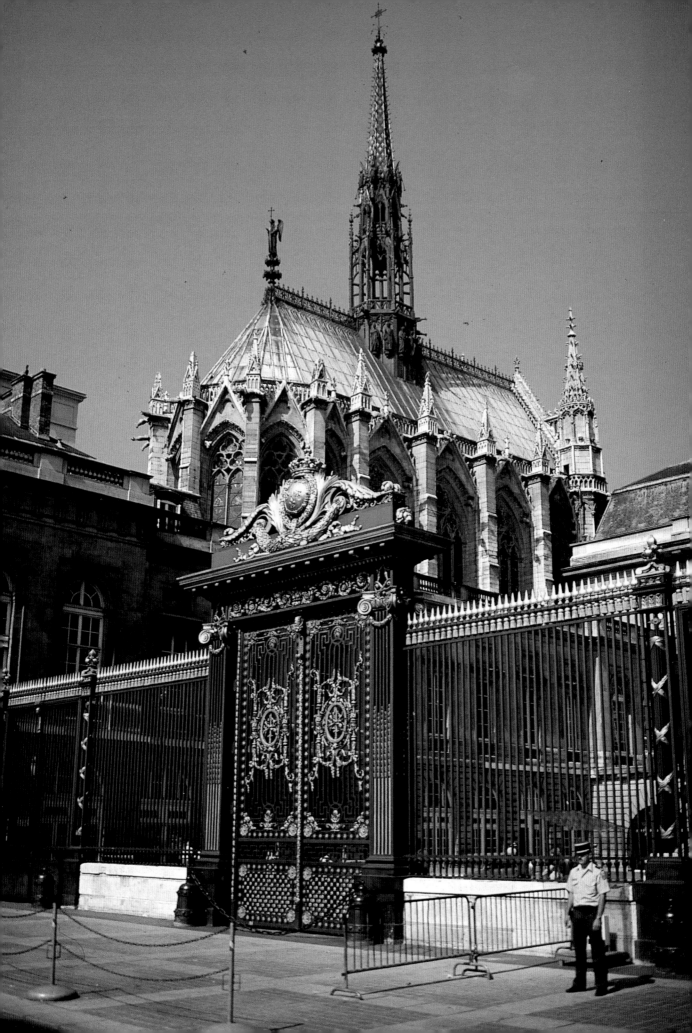

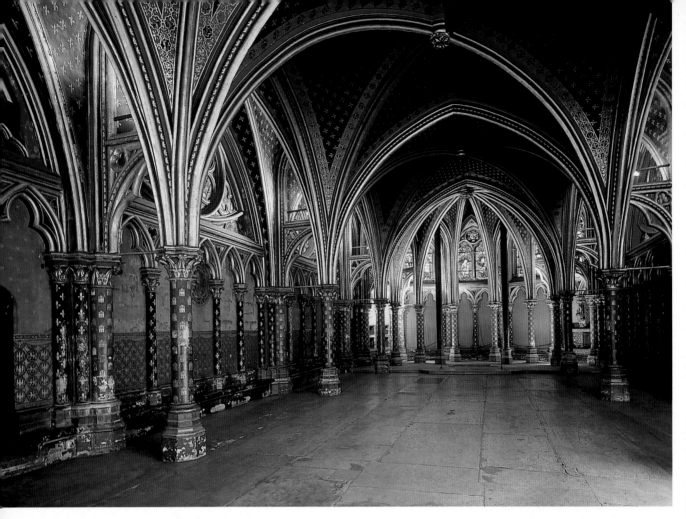

The interior of the Lower Church, entered through a twin portal. Centuries of visitors to the church have worn away the reliefs of the tomb slabs in the pavement.

The delicate polychrome windows of the Upper Church look like lace and the sunlight shining in creates an unreal atmosphere which completely envelops the awe-struck visitor.

cusps. The steep sloping roof is adorned by a slim and delicate marble balustrade, and this graceful piece of architecture is splendidly crowned by a slender openwork spire 65 m. (246 ft.) high. Two more towers with spires stand on each side of the facade, in front of which is a porch; above the porch is a large rose-window with cusps, dating from the end of the 15th century, its subject illustrating the Apocalypse. The whole work is marked by its lightness: the structural elements lose their consistency to become subtle embroidery, delicate lacework. The ribbing becomes slender, the pinnacles finer, until the architecture almost disappears, leaving only the huge stained-glass windows.

Lower Church. There is without doubt a sudden change of atmosphere, style and emotion when one descends from the Upper to the Lower Chapel. Only 7 m. (23 ft.) high, it has three aisles, but the nave is enormous compared to the two much smaller aisles at the sides. Trilobate arch motifs supported by shafts recur along the walls. The apse at the end is polygonal. But here too, as in the Upper Chapel, it is the color which predominates.

The rich polychrome decoration overshadows the architecture, which is thus transformed into a simple support for the decorative element.

Upper Church. Climbing a staircase from the Lower Chapel, one reaches the Upper Chapel, a splendid reliquary with the appearance of a precious jewel-case. Without aisles, it is 17 m. (55 ft.) wide and 20 m. (67 ft.) high. A high plinth runs all around the church, interrupted by perforated marble arcades which from time to time open up onto deep niches. In the third bay are the two niches reserved for the king and his family. On each pillar is a 14th-century statue of an Apostle. The architecture is thus lightened as much as possible in order to leave room for the huge stained-glass windows, nearly 15 m. (50 ft.) high. Whereas in the art of the Romanesque period a church's paintings had been half-hidden in an apse, in the curve of an arch or under a wide vault, here in this Gothic creation the pictures are magnificently transferred to the stained-glass windows, triumphantly presented to the gaze of all and illuminating the whole church with their precious colors. The fifteen stained-glass windows of the Sainte-Chapelle, belonging to the 13th century, contain 1134 scenes and cover an area of 618 sq. meters; they illustrate, in splendid colors and in an excited, almost feverish style, Biblical and Evangelical scenes.

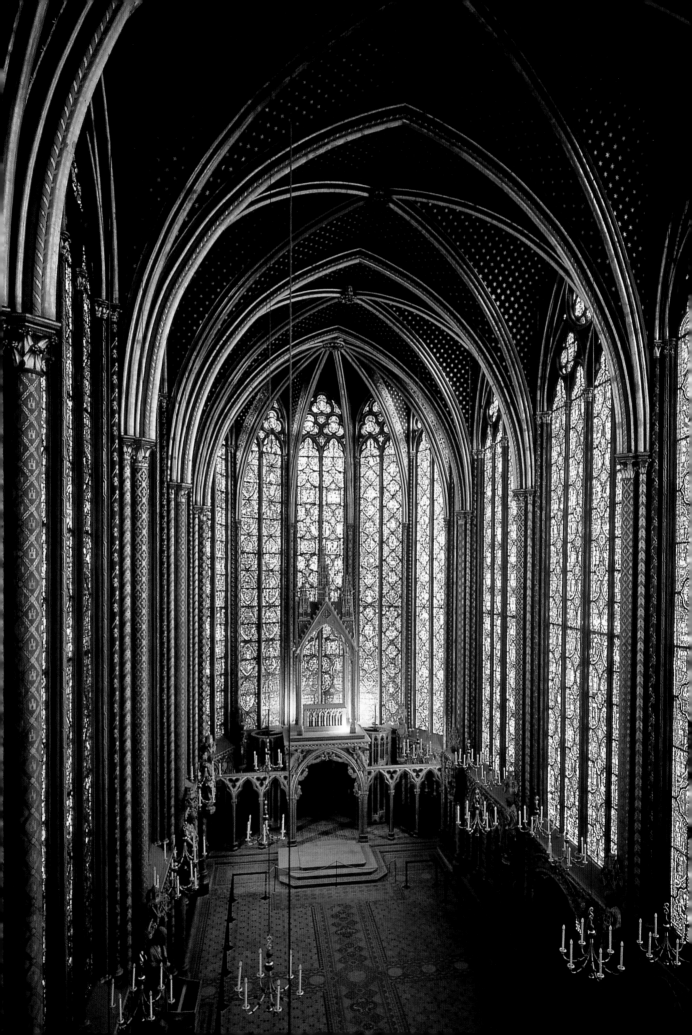

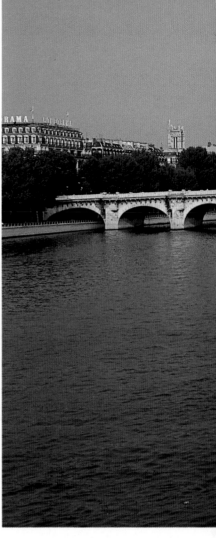
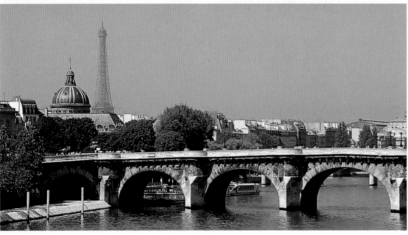

The Square du Vert-Galant, a charming corner of the Cité, is located on the western point of the island, the equestrian monument of Henry IV at the center of the Pont-Neuf, and the bridge towards the "rive gauche". In the background, on the left, the dome of the Institut de France and the Eiffel Tower.

A few pictures of the Pont-Neuf, the oldest and most beautiful bridge in Paris, with the "bateaux-mouches" moored at the embarkation points along the banks of the river, ready to glide over the waters of the Seine with their loads of tourists.

SQUARE DU VERT-GALANT

Known by the nickname given to Henry IV, "Vert-Galant", this pleasant little enclosed garden is reached via a stairway behind the statue of the king. Here one is actually at the end of the Cité, and at this point the comparison of it with the prow of a ship comes spontaneously. The garden occupying the square, in fact, thrusts out over the calm waters of the Seine like the bow of a ship plowing the waves. The landscape which opens up before one here is among the most evocative offered by the city: the visitor is in almost direct contact with the river, and in one vast sweep his gaze takes in the majestic banks, the graceful buildings, the green of the trees and the elegant outlines of the bridges.

STATUE OF HENRY IV

François-Fréderic Lemot erected this equestrian statue dedicated to Henry IV in 1818, to replace the previous work by Giambologna which had been placed here when Marie de' Medicis was queen, after the assassination of Henry IV in 1610, but torn down in 1792.

PONT-NEUF

Despite its name, which means "New Bridge", the Pont-Neuf, designed by Du Cerceau and Des Illes, is the oldest bridge in Paris: it was begun in 1578 under Henry III and completed under Henry IV in 1606. From the point of view of its design, however, it is decidedly a "new"bridge, indeed revolutionary compared with previous designs. All the other bridges in the city, in fact, had had tall houses built on the sides, hiding the view of the river. Here instead a perspective on the Seine was created and the bridge, with its two round arches, became an enormous balcony thrust out over the river. The Parisians appreciated its beauty and importance at once, and the bridge became a meeting place and favorite promenade. At the beginning of the 17th century, it even saw the birth of the French comic theater, when the famous Tabarin gave his performances here.

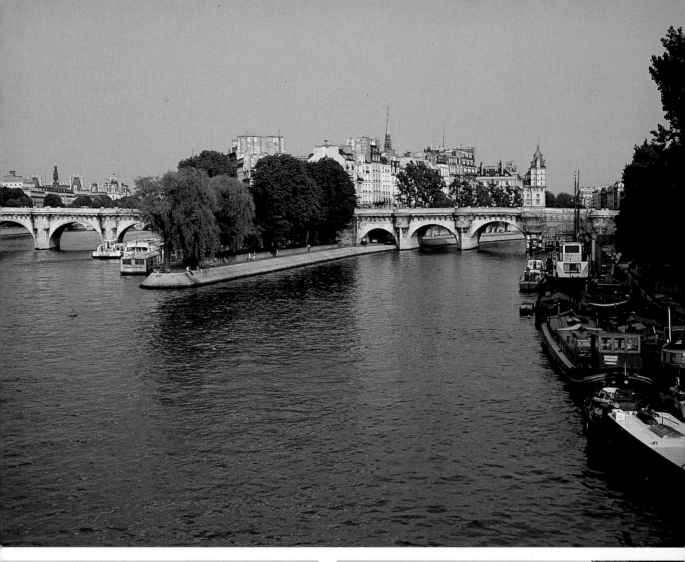

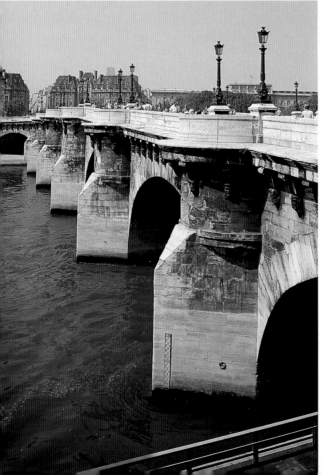

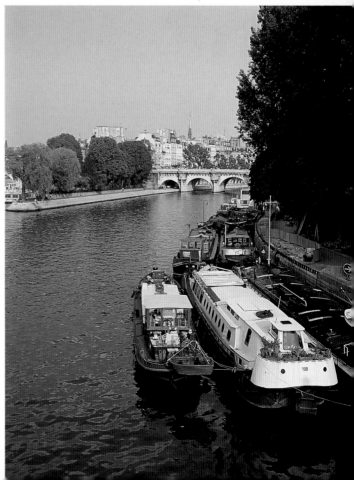

Châtelet
Tour St-Jacques - St-Germain-l'Auxerrois - Hôtel de Ville

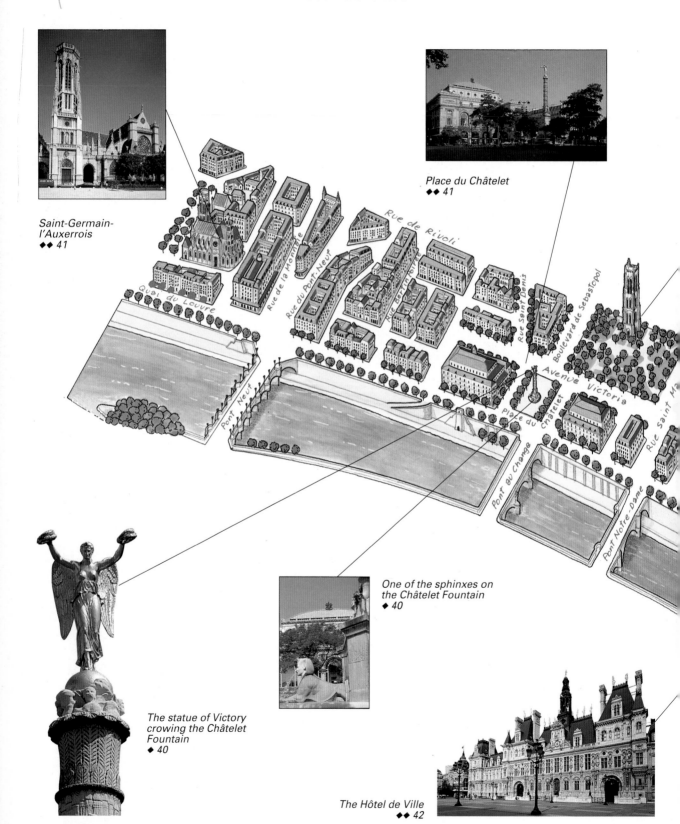

Saint-Germain-l'Auxerrois
◆◆ 41

Place du Châtelet
◆◆ 41

One of the sphinxes on the Châtelet Fountain
◆ 40

The statue of Victory crowing the Châtelet Fountain
◆ 40

The Hôtel de Ville
◆◆ 42

TOUR SAINT-JACQUES

Erected between 1508 and 1522, it is 52 m. (170 ft.) high and belongs to the most elaborate Gothic style. Narrow windows alternate with niches crowned by spires and pinnacles, in which there are many statues. The statue at the top of the tower of St. James the Greater is by Chenillon (1870).

The Tower is all that remains of the old Church of Saint-Jacques de la Boucherie, one of the most important churches in Paris at the time, when it was the point of departure for pilgrimages directed to the sanctuary of Santiago de Compostela. The building was demolished in 1797 but the tower was left standing. Used for various experiments on the atmosphere carried out by Blaise Pascal (physicist, mathematician, philosopher and writer of the 17th century), it has served as an observatory for the metereological service since 1891.

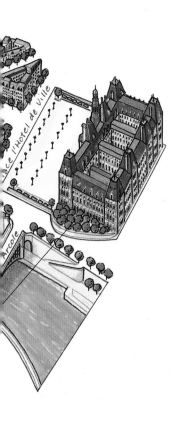

Tour Saint-Jacques, one of the finest monuments in Flamboyant Gothic style in the city.

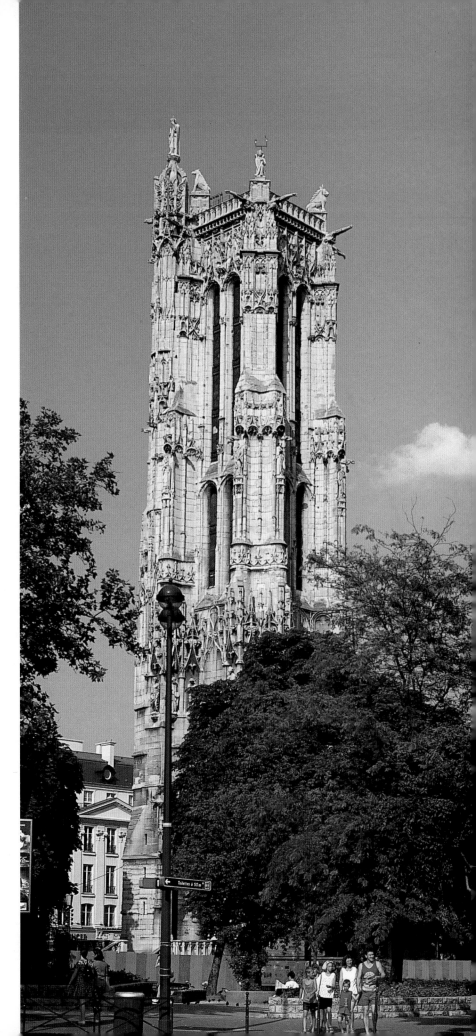

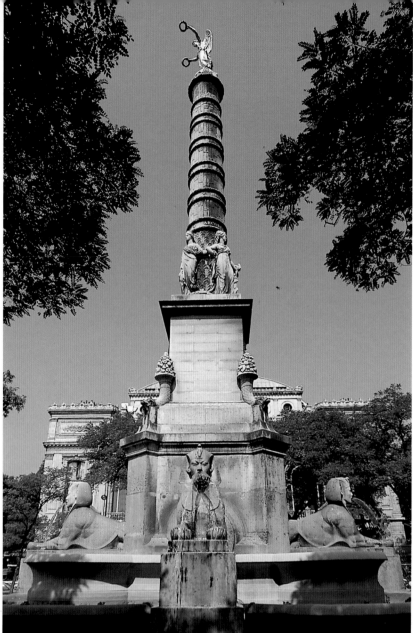

Facing page: the Châtelet Fountain with various details, and the Théâtre du Châtelet, one of the largest in Paris, which stands on the square of the same name together with the Théâtre de la Ville.

On this page, the Châtelet Fountain in a 19th-century painting by Etienne Bouhot in the Musée Carnavalet, and the square of the Louvre with the Church of Saint-Germain-l'Auxerrois, the neo-Gothic bell tower and the Mairie (or town hall) of the Arrondissement.

PLACE DU CHÂTELET

The square takes its name from the ancient fortress, the Grand Châtelet, built to defend the Pont au Change in front of it and destroyed under Napoleon I. But the present appearance of the square dates from the time of Napoleon III. In the center is the Châtelet Fountain (also called the Fountain of Victory or of the Palm), with its base adorned by sphinxes and statues, dating from 1858.

ST-GERMAIN-L'AUXERROIS

In front of the eastern part of the Louvre is a small square dominated by the symmetrical facades of the Mairie, or town-hall, of Paris's First Arrondissement, dating from 1859, and of the church of St-Germain-l'Auxerrois. The two buildings are separated by a bell-tower, built in the neo-Gothic style in 1860. Also called the "Grande Paroisse", the Great Parish Church, because it was the royal chapel of the Louvre in the 14th century, St-Germain-l'Auxerrois stands on the site of a previous sanctuary dating from the Merovingian era. Its construction was begun in the 12th century and continued until the 16th. On the facade is a deep porch built between 1435 and 1439 in the Gothic style, with five arches, each one different from the others, its pillars adorned by statues. Other statues, depicting saints and kings, are in the three portals. Higher up is a fine rose-window surmounted by a cusp, next to which is the church's bell-tower dating from the 11th century. The sight of the interior of the church is impressive: it has five aisles, divided by piers, transept and choir.

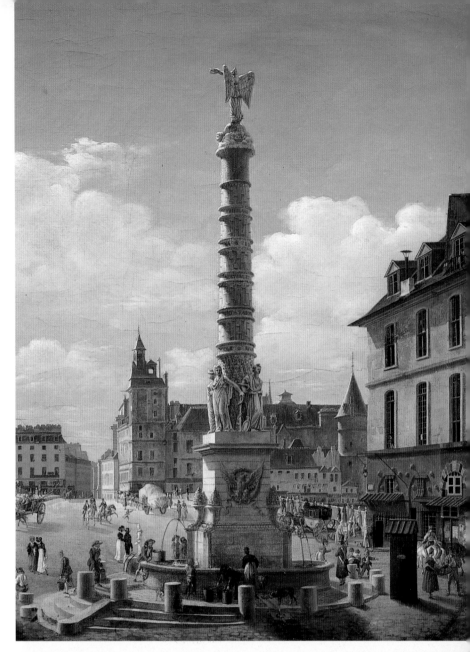

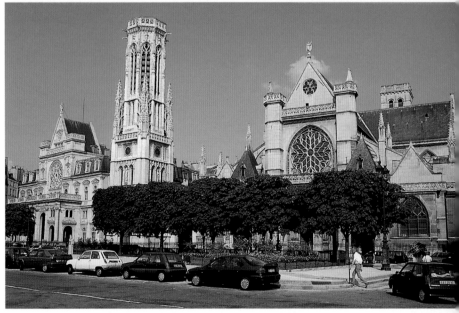

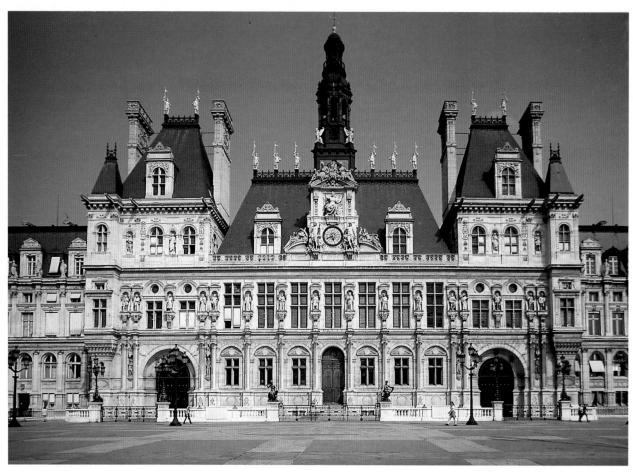

The facade of the Hôtel de Ville, richly decorated with statues of illustrious men and with allegorical depictions of the cities of the province.

Details of the facade; the statue of the woman, above the clock, is the allegory of the city of Paris, and above her are the figures of the two rivers of the city, the Seine and the Marne.

It also contains numerous works of art, among which a worthy example is the royal pew which F. Mercier carved from wood in 1682. Also in polychrome wood is the statue depicting St. Germain, while the statue of St. Vincent is of stone but it too is enlivened by the use of warm colors. Both these works date from the 15th century. Among other works of art worth mentioning is a Flemish reredos in carved wood, the scenes of which depict moments in the life of Jesus.

HÔTEL DE VILLE

In the centre of a huge square which for five centuries was the site of public executions is the venerable Hôtel de Ville, today the municipal headquarters of the city. On the site which it occupies there was previously a 16th-century building, designed by Domenico da Cortona: built in the Renaissance style, it was destroyed by fire in 1871, during the struggles which led to the fall of the Commune. The later building thus takes its inspiration from this lost edifice. It was designed by the architects Deperthes and Ballu, who completed it in 1882. The complex is certainly imposing and original, with its various pavilions surmounted by domes in the shape of truncated pyramids and with a forest of statues in every angle. In fact, there are no less than 136 statues on the four facades of the building, while on the terrace is the statue depicting Etienne Marcel, leader of the Parisian merchants and fomenter of the disorders which crippled Paris in the 14th century. Over the centuries the building has been the scene of important historical events. The most tragic of all, perhaps, took place on the morning of 27 July 1794, the day which in the new calendar created by the Republicans was called the 9th of Thermidor. Robespierre, the Incorruptible, was closed inside the Hôtel with his followers, trying to find a way of avoiding the threat of a civil war which he knew would certainly create havoc among the factions that had emerged within the Republican system. When the soldiers of the Convention burst into the room, Robespierre tried to commit suicide by shooting himself in the throat, but he succeeded only in inflicting a jaw wound. He was dragged off, to be executed the following day.

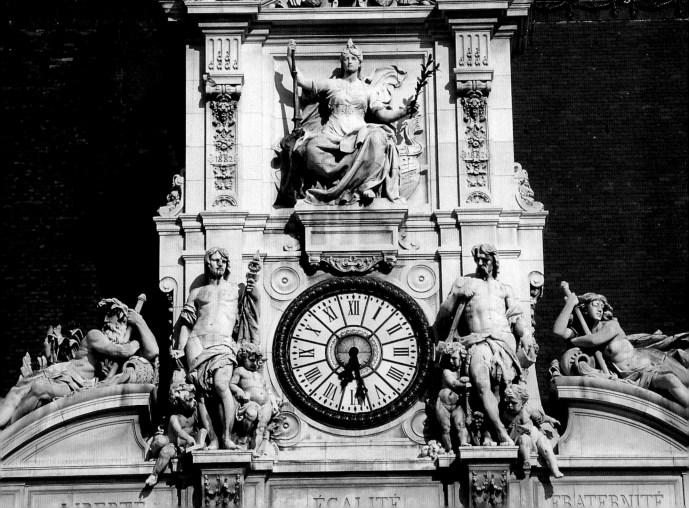

Les Halles

La Bourse - St-Eustache - Tinguely Fountain - Forum des Halles - Fountain of the Innocents - Beaubourg

One of the many fountains to be found throughout the center of Paris, whose purpose in the past was to provide the inhabitants of the city with sufficient water

Saint-Eustache
◆◆ 46

The Pompidou Center (Beaubourg)
◆◆ 51

The Produce Exchange
◆◆ 45

The Forum des Halles
◆◆ 49

The Fountain of the Innocents
◆◆ 50

The Tinguely Fountain in Place Igor Stravinsky
◆◆ 47

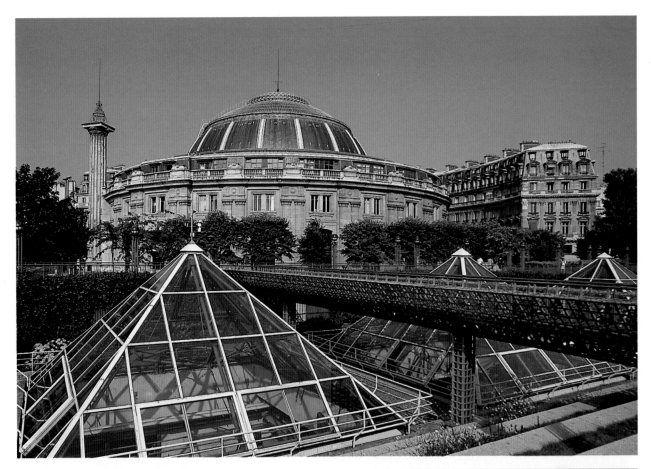

The circular building of the Produce Exchange with the pyramid of the tropical garden greenhouse in the foreground, and two views of the public spaces realized in the area after the transfer of the nearby central market of Paris.

THE PRODUCE EXCHANGE
(Bourse du Commerce)

The old wheat market built in 1765 by the provost of the traders, the Produce Exchange is nowadays an imposing circular building adorned with a monumental series of paired pilaster strips. The offices form a crown around the large inner hall topped by a dome in glass and steel.

The sixteenth-century fluted column rising up near the Exchange comes from the palace of Catherine de' Medici and was used as an observatory by the royal astronomer Ruggeri.

When the area between the Exchange building and the Church of Saint-Eustache was redesigned, modern structures and public spaces were added, enriched by works of modern art, such as the *Ecoute* by Henri de Miller, a colossal head which seems to be listening to what is happening in the area.

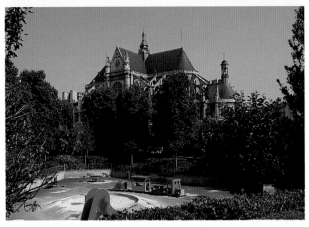

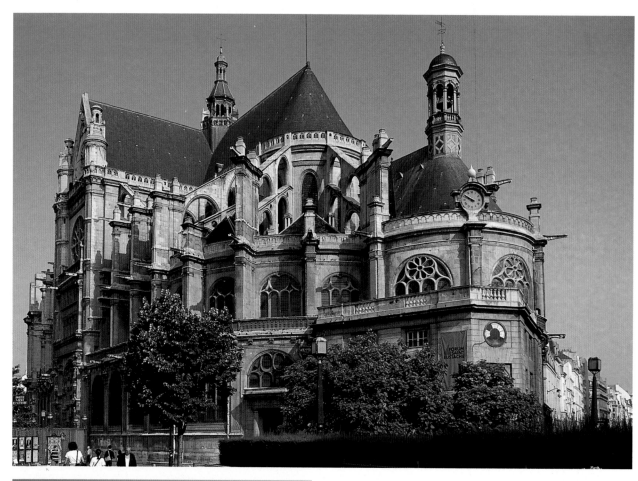

View of the church of Saint-Eustache with the chapel of the Virgin projecting from the apse and the right flank of the building with the modern sculpture Ecoute *by Henri de Miller.*

SAINT-EUSTACHE

At the edge of the area once occupied by the central food market, Saint-Eustache is one of the most surprising churches in Paris. Building commenced in 1532 and ended only in 1637. It is distinguished by an unusual mixture of styles: a plan based on that of Notre-Dame, flamboyant Gothic vaults and Renaissance decoration consisting of three rows of superposed, tapered columns.

In a chapel of the choir lies the tomb of Colbert, Louis XIV's famous finance minister, by the sculptors Coysevox and Tuby according to a drawing by Le Brun.

MOLIERE'S HOUSE
Two houses bear witness to Molière's life in Paris. He was born in 1622 in the house at No. 21 Rue Saint-Honoré. Having fallen ill on the stage of the Palais Royal on 17th February 1673, he was transported, dying, to the house at No. 40 Rue de Richelieu.

PLACE IGOR STRAVINSKY
The square is located between the Pompidou Center and the Church of Saint-Merri and contains a large fountain dedicated to the Russian composer: the modern sculpture, grotesque varicolored figures and strange devices which move under the streams of water, are by the artists Niki de Saint-Phalle and Jean Tinguely.

QUARTIER DE L'HORLOGE
Alongside the Centre Pompidou, this modern pedestrian district owes its name to Jacques Monestier's famous clock, installed in 1979. Built of brass and steel, this device is electronically driven and programmed. At the chime of every hour, an automaton armed with a sword and shield combats and defeats the three animals surrounding it, symbolizing the three elements: Dragon-Earth, Bird-Air and Crab-Water.

The old and the new nonchalantly live side by side in many corners of the city: a typical road sign, the plaque on the house where Molière was born, the sixteenth-century church of Saint-Merri flanked by the Tinguely Fountain and the "Defender of Time", a large clock from which the quarter takes its name.

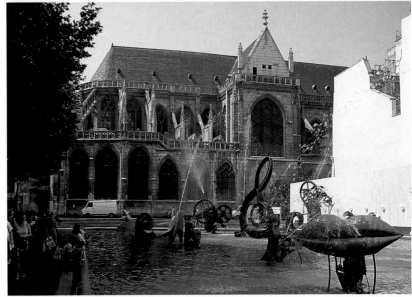

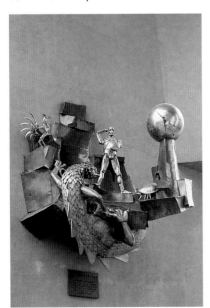

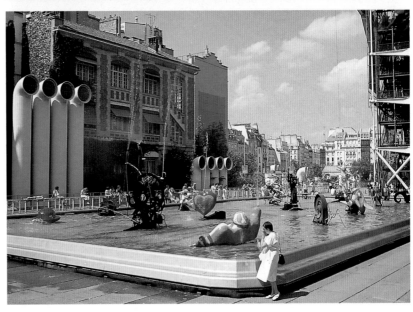

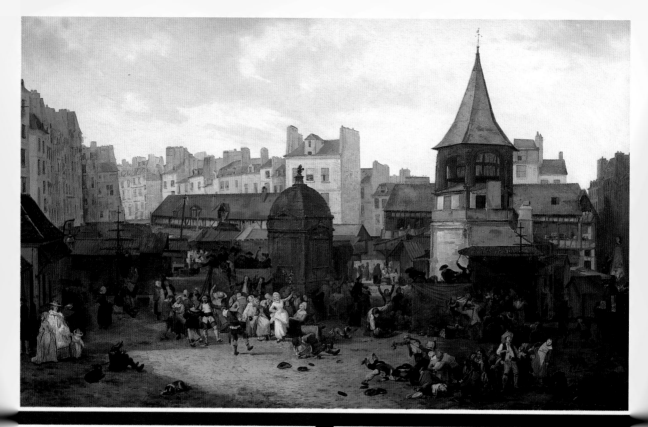

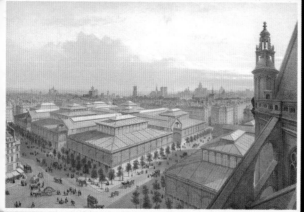

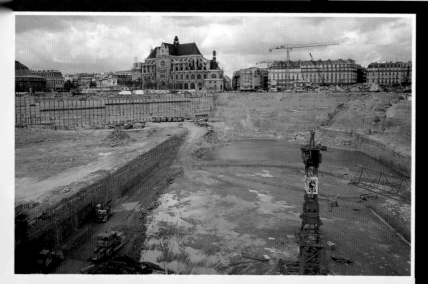

The most lively district in the city, Les Halles was defined by Emile Zola, in a colorful expression, the "underbelly of Paris". Indeed, **Les Halles yesterday** housed the central food market in the city, ten pavilions in steel, iron and cast iron begun in 1854, on a design by Victor Baltard.

The area of Les Halles: in 1782 in a painting by Philibert-Louis Debucourt (Musée Carnavalet); two images of Les Halles as they were one hundred years ago; the area during the impressive transformation works.

After the market was transferred to Rungis in 1969, demolition of the enormous pavilions was begun in 1971.

In a new concept of urban space, **Les Halles today** houses, at the feet of the Gothic church of Saint-Eustache, the modern Forum, over forty thousand square meters of glass and aluminium, with marble staircases and furnishings, which spreads out over four subterranean levels around an open-air square. Inaugurated on September 4, 1979, designed by the two ar-

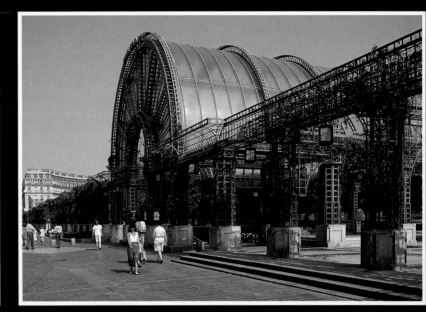

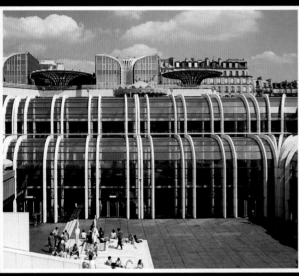

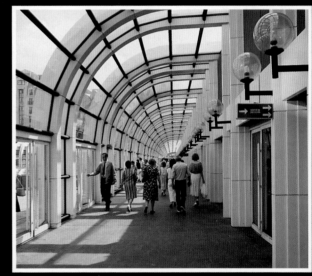

chitects Claude Vasconi and Georges Pencreac'h, the Forum now contains boutiques of all kind - clothing, art objects and gastronomy, household objects, entertainment areas, restaurants and ten cinemas, banks and information centers. There are also four métro lines and two of the RER.

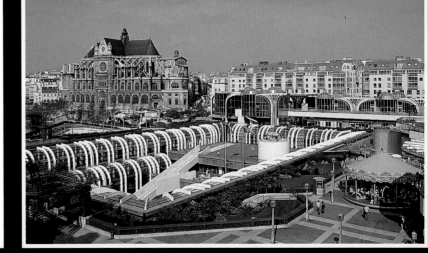

The area of Les Halles as it is today, with its modern structures in glass and aluminium.

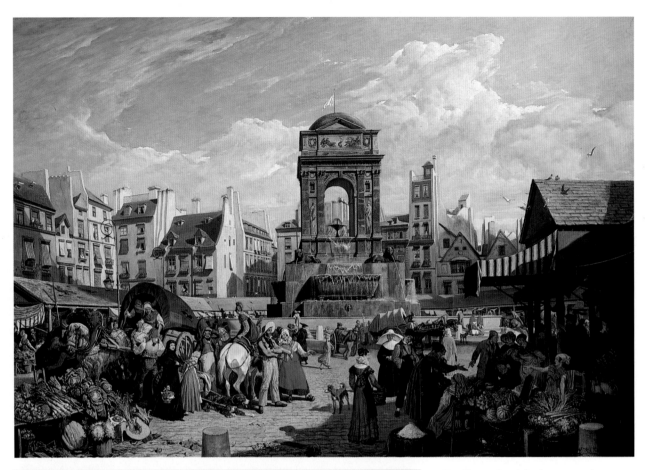

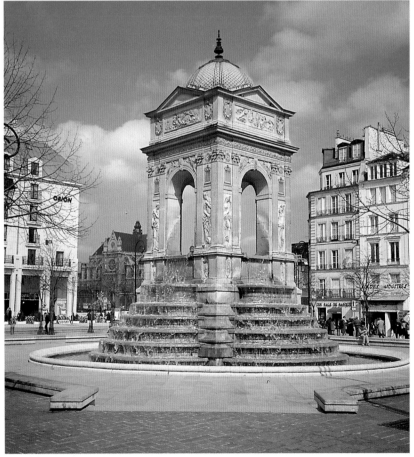

The Fountain of the Innocents in a picture painted by John James Chalon in 1822, and now in the Musée Carnavalet, in the midst of the stands of the market then held in the square, and the monument today.

FOUNTAIN OF THE INNOCENTS
In the form of a classical aedicule with a square ground plan and with arches at the sides and a frieze running along the pediments at the top, this fountain set at the center of the tree-shaded square of the same name is one of the masterpieces of the French Renaissance. The delicate bas-reliefs which decorate it, by Jean Goujon, depict nymphs, tritons and marine allegories.

Originally the fountain was set against a wall in the square which, from the late Middle Ages, contained the cemetery of the Innocents. In 1786 the cemetery was suppressed and after that the fountain, with the addition of the fourth side, was set where it is now.

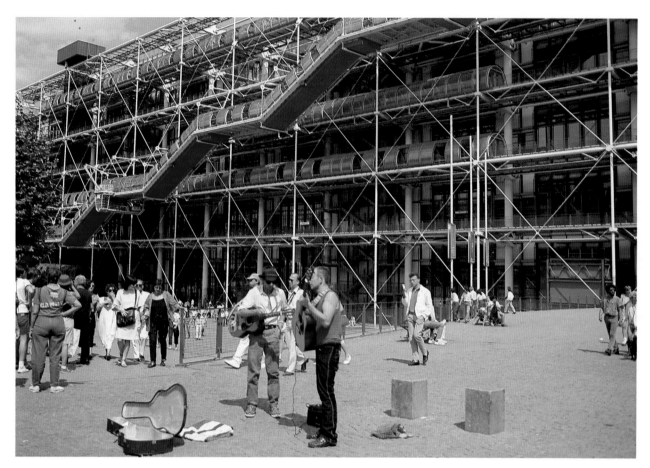

The Centre Pompidou, a true center for contemporary culture, with the ramps of the escalator which diagonally cut its unique facade. Street artists often use the crowded square as the stage for their performances.

POMPIDOU CENTER
(Beaubourg)

In 1969, the then President of the Republic, Georges Pompidou, decided to create an important cultural center in the area known as the "plateau Beaubourg". An international call to tender was announced and the project of Renzo Piano and Richard Rogers was accepted. Building began in April 1972 and the center was opened by Giscard d'Estaing on the 31st January 1977. The building, an "urban machine", as it has often been described, occupies an area of one hundred meters square. Each external pipeline is painted a different color because each color corresponds to a different function: blue corresponds to the climatization plant, jellow the electrical installation, red the circulation and green the water circuits. The steel skeleton, as well as the stairs, corridors, lifts, are outside the building, so as to leave a greater freedom for the space inside which is articulated as follows: rooms for lectures and meetings are in the basement level; on the ground floor is a general information center, a room devoted to the latest developments in the field of publishing and two rooms for children; in the mezzanine there are galleries of modern art, the Centre de Creation Industrielle and a cinema; the Public Information Library on the first floor also spreads out on the two subsequent floors; on the third and fourth the National Museum of Modern Art is located (with the third floor for contemporary art); the fifth floor, from which a splendid panorama of the city can be had, is reserved for temporary exhibits.

In the Museum, one of the largest in the world dedicated to modern art, the artistic currents which left their mark on the twentieth century (Fauvism, Cubism, Nonobjective art, Futurism, Dadaism, Surrealism, Post-Abstractism) are illustrated by works of artists such as Matisse, Picasso, Braque, Kandinsky, Klee, Mondrian, Miró, Max Ernst, Dalí, De Chirico, Magritte, Chagall, Sironi, Calder, Man Ray.

Louvre

Pei's Pyramid
◆◆ 57

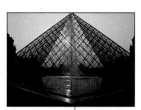

The Cour Napoléon
◆◆ 56

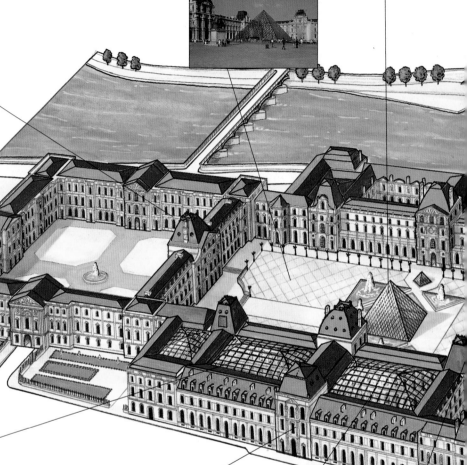

On the west, the Pavillon Sully closes the great Cour Carrée designed by the architects Lemercier and Le Vau

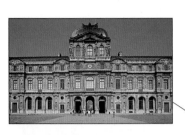

The Cour Puget, in the Richelieu Wing, houses various pieces of 17th-century French sculpture under its glass vault

Rue d

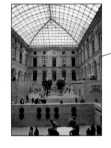

The Richelieu Wing. Renovation of this wing led to the covering in glass of the Cour Puget, the Cour Marly and the Cour Khorsabad which evokes the Assyrian palace of Sargon II

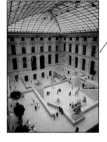

The famous Horses of Marly, masterpiece by Guillaume Coustou (1745), have found an ideal home in the Cour Marly, while copies now replace them in Place de la Concorde.

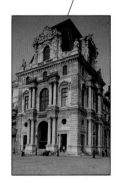

The Pavillon Turgot stands across from the Pavillon Mollien, on the side of Rue de Rivoli. The ornate apartments of Napoleon III inside are now open to the public.

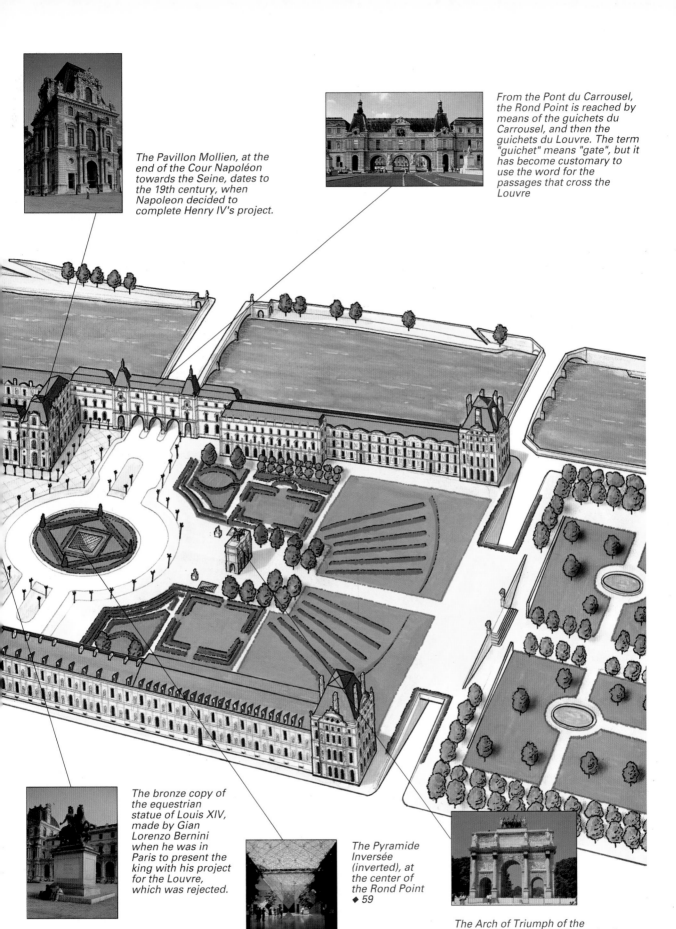

The Pavillon Mollien, at the end of the Cour Napoléon towards the Seine, dates to the 19th century, when Napoleon decided to complete Henry IV's project.

From the Pont du Carrousel, the Rond Point is reached by means of the guichets du Carrousel, and then the guichets du Louvre. The term "guichet" means "gate", but it has become customary to use the word for the passages that cross the Louvre

The bronze copy of the equestrian statue of Louis XIV, made by Gian Lorenzo Bernini when he was in Paris to present the king with his project for the Louvre, which was rejected.

The Pyramide Inversée (inverted), at the center of the Rond Point ◆ 59

The Arch of Triumph of the Carrousel, inspired by the arch of Septimius Severus in Rome, was erected to celebrate Napoleon's victories in 1805

53

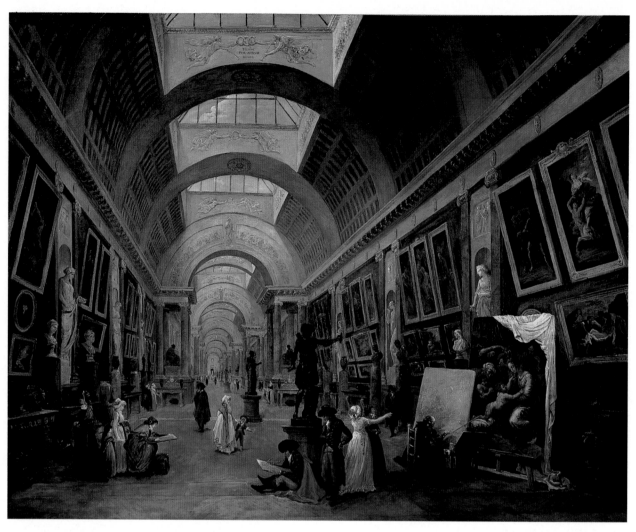

Hubert Robert (1733-1808) held the post of curator of paintings in the Great Gallery from 1795 to 1802; in this painting of 1796 he is shown illustrating his project for lighting the gallery, first nucleus of the future museum.

The moat and the basement of the Keep dating to the period of Philippe Auguste and Charles V and the Louvre as it was in 1715 and 1870 in scale models (1:1000) made by R. Munier and S. Polonovski.

THE LOUVRE

History of the Palace and Museum

THE PALACE

The Louvre dates back to 1200, when Philip Augustus had a fortress built near the river for defense purposes: it occupied more or less a fourth of today's Cour Carrée. The fortress was not, then, the royal residence (the king, in fact, preferred living in the Cité) but it housed, among other things, the royal treasure and the archives. In the 14th century Charles V, the Wise, rendered the fortress more habitable and took it as his residence. One of his additions was the famous Librairie. After his reign the Louvre was not used as the royal residence again until 1546, when Francis I commissioned the architect Pierre Lescot to improve the residence and render it more in keeping with the new Renaissance tastes. He had the old fortress demolished and began the construction of the southwest wing of what is now the Cour Carrée. Work continued under Henry II. After his death, Caterina de' Medici entrusted Philibert Delorme with the construction of the Tuileries Palace and a great gallery flanking the Seine was to join it to the Louvre. Work, interrupted at Delorme's death, continued under Henry IV, who had the Great Gallery and the Pavillon de Flore terminated. The enlargement of the edifice continued under Louis XIII and Louis XIV; the ar-

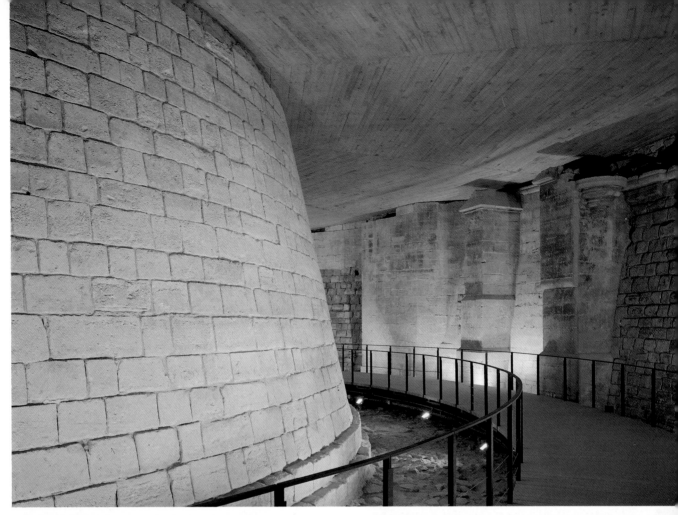

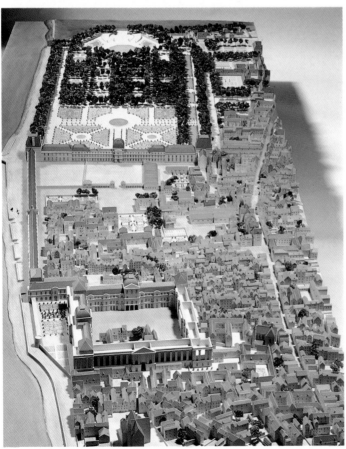

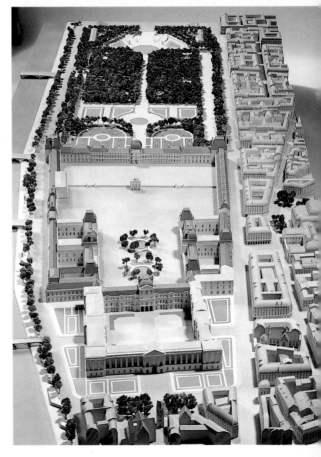

chitects Lemercier and Le Vau gave the Cour Carrée its present form; Claude Perrault was commissioned to build the east facade with its colonnade. When the court moved to Versailles in 1682, work on the Louvre was almost totally abandoned: even the palace itself became so rundown that in 1750 the idea of tearing it down was broached. One may say that the women of the Parisian markets saved the Louvre when they marched on Versailles on October 6, 1789 to bring the royal family back to Paris. After the tumultuous years of the Revolution, Napoleon I finally took up work on the Louvre again. His architects, Percier and Fontaine, began construction of the north wing along the Rue de Rivoli. It was finished in 1852 under Napoleon III, who decided, finally, to complete the Louvre. With the fire and consequent destruction of the Tuileries during the siege of the city in May of 1871, the Louvre took on its present aspect.

THE COLLECTIONS

The collection of works there exhibited is so vast that the Louvre has often been defined "the world's most important museum." From an initial nucleus of works, the Louvre collection grew with the collections of the kings of France; its continual expansion has since been assured by a wise acquisition policy and generous donations. Francis I is unanimously recognized as the founder of this important collection. The sovereigns preceding him had commissioned and bought works of art - especially paintings - but until this time these were isolated episodes. Francis I (1515-1547) began a real and proper collection of all genres of works in order to enrich the royal residence at Fontainebleau. He succeeded in commissioning the most important artist of the times, Leonardo da Vinci, and thus in attaining ownership of some of Leonardo's most important works: for example, the "Mona Lisa " and the " Virgin of the Rocks ". During the same period, works by such Italian artists as Andrea del Sarto, Titian, Sebastiano del Piombo, Raphael became part of the collection. Francis I's successors did not show much interest in the collection of works of art. They limited themselves to commissioning a few portraits by contemporary French artists: Clouet and Corneille, for example. A further impetus was given to the collections during the reign of Louis XIII. Even though he was rather indifferent to artistic matters, his celebrated Minister, Cardinal Richelieu, was a true collector. At his death, Richelieu left his collections to the Crown, whose holdings were thus enriched by such masterpieces as "The Pilgrims of Emmaus" by Veronese and Leonardo's "Saint Anne". Marie de' Medicis, the King's mother, also contributed to the growth of the collection: she ordered a certain number of canvases from Rubens for her new residence in Luxembourg. Nevertheless the collection was still relatively modest. An appraisal of the time counts 200 paintings.

With the successor, Louis XIV, the collection was to make some really important progress: it is enough to recall that, at the time of his death, the "Royal Collection" counted over 2000 paintings. First the king was wise enough to buy, at his Minister Colbert's suggestion, a part of Cardinal Mazarin's collection. He then had the great good luck to be able to buy the collection of Charles I of England, which Cromwell had put up for sale. This collection was very important in that

it had previously absorbed the collections of the Mantuan Gonzaga princes. The Sun King, moreover, collected numerous works by such French artists as Poussin, Lorrain, Le Brun, Mignard. His successor, Louis XV, was not as capable. Only a very few works by deceased artists enriched the collection; nevertheless, he purchased numerous works by such contemporary artists as Chardin, Desportes, Vernet, Van Loo, Lancret. Under Louis XVI numerous works by 17th-century Italian artists were acquired: these came from Amedeo di Savoia's collection, dispersed with the Succession. During Louis XVI's reign demands that the royal collections be opened to the public became more insistent. Already in 1749 an exhibition of a limited selection of the works was opened in the Palais du Luxembourg. Diderot had explicitly asked, in 1765 in the Encyclopaedia, that the Louvre be used for the exhibition of the works contained in the Royal Collection. This turmoil was heard by the "Constructions Director" Count d'Angiviller, who planned the "Grande Galerie" especially for this purpose. Moreover, he filled in some of the gaps in the collection: he completed the representation of French artists and purchased numerous works of the Flemish school. Nevertheless the project was still incomplete at his death: only the Revolution was finally to put it into effect.

In 1792 the revolutionary government decided to transfer the Royal Collections, now property of the Nation, to the Louvre. The "Central Museum of Art " opened on August 10, 1793, with the presentation of a selection of 587 works. New work was undertaken to make room for the works confiscated from churches, noble families and local administrations that had been abolished, and which came to the Louvre in this period. Under Napoleon, the Museum was enlarged and transformed. The Department of Greek and Roman Antiquity was formed, the archaeological collections grew. Nevertheless, the Egyptian Antiquities Department would not be founded until 1826. The Emperor established a system of acquisitions which, although it seems highly criticizable today, was at the time considered not only admissible but even "glorious". He "requisitioned" works of art from the conquered countries and sent them to the Louvre (then called "Napoleon Museum"). An enormous number of works was directed toward France from Belgium, Holland, Germany, Austria and Italy. This proved, however, to be a short-lived enlargement: by the end of 1815 about 5000 of these works had been returned to their legitimate owners. Nevertheless, thanks to various agreements and particular exchanges, and also to certain subterfuges, a hundred or so works remained in Paris.

In the 50 years following, expansion centered on the Oriental collections. The Assyrian Collection profited from Botta's expedition, the Egyptian Collection from the illuminated guidance of Champollion, the decipherer of hieroglyphics.

Other important additions to the collection were made under Napoleon III: the purchase of the Campana collection and the acquisition of the La Caze bequest containing enormously important works by Watteau, Fragonard, Chardin, Hals. From this time on the acquisitions policy continued and led to the enlargement of the collections. Nor must we forget the great merit of the numerous patrons of the arts who donated their collections to the Museum.

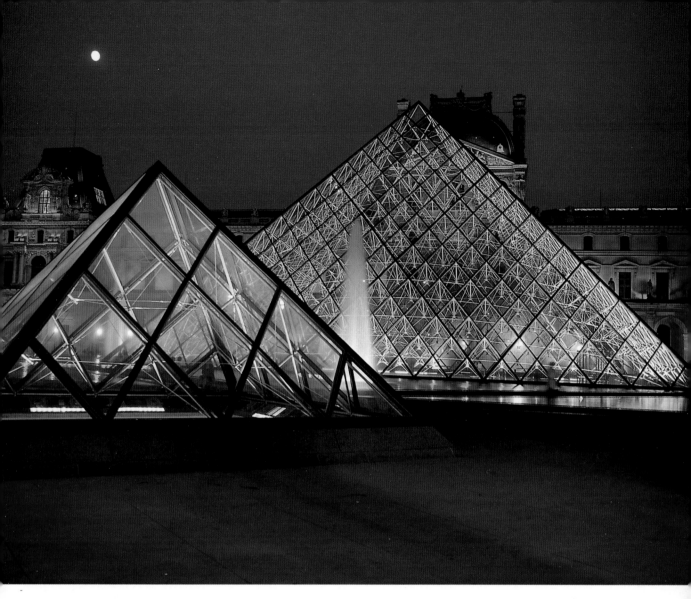

An impressive picture of the Pyramid of the Louvre at night.

THE GRAND LOUVRE

From the very beginning, when it was first installed in the palace of the Louvre in 1793, the museum has had to suffer all the limitations of a building which was never meant to be used for this purpose. The space required for a coherent presentation of the collections, which are among the richest in the world, and their exhibition to a vast public, was insufficient. The Louvre was, in other words, a museum filled to overflowing, and ill equipped to receive the growing number of visitors.

When, in 1981, it was decided to turn the entire palace over to the collections, transferring the Ministry of Finance to Bercy, François Mitterand initiated a vast and ambitious program for the restructuration of the Museum. Studies in museology and town plan-

ning were the first steps towards the achievement of the Grande Louvre, and the Chinese-born American architect, Ieoh Ming Pei, was entrusted with the organization of the Cour Napoléon as reception center for the museum, and with the finalization of a program for the redistribution of the collections within the new spaces.

COUR NAPOLEON

The two long buildings which faced each other made a centralization of the basic functions of the museum essential. By using the area under the Cour Napoléon for this purpose, in 1983 I. M. Pei designed a vast underground hall set at the center of the court under a

57

pyramid in transparent glass that was supported by a fine network of metal cables. Twenty-one meters high, the pyramid is surrounded by seven basins and by fountains, and is flanked by three low pyramids which provide light for the entrance galleries to the three wings of the Museum (Richelieu, Sully, Denon) where the collections will be redistributed.

For quite some time the pyramid was hotly debated. Actually the operation was anything but simple: a modern complex for the reception of the public, furnished with all the technical requisites indispensable for the life of a modern museum, had to be built in the heart of this historical site, which many considered already full to the brim with architecture and history. Without in the least changing the exterior aspect of the building, the solution adopted permits the focalization of the main entrance without concealing the palace and provides sufficient illumination for the enormous subterranean space. The transparency of the pyramid, with its pure geometric forms, reminiscent of ancient architecture, permits the visitor to remain in constant visual contact with the Palace of the Louvre.

The reception hall under the pyramid is also flanked by an auditorium, a space for temporary exhibitions and a new section dedicated to the history of the Palace. A chronological exhibit of documents, projects, prints, drawings, models and original works which bear witness to the various stages in the history of the Louvre, is to be found in the two rooms which flank the hemicycle where the vestiges of the decoration created by Jean Goujon (1510-1566) for the upper part of Pierre Lescot's building are on exhibit.

CASTLE OF PHILIPPE AUGUSTE

The achievement of the Grande Louvre was accompanied by an extensive scientific project aimed at highlighting the history of the Palace with archaeological excavations in the Cour Carrée, in the Cour Napoléon and in the Cour du Carrousel.

The excavations begun in 1983 under the Cour Carrée have brought to light the foundations of the original fortress of Philippe Auguste.

Access to the moats of the outer circle of walls is under the Pavillon Sully. Still extant is the foundation of the imposing defensive system, about six meters high, composed of a square with circular towers, built by Philippe Auguste at the end of the twelfth century. The pylon of the drawbridge in the north moat was added to this system by Charles V, thus permitting him to reach the garden.

A tunnel that passes through the eastern curtain wall leads to the Keep and the Room of St. Louis, which the king had vaulted in 1230-1240. It lies under the present Room of the Caryatids.

NEW INSTALLATION OF THE MUSEUM

The definitive transformation of the Louvre from palace to museum took place on November 20, 1993, with the inauguration of the new Richelieu Wing, two hundred years after the Louvre was opened to the public. The museum today is organized into seven departments (Oriental (Near Eastern) Antiquities and Art of Islam; Egyptian Antiquities; Greek, Etruscan and Roman Antiquities; Art Objects;

Sculpture; Graphic Arts; Painting) *distributed in three wings with access from the Napoleon hall beneath the great Pyramid.*

Very generally, the collections are distributed as follows:

RICHELIEU WING
Oriental or Near Eastern Antiquities and Islam; Sculpture (mezzanine and ground floor)
Art Objects (first floor, *where the apartments of Napoleon II, open to the public for the first time, are also to be found*)
Painting, *French, from the 14th to 17th century, Dutch, Flemish and German painting;* **Graphic arts**, *with the Northern Schools* (second floor)

SULLY WING
Egyptian Antiquities; Near Eastern Antiquities and Islam; Greek, Etruscan and Roman Antiquities; Sculpture; Art Objects (mezzanine, ground floor and first floor)
Painting, *French, from the 17th to 19th century;* **Graphic arts**, *with the French School* (second floor)

DENON WING
Greek, Etruscan and Roman Antiquities; Sculpture (mezzanine and ground floor)
Art Objects; Painting, *with large size nineteenth-century French painting, Italian painting and Spanish painting;* **Graphic Arts**, *with the Italian school* (first floor).

Pei's Pyramid seen from the outside and, below on the right, from the inside. The Cour Napoléon during the imposing restructuration works and the inverted Pyramid which lets light into the subterranean complex.

*One of the **Winged Bulls** from the palace of Sargon II, which have been placed in the Cour Khorsabad, on the ground floor of the Richelieu wing.*

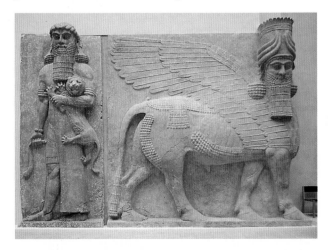

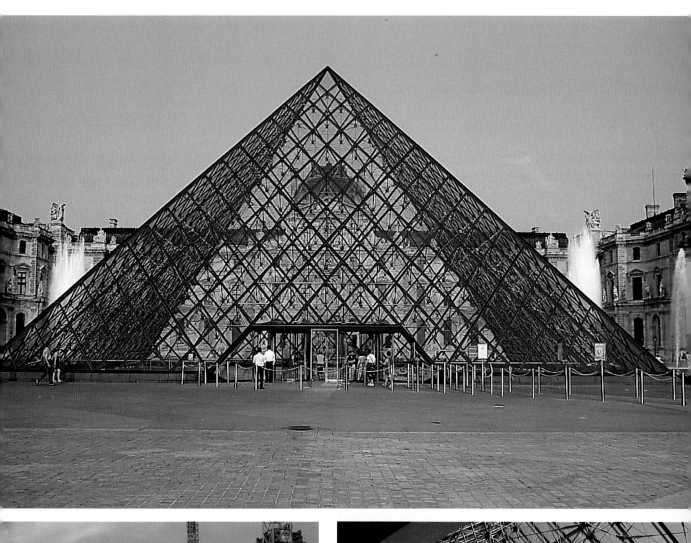

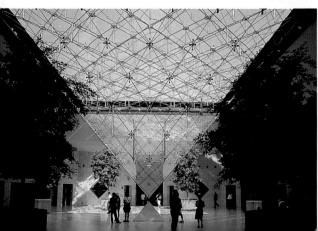

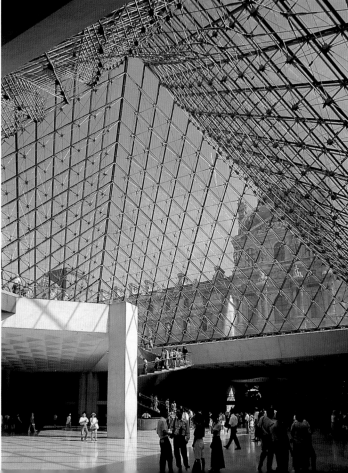

Ever since its institution, the section of Oriental Antiquities has been linked to the archaeological discoveries in the Near East made in the course of the nineteenth century.

An initial «Assyrian Museum» was inaugurated in 1847 by Louis Philippe after the discovery of the site of Khorsabad in northern Mesopotamia by Paul Emile Botta. The Winged Bulls which guarded the entrance to the Assyrian palace of Sargon II (724-705 B.C.) bear witness to this vigorous art which began in the ninth century B. C. Masters of the East from the ninth to the seventh century, the Assyrians built enormous palaces which were decorated with bas-reliefs which served to glorify the feats of the sovereigns.

Thirty years later Ernest de Sarzec began to explore the southern part of what is now Iraq and on the site of modern Telloh unearthed the impressive series of

statues of Gudea, the first evidence of a much older civilization (circa 2150 B. C.). As a result, the section of «Oriental Antiquities» was established in 1881. After the fall of the early Sumerian dynasties, Gudea, prince of Lagash, initiated a renaissance of the arts devoted to the exaltation of an ideal of serene piety.

Even earlier is the statue of the Intendant Ebih-II (2400 B. C.), discovered in Mari by André Perrot in 1934. A holy image placed inside a sanctuary, this work testifies to the high degree of refinement achieved by Sumerian sculpture in the course of the third millennium.

In the sixth century the region gradually passed first under the dominion of the Chaldean kings, and then under that of the powerful Persian empire, which had sprung up in western Iran. Reliefs, such as the Lion, from Susa, date to this period.

*Discovered in 1852 near Saqqarah in an excavation campaign led by Mariette, the **Seated Scribe** is a masterpiece of Egyptian sculpture. Presumably made around 2500 B.C., it is 53 cm. high and is in painted limestone, with inlays of semi-precious stones in his eyes. The fixed stare, the rigidly geometric composition, the severe frontality of the massive figure distinguish the scribe most of all. Even so he is animated by an intense inner life: the Scribe seems to be questioning us with his eyes, ready to begin his work on the papyrus scroll which he holds in his lap.*

Lion *in relief on glazed brick, from the imperial palace of Susa, a city that together with Persepolis was one of the capitals of the kingdom of the Achaemenid dynasty. The unknown artist has succeeded beautifully in rendering the litheness of the feline gait.*

As in the case of Oriental antiquities, the creation of the section dedicated to Egyptian antiquities was directly dependent on scientific research: in 1826 Champollion, who four years earlier had deciphered the hieroglyphs, was entrusted with the organization of a section on ancient Egypt as part of the new Charles X museum. Thereafter the collections were enlarged by a continuous succession of acquisitions, donations and archaeological excavations, above all those carried out by Mariette in 1852 in Saqqara and in which various masterpieces such as the **Seated scribe,** or the **Pectoral in the form of vulture with the head of a ram** were brought to light.

The scribe, as well as the **Head of King Didufri,** date to the Old Kingdom (2700-2200 BC. circa), the glorious period of the great pyramids of Giza and Saqqara, near Cairo. Sculpture of this period is essentially funerary in character: the statue, which represents the deceased, had to be a good likeness, and the works of this period are to all effects portraits.

After the obscure centuries of the First Intermediate Period, which has left few works of art, Egypt once more discovered its unity and force in the course of the Middle Kingdom (2060-1768 B. C.). The works of this time are marked by a seductive stylization, with slender limbs and harmonious proportions. The large statue of **Nakht is** a good example.

The wars of liberation against the Hyksos, invaders who had come down from the Near East one hundred and fifty years earlier, resulted in the New Kingdom (1550-1080 B. C. circa). The 18th dynasty produced some of the most captivating and moving sculpture in ancient Egypt such as **Hatshepsut and Sennefer** or the statue of **Akhenaton,** figures imbued with grace and spontaneity.

GREEK, ETRUSCAN AND ROMAN ANTIQUITIES

The section of Greek, Etruscan and Roman Antiquities is one of the oldest in the museum of the Louvre. The cult of «antiquity» goes back to the Renaissance. Francis I commissioned various copies in bronze of antique sculpture from Primaticcio for the palace of Fontainebleau.

Original Greek and Roman marble sculpture which Louis XIV had collected in Versailles formed the initial core of the museum collection. During the Revolution, expropriations brought in further works, such as the fragment of the **Parthenon frieze** *requisitioned from the Count of Choiseul-Gouffier, to be followed by various acquisitions, such as the Borghese collection in 1808, unquestionably one of the most important.*

The inauguration of the first «museum of Antiquity», in 1800, was marked in particular by the presentation of the works that Napoleon had requisitioned in Rome from the Vatican Museums and from the Capitoline Museum (above all the Laocoön and the Apollo Belvedere), which were returned to Italy in 1815.

Some of the most famous masterpieces of which the department is justly proud were added to the collection in the nineteenth century: the **Venus of Milo,** *given to Louis XVIII by the Marquis de Riviere; the* **Olympia marbles,** *donated by the Greek senate in thanks for the services rendered by France in the course of the Greek wars for independence; the* **Victory of Samothrace,** *sent by Champoiseau in 1863; and lastly the almost four thousand pieces of the Campana collection.*

Discovered in 1820 by a peasant on the island of Milo in the Cyclades, this statue became the prototype of Greek female beauty. Slightly more than two meters tall, the **Venus of Milo** *dates to the Hellenistic period (late 2nd cent. B.C.), but almost certainly derives from an original by Praxiteles, as indicated by the position of the figure, slightly unbalanced and almost leaning upon an imaginary support which makes her delicately twist and curve her torso inwards. The nude body of the goddess, endowed with lightness by the Parian marble, emerges from the folds of her garment which is slipping towards the ground, just barely held up by the slightly bent left leg.*

The **Victory** *or* **Nike of Samothrace** *(from its find site), 2 meters 75 cm high, is in Parian marble and dates to circa 190 B.C. when the inhabitants of Rhodes succeeded in winning several battles against Antioch III. The Nike stands erect on the prow of the ship which she will guide to victory: the impetuous sea wind strikes her with its full force, twisting her garments which cling to her limbs, in an almost Baroque treatment of the drapery, and violently forces her wings backwards.*

The number and variety of French paintings in the Louvre make it the most important collection of its kind in the world. It is not however the oldest of the museum collections, for throughout the sixteenth century interest had centered on Italy, both for works of antiquity and for those by the great masters who dominated that century (Leonardo da Vinci, Raphael, Titian, etc.). The supremacy of the French school did not begin until Louis XIV.

THE PRIMITIVES AND THE SIXTEENTH CENTURY

During the fifteenth century French painting gradually freed itself from the Gothic world. In Burgundy various artists such as Bellechose or Malouel adopted a «Franco-Flemish» style where Northern realism went hand-in-hand with the charming stylizations of International Gothic art. In Avignon, where French and Italian influences intermingled, the result was an unadorned monumental style of which the **Pietà** is a supreme expression. This twofold Flemish and Italian influence is particularly evident in works such as the **Portrait of Charles VII** by Jean Fouquet or the **Magdalen** by the Master of Moulins.

When Charles VIII returned from his first expedition into Italy, France looked to the Peninsula. Called by Francis I to decorate his royal chateau of Fontainebleau, Rosso Fiorentino and Primaticcio created a school of Mannerist painting in France that was to dominate the entire century.

With the exception of the **Portrait of Francis I** by Jean Clouet, which was expressly commissioned for the royal collections, all these works found their way into the Louvre only later. Not until the nineteenth century did the curators of the museum and the public begin to take an interest in the early masters of French painting.

THE SEVENTEENTH CENTURY

Most of the various tendencies which appeared under the reign of Louis XII came from Italy (Valentin, Claude Vignon, Simon Vouet), but they were often reinterpreted in an extremely personal way (Georges de la Tour) or blended with other Northern influences (Louis Le Nain). When Louis XIV ascended the throne, all the talents were directed towards a type of classicism aimed at glorifying the greatness and power of the State, identified with the person of the Sun King. The prime moving force was Charles Le Brun, whose dictates influenced the arts and paved the way for the imposing decorative compositions commissioned by Louis XIV.

After Francis I, the greatest sovereign patron of the arts was Louis XIV. He unceasingly bought and commissioned paintings for Versailles and the other royal chateaux from his Court painters (Le Brun, Mignard) and precedent masters (Poussin, Claude Gellée). The king purchased about thirty works by Poussin, absolute point of reference for the academy, which are now in the Louvre.

THE EIGHTEENTH CENTURY

The beginning of the eighteenth century is characterized by the emergence of a reaction against the overly strict rules of Classicism. This reaction was embodied in the style known as «rocaille» or «rococo», a pleasing noncommitted art which began at the end of the reign of Louis XIV and which was affirmed under the Regency with Watteau's «fête galants». This art, of an extreme sensibility and poetry, was championed by diverse personalities such as François Boucher, favorite painter of Madame de Pompadour, Honoré Fragonard and Jean Baptiste Chardin, intimist painter of still lifes.

Unlike his contemporaries, Louix XV was not a collector. With the exception of a few acquisitions of works by living artists, the eighteenth-century collection preserved in the Louvre is due in great part to the donations which the great collector La Caze made to the museum in 1869 (among these **Gilles** by Watteau and the **Bathers** by Fragonard).

The end of the century was dominated by the neoclassic style, inspired by the recent discoveries in Pompeii and Herculaneum. Its greatest representative is without doubt David, and the Louvre owns his most outstanding and monumental compositions, such as the **Oath of the Horatii**, purchased from the Conte d'Angiviller, Director of Building under Louis XVI, or the **Coronation of Napoleon I**, which the emperor had commissioned in 1806 to commemorate his recent ascent to the throne.

THE NINETEENTH CENTURY

In 1818 the Restoration created the museum of Luxembourg, the first museum of contemporary art, where most of the great paintings of classic art were collected before reaching the Louvre (Girodet, Guérin, Gérard, Prud'hon), as were those by the new masters of Romanticism. Some of the greatest masterworks of «living» painting thus became part of the national collections, purchased directly from the Salon by the Conte de Forbin, Director of the Museums: **Dante and Virgil in Inferno** and **The Massacre at Chios** by Delacroix, as well as the **Raft of the Medusa** by Géricault. This policy of acquiring works by the Romantics continued under Louis Philippe. But it was not until the end of the century that the principal works of Ingres, the **Grande Odalisque** (1899) and the **Turkish Bath** (1911), made their entrance into the Louvre.

*This famous intensely realistic portrait of **Charles VII King of France** by Jean Fouquet (1420 ca - 1480 ca) seems to have been painted around 1444, in other words shortly after the painter's trip to Italy. The picture was given by the king to the Sainte Chapelle of Bourges, where it remained until 1757, when the church was demolished. It entered the collections of the Louvre in 1838. The painting shows us the king in a three-quarter view, richly dressed and clearly detached from the background.*

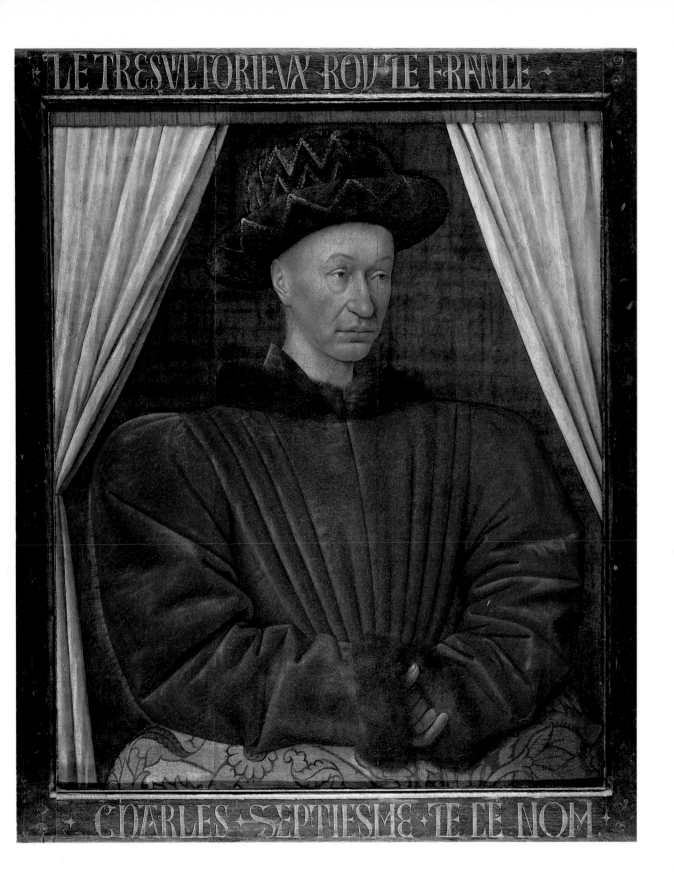

The panel of the **Pietà of Villeneuve-lès-Avignon** was named after the place where it was found in a church in 1801 after having been saved from a fire in 1793. The attribution of this outstanding masterpiece of International Gothic art is uncertain. The group stands out powerfully against the gold ground, the last remaining sign of the Gothic. In splendid color contrasts, the body of Christ lies abandoned on his Mother's lap, while St. John holds his head with his hand. A strong sense of pathos and profound emotion is created by the horizontal line of Christ's body which tragically interrupts the static compactness of the group around him.

The preferences of Nicolas Poussin (1594-1665) were for large compositions of a mythological and historical nature such as this **Rape of the Sabine Women**. Born in France, Poussin lived for many years in Rome, where he died. Here the painter was in touch not only with the world of the Baroque, which was slowly taking shape, but also with that of the late Renaissance which still survived in the works of Raphael in the Vatican.

Claude Lorrain (1600-1682), who painted this **Campo Vaccino in Rome**, also lived and worked in Rome for many years, like Poussin. His landscapes are full of a warm, golden light, typical of those sleepy afternoons when the shadows grow to enormous length; passionately in love with antiquities, his eyes linger on the broken pediment, on columns lying full-length on the ground, on over-turned capitals, in a landscape he saw as intimate and evocative.

Diana Resting after her Bath, by François Boucher (1703-1770). A typical representative of the French Rococo style, Boucher was the court painter at the time of Louis XV, and enjoyed the patronage of Madame de Pompadour. His is a festive, refined art, full of the joy of living; the female bodies he loved painting are perfectly proportioned, in the triumphant nudity of adolescence, with their tenuous delicate warm tones.

Jean-Honoré Fragonard (1732-1806) was the best-known and best-loved representative of French Rococo: a pupil of Boucher, the sensual quality of his color and the fullness of his forms reveal his strong debt to the style of Rubens. **The Bathers**, painted after the artist's first trip to Italy, is almost a hymn to life, to sensuality and joy, in forms that have become almost immaterial and ethereal .

67

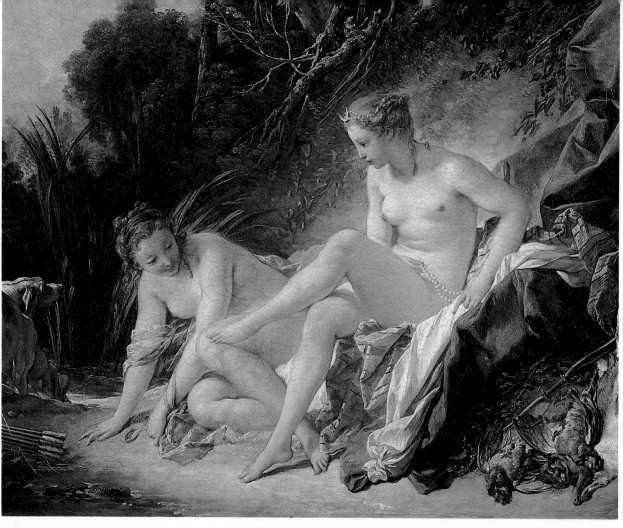

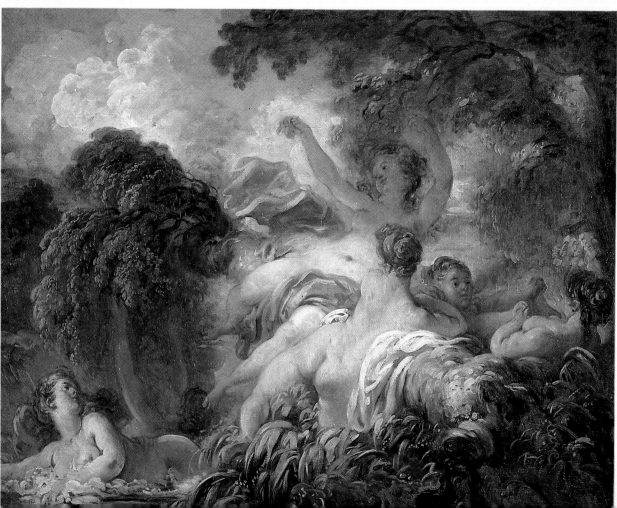

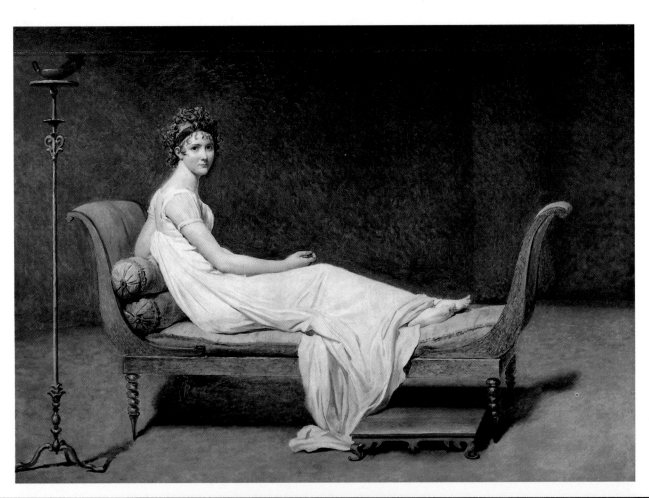

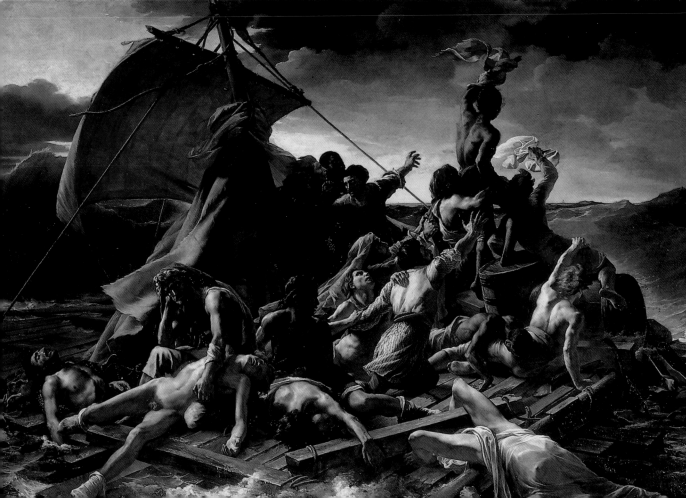

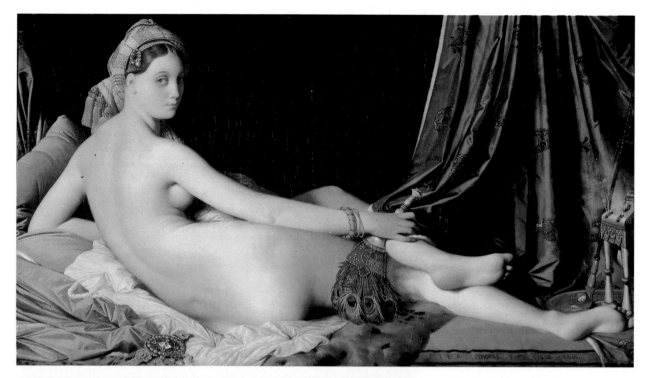

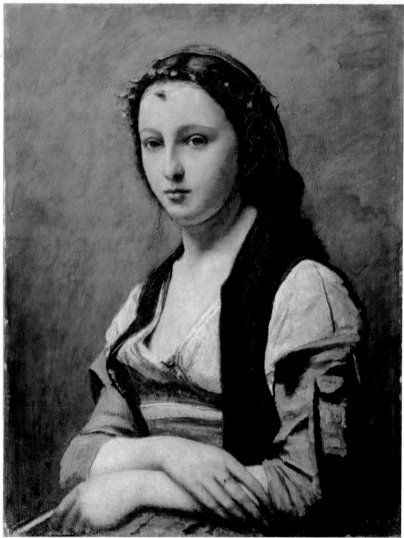

In this **Grande Odalisque** languidly resting on silk cushions, the pure play of line so dear to Jean-Auguste Ingres (1780-1867) is particularly evident: an antique statue seems to have come to life and the body is endowed with a palpable humanity.

Painted in 1868 in the same pose as Leonardo's Mona Lisa, this splendid **Woman with the Pearl** is a sort of prototype of all the portraits by Camille Corot (1796-1875): a decisive and confident line, a calm light that envelops the entire figure and that sense of peace and serenity which characterize the great painter's style.

The **Portrait of Madame Récamier** by Jacques-Louis David (1748-1825) is an image of great purity, of acute psychological introspection and warm humanity. The background is anonymous, purposely left in the shade so as to make the lovely figure of the woman who delicately turns her head towards the spectator stand out all the more.

The Raft of the Medusa by Théodore Géricault (1791-1824) was inspired by the tragic shipwreck of the French frigate Medusa on its way to Senegal. The survivors were left adrift on the ocean on a raft. Géricault captured on canvas the moment in which the victims of the shipwreck sighted a sail on the horizon and it seems as if a tremor of life and hope can be felt on this raft of horror and death.

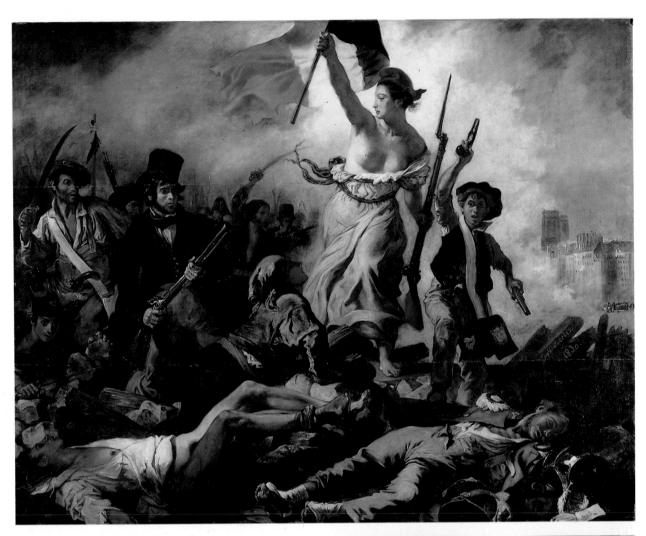

Liberty Leading the People, by Eugène Delacroix (1798-1863). This picture, in a sense a political poster, was painted to celebrate the day of July 28, 1830, when the people rose up and dethroned the Bourbon king. Despite the rhetoric that pervades the picture, Delacroix fully participates in the event: in the figure of Liberty moving forwards, in the boldness of the people who follow in contrast to the lifeless figures of the dead piled up in the foreground, in the heroic poses of the people fighting for liberty, in all this there is the feeling that the artist is involved heart and soul.

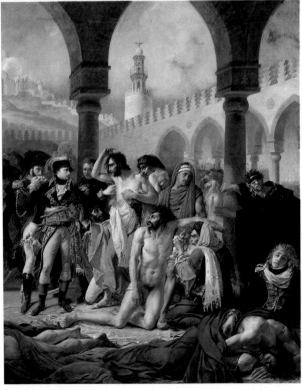

Napoleon Visiting the Plague-stricken at Jaffa (detail), by Jean-Antoine Gros (1771-1835). Having encountered Napoleon's favor, Gros began to paint a series of large works meant to celebrate the battles, events, victories of the Emperor. Thus, as a faithful and impassioned reporter, he painted this enormous picture (more than seven meters long and over five meters high) to exalt Napoleon's courage in the Syrian campaign.

THE PRIMITIVES AND THE EARLY RENAISSANCE

The revolution that had been launched in the various fields of thought and art is characterized by the return of the lessons of Antiquity, a return to Greek and Roman models. It gathered impetus in the fourteenth century, and took definitive shape in the second half of the fifteenth century.

Cimabue's solemn **Maestà** (1270) announced an initial reaction against the hieratic Byzantine models. The artist replaced the formal linearity of Byzantium with a delicate modulation of volumes, freed the figures from their static poses, heralding the large altarpieces of Duccio and Giotto.

During the fifteenth century, under the twofold influence of architecture (Brunelleschi) and sculpture (Donatello, Ghiberti), Italian painting moved towards the Renaissance. The artists of the Florentine school, the most famous at the time, distinguished themselves above all in their feeling for three-dimensional form and their passion for experimentation, particularly in the field of linear perspective, a crucial innovation which was to determine the pictorial idiom for various centuries. The dominant features of this school were determined by three painters: Masaccio established in its entirety the three-dimensional humanist ideal of the Renaissance, Paolo Uccello gave his **Battle of San Romano** the monumentality of a high relief by means of his daring foreshortenings and the decorative stylization of form, emphasized by the cool colors; Fra Angelico integrated the lingering medieval universe of his **Coronation of the Virgin** with new discoveries in form and movement: breadth and balance of the structure, respect for perspective.

In the middle of the century these studies led to the perfect mastery of volume and perspective, the greatest representatives of which were Piero della Francesca, Andrea Mantegna (**Saint Sebastian**), Antonello da Messina (**Il Condottiere**) and Giovanni Bellini.

The Classicist centuries had paid no heed to these painters who were not represented in the royal collections. Merit for the first acquisitions for the Louvre go to Vivant Denon, Director of Museums under Napoleon. But the Primitives did not became fashionable in France until Napoleon III acquired the Campana collection, which brought around a hundred pictures to the Louvre, with the rest in what is now the Museum of the Petit Palais in Avignon.

THE HIGH RENAISSANCE

At the beginning of the sixteenth century, the Rome of the popes once more became the artistic capital, a role it had lost with the decline of Antiquity. All the projects and achievements of Bramante, Michelangelo, Raphael were centered around the monumental undertaking of St. Peter's. This century also witnessed the birth of the Venetian school with its triumphant stress on color, of which Giorgione was the guiding spirit with his disciple, Titian, its most illustrious representative.

The section dedicated to the works of these artists contitutes one of the Louvre's most irreplaceable treasures, first and foremost for its unique collection of works by Leonardo da Vinci. Invited by Francis I, Leonardo came to stay in the chateau of Clos Luce near Amboise in 1516. On his death, Francis I acquired various of the great painter's works (in particular «**La Gioconda**» and the **Virgin of the Rocks**) around which other masterpieces of the Italian Renaissance were gathered (Raphael's **The Holy Family** and **La Belle Jardinière, Charity** by Andrea del Sarto, etc.).

This first fund, kept for a long time in the chateau of Fontainebleau, eventually was greatly enriched when Louis XIV acquired a part of the gallery of Cardinal Mazarin (1661) and that of the banker Jabach (1662-1671). Works such as Raphael 's **Portrait of Baldassarre Castiglione,** Titian's **Concert Champêtre** and the **Woman at the Looking Glass**, the painting by Correggio known as **The Sleep of Antiope** made their way into the Louvre. The Renaissance in its essence was thus already there when the Louvre was first created in 1793. Of the immense number of paintings requisitioned in Italy during the Revolution and the empire, only a few remained in the museum, such as the **Wedding of Cana** by Veronese, of outstanding importance.

THE SEVENTEENTH AND EIGHTEENTH CENTURY

At the end of the sixteenth century a new chapter in painting began in Italy. Caravaggio, with his esthetics and his technique, exercised a profound influence on European art. The **Death of the Virgin,** bought by Louis XIV, at the time created a scandal as a result of its realism and the excessively accentuated dramatization of the contrasts of light and dark.

Subsequently, numerous paintings of the school of Bologna (the Carraccis, Reni, Guercino, Domenichino), purchased or donated to Louix XIV by Italian art lovers, came to enrich the royal cabinet.

The Madonna and Child in Majesty by Cimabue (towards 1240-after 1302). The fundamental characteristics of Cimabue's painting clearly emerge in this panel: a precise incisive line and a strong chiaroscuro used together to create a powerful three-dimensionality.

On the following pages:
Mona Lisa (La Gioconda) by Leonardo da Vinci (1452-1519). Mona Lisa's faint smile reflects the atmosphere of delicacy and gentleness which pervades the entire picture. To achieve this effect, Leonardo made use of the sfumato technique, a gradual dissolving of the forms, an uncertain sense of the time of day and the continuous merging of lights and shade.

Madonna and Child with the Infant St. John (La Belle Jardinière) by Raphael (1488-1576). Painted in 1507, this picture belongs to Raphael's Florentine period, between 1504 and 1508. The serene and tranquil beauty of the Virgin set in the midst of a meadow full of plants and flowers are why it has been called "La Belle Jardinière".

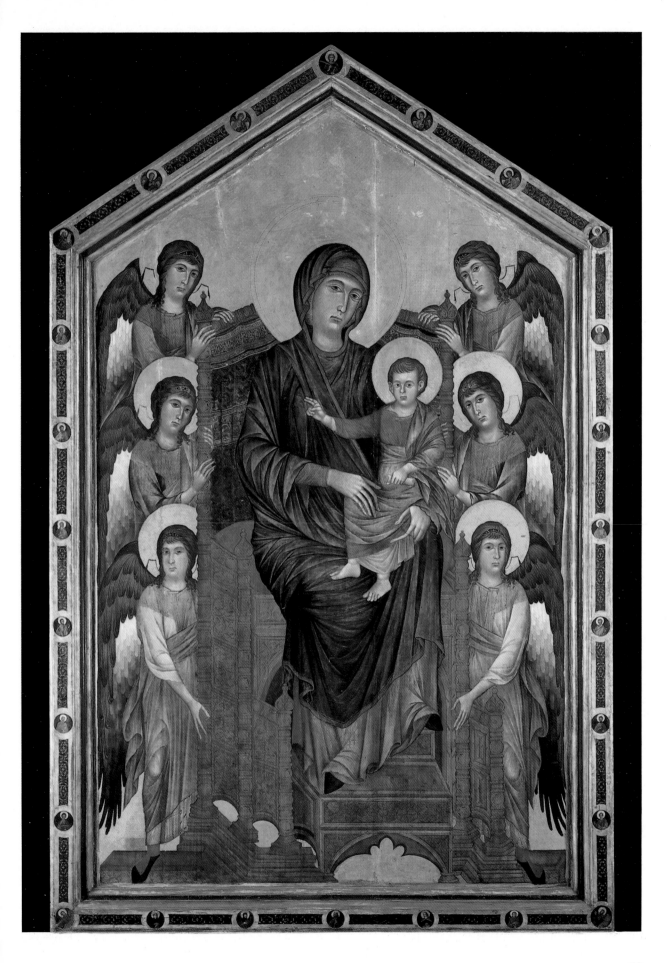

73

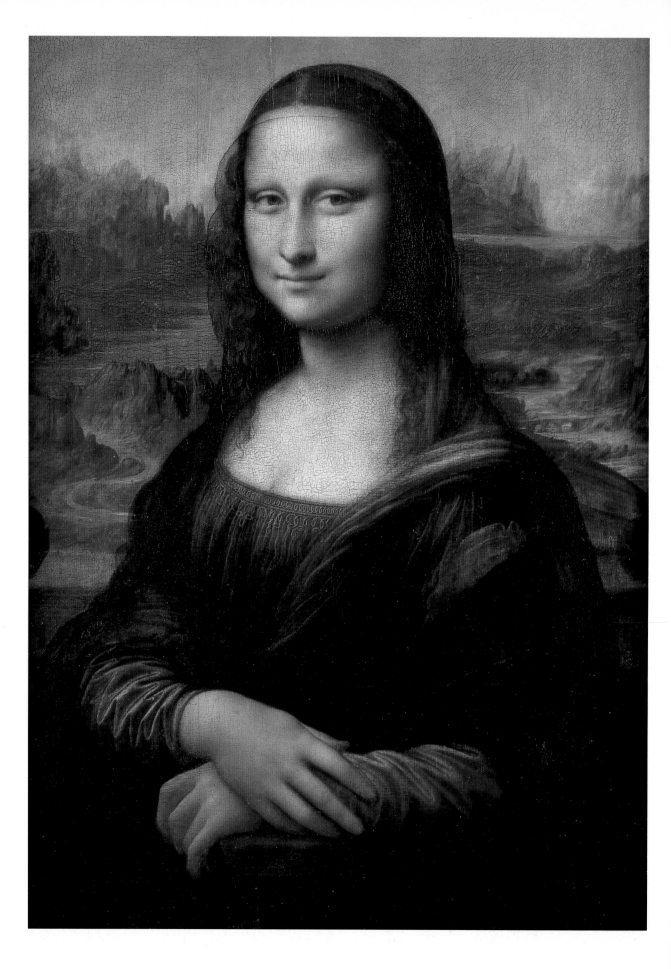

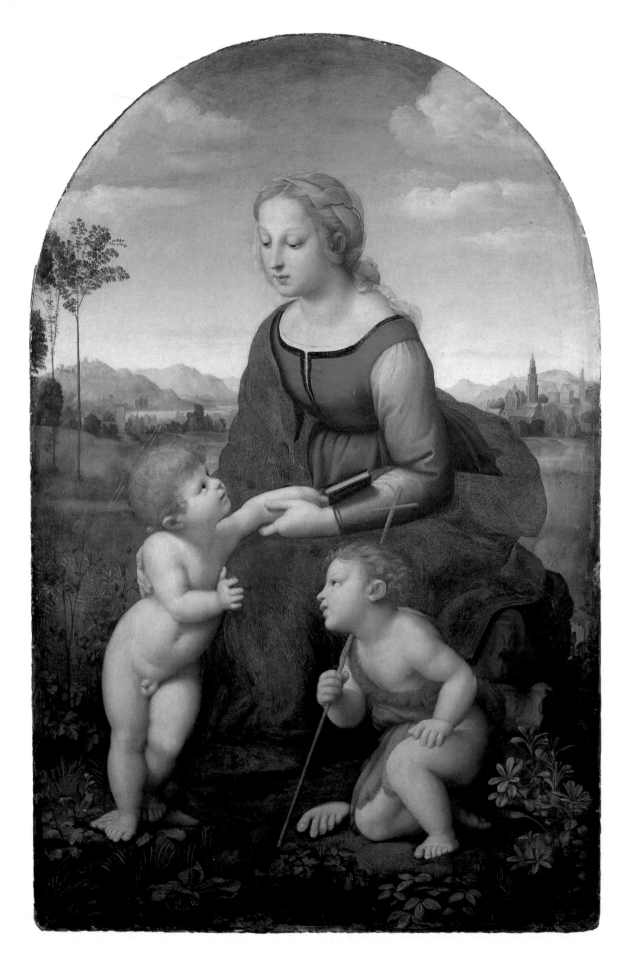

In the eighteenth century, Italian painting had its last moment of splendor in Venice. Unfortunately this period is represented in the Louvre in a fragmentary manner, despite an important group of canvases by Pannini, purchased under Louis Philippe, and the entrance, with the confiscations of the Revolution, of the admirable series of **Venetian Fêtes** by Francesco Guardi. After the last war, the collection continued to grow and by now includes works by Canaletto, Tiepolo, Piazzetta, Pietro Longhi and Crespi.

FLEMISH AND DUTCH PAINTING

THE PRIMITIVES

The painting of the Nordic school is the result of a synthesis between the precise linear expression of the miniaturists, the subtle range of colors of the Italians and Gothic naturalism. All these features are already present in the works of the Van Eyck brothers, in particular in **The Virgin and the Chancellor Rolin** (circa 1435) where a realism that was to become one of the specific characteristics of this school is affirmed. Subsequently various painters such as Rogier van der Weyden (**Annunciation**) or Memling (**Portrait of an Old Woman**) were to dilute this realism with a melodic linearity that recalls the Gothic. Various features of this style were to be continued beyond the limits of this century by two great masters: Hieronymus Bosch (**The Ship of Fools**) and Bruegel the Elder (**The Cripples**).

It is highly probable that the collection of Francis I also included various contemporary Flemish paintings. Even so not until the creation of the Musée Napoleon did the Flemish primitives become famous. Among the numerous works requisitioned, only those by Van Eyck and Roger van der Weyden, as well as **The Banker and his Wife** by Quentin Metsys, bought in Paris in 1806, remained in the Louvre.

THE SEVENTEENTH CENTURY

From the sixteenth century on, the political and religious rupture between the northern and southern provinces of the Low Countries played a part in the divergence that took place between the Flemish and Dutch schools. Once it had become independent, Holland developed an art all its own, imbued with the severe and somber atmosphere of the reformed church and favored by a new wealthy bourgeois class. Rembrandt and Frans Hals portrayed the assemblies of the great confraternities of their times with a keen psychological intensity. Flemish painting, on the other hand, was dominated by the genius of Rubens. The first paintings to enter the royal collections in the seventeenth century were those by living artists who had come to Paris to work for the queen, Marie de Médicis: Frans Poubrus, who painted the official portrait of the queen, and Rubens, called to execute the decoration of the gallery in her palace in Luxembourg (**The Disembarkation of Marie de Médicis in Marseilles**). Masterpiece of Baroque painting, this work however was not to influence French Classicism until the end of the century, a period in which those who championed «color» prevailed over the Poussinists, who argued the primacy of drawing. The collections of Flemish painting multiplied and the king's cabinet was enriched by new works by Rubens (**Kermesse**) and Van Dyck, not to mention the great Dutch masters (in particular the **Portrait of the Artist at his Easel** by Rembrandt).

With Louis XVI, and more precisely, with his Director of Constructions, Conte d'Angiviller, the collection was substantially enlarged. Imbued with the encyclopedic spirit of his contemporaries, d'Angiviller did all he could to fill the lacunae in the museum, above all as far as the Northern schools were concerned. Other paintings by Rubens (**Helene Fourment)** Van Dyck (**Charles I, King of England**) and Rembrandt (**Supper in Emmaus**), as well a.s works by Jordaens, Ruisdael and Cuyp, were purchased.

This fund was further enriched by various masterpieces which Doctor La Caze donated during the Second Empire, in particular the **Bohemienne** by Frans Hals and **Bathsheba** by Rembrandt.

Rogier van der Weyden (1399-1464) reproposes in this **Annunciation** the Flemish concept of space: a small interior with a wealth of details, an open window that lets us glimpse the countryside in the form of a river, a highly natural atmosphere.

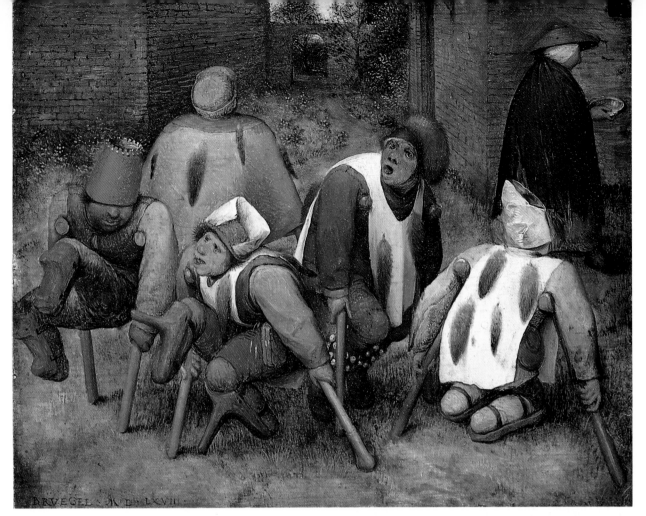

Pieter Bruegel (1525/30-1569) painted **The Cripples** in 1568. The faces of only two of the six figures are visible: the others are nothing but deformed bodies, solid volumes painted in strong color contrasts. The fox tails hanging from the ragged clothes identified the lepers, so that people could keep at a distance. It is highly likely that in these figures with their odd carnival hats (a crown, a bishop's miter, perhaps alluding to various social strata) Bruegel intended this picture as a satire of humanity, divided to be sure into social castes and privileges, but also tragically alike in their misfortunes.

When Rembrandt van Rijn (1606-1669) painted this **Self-portrait at the Easel** he was no longer young: his patrimony had been lost and his popularity was on the wane. Faithful as always to his search for light, Rembrandt painted himself with absolute sincerity: the face that looks out at us is that of a man who is tired but who has not given in to the vicissitudes of life.

The Lacemaker is one of the best-known works by Johannes Vermeer (1632-1675). The perfect harmony of light, forms and colors achieved in his compositions transfigures the simple character of the theme and raises it to the most exalted spheres of absolute values.

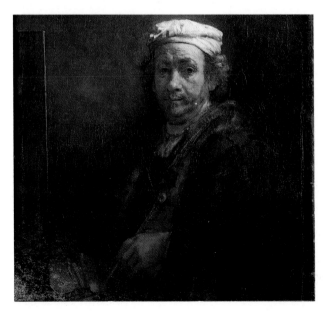

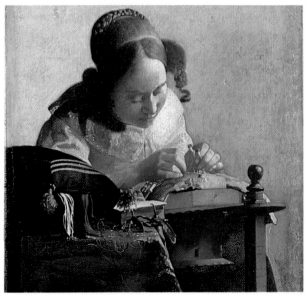

The collection of Spanish painting in the Louvre is of recent date. Classicist Europe from the sixteenth to the eighteenth century ignored or misinterpreted this school: Ribera was the only one who achieved glory, but as a Neapolitan painter. Despite the fact that two successive queens came from Spain, Anne of Austria and Maria Theresa, only three artists - Velazquez, Collantes and Murillo - were represented in the royal collections. **The Burning Bush** *by Collantes and the* **Portrait of the Infanta Margarita** *by Velazquez, a gift of Philip IV to his sister, queen Anne of Austria, were practically the only Spanish works to be found in Louis XIV's collection. Under the reign of Louix XVI a few pictures by Murillo, the first Spanish artist to be known and appreciated in France, were added. Included among these was* **The Young Beggar,** *one of his masterpieces, which was purchased from the dealer Lebrun.*

With the advent of Romanticism everything changed and Spain became fashionable. During the Empire, collections which were the fruit of confiscation during the Napoleonic wars, such as those of Giuseppe Bonaparte and Marshal Soult, had a distinct advantage. Louis Philippe however can be credited with introducing the masterpieces of the Golden Century to the public at large: his collection, duly purchased in Spain by his emissary, Baron Taylor, and exhibited at the Louvre from 1838 to 1848, was to be a fertile source of study for young artists such as Courbet and Manet. Unfortunately this collection of more than four hundred works went with the sovereign into exile and was eventually sold at auction in London in 1853. The only painting the Louvre was later able to recuperate was the **Christ on the Cross** *by El Greco, purchased in 1908.*

While on the one hand this great loss is deplorable, on the other the quality of the acquisitions and donations in the second half of the nineteenth and in the twentieth century are highly laudable. During the Second Empire, the breaking up of the Soult collection permitted five masterpieces to enter the Louvre, including two scenes from the **Life of Saint Bonaventura** *by Zurbaran. A few years later, the La Caze bequest brought in the famous* **Club-footed Boy** *by Ribera. Lastly, at the beginning of the twentieth century, a series of prestigious acquisitions filled a few outstanding lacunae. The primitive masters were included in the selection (Mastorell, Huguet, the Master of San Ildefonso) and thus some of the important works by seventeenth-century masters missing from the fund (Valdés Leal, Alonso Cano, Espinosa) were appropriated.*

Despite its limitations, the Spanish collection of the Louvre, at present numbering around fifty pictures, is sufficiently representative and provides a complete panorama of the various periods with divers outstanding works.

Unlike other Spanish painters, Esteban Murillo (1618-1682) kept away from the luxuries of the court as well as from an overly gloomy and obsessive mysticism. Even so it is above all in the conditions of poverty that the painter attempted to find the most beautiful and delicate aspects. This pathetic and delicate figure of a **Young Beggar** *inspires us with a feeling of tenderness and piety, but not repulsion.*

The Portrait of the Infanta Margarita belongs to the most successful and mature period of the artistic activity of Diego Velázquez (1599-1660) at the court of Spain. The colors have achieved their warmest tones, the relationship of hues is precise, the light that plays on the face of the child fuses with the golden-blond mass of her hair.

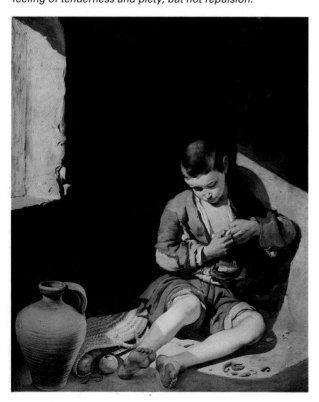

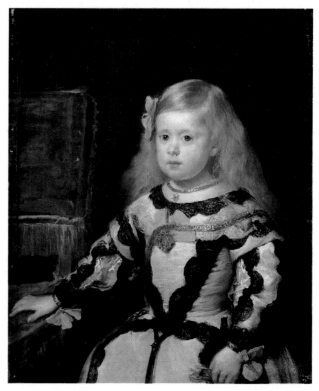

The importance of the collection of German painting in the Louvre is indisputable, even though the number of pictures included is relatively small.

The fifteenth century is dominated by a deservedly interesting group comprised of painting of the school of Cologne. The Master of the Holy Family and the St. Severin Master adhere to the style of Stephan Lochner, whose personality dominated the first half of the fifteenth century, while the influence of Flemish art can be noted in the works of artists such as the Master of St. Bartholomew (panel of the **Descent from the Cross**).

The star of the collection dates to the Renaissance. The origins of this section are particularly prestigious: the five portraits by Holbein, the glory of the museum, entered the royal collection in the seventeenth century. The **Portrait of Erasmus** was a gift of Charles I of England to his brother-in-law, Louis XIII. The other four paintings (in particular the portraits of **Nicholas Kratzer**

and **Anne of Cleves**) were part of the collection of the banker Jabach which Louis XIV purchased in 1671. In these paintings Holbein gives proof of his talent as a portrait painter, combining a meticulous attention to reality with a surprising feeling for the simplification of volume and form.

Albrecht Dürer who, together with Holbein, was a classic example of the Humanist artist of the German Renaissance, is represented by his **Self-portrait** of 1493 which entered the Louvre in 1922.

The collection also includes sundry paintings by Lucas Cranach, in particular a **Venus** acquired in 1806.

Other names, in addition to these great three, bear witness to the wealth of art resources to be found in sixteenth-century Germany, but their presence in the Louvre is only fragmentary, with canvases by Hans Baldung Grien (**The Knight, the Maiden and Death**), Wolf Huber and Hans Sebald Beham.

__Portrait of Erasmus of Rotterdam__ by Hans Holbein the Younger (1497-1543). This picture in the Louvre, painted in 1523 during Holbein's sojourn in Basle, may be the finest portrait of the great reformer. It is certainly the most famous, and has become the image of the humanist.
Erasmus is shown absorbed in writing his Commentary on the Gospels of St. Mark.

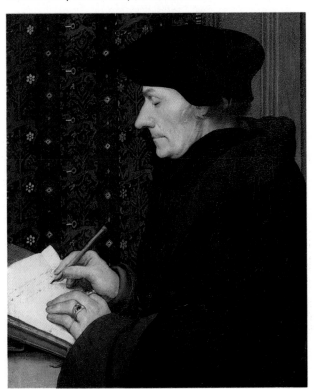

__Self-portrait with a Ricinus Flower__ by Albrecht Dürer (1471-1528). In the course of a study trip which Dürer undertook in 1493 between Basle and Strasbourg, he painted this self-portrait which he probably sent to his fiancée, whom he then married when he returned to Nürnberg. The ricinus flower he holds in his right hand is thought to be a symbol of conjugal fidelity but also of the Christian faith, if we read the inscription at the top which says "My things go as ordained on high".

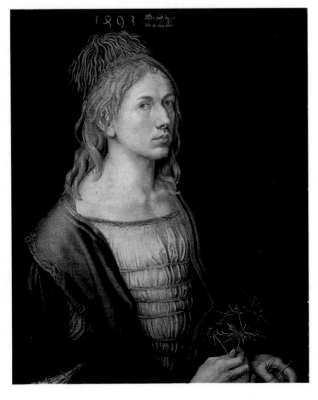

In the history of the Musée du Louvre, the creation of a department dedicated to sculpture (Medieval, Renaissance and Modern) is of relatively recent date. When the museum opened its doors the only examples of sculpture were Michelangelo's **Prisons,** confiscated as the belongings of emigrants from the daughter of Maréchal de Richelieu. It was not until 1824 that the «Galerie d'Angoulême», the first section of sculpture, was opened by Comte de Forbin, at the time rector of the museums. A sculpture section worthy of the name, no longer subject to the department of Antiquity or of the Decorative Arts, was not instituted until 1871. The collection inherited numerous funds, which up to then had been scattered here and there and which were only subsequently brought together in the Louvre: old royal collections, collections from the Academy and lastly sculpture from the old «Museum of French Monuments», created by Alexandre Lenoir, and which comprised works dating to the Middle Ages and the Renaissance originally in churches and monasteries. These facts explain why the French school predominates in this section, even though foreign schools, at least for the fifteenth and sixteenth centuries, are not excluded. Among the me-dieval works, of which the Louvre offers a brilliant panorama, particular note should be taken of the statue of **Charles V** (circa 1365-1380), a fine example of the development of realism in portraiture, and the surprising **Tomb of Philippe Pot** (late fifteenth century), supreme achievement of a type of sculpture inaugurated by Claus Sluter at the court of Burgundy. The French Renaissance is represented by two great artists: Jean Goujon, with a fine bas-relief from the Fountain of the Innocents, and Germain Pilon, who executed the funeral monuments of king Henry II. By the middle of the seventeenth century sculptors were in the service of the monarchy of Versailles, where Classicism consisting of measure and reason dominated. Only Puget, in Provence, saved himself from the influence of the court and created a vivid and impassioned work. This Baroque influence continued in the middle of the eighteenth century as witnessed by the **Horses of Marly** by Nicolas Coustou. A tendency to return to antiquity appeared in the middle of the century, dominated by artists such as Pigalle Bouchardon, Falconet, who created a neoclassic style, which received its official connotation from the Venetian Canova (**Cupid and Psyche**).

The **Tomb of Philippe Pot** has been attributed to Antoine le Moiturier (1425 ca- 1497) known also as "maistre Anthoniet" on account of the evident similarities in the style and composition to be found in the tombs of Champmol in Dijon. The dead man, enclosed in his suit of armor, is carried by eight figures hermetically enveloped in their somber mourning weeds.

The **Statue of Charles V**, French art, 14th century. The **Prisons** by Michelangelo (1475-1564) were made for the Tomb of Julius II (never finished) and perhaps represent, in Michelangelo's symbolism, the arts prisoners of death after the demise of the pope who had so long protected them, but they are also an expression of the artist's tormented spirit as he attempts to dominate the material of his art.

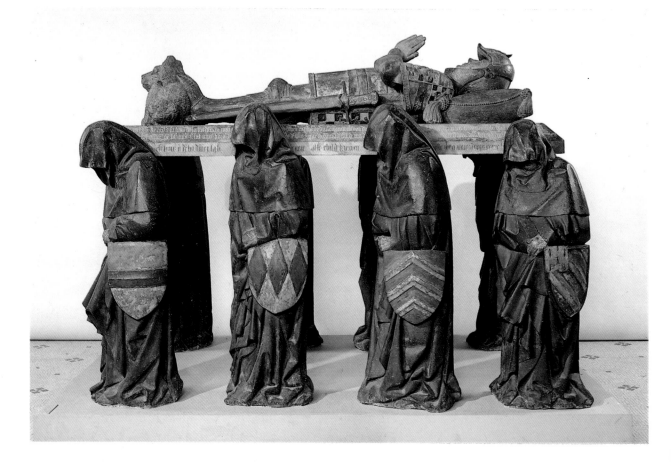

ART OBJECTS

When the main Museum was opened, the section dedicated to the minor arts was essentially the result of two acquisitions. In 1793 it was decided to transfer to the Louvre part of the treasure of the abbey of Saint-Denis, including the sacred **regalia** of the kings of France and the precious vases the abbot Suger had collected in the twelfth century. In 1796 the collections in the Louvre were completed by the vases in pietra dura and the bronzes collected by Louis XIV and kept, ever since 1774, in the storerooms for the custody of the furnishings of the Crown, in what is now the Ministry of the Navy. This original fund was enriched in the course of the nineteenth century by prestigious acquisitions and donations: the acquisition of the collections d'Edmé-Antoine Durand (1825) and of the painter Pierre Révoil (1828) considerably enlarged the section devoted to objects from the Middle Ages and the Renaissance (stained glass, enamels, ivories, tapestries and furniture), the Charles Sauvageot donation in 1856 on the other hand includes one of the largest collections of ceramics of the school of Palissy, lastly, the acquisition, in 1861,

of the Campana collection by Napoleon III made the Louvre one of the most important museums in the world for its collection of Italian majolica.

Thanks to these rich acquisitions, in 1893 a section was constituted within the Louvre that was dedicated to Objects from the Middle Ages, from the Renaissance and from Modern times, distinguished from those in the departments of Antiquity and Sculpture. From then on the collection never stopped growing, thanks to new and important donations such as those of Baron Adolphe de Rothschild (1901) and the wife of Baron Salomon de Rothschild (1922).

The section dedicated to furniture, tapestries and bronzes of the seventeenth and eighteenth centuries owes its origins to the assignments of 1870 and 1901 by the storerooms for the safeguarding of the furnishings of the Crown (later Mobilier National) consisting of deposits from precedent royal residences (above all those of Saint-Cloud and the Tuileries), to which were added the donations of Isaac de Camondo(1911), Baron Basile de Schlichting(1914) and René Crag-Carven (1973).

Palais Royal

*Comédie Française -
Monument to Molière -
Place des Victoires*

The Statue of the
Sun King in Place
des Victoires
◆◆ 86

The statue of
Molière
◆ 85

One of the buildings
occupied by the Bank of
France was built by
Mansart in 1640 and
renovated in the 18th
century; the sumptuous
Galerie Dorée was part of
the original structure

Place André Malraux
◆ 85

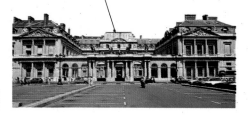
The Palais Royal
◆◆ 83

The neo-Gothic Oratory
of prince Napoleon
Joseph Jérôme
Bonaparte, the
emperor's cousin, and
his wife princess Maria
Clotilde of Savoy, who
moved to the nearby
Palais-Royal after their
wedding

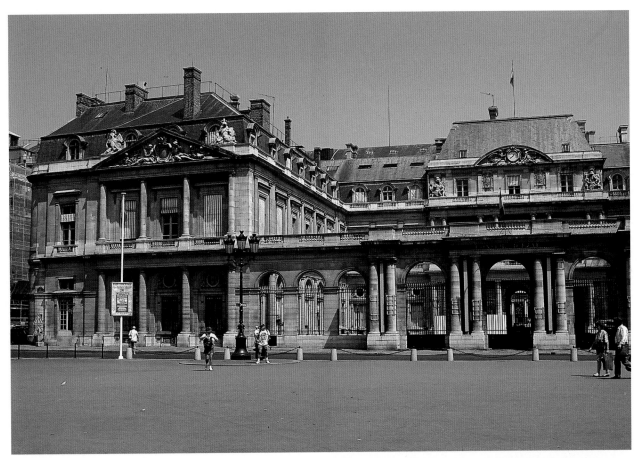

View of the facade of the Palais Royal, the elegant Art Nouveau entrance to the subway in Place du Palais Royal and an on the spot performance of one of the many street artists to be found in the zone frequented by tourists.

PALAIS ROYAL

This palace, built by Lemercier between 1624 and 1645, was originally the private residence of Cardinal Richelieu, who bequeathed it on his death in 1642 to Louis XIII. Today the seat of the Council of State, it has a colonnaded facade erected in 1774 and a small courtyard, from which one passes through a double colonnade into its beautiful and famous garden. The garden, planned in 1781 by Louis, extends for nearly 225 meters, with green elms and lime-trees and a profusion of statues. It is surrounded on three sides by robust pillars and a portico which today accommodates interesting shops with antiques and rare books. During the Revolution it became a meeting-place for patriots: here the anti-monarchist aristocrats, among them the Duke of Orléans who was later to be rebaptised Philippe Egalité, met to discuss the state of the country and the historical developments about to be unleashed. In these gardens, in front of the Café Foy

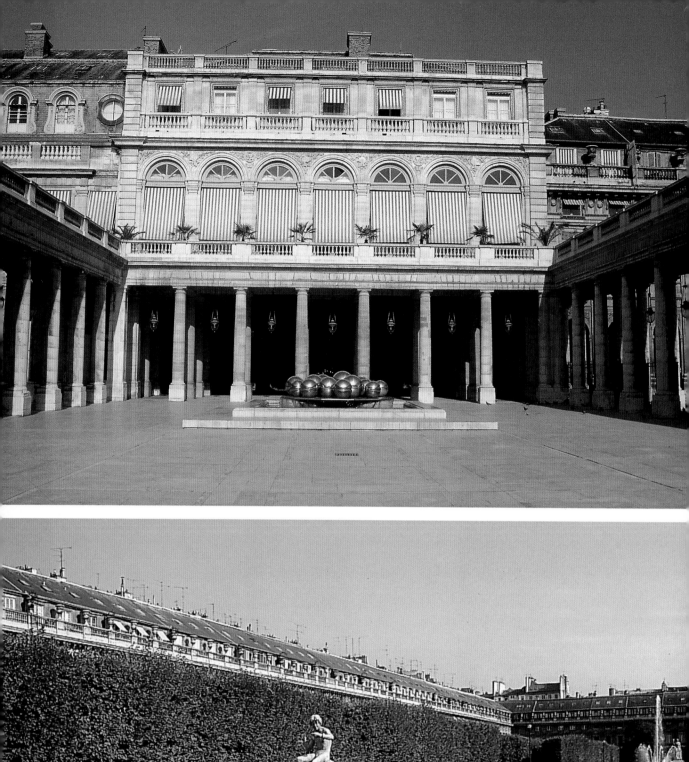
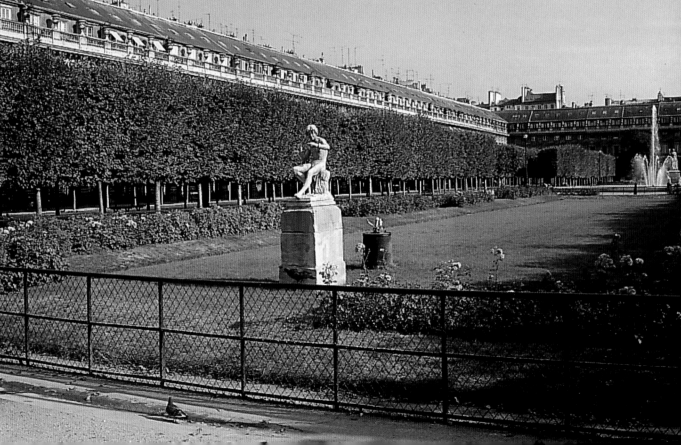

to be exact, on 12 July 1789, Camille Desmoulins harangued the crowd, inflaming them with his passionate speech. Later, he was to tear a green leaf from one of these trees and put it in his hat as a cockade. The crowd followed his example and two days later, at the storming of the Bastille, many wore the leaf emblem.

The double colonnade which joins the court of honor of the Palais Royal with the large park behind it, with one of the two pools with large steel spheres by Pol Bury.
The park of the Palais Royal is almost an island of green surrounded by three buildings that are all alike and which open in long porticoes on the ground floor, where antique dealers, used-book sellers and philatelic shops are located.

Various nooks and corners in the quarter. The Théâtre de France, headquarters of the Comédie Française, in the foyer of which is the armchair on which Molière died as he was playing a part in his Le Malade imaginaire. One of the two fountains which decorate the Place André Malraux; the Théâtre de France overlooks this and the adjacent Place Colette.
The statue of Molière on the 19th-century fountain designed by Louis Visconti.
Two putti decorate the facade of a restaurant in the area.
View of the Galerie Colbert with the rotonda.

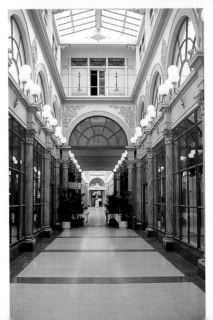

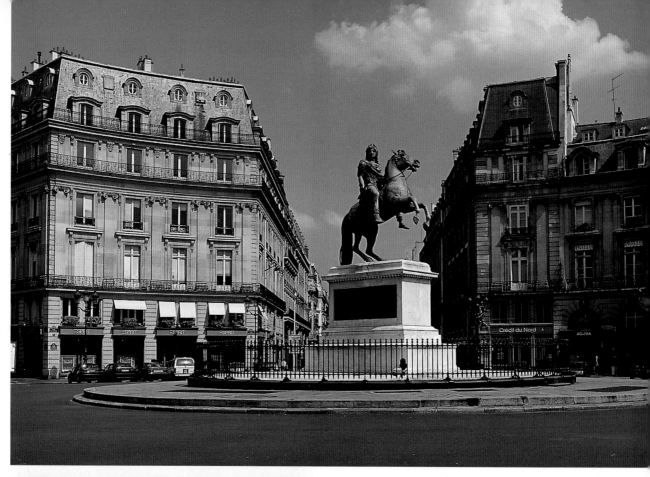

Views of Place des Victoires.

PLACE DES VICTOIRES

This circular square was created in 1685 to serve as setting for the allegorical statue of Louis XIV, which the Duc de la Feuillade had commissioned from Desjardins. The statue, destroyed during the Revolution, was replaced by another statue in bronze by Bosio.

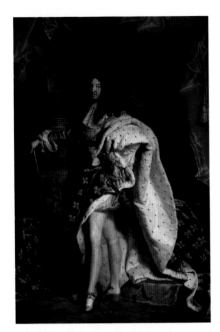

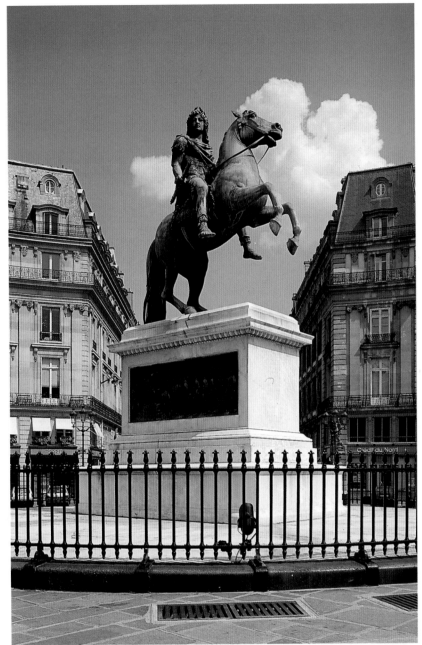

"Gala" portrait of Louis XIV by Hyacinthe Rigaud (1659-1743), in the Louvre; equestrian statue of the Sun King, in whose honor the square was designed; a detail of the monument with the bas-relief of a battle and one of the buildings which surround the square.

Opéra

*Place Vendôme - La Madeleine -
Place des Pyramides -
Rue de Rivoli - St-Roch*

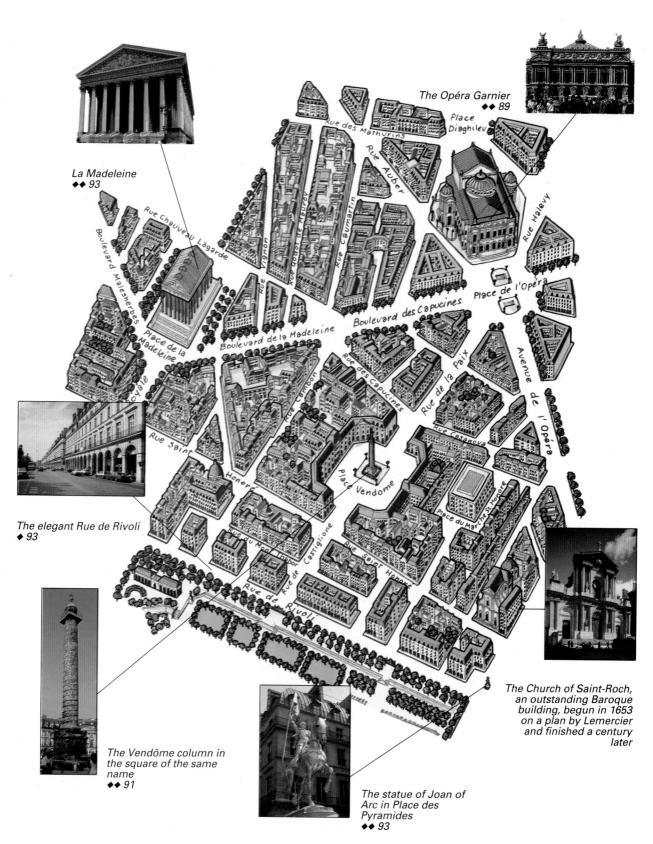

The Opéra Garnier
◆◆ 89

La Madeleine
◆◆ 93

The elegant Rue de Rivoli
◆ 93

**The Vendôme column in
the square of the same
name**
◆◆ 91

**The statue of Joan of
Arc in Place des
Pyramides**
◆◆ 93

**The Church of Saint-Roch,
an outstanding Baroque
building, begun in 1653
on a plan by Lemercier
and finished a century
later**

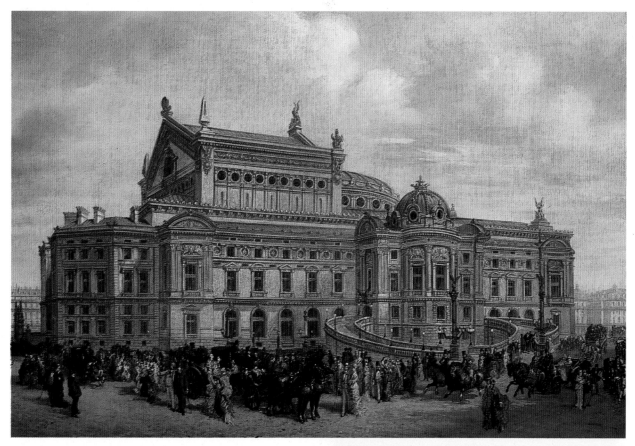

The Opéra from Rue Auber in a 19th-century painting in the Musée Carnavalet. The double ramp, which allowed the sovereign to reach the floor of the boxes in his carriage, leads to the Musée de l'Opéra.

The staircase of honor of the Opéra in a painting of 1877 by Louis Béroud on exhibit in the Musée Carnavalet.

OPÉRA

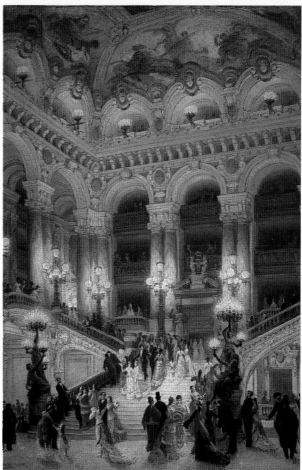

The largest theater for lyric opera in the world (in fact its surface area covers nearly 120,000 square feet, it can accommodate more than 2000 people and there is room on its stage for no less than 450 performers), it is also perhaps the most interesting building from the era of Napoleon III. Designed by Garnier and built between 1862 and 1875, its facade displays that profusion of decorative elements which was typical of the era. An ample stairway leads up to the first of the two orders into which the facade is divided, with its large arches and robust pillars, in front of which are numerous marble groups of sculpture. At the second pillar on the right can be seen what is considered the masterpiece of Jean-Baptiste Carpeaux, *The Dance* (the original is now in the Louvre). The second order of the facade consists of tall double columns which frame large windows; above is an attic, with exuberant decoration, and above this again the flattened cupola. The interior is just as highly decorated as the facade: the monumental stairway is enriched by marbles, the vault is decorated with paintings by Isidore Pils and the hall has a large painting by Chagall done in 1966.

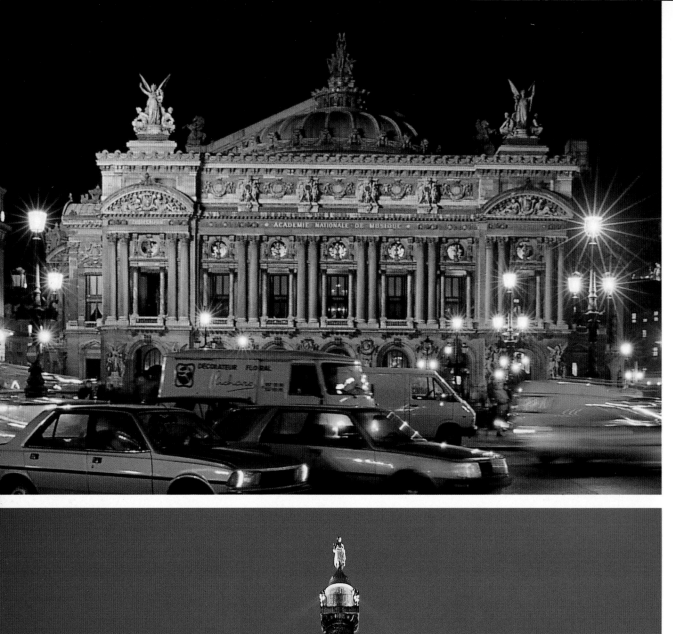

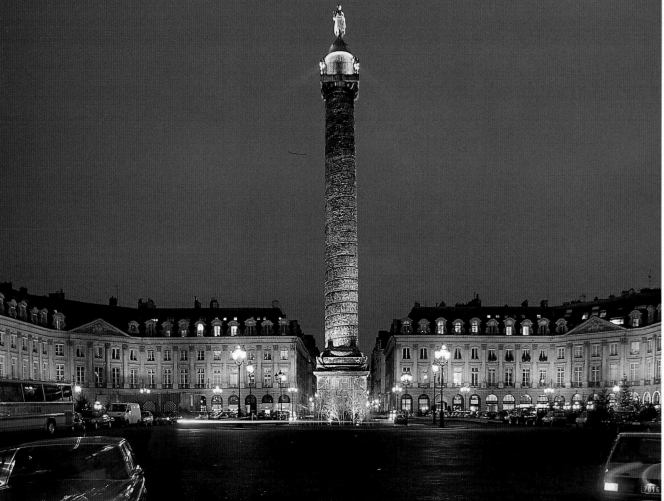

PLACE VENDÔME

Another masterpiece by Jules Hardouin-Mansart (who had already designed Place des Victoires), this square received its name from from the fact that the Duke of Vendôme had his residence here. It was created between 1687 and 1720 to surround an equestrian statue by Girardon dedicated to Louis XIV, later destroyed, like so many others, during the Revolution. A perfect example of stylistic simplicity and austerity, it is octagonal in form and surrounded by buildings which have large arches on the lower floor; on the foreparts of the buildings are skilfully distributed pediments and they are crowned, on the roofs, by numerous dormer-windows, so typical that some have thought to see in this square a synthesis of the spirit and style of Paris. There are important buildings here today: the famous Hôtel Ritz at number 15, the house where Chopin died in 1849 at number 12 and the residence of Eugenia de Montijo, future wife of Napoleon III. In the center of the square stands the famous column erected by Gondouin and Lepère between 1806 and 1810 in honor of Napoleon I. Inspired by the Column of Trajan in Rome, it is 145 feet high and around the shaft is a spiral series of bas-reliefs, cast from the 1200 cannons captured at Austerlitz, in which the sculptor Bergeret sought to hand down to posterity the Napoleonic exploits. On the top of the column, Antoine-Denis Chaudet erected a statue of the emperor which was destroyed in 1814 and replaced by that of Henry IV. Later, in 1863, a statue of Napoleon was put back in place, but eight years later again, at the time of the Commune (when the voice of the great painter Gustave Courbet had a decisive say), the statue was taken down once more, only to be replaced once and for all by another replica of Napoleon three years afterwards.

View by night of the magnificent facade of the Théâtre de l'Opéra and the majestic Place Vendôme with the column set up in honor of Napoleon I.

The Vendôme column, with reliefs which narrate the feats of Napoleon, and with the statue of the emperor on top, and view of the square during a temporary exhibition of the sculpture of Salvador Dalí.

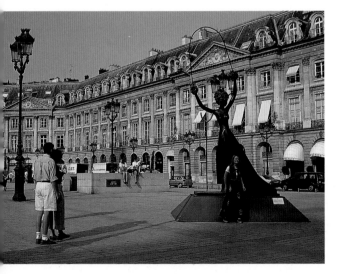

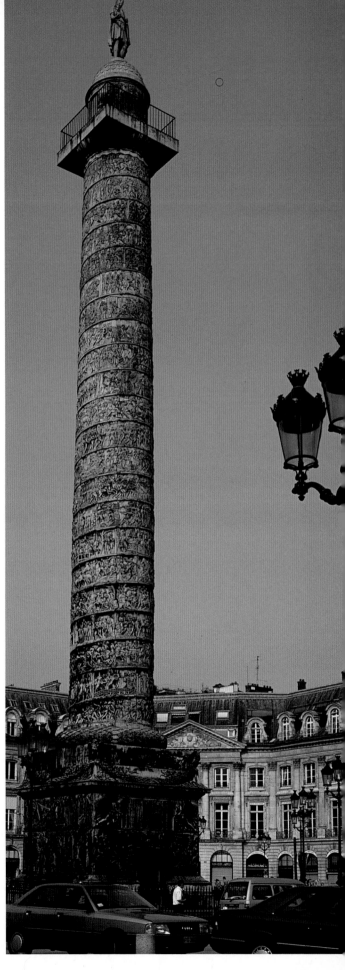

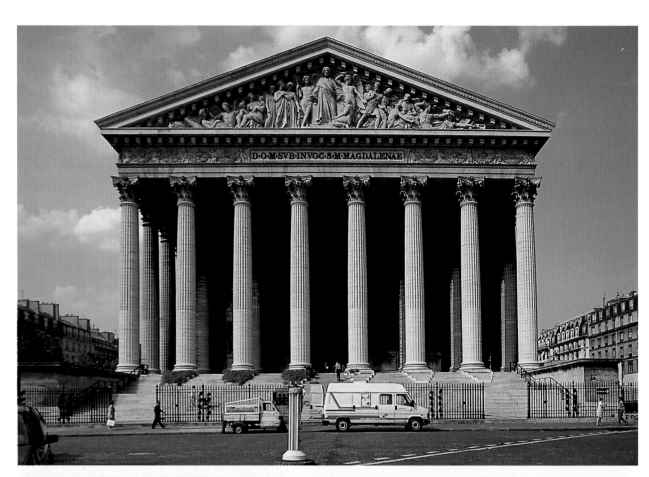

LA MADELEINE

It was Napoleon who wanted to erect a monument in honor of the Great Army, built along the lines of the Maison Carrée at Nîmes. To do so, he had a previous structure, which was not yet complete, totally demolished, and work was resumed from scratch in 1806, under the direction of the architect Vignon. In 1814 it became a church dedicated to St. Mary Magdalene, standing in the center of the square of the same name. It has the form and structure of a classical Greek temple: a high base with a large stairway in front, a colonnade with 52 Corinthian columns 20 m. (65 ft.) high running round the outside of the structure and a pediment with a large frieze sculpted by Lemaire in 1834 and representing the Last Judgment. The interior is aisleless, and it has a vestibule, in which are two sculptural groups by Pradier and Rude, and a semicircular apse. Above the high altar is a work by an Italian artist, the Assumption of Mary Magdalene by Marocchetti.

PLACE DES PYRAMIDES

Along Rue de Rivoli, almost at the level of the Pavillon de Marsan, is the small, rectangular square called Place des Pyramides, which has buildings with porticoes on three sides. In the center of the square is the equestrian statue of Joan of Arc, a work done by Frémiet in 1874.

RUE DE RIVOLI
This street, parallel to the Seine, connects Place de la Concorde to Place de la Bastille. It is one of Napoleon's greatest urbanistic successes — by two architects of the empire, Percier and Fontaine — but it was only completed during the reign of Louis-Philippe. In the section that skirts the Tuileries and the Louvre, one can admire, on the one side, an elegant portico with numerous shops.

The classic facade of the Madeleine and the interior as designed by Contant d'Ivry in a painting by Pierre-Antoine Demachy (1723-1807) in the Musée Carnavalet.

The equestrian statue of Joan of Arc in the center of Place des Pyramides.

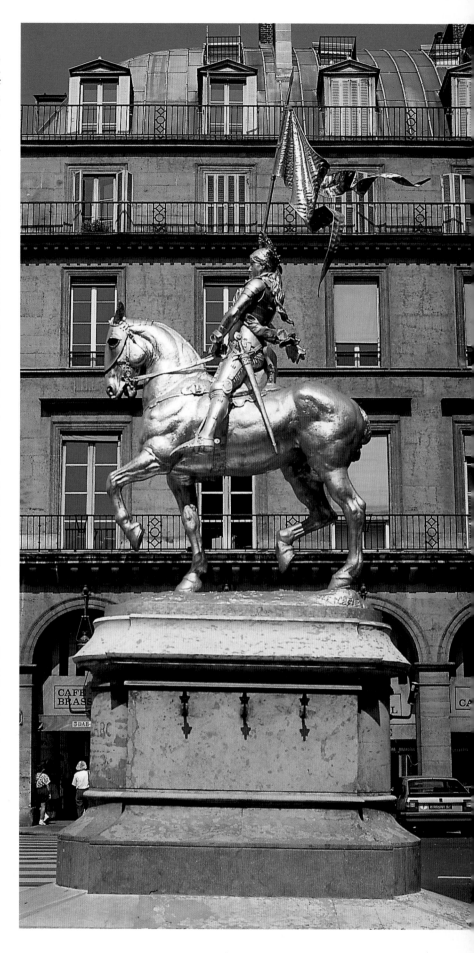

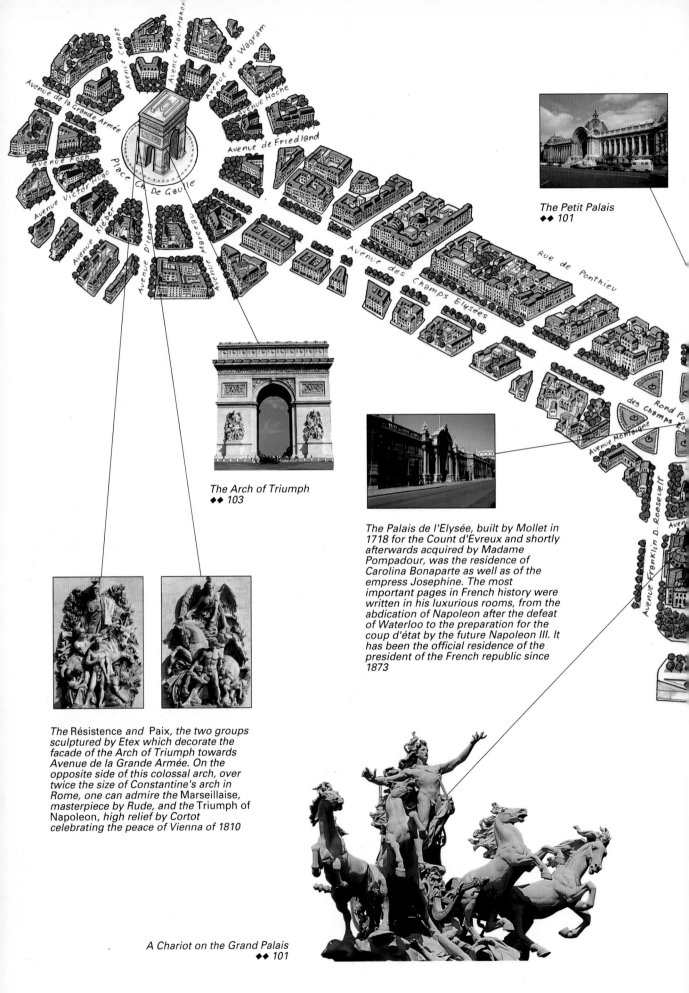

The Petit Palais
◆◆ *101*

The Arch of Triumph
◆◆ *103*

The Palais de l'Elysée, built by Mollet in 1718 for the Count d'Evreux and shortly afterwards acquired by Madame Pompadour, was the residence of Carolina Bonaparte as well as of the empress Josephine. The most important pages in French history were written in his luxurious rooms, from the abdication of Napoleon after the defeat of Waterloo to the preparation for the coup d'état by the future Napoleon III. It has been the official residence of the president of the French republic since 1873

The Résistence *and* Paix, *the two groups sculptured by Etex which decorate the facade of the Arch of Triumph towards Avenue de la Grande Armée. On the opposite side of this colossal arch, over twice the size of Constantine's arch in Rome, one can admire the* Marseillaise, *masterpiece by Rude, and the* Triumph of Napoleon, *high relief by Cortot celebrating the peace of Vienna of 1810*

A Chariot on the Grand Palais
◆◆ *101*

Champs-Elysées

Tuileries - Concorde - Grand Palais - Petit Palais - Arch of Triumph - Elysée

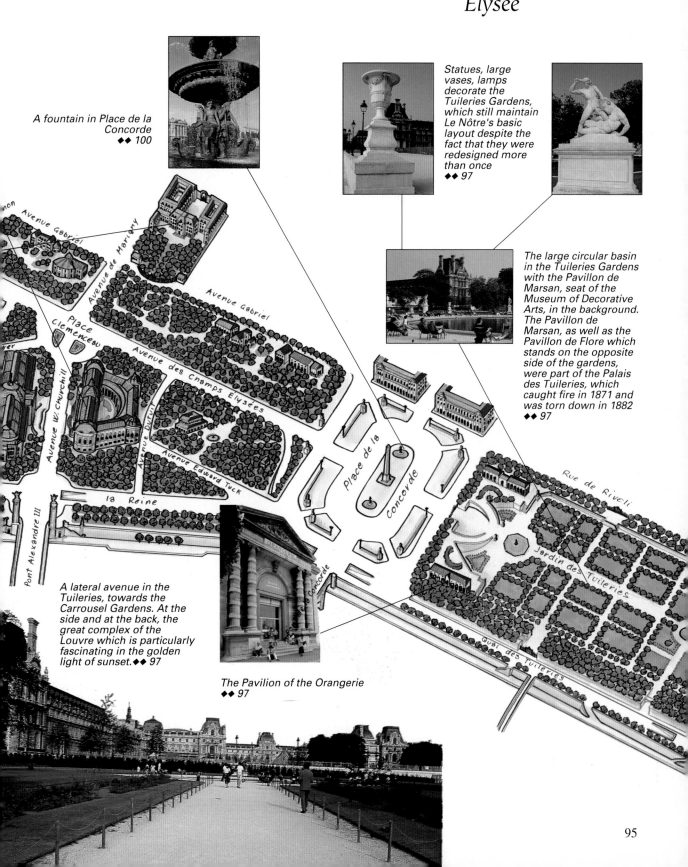

A fountain in Place de la Concorde
◆◆ 100

Statues, large vases, lamps decorate the Tuileries Gardens, which still maintain Le Nôtre's basic layout despite the fact that they were redesigned more than once
◆◆ 97

The large circular basin in the Tuileries Gardens with the Pavillon de Marsan, seat of the Museum of Decorative Arts, in the background. The Pavillon de Marsan, as well as the Pavillon de Flore which stands on the opposite side of the gardens, were part of the Palais des Tuileries, which caught fire in 1871 and was torn down in 1882
◆◆ 97

A lateral avenue in the Tuileries, towards the Carrousel Gardens. At the side and at the back, the great complex of the Louvre which is particularly fascinating in the golden light of sunset.◆◆ 97

The Pavilion of the Orangerie
◆◆ 97

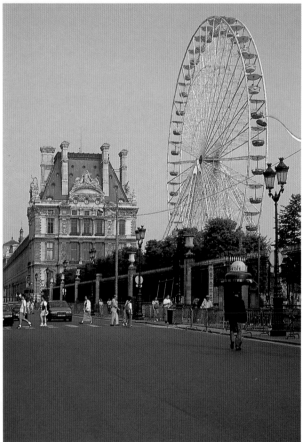

The gardens of the Tuileries, the amusement park, and the central pool.

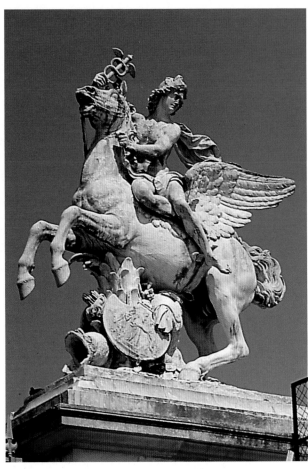

One of the statues on top of the two piers at the gate between the gardens and Place de la Concorde, a detail of the fine wrought ironwork and the pavilion of the Orangerie, twin of the one in the Jeu de Paume, now a museum.

GARDENS OF THE TUILERIES

They stretch about one kilometer from Place du Carrousel to Place de la Concorde. The ground was bought by Catherine de' Medici in 1563 to create an English style garden. Designed by Le Nôtre in 1663, the present garden of the Tuileries consists of two large areas connected by a central avenue flanked by flower-beds containing statues.

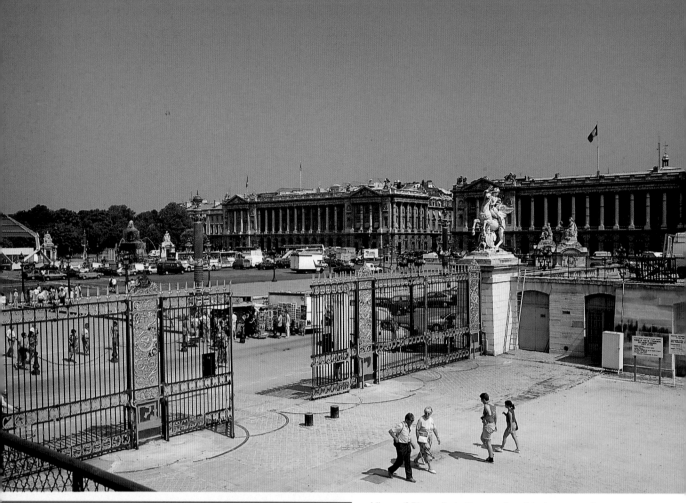

View of Place de la Concorde with the two columned buildings and the obelisk that stands at the center.

Details of Place de la Concorde, with the statues and richly ornamented lamps which are part of the urban furnishings.

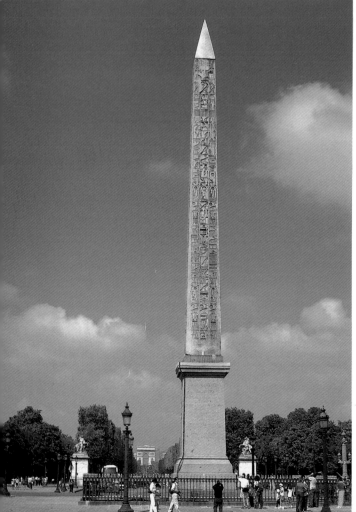

PLACE DE LA CONCORDE

Created between 1757 and 1779 to a design by Jacques-Ange Gabriel on land donated by the king in 1743, the square was originally dedicated to Louis XV and there was an equestrian statue of the king, a work by Bouchardon and Pigalle, in the center, pulled down during the French Revolution. In the Revolution, this became the site of the guillotine, under whose blade so many great figures of the time lost their heads: from the king, Louis XVI, and his queen, Marie Antoinette, to Madame Roland and Robespierre. The square became Place de la Concorde in 1795, and its present-day appearance dates from work supervised by the architect Hittorf between 1836 and 1840. In the center of the square today stands the Egyptian obelisk from the temple of Luxor, donated to Louis Philippe in 1831 by Mehmet-Ali. Erected in 1836, it is 23 m. (75 ft.) high and covered with hieroglyphics which illustrate the glorious deeds of the pharaoh Ramses II. Eight statues, symbolising the main cities of France, stand at the corners of the square. To the north of the square, on either side of Rue Royale, are the colonnaded buildings (these too designed by Gabriel) containing the Ministry of the Navy and the Hôtel Crillon.

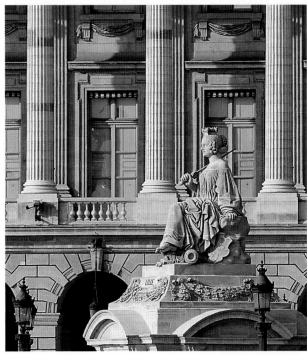

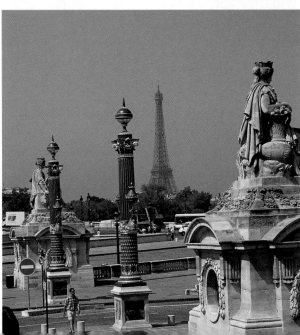

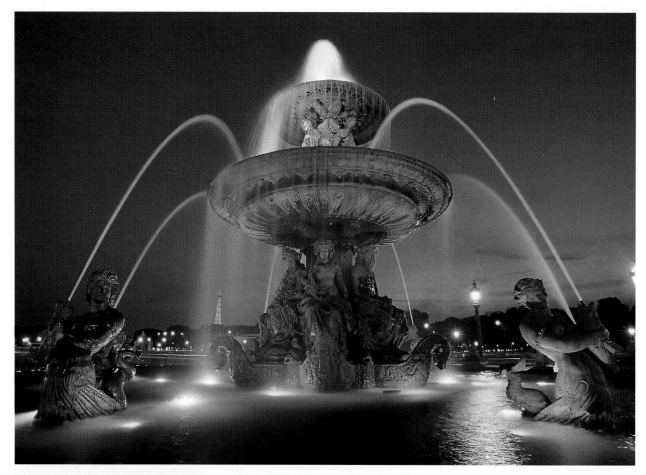

A fountain in Place de la Concorde and two details.

FOUNTAINS

Built on the model of the fountains in St. Peter's Square in Rome, these two fountains at the sides of the obelisk were erected by Hittorf between 1836 and 1846; they have several basins and the statues adorning them are allegories of rivers. There are perhaps few squares in the world with the magic atmosphere of enchantment present at every hour of the day in this square. Indeed at night, under the light of the streetlamps, its atmosphere becomes unreal, almost fable-like.

GRAND PALAIS

The World Fair held in Paris in 1900 was an important step in the history of the city's art and architecture. For the occasion, monuments and works of art were created in a modern style which was almost too eclectic and bombastic. As a reflection of this taste, the two adjacent buildings called the Petit Palais and the Grand Palais were erected, both of huge dimensions

and characterised by their ample colonnades, friezes and sculptural compositions. The Grand Palais, built by Deglane and Louvet, has a facade with Ionic columns, 240 m. (787 ft.) long and 20 m. (65 ft.) high. Today important artistic events take place here, including exhibitions of painting, whereas previously its vast area served for fairs, motor shows and similar exhibitions. Part of it is permanently occupied by the Palais de la Découverte (Discovery), where the latest conquests of science and steps in man's progress are celebrated.

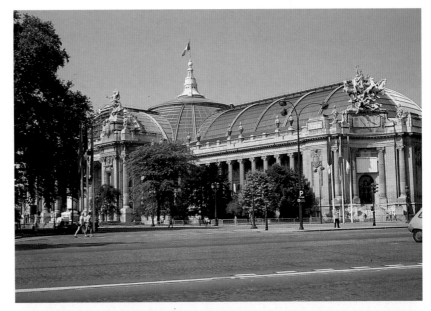

CHARIOTS

The corners of the Grand Palais are crowned by enormous chariots which give very much the impression that they want to hurl themselves from the points where they stand into the surrounding space. The inside of the Grand Palais has a huge room covered by a flattened cupola 141 feet high.

PETIT PALAIS

Built by Charles Girault for the World Fair in 1900 in an eclectic style typical of the late 19th century, it consists of a monumental portico crowned by a dome and flanked by two colonnades. At present, it contains the collection of the City of Paris with countless 19th-century paintings and sculptures and Tuck and Dutuit collections.

The Grand Palais, one of the chariots, and the Petit Palais.

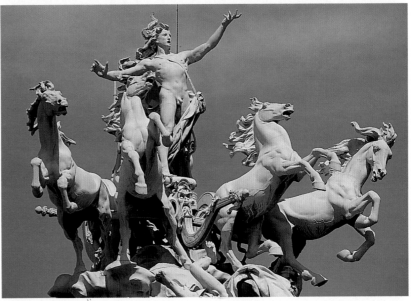

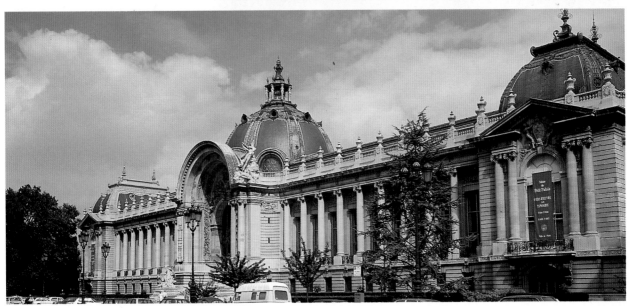

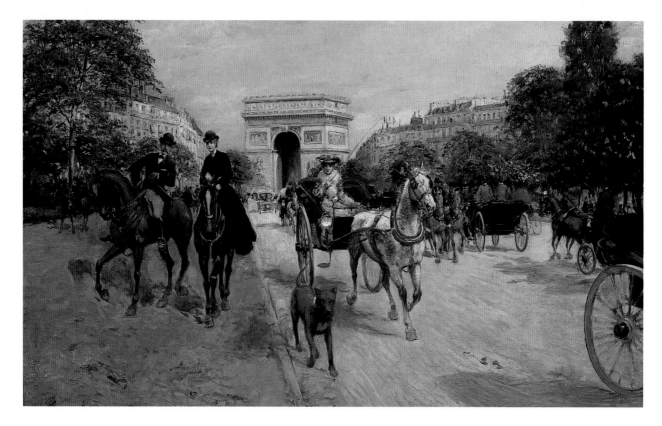

CHAMPS-ELYSEES

Originally this vast area lying to the west of Place de la Concorde was swamp land. After its reclamation, le Nôtre in 1667 designed the wide avenue called Grand-Cours (it became the Champs-Elysées in 1709), reaching from the Tuileries as far as Place dell'Etoile, today called Place de Gaulle. At the time of the Second Empire, this became the most fashion- able meeting-place and upper-class residential area in all Paris. Today it may no longer have its one-time aristocratic character, but it has lost nothing of its beauty and elegance: luxurious shops, theaters, fa- mous restaurants and important airline offices line the boulevard which is always full of Parisians, tourists and a cosmopolitan throng.

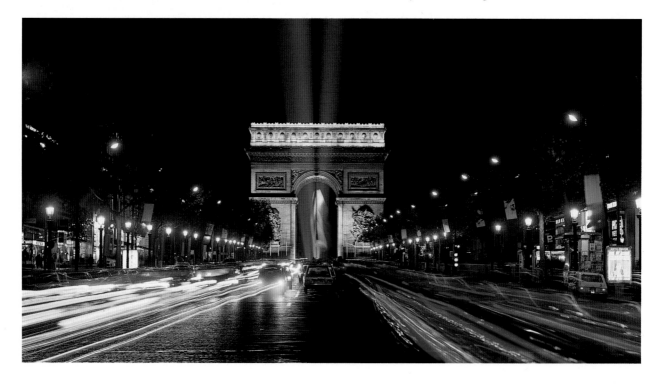

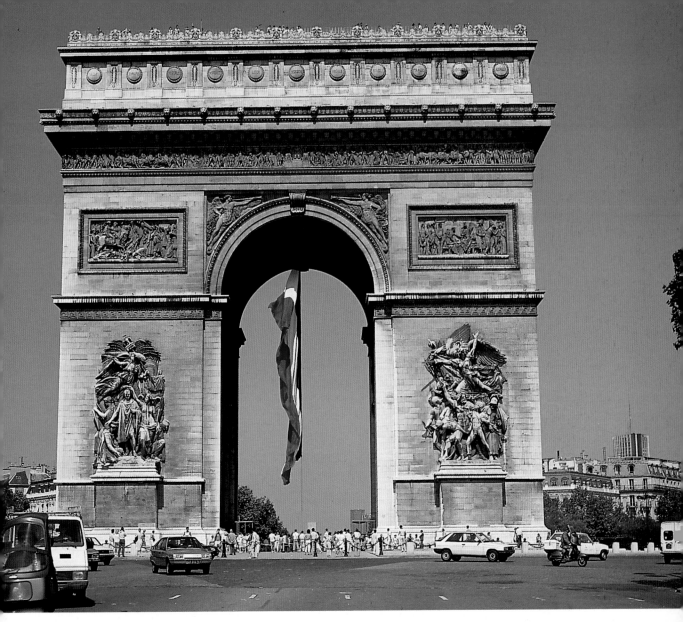

The Arch of Triumph in the early 1900s in a painting by Georges Stein (Musée Carnavalet) and in a view by night from the Champs-Elysées.

The Arch of Triumph ordered by Napoleon as a memorial to the Great Army.

ARCH OF TRIUMPH

At the end of the Champs-Elysées, at the top of the Chaillot hill, is the large Place de Gaulle; radiating outwards from this square are no less than twelve main arteries. Isolated in the center stands the powerful and imposing Arch of Triumph, begun by Chalgrin in 1806 under Napoleon, who ordered it as a memorial to the Great Army. Completed in 1836, it has a single barrel-vault and actually exceeds in size the Arch of Constantine in Rome: in fact it is 50 m. (164 ft.) high and 45 m. (147 ft.) wide. The faces of the arch have huge bas-reliefs, of which the best known and finest piece is that on the right, on the part of the arch facing the Champs-Elysées, depicting the departure of the volunteers in 1792 and called the "Marseillaise". The principal victories of Napoleon are celebrated in the other bas-reliefs higher up, while the shields sculpted in the top section bear the names of the great battles. Under the arch, the Tomb of the Unknown Soldier was placed in 1920 and its eternal flame is tended every evening. There is a history of the monument in a small museum inside the arch, where one can read the names of no less than 558 generals, some of them underlined because they died on the battlefield.

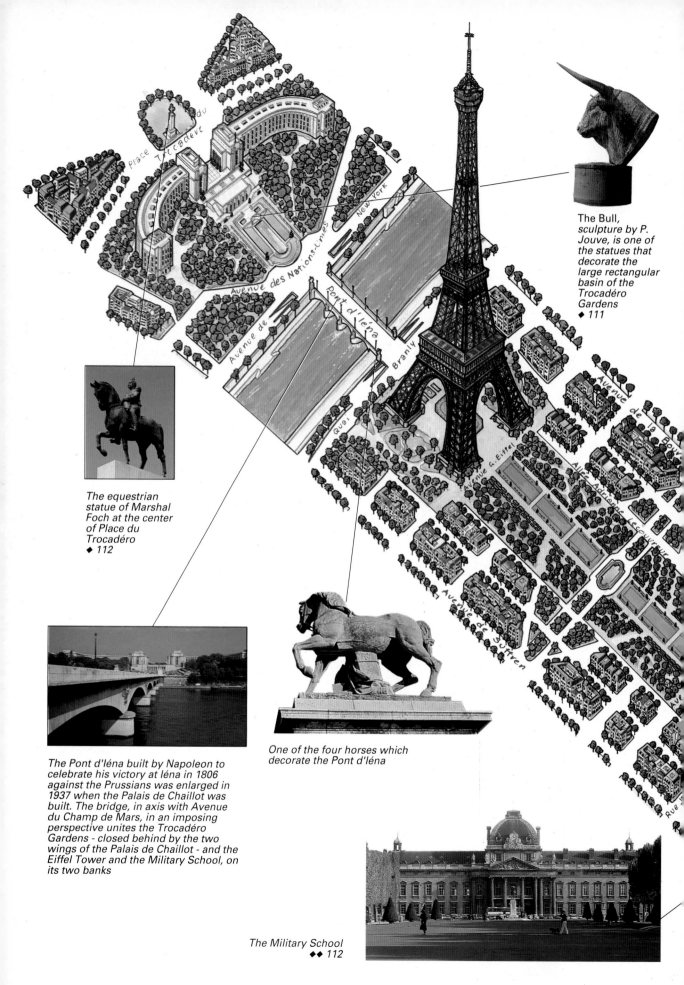

The Bull, sculpture by P. Jouve, is one of the statues that decorate the large rectangular basin of the Trocadéro Gardens
◆ 111

The equestrian statue of Marshal Foch at the center of Place du Trocadéro
◆ 112

One of the four horses which decorate the Pont d'Iéna

The Pont d'Iéna built by Napoleon to celebrate his victory at Iéna in 1806 against the Prussians was enlarged in 1937 when the Palais de Chaillot was built. The bridge, in axis with Avenue du Champ de Mars, in an imposing perspective unites the Trocadéro Gardens - closed behind by the two wings of the Palais de Chaillot - and the Eiffel Tower and the Military School, on its two banks

The Military School
◆◆ 112

Eiffel Tower

Palais de Chaillot - Trocadéro
Military School - Pont d'Iéna

Gustave Eiffel (1832-1923), at the center of the photo, poses with his collaborators during the construction of the famous tower which carries his name and which, despite all the criticism, soon became a symbol of Paris

The Eiffel Tower
◆◆ 106

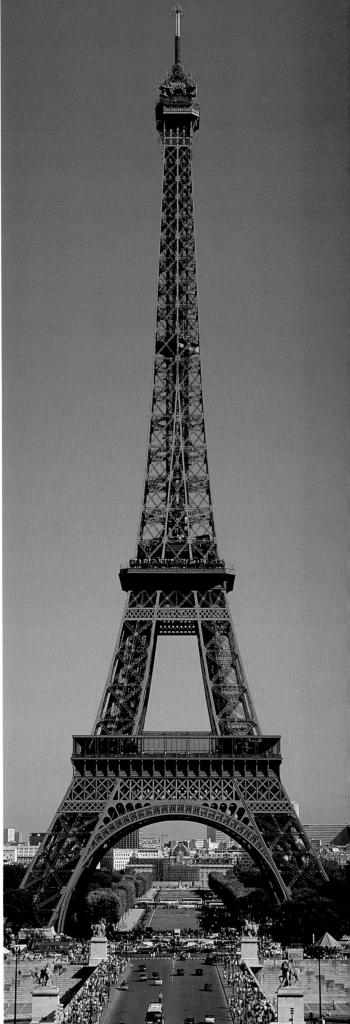

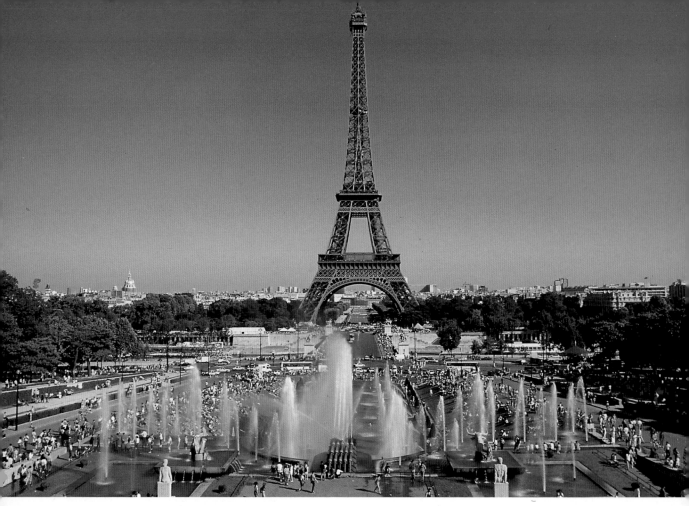

The jets of water in the great pool in the Trocadéro Gardens seem to bathe the base of the Eiffel Tower which rises skywards, on the other side of the Seine.

EIFFEL TOWER

If the symbol of Rome is the Colosseum, then Paris's symbol is without doubt the Eiffel Tower: both are monuments unique in planning and construction, both stir admiration by their extraordinary dimensions, and both bear witness to man's inborn will to build something capable of demonstrating the measure of his genius. The tower was erected on the occasion of the World Fair in 1889. These were the years of the Industrial Revolution, of progress and of scientific conquests. The attempt was made to adapt every art to the new direction which life had taken and to make every human activity correspond to the new sensibility created by the rapidly changing times. Architecture also underwent radical changes: glass, iron and steel were the new construction materials, the most suitable ones to make buildings lighter, more dynamic and more modern. The engineer, in short, had taken the place of the architect. And indeed it was an engineer, Gustave Eiffel, who drew – not on paper but on the surface of the sky itself – these extraordinary lines of metal, which soar above the Parisian skyline and seem to triumph over all the older monuments of the city. While the older buildings symbolise the past, the Eiffel Tower anticipates the future and the conquests which man will achieve. Altogether 320 m. (1050 ft.) high, the Eiffel Tower is an extremely light, interlaced structure in which no less than 15,000 pieces of metal are welded together. Its extraordinary weight of 7000 tons rests on four enormous pylons with cement bases. It has three floors: the first at 57 m. (187 ft.), the second at 115 m. (377 ft.) and the third at 274 m. (899 ft.). On each of the floors there are bars and restaurants, allowing the tourist to pause there and enjoy the unique panoramic view: at times, on days when the visibility is perfect, one can see almost 45 miles. Beneath the Eiffel Tower is the green area of the Champs-de-Mars, a military field at one time but later transformed into a garden.

During the Ancien Régime and during the Revolution many festivals were held here, including the Festival of the Supreme Being, introduced by Robespierre and celebrated on 8 June 1794. Then, in modern times, the vast area has been used for numerous World Fairs. Today the gardens, whose design was supervised by Formigé between 1908 and 1928, are divided by wide avenues and scattered with flower gardens and small watercourses.

The Eiffel Tower in pictures which highlight the intricate metal framework.

On the following pages: the phantasmagoric illumination of the Eiffel Tower which is particularly striking at sunset.

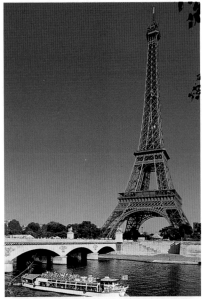
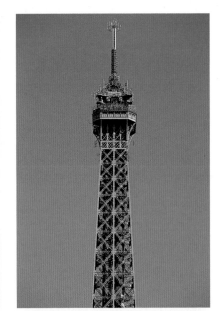
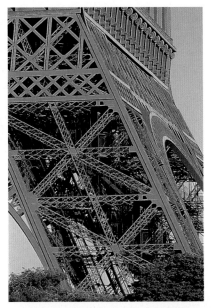
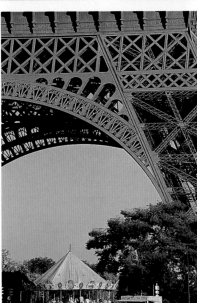
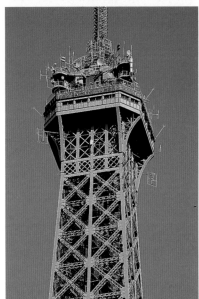
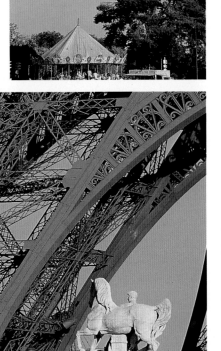
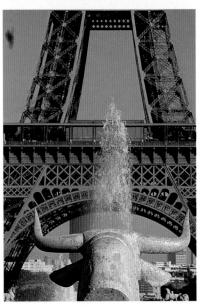

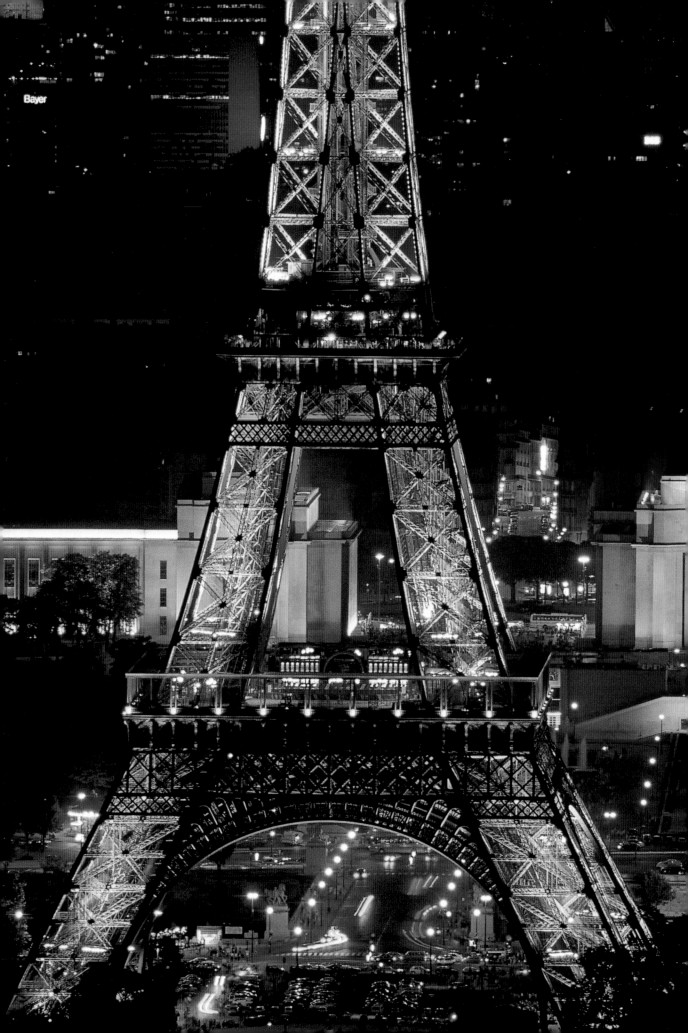

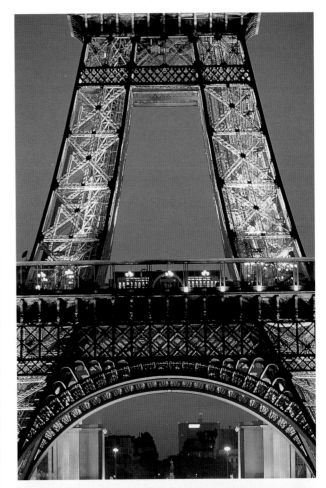

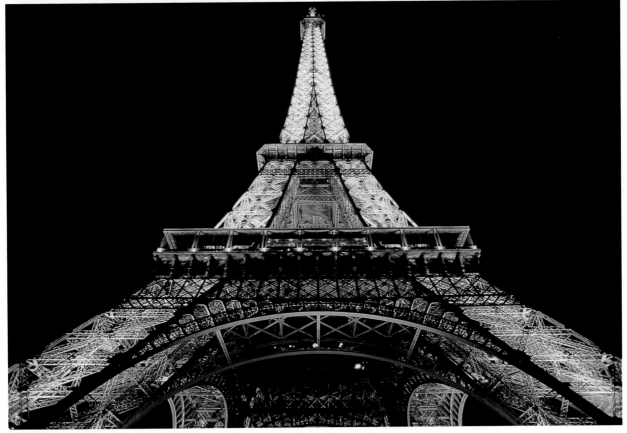

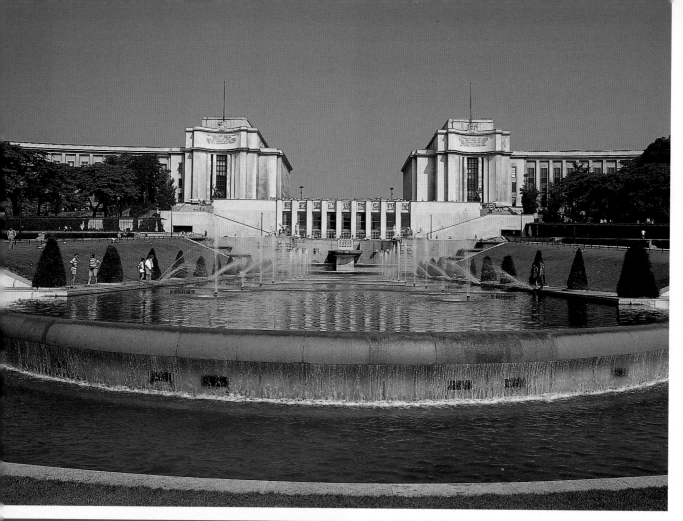

The Palais de Chaillot, with the large pool and the gardens that slope down towards the Seine, and a detail of the sculpture at the sides of the pool.

PALAIS DE CHAILLOT

Another World Fair, the one held in 1937, was the occasion for which this building was constructed. It was designed by the architects Boileau, Carlu und Azéma on the site of a previous building, the Trocadéro. The Palais de Chaillot has a central terrace with statues of gilded bronze, uniting two enormous pavilions which stretch out into two wings, as if in a long, curving embrace. From here a splendid complex of terraces, stairways and gardens slopes down to the Seine, a triumph of greenery made even more pleasant by the sounds of waterfalls and the jets of fountains. The two pavilions, on the front of which are inscribed verses by the poet Valéry, today house the Museum of French Monuments (an important collection of medieval works), the Museum of the Navy (in which is a model of the ship "La Belle Poule" which brought back Napoleon's remains from St. Helena) and the Museum of Man, with its wealth of anthropological collections and documentation of the human race.

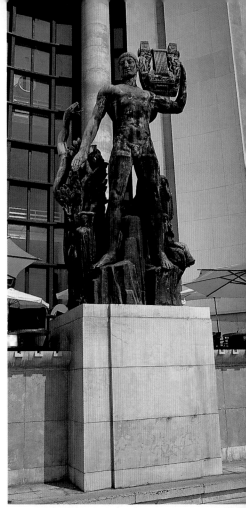

The Trocadéro gardens, which slope down towards the Seine from the two pavilions of the Palais de Chaillot and which are a rendezvous for all the tourists who come to Paris. The central part, with its large pool that extends towards the bridge of Iéna, decorated with statues and enlivened with water plays, is flanked by the park itself: a triumph of green meadows and plants run through by shady avenues. Turning one's back to the

Palais de Chaillot, whose curving wings seem to embrace the scenic park, a unique view presents itself to the spectator: the imposing but at the same time aerial mass of the Eiffel Tower; the green gardens of the Champ-de-Mars, almost the natural continuation of those of the Trocadéro; the elegant and majestic structure of the Military School with the square cupola rising up over its neo-classic facade.

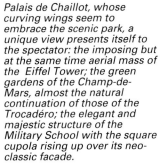
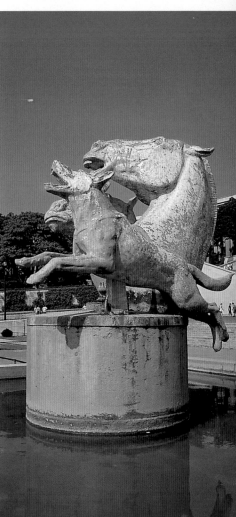
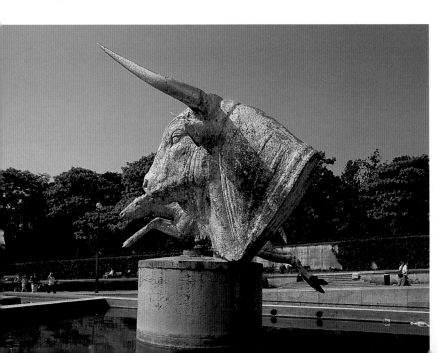

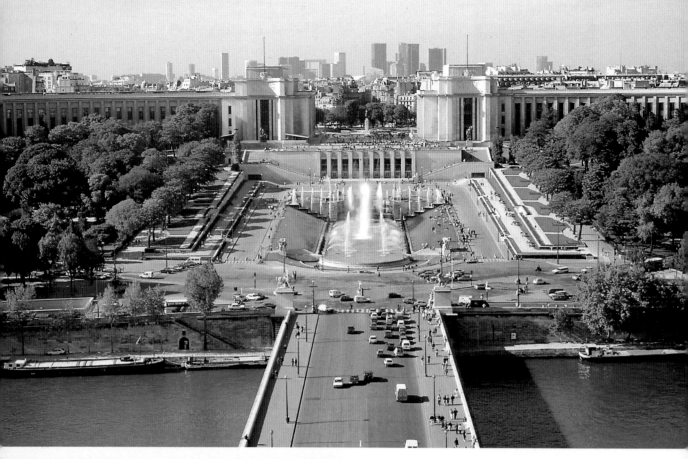

The Trocadéro Gardens, enclosed by the pavilions of the Palais de Chaillot, and the bridge of Iéna seen from the Eiffel Tower, and the equestrian statue of Marshal Foch which stands at the center of the Place du Trocadéro.

The incomparable panorama facing southeast from the Eiffel Tower, with the Champ-de-Mars bordered with the Military School at the back and the central elevation of the building in which Napoleon himself was a student.

MILITARY SCHOOL

This building, which stands at the south end of the Champ-de-Mars, was constructed as a result of the initiative of the financier Pâris-Duverney and of Madame Pompadour, both of whom wanted young men of the poorer classes to be able to take up military careers. Jacques-Ange Gabriel was the architect of the building, erected between 1751 and 1773 in a sober style characterised by its harmonious lines. The facade has two orders of windows, and in the center is a pavilion with columns which support the pediment, decorated with statues and covered by a cupola. On the back, from Place de Fontenoy, one can see the elegant Courtyard of Honor with its portico of twin Doric columns and a facade formed by three pavilions linked by two rows of columns. The building still serves as a military school today. In 1784 Napoleon Bonaparte entered it as a pupil, to leave the following year with the rank of second lieutenant in the artillery.

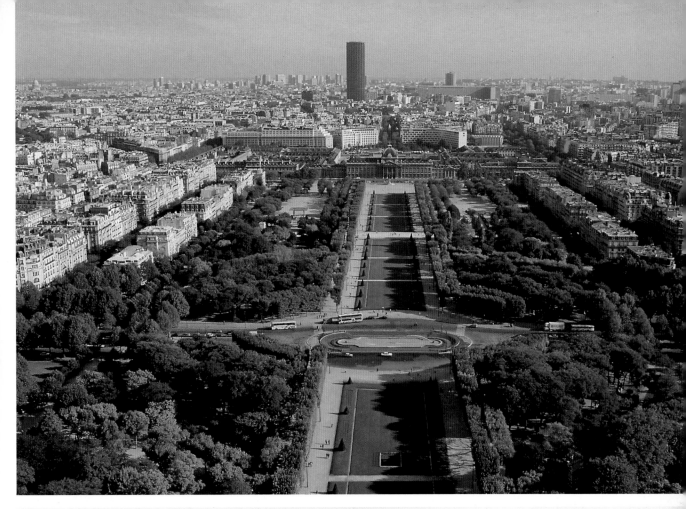

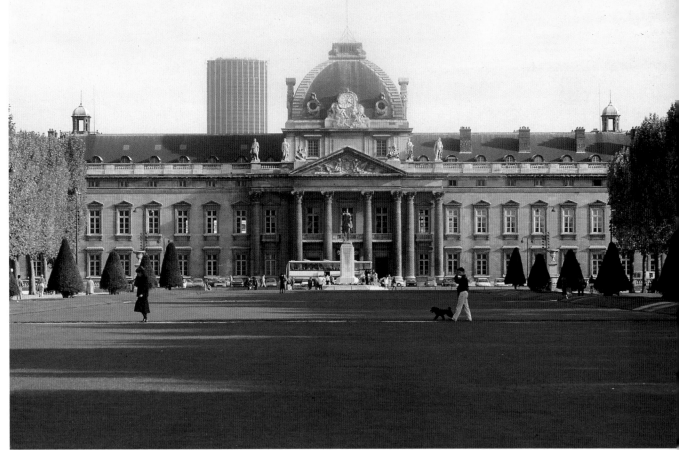

Les Invalides

Pont Alexandre III - Palais Bourbon - Musée Rodin

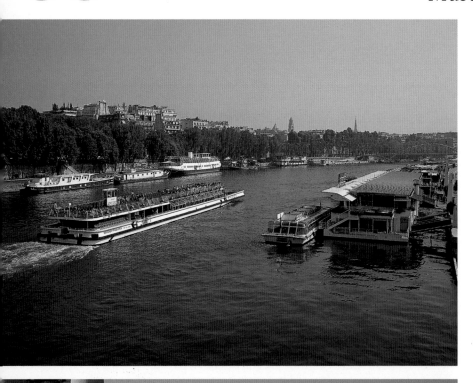

Pont Alexandre III
◆◆ 116

The bronze cannons which flank the gardens in front of the Hôtel des Invalides

Dôme des Invalides
◆◆ 121

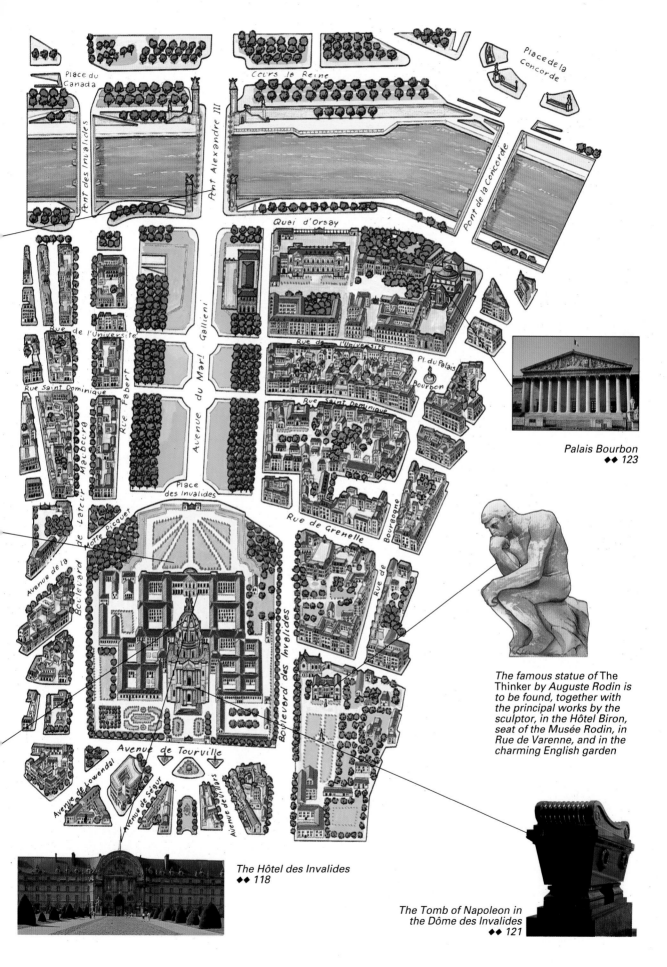

Place de la Concorde

Place du Canada

Cours la Reine

Place des Invalides

Pont Alexandre III

Quai d'Orsay

Rue de l'Université

Rue de l'Université

Pont de la Concorde

Avenue du Mar. Gallieni

Rue Fabert

Rue Saint Dominique

Rue de Latour Maubourg

Rue de Motte Picquet

Place des Invalides

Rue Saint Dominique

Pl. du Palais Bourbon

Rue de Grenelle

Rue de Bourgogne

Avenue de la

Boulevard des Invalides

Rue de

Avenue de Tourville

Avenue de Lowendal

Avenue de Ségur

Avenue de Villars

Palais Bourbon
◆◆ *123*

The famous statue of The Thinker *by Auguste Rodin is to be found, together with the principal works by the sculptor, in the Hôtel Biron, seat of the Musée Rodin, in Rue de Varenne, and in the charming English garden*

The Hôtel des Invalides
◆◆ *118*

The Tomb of Napoleon in the Dôme des Invalides
◆◆ *121*

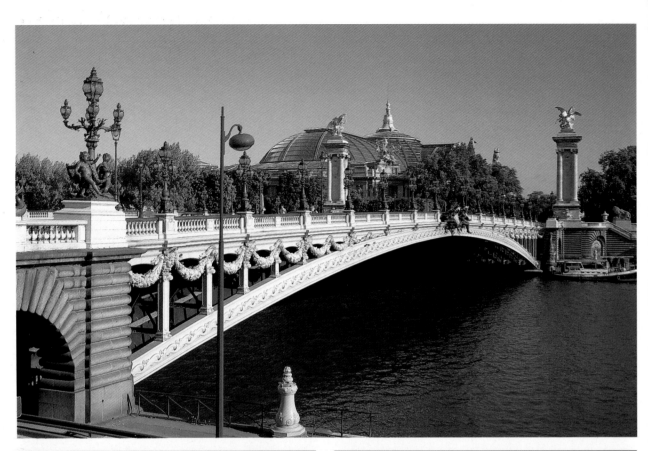

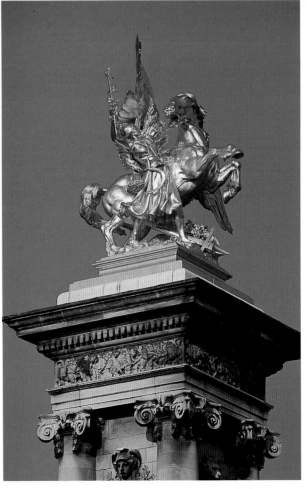

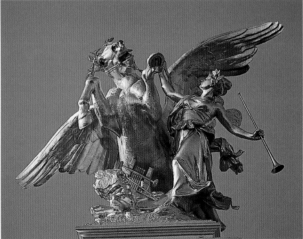

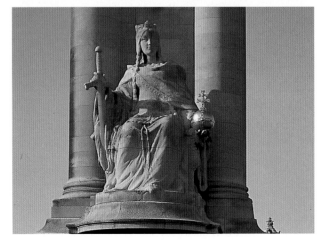

116

PONT ALEXANDRE III

One of Paris's many bridges, this has a single metal span 107 m. (350 ft.) long and 40 m. (130 ft.) wide joining the Esplanade des Invalides to the Champs-Elysées. Built between 1896 and 1900, it is named after Czar Alexander III, whose son, Nicholas II, inaugurated the bridge, which was built to celebrate the creation of the alliance between the Russians and the French. Garlands of flowers, lamps held up by cherubs and allegorical figures of marine deities make up the decorative motifs of the bridge. On the two pylons on the right bank are representations of medieval France and modern France, while on the left-bank pylons are statues representing Renaissance France and the France of the time of Louis XIV. Allegorical representations of the Seine and the Neva, symbols again of France and Russia, decorate the pylons at the entries to the bridge.

Page 114
A view of the Seine and the Pont Alexandre III with the Dôme of Les Invalides in the background.

Pont Alexandre III, the most elegant of Paris bridges, and details of the pylons, statues, and lamps which decorate it in the style of the times.

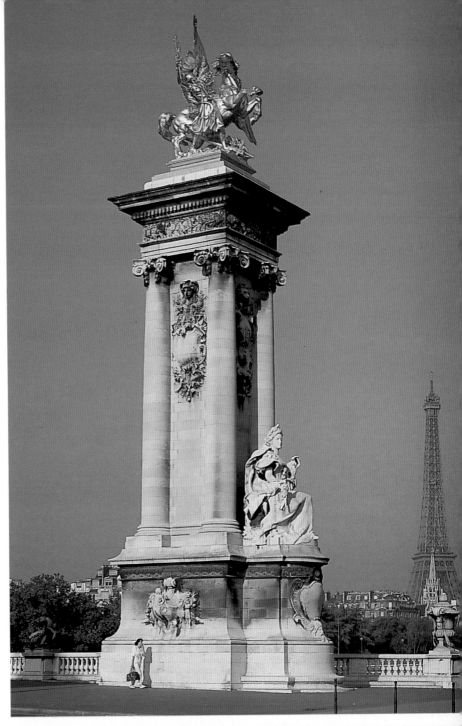

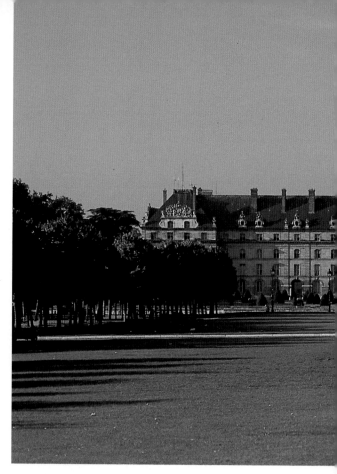

Les Invalides seen from the Pont Alexandre III, the artistic wrought iron gateway which leads to the gardens in front and, on both pages, the facade of the Hôtel dominated by the Dôme.

Cannons lined up in the gardens in front of the Hôtel.

LES INVALIDES

Stretching between Place Vauban and the Esplanade des Invalides, this vast complex of buildings includes the Hôtel des Invalides, the Dôme and the church of St. Louis. The whole construction, ordered by Louis XIV and entrusted to Libéral Bruant in 1671, was built to house old and invalid soldiers who were then often forced to beg for a living. Completed in 1676, it later saw the addition of the church of St. Louis and the Dôme, designed by J. Hardouin-Mansart. The vast square of the Esplanade, 487 meters long and 250 meters wide, designed between 1704 and 1720, creates the right surroundings for the Hôtel des Invalides. In the garden in front of the Hôtel are a line of bronze cannon from the 17th and 18th centuries, eighteen pieces which belong to the "triumphal battery" and are fired only on important occasions, and at the sides of the entrance are two German tanks captured in 1944. The severe and dignified facade, 196 m. (643 ft.) long, has four orders of windows and a majestic portal in the center, surmounted by a relief representing Louis XIV with Prudence and Justice at his sides. Entering the courtyard, one can see the regular forms of the four sides with their two stories of arcades. The pavilion at the end thus becomes the facade of the church of St. Louis. In the center is the statue of Napoleon by Seurre, which was previously on top of the column in Place Vendôme. Worth see-

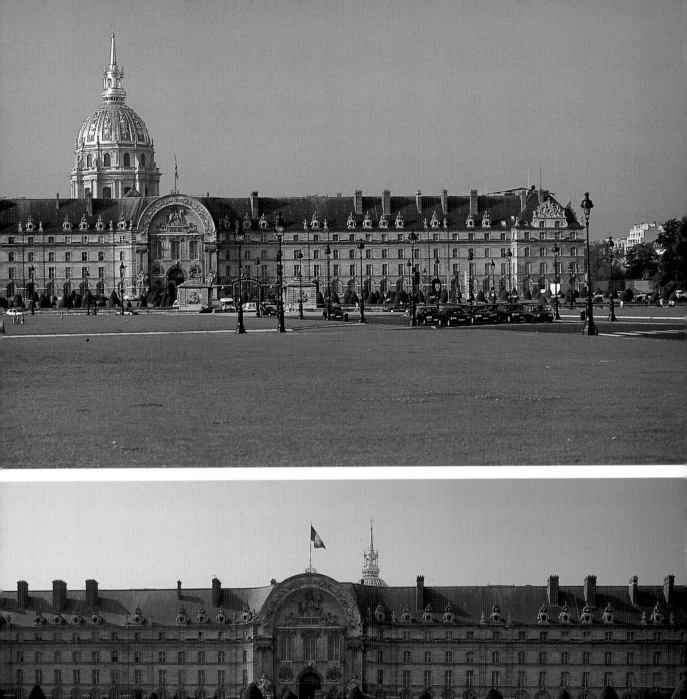
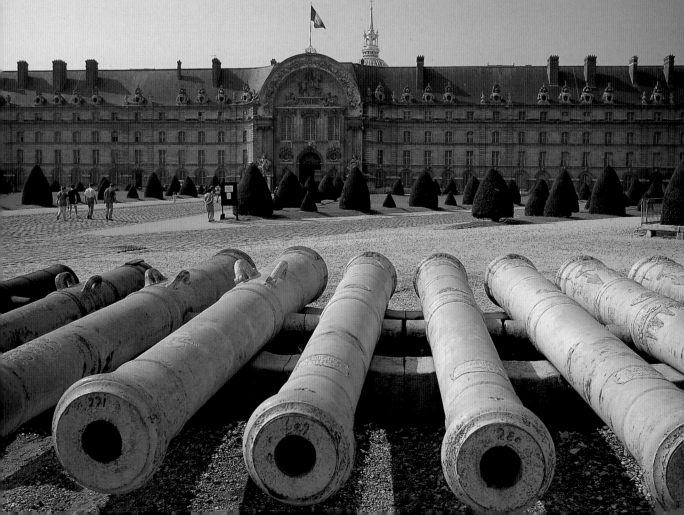

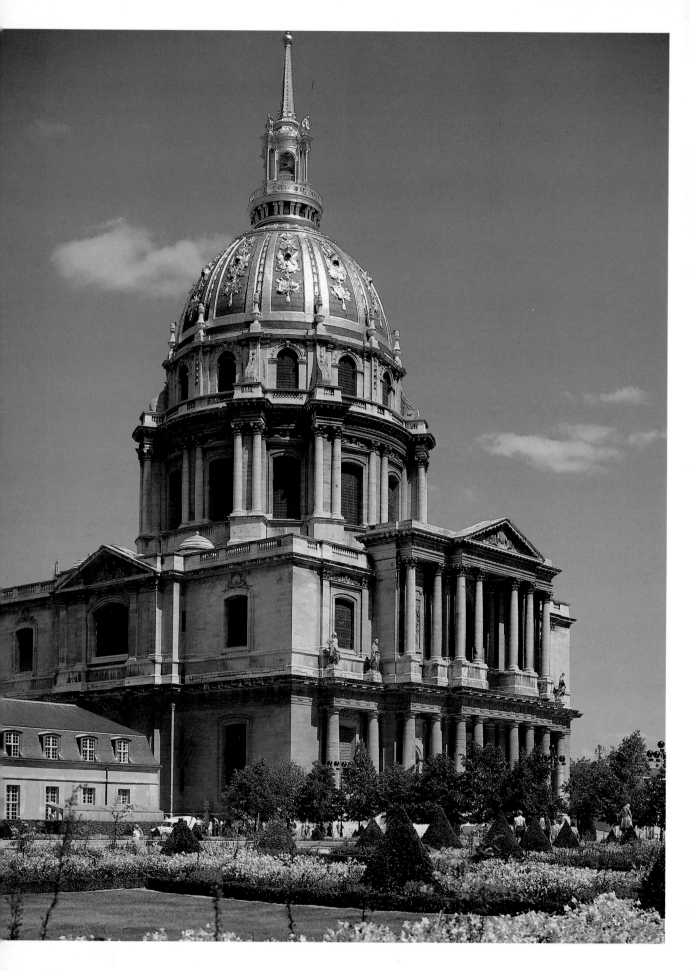

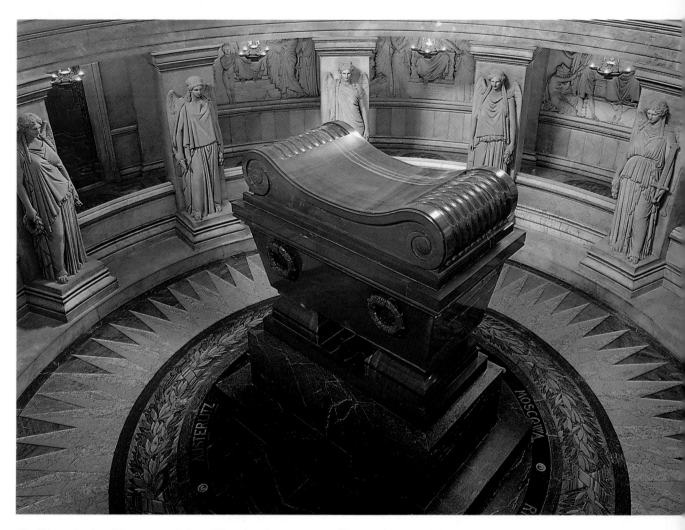

The Dôme des Invalides, a true shrine of Napoleonic memories, is considered the masterpiece of the architect Hardouin-Mansart.

The porphyry sarcophagus, over which twelve statues representing Victory keep timeless vigil, contains the mortal remains of Napoleon, in the crypt of the Dôme des Invalides.

ing inside the church of St. Louis-des-Invalides is the Chapel of Napoleon, in which is kept the hearse in which the remains of the emperor were taken to St. Helena for burial and the sarcophagus in which Napoleon's body was brought back to France in 1840.

DÔME DES INVALIDES

Considered one of the masterpieces of the architect Hardouin-Mansart, it was erected between 1679 and 1706. Pure forms and a classical, sober style are the characteristic of this building, with its square plan and two orders. The facade is a work of elegance and symmetry: above the two orders of columns surmounted by a pediment is the solid mass of the drum with its twin columns, from which, after a sober series of corbels, the slim cupola springs with its decorations of flower garlands and other floral motifs. The gilded leaves with which the top is decorated shine in the sunlight, and the structure is terminated by a small lantern with spire 107 m. (350 ft.) above ground level. The interior, in the form of a Greek cross, reflects the simplicity characteristic of the exterior. In the pendentives of the dome Charles de la

Fosse painted the four Evangelists, while in the center he depicted the figure of St. Louis offering Christ the sword with which he has defeated the infidels. Directly under the dome is the entrance to thé crypt which contains the tomb of Napoleon. Indeed, this church could be said to be a shrine to the memory of Napoleon. Here too are tombs of members of the emperor's family, as well as those of other great Frenchmen. In the chapels on the right are the tombs of Napoleon's brother, Joseph Bonaparte, and of the two marshals Vauban and Foch. The emperor's other brother, Jérôme, is buried in the first chapel on the left.

TOMB OF NAPOLEON I

Napoleon Bonaparte died on 5 May 1821 on St. Helena, but not until seven years later were the French able to obtain permission from England to bring back the remains of their emperor to his own country. Louis Philippe sent his son, the prince of Joinville, to St. Helena to supervise the exhumation of the emperor's body. The re-entry into France was the last triumphal voyage of the Frenchman best loved by his people, most venerated by his soldiers and most

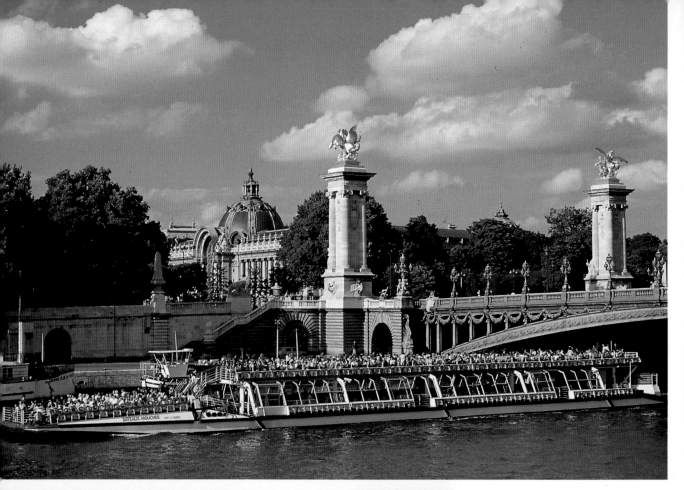

A "bateau mouche" glides under the Pont Alexandre III and a haunting picture of the Seine at sunset.

feared by his enemies. In September 1840 a French ship carried the body of Napoleon to Le Havre, then slowly made the entire trip up the Seine as far as Paris. On 15 September, in a snow storm, almost the entire city attended the funeral of the emperor, whose body moved in a slow procession along the great boulevards, passing under the Arch of Triumph and descending the Champs-Elysées to come to rest here in the Dôme des Invalides and thus end at last Napoleon's long exile. Like those of an Egyptian pharaoh, the remains were contained in six coffins: the first of tin, the second of mahogany, the third and fourth of lead, the fifth of ebony and the sixth of oak. These were then placed in the huge sarcophagus of red granite, in the crypt specially planned for the purpose by the great architect Visconti. Here 12 enormous Victories, the work of Pradier, keep a vigil over the emperor, as if to symbolise the whole French people, finally reunited with their great hero. And as

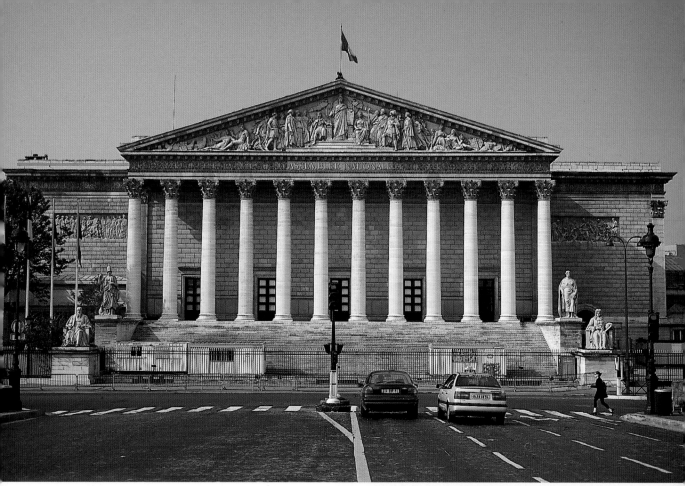

The Palais Bourbon, seat of the National Assembly, and a view of the facade with one of the four statues which flank the steps.

if to unite him after death with one from whom he had been divided during his life, next to the tomb was placed the tomb of Napoleon's son, the King of Rome, known romantically as l'Aiglon (the "Eaglet").

PALAIS BOURBON

This building bears the signature of no less than four famous architects: Giardini began it in 1722, Lassurance continued its construction, and Aubert and Gabriel completed it in 1728. It was originally built for the daughter of Louis XIV, the Duchess of Bourbon, who gave her name to the building. In 1764 it became the property of the Condé princes, who had it extended to its present dimensions, an imposing and noble structure looking over the square of the same name. Between 1803 and 1807 Napoleon had Poyet construct the facade, facing towards the Seine and harmonizing with the facade of the Madeleine church opposite it in the distance, at the end of Rue Royale. The portico of the facade has an allegorical pediment, sculpted by Cortot in 1842. Other allegorical bas-reliefs on the wings are the work of Rude and Pradier. The interior has a wealth of works of art: suffice it to say that Delacroix between 1838 and 1845 decorated its library with the History of Civilization and in the same room are busts of Diderot and Voltaire sculpted by Houdon.

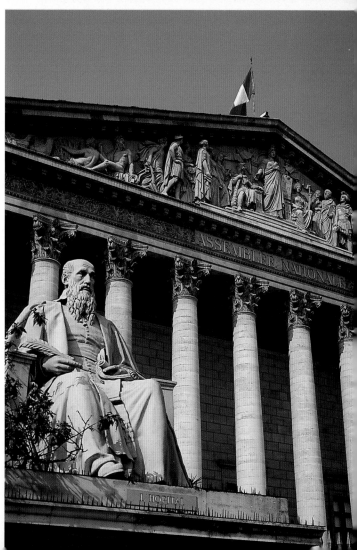

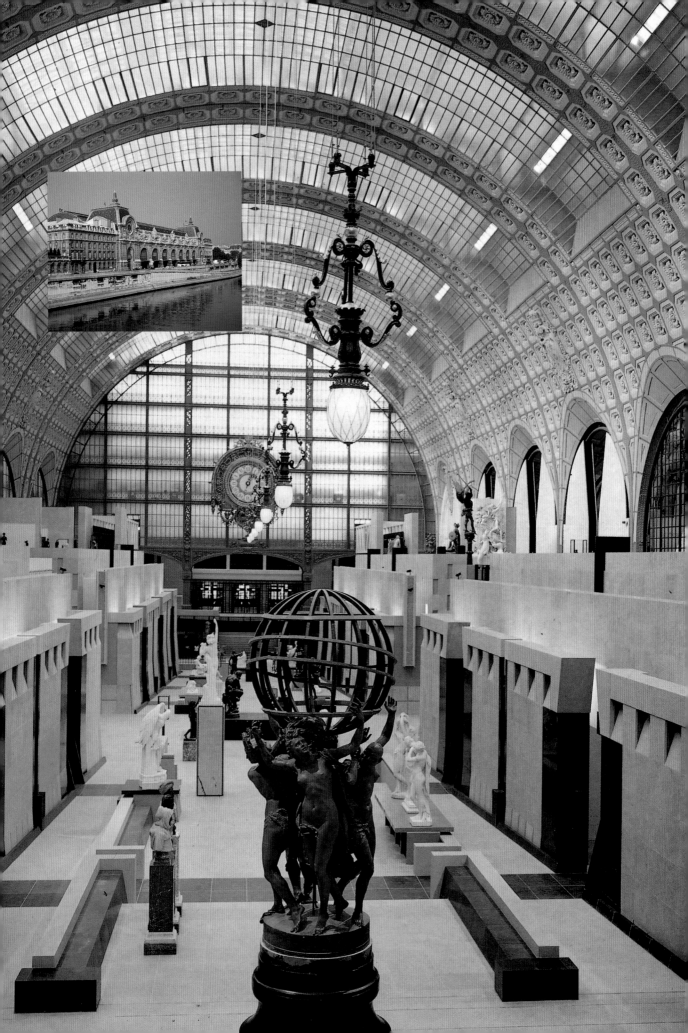

Musée d'Orsay

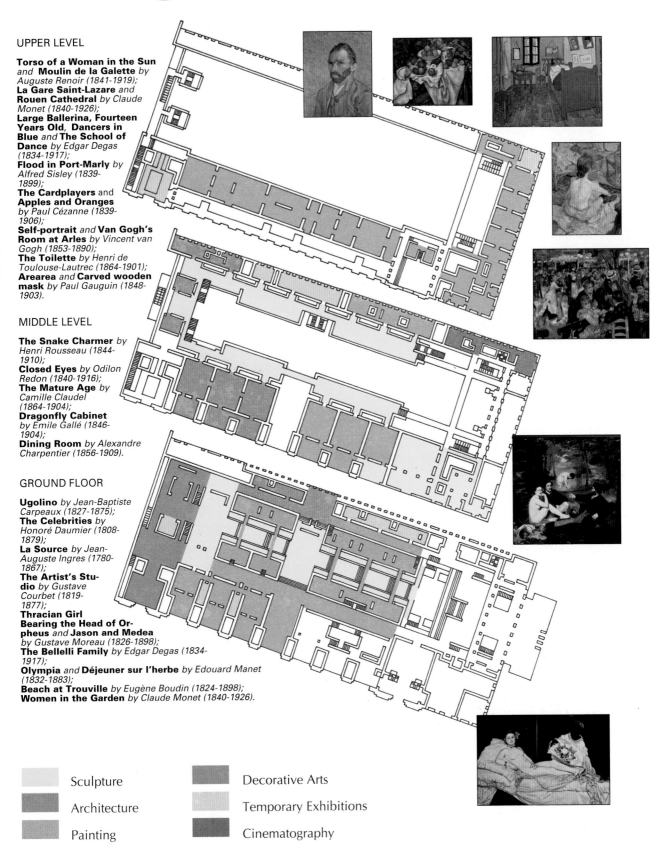

UPPER LEVEL

Torso of a Woman in the Sun *and* **Moulin de la Galette** *by Auguste Renoir (1841-1919);*
La Gare Saint-Lazare *and* **Rouen Cathedral** *by Claude Monet (1840-1926);*
Large Ballerina, Fourteen Years Old, **Dancers in Blue** *and* **The School of Dance** *by Edgar Degas (1834-1917);*
Flood in Port-Marly *by Alfred Sisley (1839-1899);*
The Cardplayers *and* **Apples and Oranges** *by Paul Cézanne (1839-1906);*
Self-portrait *and* **Van Gogh's Room at Arles** *by Vincent van Gogh (1853-1890);*
The Toilette *by Henri de Toulouse-Lautrec (1864-1901);*
Arearea *and* **Carved wooden mask** *by Paul Gauguin (1848-1903).*

MIDDLE LEVEL

The Snake Charmer *by Henri Rousseau (1844-1910);*
Closed Eyes *by Odilon Redon (1840-1916);*
The Mature Age *by Camille Claudel (1864-1904);*
Dragonfly Cabinet *by Émile Gallé (1846-1904);*
Dining Room *by Alexandre Charpentier (1856-1909).*

GROUND FLOOR

Ugolino *by Jean-Baptiste Carpeaux (1827-1875);*
The Celebrities *by Honoré Daumier (1808-1879);*
La Source *by Jean-Auguste Ingres (1780-1867);*
The Artist's Studio *by Gustave Courbet (1819-1877);*
Thracian Girl Bearing the Head of Orpheus *and* **Jason and Medea** *by Gustave Moreau (1826-1898);*
The Bellelli Family *by Edgar Degas (1834-1917);*
Olympia *and* **Déjeuner sur l'herbe** *by Edouard Manet (1832-1883);*
Beach at Trouville *by Eugène Boudin (1824-1898);*
Women in the Garden *by Claude Monet (1840-1926).*

Sculpture	Decorative Arts
Architecture	Temporary Exhibitions
Painting	Cinematography

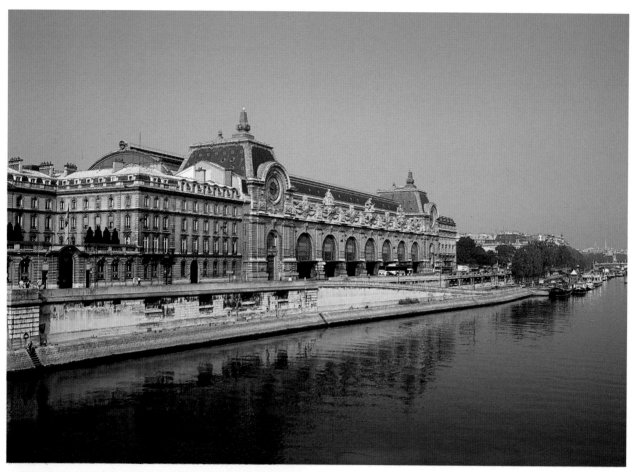

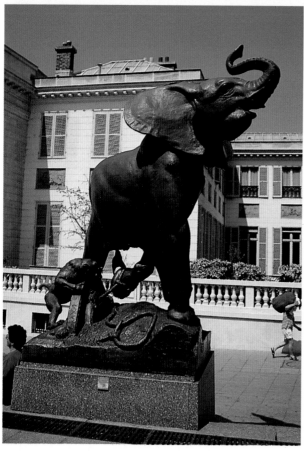

RAILROAD STATION TO MUSEUM

The Gare d'Orsay was built by Laloux on the site of the old Cour des Comptes which burned down in 1871 in the period of the Commune; the building consists of a large central concourse with metal supports, masked on the outside by a showy cut-stone facade in an eclectic style and inside by a stuccoed coffered ceiling. It became obsolescent in 1939 and when demolition threatened, in 1973 the station was included in the Inventory of Historical Monuments. This was also when, under the presidence of Georges Pompidou, it was proposed to turn the building into a museum. In 1978 Giscard d'Estaing took up the project anew and the restructuration of the station was entrusted to the équipe ACT Architecture. The transformation was concluded in 1980 by the Italian architect Gae Aulenti who was in charge of the internal architectural installations and the conversion into a museum.

THE COLLECTIONS

The Musée d'Orsay exhibits work of the second half of the nineteenth century, from 1848 to 1905 circa irregardless of expressive means or technique.

One of the principal purposes of the new museum was to gather together in one place the collections that up to then had been dispersed in various museums - the Louvre, the Jeu de Paume (Impressionists) and the Palais de Tokyo (Post-impressionists).

The origins of these collections of Impressionists and Post-impressionists is in great part due to the generosity of private collectors. The first Impressionist painting to make its way into the museum of Luxembourg, meant to house works by living artists from the time of its inception under Louis Philippe, was Manet's **Olympia,** purchased in 1889 thanks to a public subscription promoted by Monet. Despite an occasional timid acquisition by the State (Renoir's Girls at the Piano and Fantin-Latour's Atelier aux Batignolles), it was the large donations of the end of the century which led to the entrance en masse of the Impressionists in Luxembourg. In 1894, the Gustave Caillebotte bequest contained around forty pictures including Manet 's Balcony, the **Gare Saint-Lazare** by Monet, the Red Roofs by Pissarro, Renoir's **Moulin de la Galette** and **Torso of a Woman in the Sun.** In 1906 the Moreau-Nélaton donation included a dozen paintings by Monet, by Sisley and Manet's **Le Déjeuner sur l'herbe.** Lastly in 1908 the Isaac de Camando bequest was composed of a goodly number of masterworks, such as Absinthe and Dancing School by Degas, the **Rouen Cathedral** series by Monet, The Fifer by Manet, Cezanne's **Cardplayers** and the Clowness Cha-U-Kao by Toulouse Lautrec.

Other donations, such as those of Paul Gachet (works by Van Gogh and Cezanne), d'Antonin Personnaz and Eduard Mollard, were to follow.

The **Ground Floor** is dedicated to the period 1850-1875. On either side of the concourse, in which the large sculpture from Rude to Capreaux is installed, are a series of rooms which exhibit:

on the right: the inheritance of Classicism and Romanticism, up to the beginning of Symbolism, as well as the early works of Degas,

on the left, on the side of the Seine: Realism (Daumier, Courbet, Millet, etc.) up to the beginnings of Impressionism.

The **Upper Level** is entirely reserved for the Impressionist painters (Monet, Renoir, Degas, Pissarro, Sisley, Cezanne) and the Post-impressionists.

On the **Intermediate Level** the diverse movements of the last third of the nineteenth century pass in review. Symbolism, Art Nouveau, Naturalism. On the whole the terraces are dedicated to sculpture by Rodin, Camille Claudel, Bourdelle and Maillol.

THE ART BEFORE 1870

CLASSICISM AND ROMANTICISM

The itinerary of the visit to the Musée d 'Orsay begins with an homage to Ingres and Delacroix, the two leading personalities who embodied the conflict between Classicists and Romanticists during the first half of the nineteenth century.

A disciple of David, Ingres was the absolute master of the elegant flowing contour with a predilection for undulating lines. **La Source** (1856) is the most famous example of this love for a subtle use of sfumato and sinuous forms, shared by his disciples Hippolyte Flandrin and Amauray-Duval. Diametrically opposed is the technique of Delacroix, which Baudelaire so greatly admired, describing it as «an authentic explosion of colors». Representatives of this movement in the field of sculpture were talented artists such as François Rude, Augustin Preault or Barye.

Chasseriau, disciple of Ingres and admirer of Delacroix, attempted to reconcile the two rival schools in drawing and color. His large decorative paintings influenced artists such as Puvis de Chavannes and Gustave Moreau, whose poetical, mysterious, other-worldly paintings foreshadowed the late nineteenth-century Symbolist works.

The Musée d'Orsay seen from the Seine and one of the statues in the square in front of the building on Rue Bellechasse.

REALISM

Around 1848 a reaction against Romanticism began to emerge: Realism. It tended towards a more faithful imitation of nature and aspired to bear witness to daily reality, social truth. Corot and the Barbizon School (Paul Huet, Théodore Rousseau, Diaz, Troyon, Daubingny) were in a sense the link between the two movements. While their roots lay in Romanticism, eventually the affirmation of realistic veracity and a worship of nature became manifest in their works. In their attempts to capture the intense impalpable vibrations of light, they were the harbingers, above and beyond Realism, of the future Impressionist movement.

Realism found its great champion and theoretician in Courbet. His two great compositions (Funeral in Ornans and **The Artist's Studio**), refused by the Salon juries of 1850 and 1855, give full play to all his talents as colorist and portrait painter. Millet and Daumier are the other two great figures who attempted to transfer their social ideas into their works. A vigorous and synthetic line delineates Millet's peasants, subjects considered subversive in the Second Empire, in broad and static monumental silhouettes imbued with inherent majesty. This three-dimensional synthesis which refuses anecdote is also to be found in the caricatures of Daumier, painted in broad powerful masses (**Celebrities**).

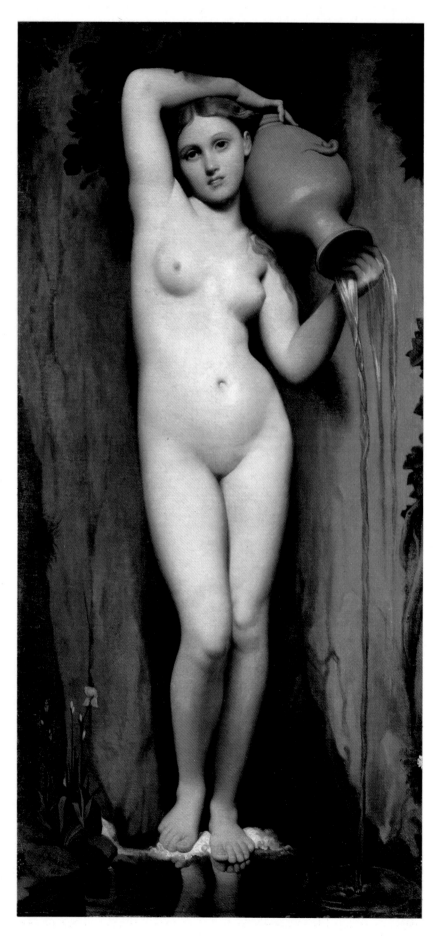

La Source, finished in 1856, is one of the last works painted by Jean-Auguste Ingres (1780-1867). This splendid female nude was unanimously received with enthusiasm: the sinuous line of the body, which had already found expression in odalisques and bathers, might here be said to have achieved an absolute harmony and perfection.

Jason and Medea, by Gustave Moreau (1826-1898). In its wealth of details, complexity of vision and pervasive atmosphere of mysticism, the precious refined art of Moreau has many points of contact with Symbolist poetry. To be noted in this painting is the quotation from Leonardo in the background landscape on the left, which recalls that in the "Virgin of the Rocks". The scroll that winds around the column bears verses from Ovid's Metamorphoses. There are also quotations from the antique in Moreau's other picture, the **Thracian Girl Bearing the Head of Orpheus.** It is said that Moreau was inspired by the head of one of Michelangelo's "Prisons" when he painted the head of the bard resting on his lyre. In both pictures the glowing colors, the intimations of mysticism and sensuality, the mysterious surreal landscapes create a magic dreamlike atmosphere.

The Artist's Studio, by Gustave Courbet (1819-1877). The painter shows himself in a large room, real and unpretentious, as he paints a large landscape, inspired by Truth, the nude woman behind him. Recognizable on the right are Baudelaire, Proudhon, the art patron Bruyas, the writer Champfleury. The others are set on the left, "the other world of banal life, the people, misery".

128

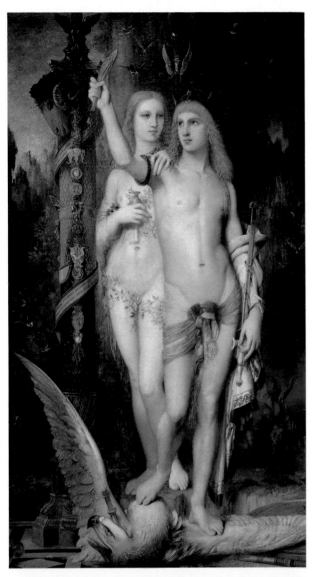

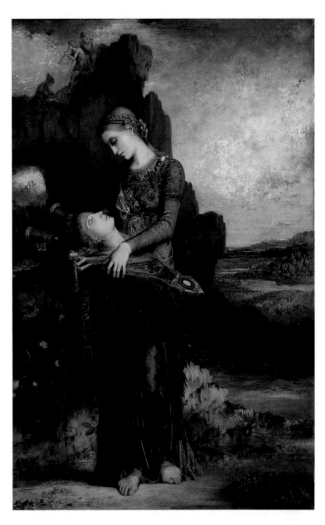

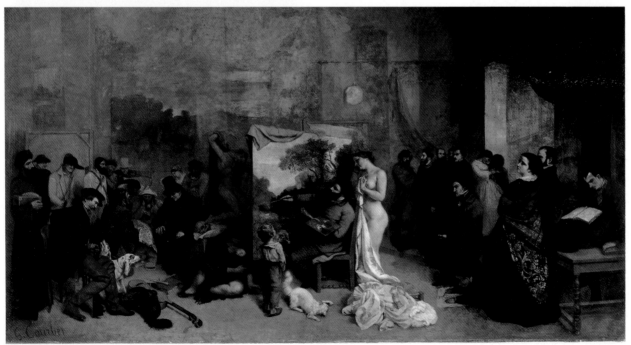

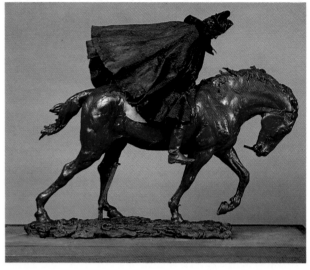

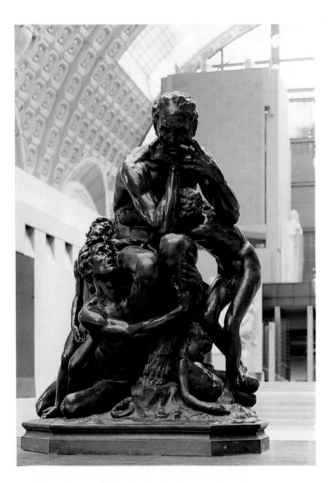

Ugolino, bronze group by Jean-Baptiste Carpeaux (1827-1875). There is something powerful and terrible in this dramatic work.

The Traveller, by Ernest Meissonier (1815-1891). Famous above all as a genre painter, he was most successful in the field of sculpture.

Below: In *The Celebrities*, Honoré Daumier (1808-1879) reveals the true nature of his personages with scathing realism.

The Bellelli Family, by Edgar Degas (1834-1917) is simple and severe in its composition.

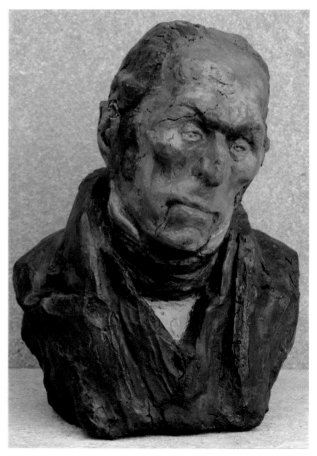

The painters who can be grouped together from 1874 on under the term of Impressionists all came from the Realist movement in which observation from nature was stressed. Influenced by the English painters (Constable, Turner, Bonington) and by the Barbizon school, Jongking and Boudin captured the fleeting effects of atmospheric changes in their works. Boudin's limpid painting, describing the vibrations of light in his views of the beaches of Normandy, animated by the elegant crowd of summer excursionists (**Beach at Trouville**), profoundly influenced the young Claude Monet, whose family had gone to live in Le Havre. Without breaking with the classic concept of drawing and color, Degas and Manet were to be the two great precursors of Impressionism thanks to the way in which they used color.

When Manet's **Dejeuner sur l'erbe** and the **Olympia** were presented at the Salons of 1863 and 1865 they aroused a downright scandal, both on account of the subject matter, judged immoral and provoking, and in the brutality of the style. Manet's breaking up of the masses by means of strong contrasts of color and light makes him a «primitive» of a new era. The works by Degas, on the other hand, manifest a masterly play of chiaroscuro, with strong contrasts of dark but refined colors (**The Bellelli Family**) and a bold composition (The Orchestra de l'Opéra).

At the beginning of the 1860s, Monet, Bazille, Renoir and Sisley met in the atelier of Gleyre where they became friends. Sharing the same ideas and attracted by the realist current, they continued their own studies on light in the forest of Fontainebleau, in the wake of the painters of the Barbizon school. Following Manet's example, in 1865 Monet created a free technique in which the spontaneity andfreedom of the sketch was maintained in an attempt to achieve the fleeting effect of light filtered through the leaves, with broad areas of light and shade speckling the figures gathered together in a glade. The artist 's early style,which appears in **The Picnic** (1865-1866) and in his **Women in a Garden** (1867), was to undergo a profound transformation around 1870.

Closely tied to Monet, Bazille concentrated his attention on the figure, strongly lit by a blinding light which accentuates the contrasts. Close to Manet and the Impressionists whom he admired even though he never participated in the movement, Fantin-Latour can be considered a personality apart, gifted with a keen sense of observation.

His Atelier aux Batignolles (1870) is inundated with a soft subtle light which envelops the figure in somber severe tonalities.

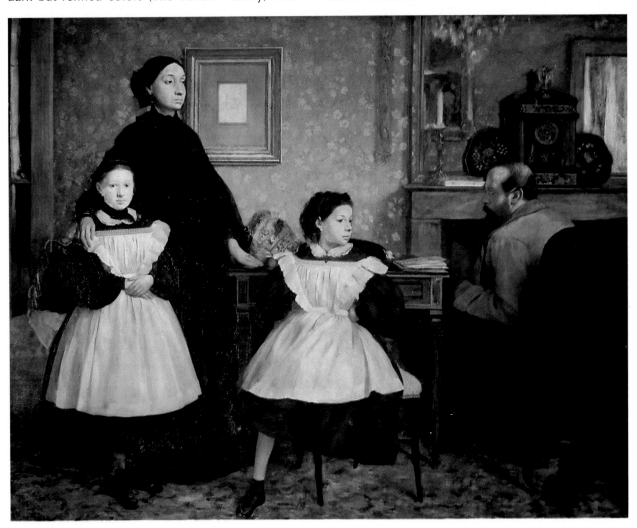

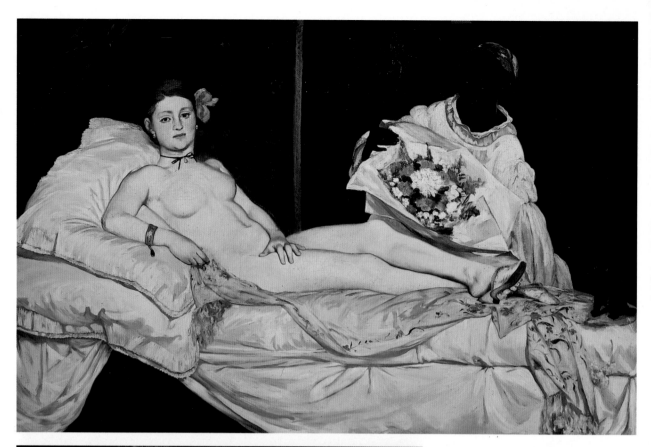

Both the **Olympia** and the **Déjeuner sur l'herbe (Picnic on the Grass)** by Edouard Manet (1832-1883), considered as the breakthrough which led to modern painting, scandalized the public and critics. Manet indeed makes a total break with tradition, destroying volume and abolishing all the intermediate color tones and half tints, relying only on a free association of luminous colors.

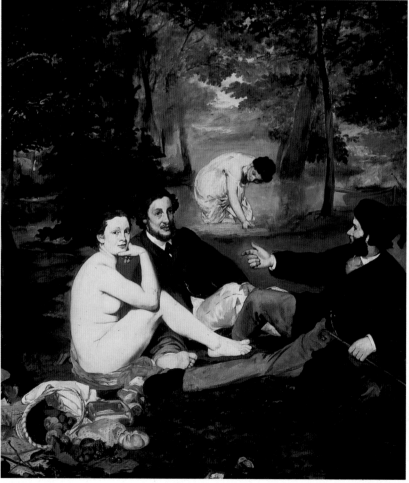

Beach at Trouville, by Eugène Boudin (1824-1898). The ever-changing skies and iridescent sea, typical of the coast of Normandy, fascinated Boudin, who found the primary inspiration for his painting in this shifting play of light.

Women in the Garden, by Claude Monet (1840-1926). This canvas reveals how profound Monet's study of the effects of light were. The sun stands directly overhead and the light falls perpendicularly on this flowering garden: the blinding white skirts, the path, the parasol - all seem to be cut in half by light and shade.

132

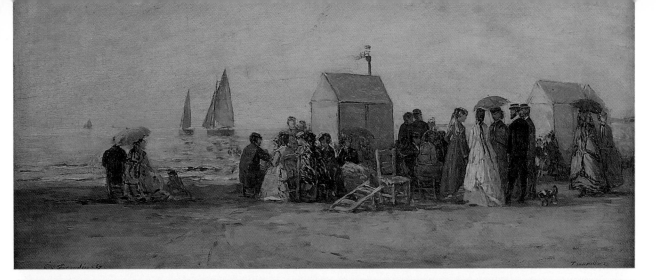

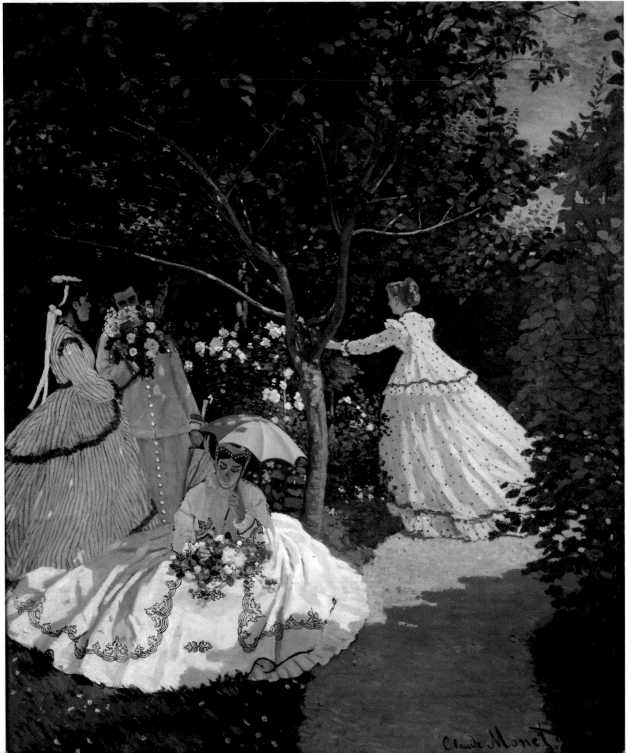

THE IMPRESSIONISTS

The official date for the birth of the movement was 1874, the year in which, on the occasion of the first independent exhibition of the group, they were first called «Impressionists», after a painting by Monet entitled Impression-Sunrise.

After the war of 1870 Claude Monet was considered the head of the movement: he established himself at Argenteuil, where almost all of them, including Manet, went to work, and began to describe the vibrations of light on the landscapes along the banks of the Seine. In his attempts at expressing a momentary vision that was dependent on the ephimeral effects of a light that constantly changed with the passing of time and the seasons, he dissolved matter, annihilating its density, in a play of fragmentary ever-changing brushstrokes (the series of **Rouen Cathedral**). Close to Monet, Sisley and Pissarro bathed their landscapes of the Ile de France in a delicately colored light.

Renoir, on the other hand, attempted to apply the principles of Impressionism to the study of the human fgure. In the **Torso of a Woman in the Sun** and in the **Moulin de la Galette**, the figure vibrates under the effect of the manifold reflections of light rendered by means of small fragmented spots which are scattered over the skin and the clothing.

An independent artist, passionately interested in photography, Degas invented a new concept of the framing of the picture, often off center (L'Absinthe) which depicts the fgures in their immediate reality. Gradually moving towards the new studies on color and artificial light in the esclusive world of the Opéra, his fgures are blanketed in a dense rich layer of warm sparkling tones (**The Blue Ballerina**).

Cezanne, on the other hand, had a distinct personality of his own and wanted «to turn Impressionism into something solid and lasting like the art in museums». He was less interested in rendering fleeting impressions than he was in grasping the permanent character of things, by means of an exemplification and synthesis of the forms, powerfully modelled by small colourful brushstrokes set one next to the other, borrowed from the technique of the Impressionists.

THE POSTIMPRESSIONISTS

In the 1880s a crisis arose within the Impressionist movement itself: Renoir, who had never abandoned the human figure, hoped for a return of drawing, of contour, of form, condemned in the name of the primacy of color. In these years Cezanne began a simplification of volumes tending towards a geometric and prismatic expression of the forms thus heralding, beyond Post-impressionism, the cubist revolution of the twentieth century.

A few young artists however oriented the movement towards new horizons. In his search for the static position of the forms, Seurat applied a new method in his painting. Known as «neoimpressionism» (or «pointillism»), it consisted in placing on the canvas small dots of juxtaposed color, meant to intensify the solidity and vivacity of the colors themselves. Gauguin, on the other hand, gradually gave up Impressionism for a more solid style with greater contrasts, using broad areas of uniform color, «inserted» or «synthetic», which enhanced the uniform purity of the intense flaming color. As for Van Gogh, he reinforced the expressive power of contrasts of complementary colors, distributed in powerful swirling brushstrokes which made him a precursor of the Fauves and the Expressionists in the following century.

Degas and Japanese prints strongly influenced the eccentric figure of Toulouse Lautrec who left his mark in the vigor of his incisive and expressive drawing which boldly renders the momentary gesture and pose of the model in its essence (**The Toilette** and The Clowness Cha-U-Kao).

La Gare Saint-Lazare and Rouen Cathedral, by Claude Monet (1840-1926). It was while he was staying in Giverny that the idea of painting the same subject repeatedly, transformed by the passing of time, the seasons, the light, came to Monet. He dedicated seven canvases to the Station of Saint-Lazare and more than twenty to the Cathedral of Rouen. What fascinated him particularly in Saint-Lazare was the effect of the light as it shone through the high glass roof and blended with the steam and smoke of the trains entering the station; in Rouen it was the ever-changing play of light throughout the day as it modified and transformed the reliefs and statues on the facade and portals, highlighting first one, and then another of the details.

Torso of a Woman in the Sun, by Auguste Renoir (1841-1919). Color, light, life: these are the three components with which the painter sets his emotions down on canvas. The forthright juxtaposition of colors, the elimination of half tones, meant that the outlines of the figures and objects almost seem to dematerialize and the whole painted surface is nothing but a succession of spots of light and colored shadows, which furnish the onlooker with an impression of movement, of animation, in a single word, of life. The sunlight seems to glow here and there in spots on this torso of a woman which emerges lazily from the green of a garden, and one really seems to feel the warmth on the skin.

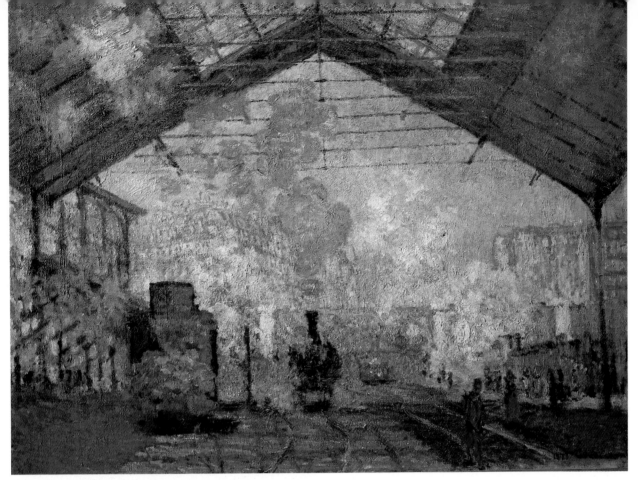

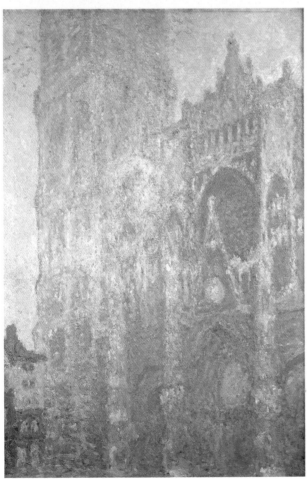

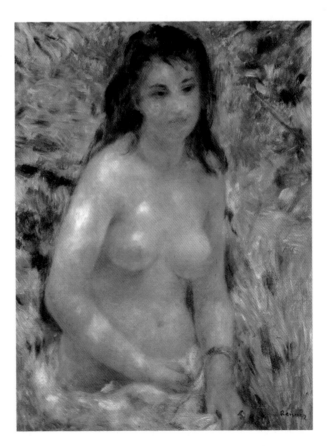

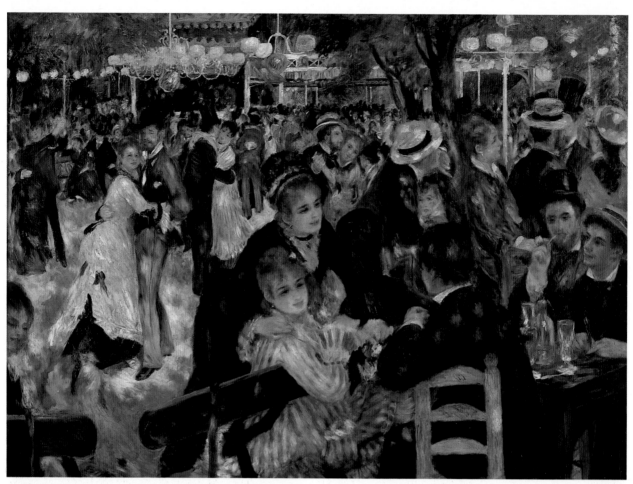

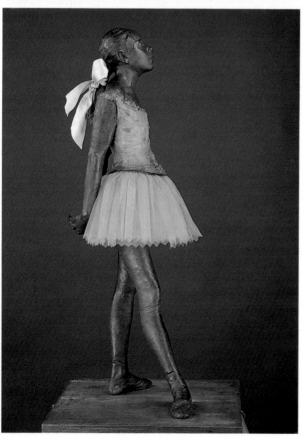

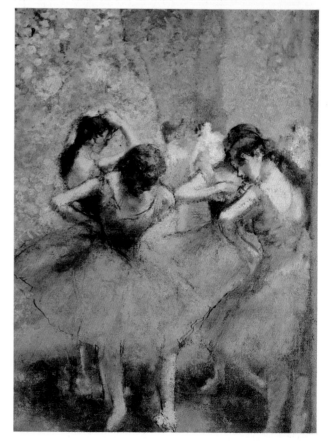

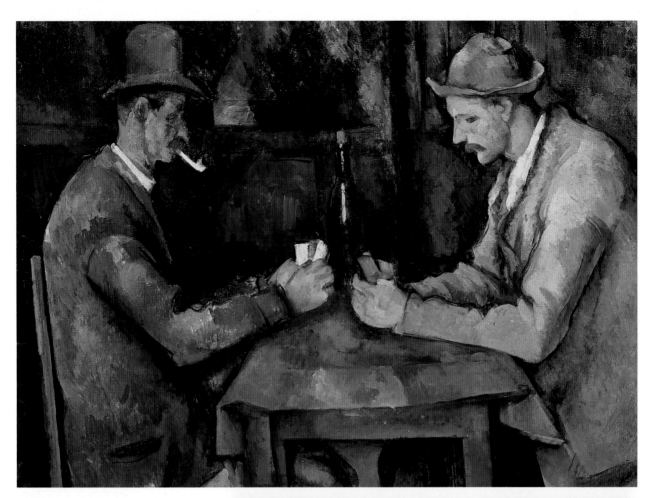

Moulin de la Galette, by Auguste Renoir (1841-1919). In this carefree dance under a pergola, the rays of sunlight seem to be filtering through the leaves and highlighting various details - a face, the corner of a chair, a straw hat.

Large Ballerina, Fourteen Years Old and *Dancers in Blue*, by Edgar Degas (1834-1917). Both the sculpture, in bronze with a "tutu" in white tulle and a bow in pink satin, and the painting bear witness to the artist's careful study of forms and movement as well as his interest for the world of dance.

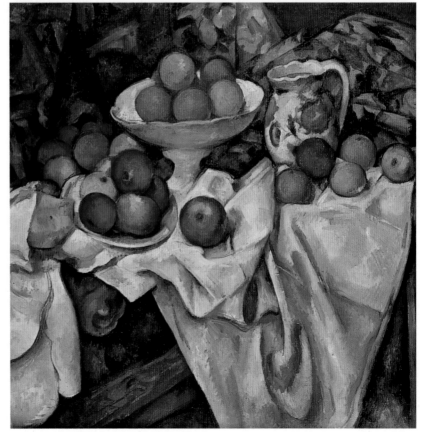

The Card-players and *Apples and Oranges* by Paul Cézanne (1839-1906). Unlike the Impressionists, Cézanne presented nature in its immutability and eternal identity; in the human figures the bodies become monumental, three-dimensional, essential in their geometric forms.

137

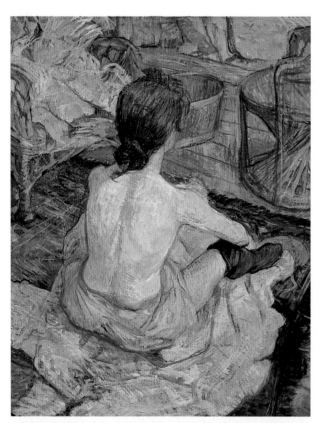

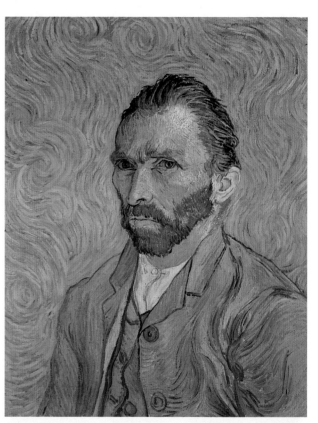

The Toilette by Henri de Toulouse-Lautrec (1864-1901). In his sketches and paintings the painter captures the melancholy hidden behind the gaudy costumes of the dancers in the café-chantant, the squalor that reigns behind the showy stuccoes and velvet of the night spots of Montmartre.

Self-portrait and **Van Gogh's Room** were painted by Vincent van Gogh (1853-1890) in Provence in 1889. The painter had come there the year before in his quest for sun and light. The fixed wild gaze of the self-portrait, done while he was a patient in the insane asylum of Saint-Rémy, testifies to the critical period he was undergoing. The painting of his room in the "Yellow House" in Arles is more serene.

Arearea and **Carved Wooden Mask** by Paul Gauguin (1848-1903). This canvas, whose title in Maori means "Joy", is also known as "The Red Dog" because of the animal figure in the foreground. Gauguin discovered primitive art in Tahiti, with its solid flat forms, the violent colors of an untamed nature, which he then transferred to canvas as he saw them. The mask shows us the face of Teha'amana, the Polynesian girl who became Gauguin's companion as well as the model for his finest works.
.

SYMBOLISM

Symbolism developed as a reaction to nineteenth-century Realism.
*The Symbolist movement was most directly influenced by Puvis de Chavannes with his large spare but poetic compositions with their clear fresh colors. This reconquest of the art of the unconscious and the dream was carried to its term by Odilon Redon (**Closed Eyes**).*
In England the Pre-Raphaelites affirmed their refection of reality and their desire to return to the Gothic art of the early Renaissance.
*A complex personality who occupies a place apart, his desire to express an inner world dominated by a devastating passion relates Rodin to the Symbolists. This same passion animated Camille Claudel in his masterpiece, **The Mature Age**, inspired by the break with Rodin. At the beginning of the twentieth century, Bourdelle and Maillol, rediscovered a type of archaism, simplifying either the model or the composition.*

ART NOUVEAU

In the last third of the nineteenth century, Art Nouveau appeared as the first movement which sought to elaborate a radically new style in the field of architecture and in the decorative arts, where eclecticism had reigned up to then. Stylistically Art Nouveau is not easy to define for it assumed different forms according to the personality of those who adhered to the movement. Some of these were: Victor Horta in Brussels, Hector Guimard in Paris, Emile Gallé and Louis Majorelle in Nancy, Otto Wagner and Joseph Hoffman in Vienna, Mackintosh in Glasgow. On the whole, Art Nouveau pursued an organic ideal aimed at reuniting form and decoration.

TOWARDS THE TWENTIETH CENTURY

*A self-taught artist, Le Douanier Rousseau holds a place all his own in the great movements of the end of the century. His exotic and fantastic subjects, often with symbolist overtones, are treated in a purposely «naif» and very modern style, which heralded the «revolutionary» movements of the twentieth century (**The Snake Charmer**).*
While the members of the «Nabis» (Bonnard, Vuillard, Maurice Denis, Valloton, Roussel), a society which had been formed in the early 1890s, never abandoned the decorative nature of painting, at the turn of the century they forsook their simplified areas of uniform color to explore the spacial virtualities of color. This study of the evocative power of pure color led to Fauvism which appeared at the Autumn Salon of 1905 (Matisse, Marquet, Derain). In a parallel manner, the three-dimensional combinations of geometric forms of Seurat and Cèzanne (to whom large retrospective exhibitions were granted in the Salons of 1905 and 1907) prefigured those of the Cubist painters (Picasso, Braque).

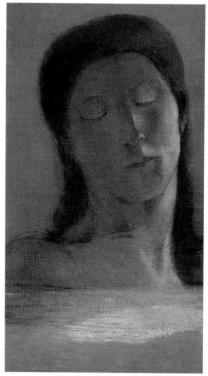

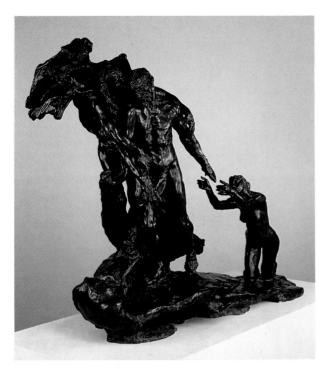

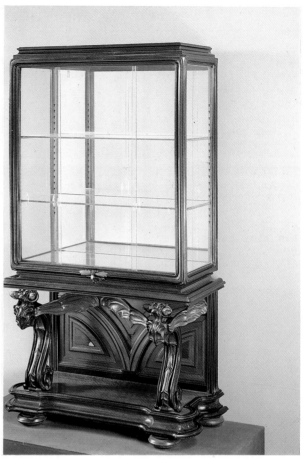

The imaginary world and highly original style of Henri Rousseau (1844-1910) are evident in **The Snake Charmer**, while **Closed Eyes** by Odilon Redon (1840-1916) is marked by its serene beauty.
The deep-seated sense of suffering of the artist is revealed in **The Mature Age** by Camille Claudel (1864-1943).
Harmony and elegance characterize the **Dragonfly Cabinet** by Emile Gallé (1846-1904) and the **Dining Room** by Alexandre Charpentier (1856-1909).

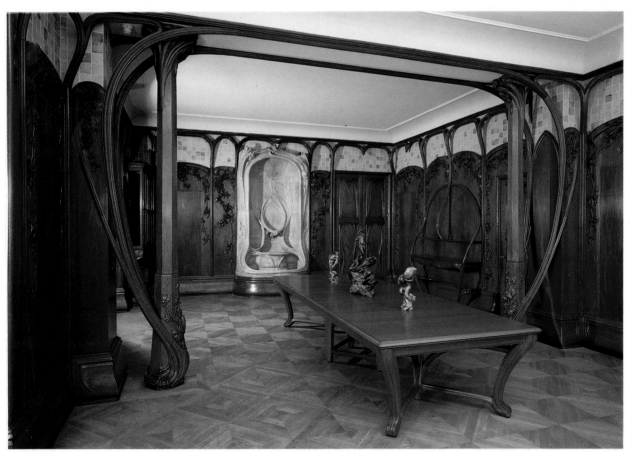

141

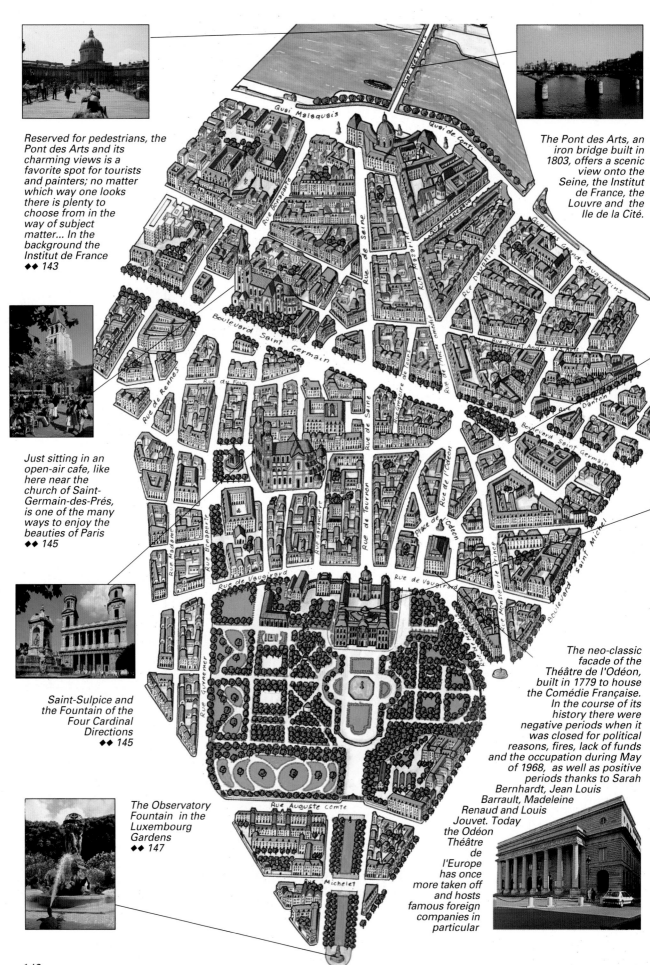

Reserved for pedestrians, the Pont des Arts and its charming views is a favorite spot for tourists and painters; no matter which way one looks there is plenty to choose from in the way of subject matter... In the background the Institut de France
◆◆ 143

The Pont des Arts, an iron bridge built in 1803, offers a scenic view onto the Seine, the Institut de France, the Louvre and the Ile de la Cité.

Just sitting in an open-air cafe, like here near the church of Saint-Germain-des-Prés, is one of the many ways to enjoy the beauties of Paris
◆◆ 145

Saint-Sulpice and the Fountain of the Four Cardinal Directions
◆◆ 145

The neo-classic facade of the Théâtre de l'Odéon, built in 1779 to house the Comédie Française. In the course of its history there were negative periods when it was closed for political reasons, fires, lack of funds and the occupation during May of 1968, as well as positive periods thanks to Sarah Bernhardt, Jean Louis Barrault, Madeleine Renaud and Louis Jouvet. Today the Odéon Théâtre de l'Europe has once more taken off and hosts famous foreign companies in particular

The Observatory Fountain in the Luxembourg Gardens
◆◆ 147

Saint-Germain-des-Prés

Luxembourg

Institut de France -
Saint-Sulpice -
Palais du Luxembourg
and Gardens -
Pont des Arts -
Théâtre de l'Odéon

The monument to Danton, made in 1889 by Auguste Paris, commemorates the figure of one of the leaders of the French revolution, executed on the orders of Robespierre during the period of the Terror

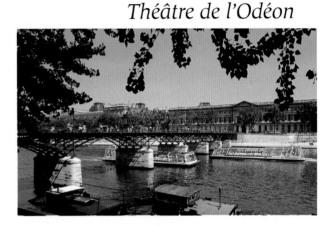

The characteristic Pont des Arts, for pedestrians only, and the Institut de France.

The Palais du Luxembourg
◆◆ 146

INSTITUT DE FRANCE

Linked to the Louvre by the picturesque Pont des Arts, the first bridge built of iron, this building was erected in 1665 as the result of a bequest by Cardinal Mazarin who in 1661, three days before his death, stipulated in his will that two million francs be spent on the construction of a college capable of accommodating 60 students, to be called the College of the Four Nations. In 1806 Napoleon ordered the transfer here of the Institut de France, which had been formed in 1795 by the union of five academies: the Academies of France, of the Sciences, of Letters, of Fine Arts and of Moral and Political Sciences. The commission for designing the building was given to Le Vau, who took the Roman Baroque edifices as his model. The facade of the central section has columns which support a pediment, above which is a fine cupola with the insignia of Mazarin sculpted on its drum. This section is linked to the pavilions at either side by two curving wings with two orders of pillars. Entering the courtyard, one can visit on the left the Mazarin Library and on the right the formal Meeting Room: here, beneath the cupola, in what was originally the college chapel, are held the solemn ceremonies for the presentation of new members of the French Academy. In the vestibule preceding this room is the tomb of Mazarin, a work done by Coysevox in 1689.

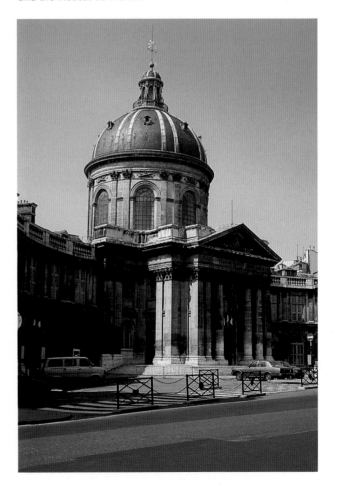

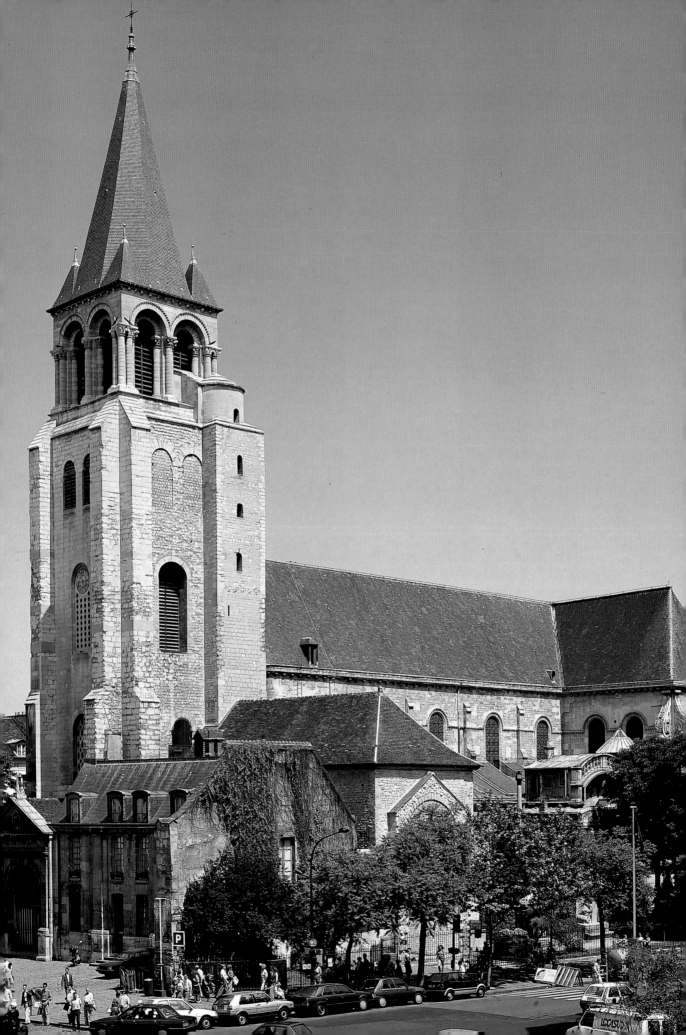

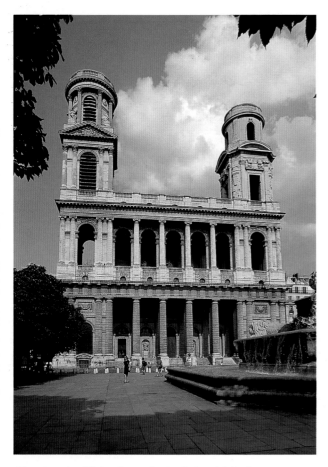

The church of Saint-Germain-des-Prés with its fine Romanesque bell tower.

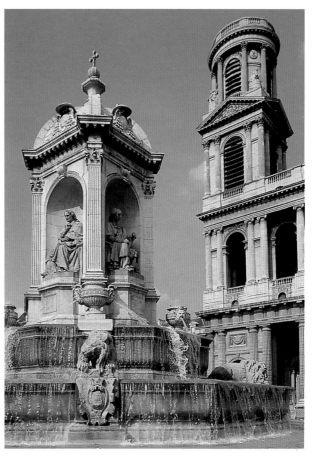

The facade of Saint-Sulpice flanked by two towers and the Fountain of the Four Cardinal Directions, in the center of the square in front of the church.

SAINT-GERMAIN-DES-PRES

Here one is emerged once more in the animated life of the quarter of St. Germain, whose typical and colorful streets interweave and cross one another to form picturesque corners. Here too is the church of Sainte-Germain-des-Prés, the oldest church in Paris, built between the 11th and 12th centuries, and destroyed no less than four times in forty years by the Normans, but each time rebuilt in its severe Romanesque forms. In the facade one can see the remains of the 12th-century portal, unfortunately half-hidden by the 17th-century portico erected in 1607. The bell-tower, on the other hand, is entirely Romanesque, its corners reinforced by robust buttresses. In the 19th century, the two towers which stood at the sides of the choir were demolished, and of the choir itself there are only a few remains. The interior has three aisles and a transept, the end of which was modified in the 17th century. As a result of the restoration of the church in the 19th century, the vaults and capitals now have decorations too rich to allow the otherwise simple and severe structure of the interior fully to be appreciated. The most interesting part of the building is the choir with its ambulatory, where the original architecture of the 12th century is still in part preserved intact. In this church

are the tombs of two illustrious figures: that of René Descartes, in the second chapel on the right, and that of the Polish king John Casimir, in the transept on the left.

SAINT-SULPICE

After Notre-Dame, this is the largest church in Paris. Six architects worked on it in the course of 134 years. The imposing facade is the work of the last one, the Florentine G.N. Servandoni, although it was partially modified by Maclaurin and Chalgrin. In its present form it consists of a double portico with a balconied loggia above and flanking towers. At the sides, the ends of the transept have two superposed orders, in Jesuit style. The interior is particularly imposing: 11 meters long, 56 meters wide and 33 high. Above the entrance is one of the finest organs in France, designed in 1776 by Chalgrin and built in 1862 by Cavaillé-Coll. The two holy water stoups set against the first two piers are none other than gigantic shells presented to Francis I by the Republic of Venice, which were then given in 1745 by Louis XV to the church. In the first chapel on the right, Eugène Delacroix painted some splendid frescoes, full of spirit and romantic power.

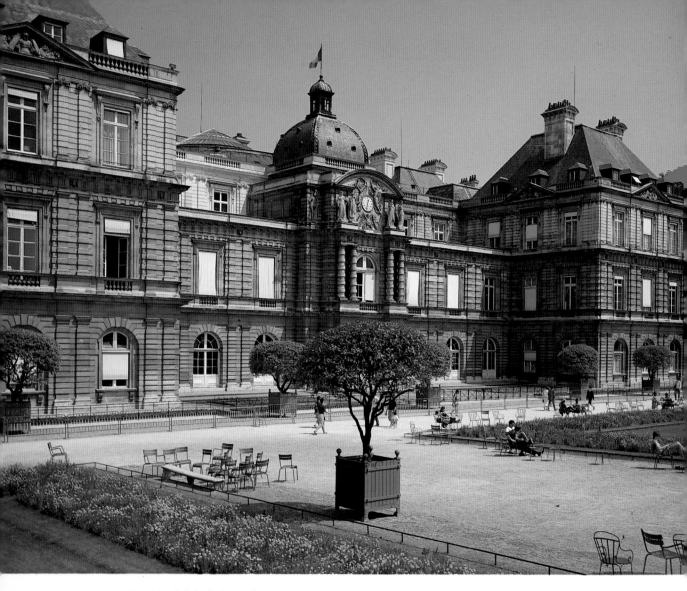

The elegant facade of the Palais du Luxembourg.

PALAIS DU LUXEMBOURG

On the death of Henry IV, his queen, Marie de' Medicis, who apparently did not feel at home in the Louvre, preferred to live in a place which in some way reminded her of Florence, the city from which she came. Thus in 1612 she acquired this mansion from the duke François de Luxembourg, together with a considerable expanse of ground, and in 1615 she commissioned Salomon de Brosse to build a palace as near as possible in style and materials to the Florentine palaces which she had left to come to France. And in fact both the rusticated stonework and the large columns and rings are much more reminiscent of the Palazzo Pitti in Florence that of any other Parisian building. The facade consists of a pavilion with two orders covered by a cupola and with two pavilions at the sides, united to the central unit by galleries. When the Revolution broke out, the palace was taken from the royal family and transformed into a state prison.

On 4 November 1795, the first Directory installed itself here, and later Napoleon decided that it would be the seat of the Senate. Inside the palace are works by Eugène Delacroix and by Jordaens.

LUXEMBOURG GARDENS

Perhaps one of the most pleasant and typical things about Paris, this city with so many different aspects, is that along with roads crowded with traffic, people and noise there are hidden angles of greenery and silence, oases of peace where time slows to a stop. One of these places which calm the spirit is the Jardin du Luxembourg, a huge public park which, because it is near the Latin Quarter, is animated every day by young people and students. Among the trees throughout its vast area there are fountains, groups of statues and even playing fields. A fine series of statues are those depicting the queens of France and other illustrious women along the terraces of the park.

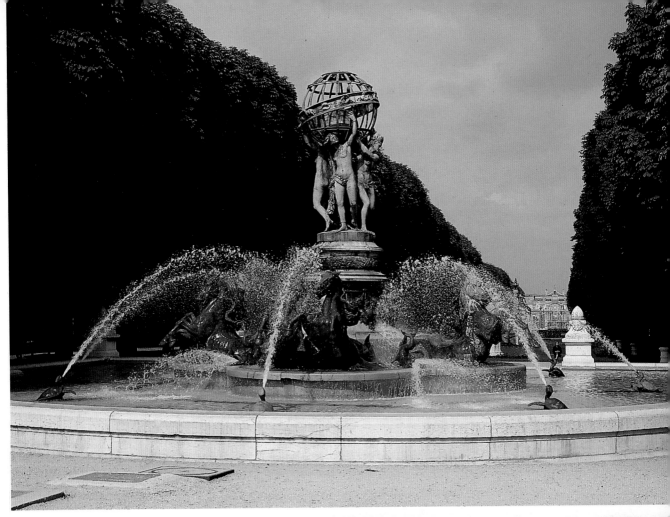

The Observatory Fountain, by Davioud, and the Medici Fountain, attributed to Salomon de Brosse. Kiosks, fountains, statues of the queens of France and of illustrious women are scattered throughout the woods in the large public park of Luxembourg.

MEDICI FOUNTAIN

At the end of a canal on the eastern side of the Palais du Luxembourg, in a lush green setting, is the splendid Medici Fountain, attributed to Salomon de Brosse. In the central niche, Polyphemus is depicted as he surprises Galatea with the shepherd Acis, a work done by Ottin in 1863, while on the back is a bas-relief by Valois dating from 1806 and depicting Leda and the Swan.

OBSERVATORY FOUNTAIN

If one leaves the Jardin du Luxembourg going in the direction of the Observatory, one passes along the magnificent tree-lined Avenue de l'Observatoire. Here, in its green setting, is the celebrated fountain, also known as the "Fountain of the Four Corners of the Earth". A work done by Davioud in 1875, it has the famous group of girls who symbolise the four corners of the earth, unusually beautiful and graceful figures sculpted by Carpeaux.

147

Latin Quarter

The Church of Saint-Séverin
◆◆ 149

The singular English bookshop, Shakespeare & Co., open till late, could have been located only in the quarter which lives in the shade of the Sorbonne. From the middle ages this was where the students lived, and at that time they spoke Latin, which is where the name of Latin Quarter comes from, and now it inevitably calls to mind intellectuals, artists and the "vie de bohème" with its eternal charm

The Saint-Michel Fountain was made by Gabriel Davioud in 1860, who turned for inspiration to the Trevi Fountain in Rome and the Medici Fountain by Salomon de Brosse, in the Luxembourg Gardens. The bronze figure of Saint Michael killing the dragon is by F.J. Duret. The fountain, with its water plays, the abundant decoration and the polychrome materials used, is emblematic of the taste of the Second Empire and was part of Haussmann's program of transformation and enrichment of the city

Hôtel de Cluny
◆◆ 150

The Church of the Sorbonne
◆◆ 150

The Panthéon
◆◆ 151

Saint-Etienne-du-Mont
◆◆ 153

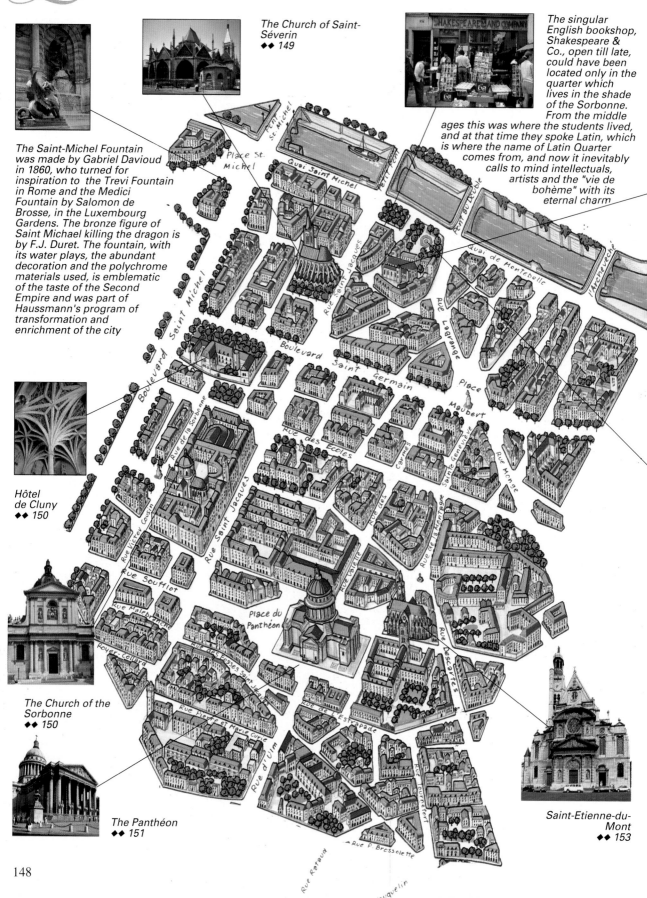

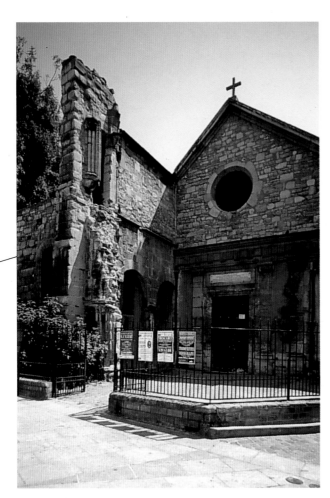

SAINT-JULIEN-LE-PAUVRE

Although small, this church is highly picturesque. It is one of the oldest churches in Paris, and was constructed in the same period as Notre-Dame (between about 1165 to 1220). The structure of the church was considerably modified in the 17th century, when two bays of the nave and the facade were demolished. Inside two fine capitals with acanthus leaves and harpies are to be seen.

SAINT-SEVERIN

Construction of the church in its present forms began in the first half of the 13th century and continued up to the end of the 16th century. The west door, dating from the 13th century, comes from the church of Saint-Pierre-aux-Boeufs, demolished in 1839. The windows and rose-window above are in Flamboyant Gothic style of the 15th century while the bell tower standing on the left dates to the 13th century. The interior has no transept but has a small choir, with a splendid double ambulatory, erected between 1489 and 1494, with the multiple rib tracery radiating out from the top of the columns.

The ancient church of Saint-Julien-le-Pauvre and a view of the apse of Saint-Séverin, in the midst of the narrow alleys of the medieval quarter.

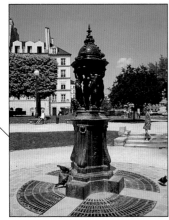

The charming cast iron fountain in Square René Viviani is one of the fifty fountains which were installed in the poorest areas of the city thanks to the munificence of the Englishman Richard Wallace. They are part of the urban furnishings typical of the 19th century and include various cast iron elements such as the circular grates around the bases of the trees, the benches in the boulevards, various types of street lamps and the "Morris columns", circular aedicules with bulb shaped dome, on which the theater billboards and advertisements were affixed

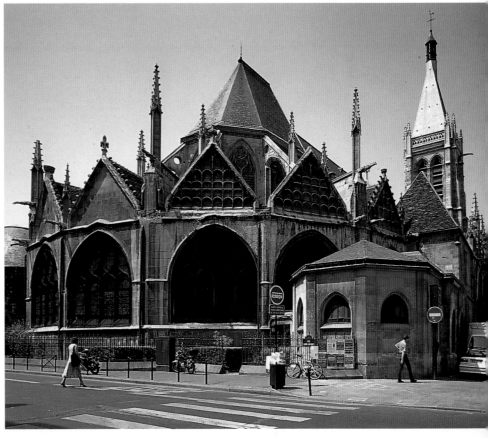

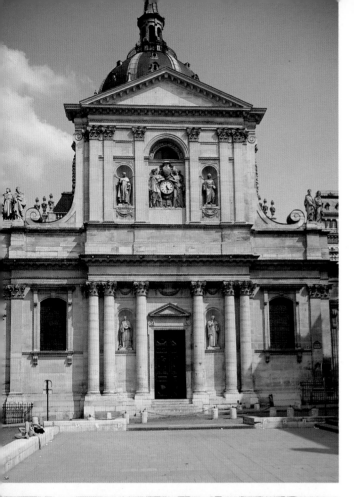

CHURCH OF THE SORBONNE

The church of the Sorbonne is one of the oldest of the university buildings: constructed between 1635 and 1642 by Lemercier, its facade is typically Baroque, with two orders below an elegant cupola. The motif of the volutes which link the lower order to the upper is Italian in origin; a pictorial note is introduced by the passage from the columns in the lower part to the flatter pilaster strips in the upper part, which creates a gradual increase in luminosity. Inside the church, in the transept, is the white marble tomb of Cardinal Richelieu, sculpted by Girardon in 1694 to a design by Le Brun.

HÔTEL DE CLUNY

Standing next to the ruins of the Roman baths (dating from between the 2nd and the beginning of the 3rd century), this building with its green lawns and gardens is one of the finest examples of so-called International Gothic architecture in Paris. On this land, owned by the monastery of Cluny in Burgundy, the abbot Jacques d'Amboise between 1485 and 1498 had a building constructed as a residence for the Benedictine monks who came from Cluny to visit the capital. During the Revolution, the building was declared by decree to be public property and sold. In 1833 it became the residence of the collector Alexandre du Sommerand and on his death in 1842, his home and his collections were acquired by the State. Two years later, the museum here was inaugurated, containing objects illustrating life in medieval France, ranging from costumes to goldsmiths' wares, from majolica to arms and from statues to tapestries. One enters the museum by a door which opens directly onto the courtyard. From this point, one can fully appreciate the elegance and sobriety of the building: two orders of cross windows and a tower with stairs adorned with the emblems of St. James. The International Gothic style is expressed here in the balustrade crowning the roof and in the dormer-windows, by now a classical motif.

In the twenty-four rooms of the museum are the collections which belonged to Alexandre du Sommerand and which, because of their multiplicity and wealth of material, give a complete panorama of what daily life must have been like in the Middle Ages. One of the most precious collections of the museum is that of the tapestries, woven in the Loire and in Flanders in the 15th and 16th centuries. In Room 11, also called the Rotonda, is the famous tapestry, "La Dame à la Licorne", from the beginning of the 16th century.

The Chapel. On this floor of the museum, the best known and most splendid room is without doubt Room 20, that is the Chapel originally used by the abbots. In the purest of International Gothic styles, it has a single pier at the centre of the room, where the ribbing of the vault meets; along the walls are a series of corbels with niches containing the statues of the Amboise family. The finest works in the Chapel are the celebrated tapestries illustrating the Legend of St. Stephen, destined for the Cathedral of Auxerre and completed in about 1490.

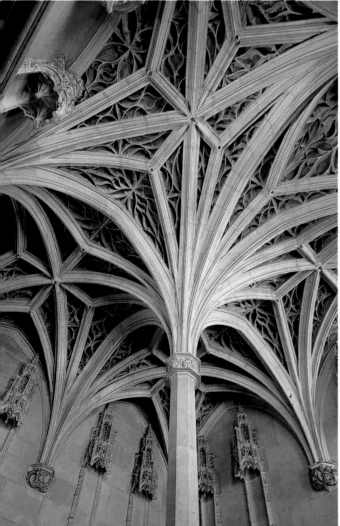

The facade of the Church of the Sorbonne and the vault of the Chapel, with its slender Gothic ribbing.

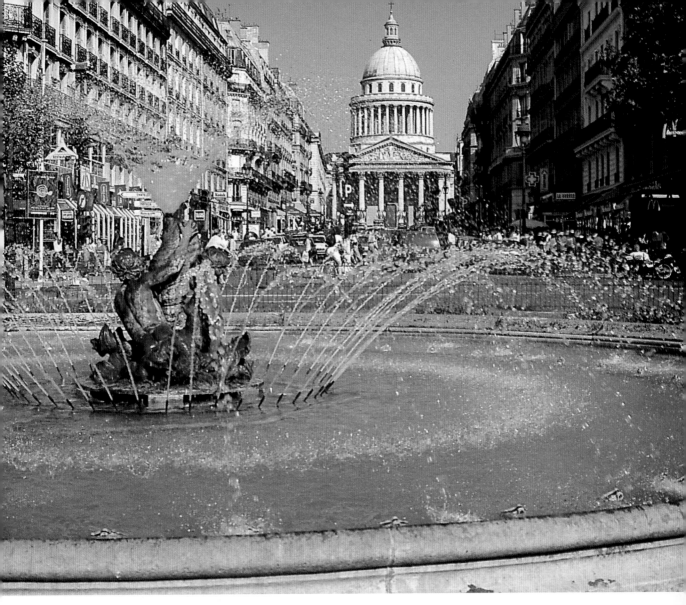

The fountain at the center of Place Rostand with the classic lines of the Panthéon in the background at the end of Rue Soufflot.

PANTHEON

Born as the church of Sainte-Geneviève in fulfilment of a vow made by Louis XV during a serious illness in 1744, it was designed by Soufflot, begun in 1758 and completed with the contribution of Rondelet in 1789. During the Revolution it became the Temple of Glory, used for the burial of great men; under Napoleon it was reopened for worship in 1806, but only until 1885, when it returned once and for all to its status as a secular temple. Soufflot, in designing it, sought a decidedly classical style, returning to the ancient world. Its dimensions, first of all, are exceptional: 110 m. (360 ft.) long by 83 m. (272 ft.) high. A stairway in front of the temple leads up to a pronaos with 22 columns, which support a pediment on which in 1831 David d'Angers sculpted the allegorical work

representing the Fatherland between Liberty and History. Here one can also read the famous inscription: "Aux grandes hommes, la patrie reconnaisante" ("To the great men, from their grateful fatherland"). The whole building is dominated by the great cupola, similar to Christopher Wren's dome on the church of St. Paul in London; here too, the drum is surrounded by a ring of Corinthian columns. The interior is in the form of a Greek cross, with the cupola above the crossing, supported by four piers, on one of which is the tomb of Rousseau. The walls are decorated with paintings, of which the most famous are those by Puvis de Chavannes, illustrating stories of St. Geneviève. The crypt which lies below the temple contains many tombs of illustrious men. Worth recalling are those of

151

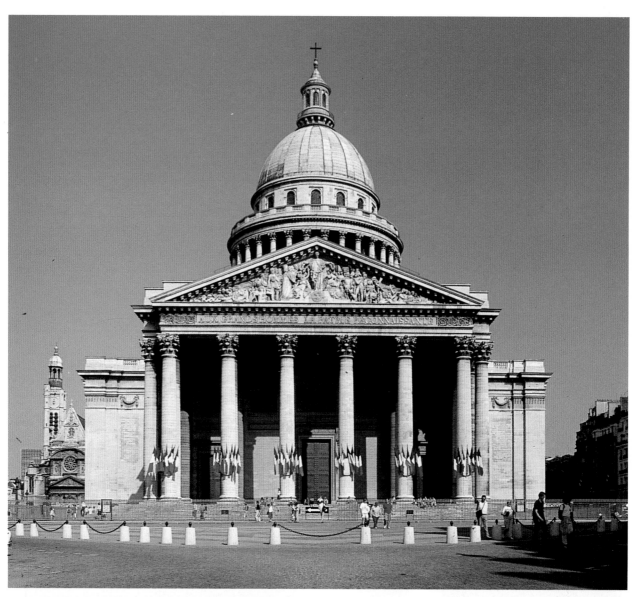

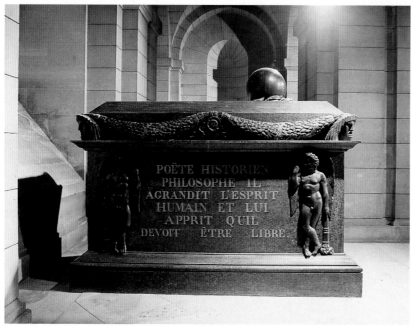

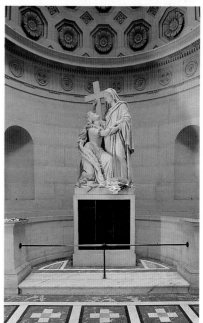

Victor Hugo (brought here in 1885), Emile Zola, Voltaire, the designer Soufflot himself, Carnot and Mirabeau. There are 425 steps leading up to the top of the cupola, from which there is a vast and impressive panorama.

SAINT-ETIENNE-DU-MONT

This church, one of the most remarkable in Paris both for its facade and for the interior, stands in the city's most picturesque zone, the Latin Quarter. From as early as the 13th century the University of Paris was established here, a university which immediately became famous throughout the world of Western culture because of the names of the great masters who gave lessons there: St. Bonaventura and St. Thomas Aquinas, to name only the most important. In this area, then, the original St-Etienne-du-Mont was built; it was begun in 1492 but completed only in 1622 with the construction of the facade. It is impossible not to be struck by the originality of this church. In fact, the facade is a bizarre amalgamation of the Gothic and Renaissance styles, but its three superimposed pediments, because of their very peculiarity, succeed in creating a unified and coherent appearance. The church also contains the reliquary of the patron saint of Paris, St. Geneviève, who in 451 saved the city from the threat of the Huns.

Interior. If the facade of the church is surprising because of its composite appearance, the interior is equally so because of the architectural innovations it contains. In Gothic style with three aisles and transept, the interior has very high cylindrical piers which support the vaults and are linked together by a gallery above the arches. But the most picturesque part of the interior of the church, which makes St. Etienne unique of its kind in Paris, is the "jubé", that is, the suspended gallery which separates the nave from the choir. Possibly designed by Philibert Delorme, it is the only "jubé" known in Paris and its construction dates from between 1521 and about 1545. The splendid fretwork of Renaissance inspiration with which it is decorated continues into the spiral staircases at the sides, thus creating an uninterrupted rhythmic effect. In the ambulatory next to the pillars of the Lady Chapel, are buried two great figures of 17th-century French literature: Pascal and Racine. The windows in the ambulatory and choir have splendid stained glass from the 16th and 17th centuries.

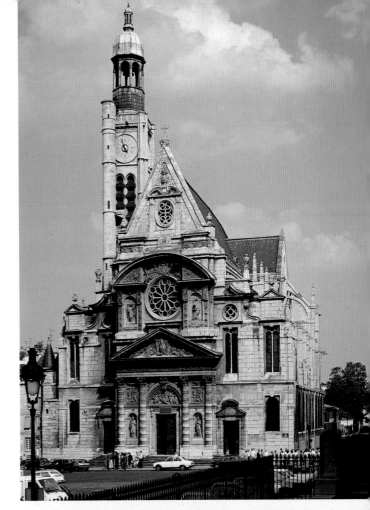

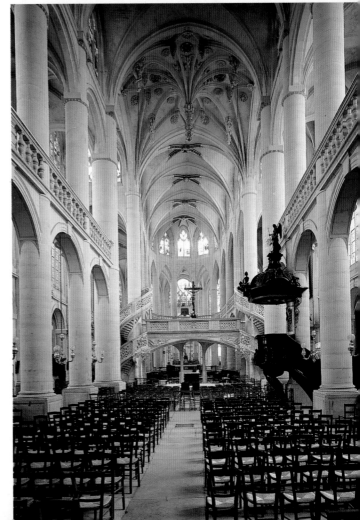

The facade of the Panthéon, like a classic temple, with the majestic dome and drum encircled by columns, and two of the tombs which contain the mortal remains of famous men.

The facade and the interior of the unique church of Saint-Etienne-du-Mont.

Le Marais

Musée Carnavalet - Place
des Vosges - Hôtel de Sully -
Musée Picasso -
National Archives

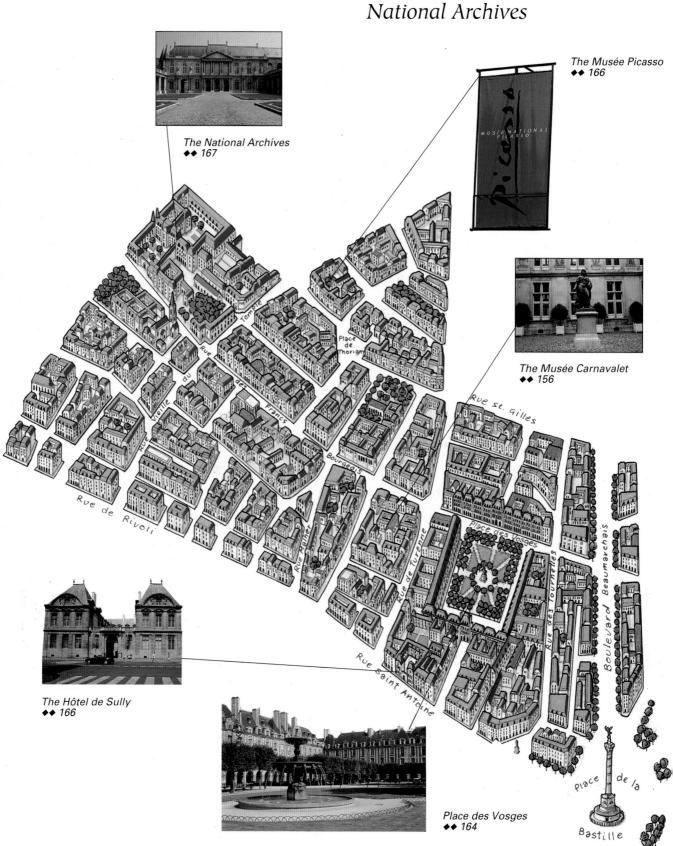

The National Archives
◆◆ 167

The Musée Picasso
◆◆ 166

The Musée Carnavalet
◆◆ 156

The Hôtel de Sully
◆◆ 166

Place des Vosges
◆◆ 164

A few pictures of the quarter of Le Marais. The name derives from the fact that in the past frequent flooding by the Seine turned the whole area into a "marais" or swamp.

LE MARAIS

This old aristocratic quarter, which became an elegant fashionable center at the beginning of the seventeenth century, began to decline when high society began to prefer other zones of the city. Today the district, on the whole inhabited by the common people, is once again becoming popular thanks to the fact that the characteristic type of French hôtel, a classic building with a court and garden, still existed here.

155

MUSEE CARNAVALET

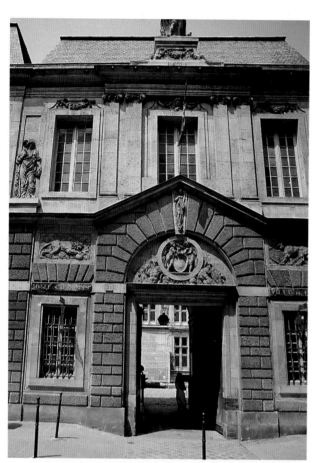

The museum is housed in two buildings joined by a corridor: the Hôtel Carnavalet, one of the finest in the city, was built in 1544 in Renaissance style and embellished with its lovely sculptural decoration by Jean Goujon; it was renovated in 1655 by François Mansart who added another story, making it what it is now. In 1677, the building was rented by the writer Marie de Rabutin, better known as the Marquise de Sévigné and in the 19th century the Museum was opened, containing historical documents of great importance and rarity related to the history of Paris, seen through its historical figures, monuments and costumes, from Henry IV to our time.

The entrance to the Musée Carnavalet, an elegant wrought iron gateway, the court and a view of the large trompe l'oeil frescoes painted in 1748 by Paolo Antonio Brunetti for the stairwell of the Hôtel de Luynes.

The Hôtel Carnavalet around the middle of the 18th century in a painting in the museum, an interior view of the building and a herm flanking the entrance to one of the museum rooms.

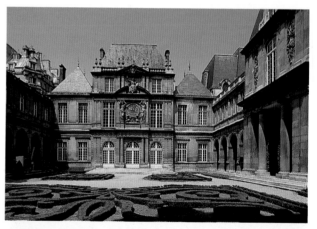

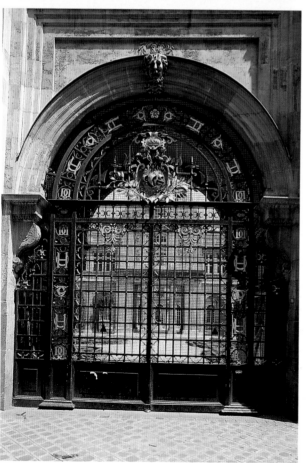

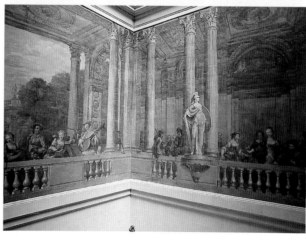

156

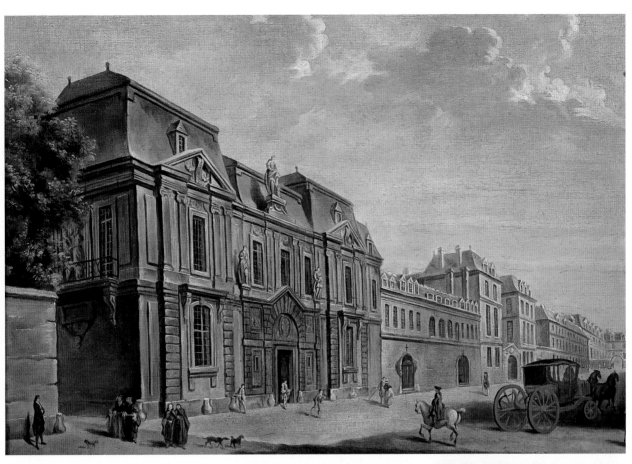

Boats of Fish-venders and Washerwomen on the Seine, in a painting by an unknown artist of the 17th century.

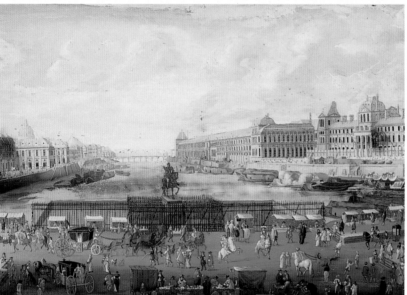

The Pont-Neuf, the Palace of the Louvre, and the College of the Four Nations, in a painting on glass by an anonymous painter of the French school of the 17th century. At the center of the bridge is the statue of Henry IV by Giambologna, torn down in 1792 and later replaced by the monument there now. With its comings and goings of people on foot and on horseback, coaches and litters passing between the stalls on the bridge, this painting provides us with a small but telling cross section of life in Paris at the time.

The City of Paris in a print by Schonk, about 1685.
The two bell towers of Notre-Dame are clearly visible among the other towers rising up above the buildings of the city.

The Fair of Saint-Germain during the Fire of 1762, by Pierre Antoine Demachy (1723-1807).

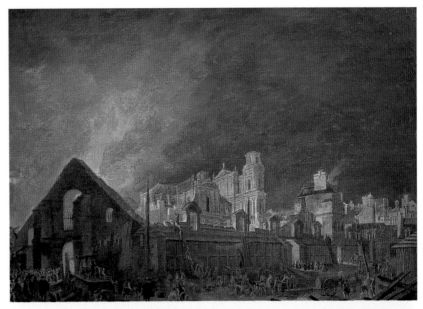

Destruction of the Emblems of the Monarchy on August 10, 1793, by Pierre Antoine Demachy (1723-1807).

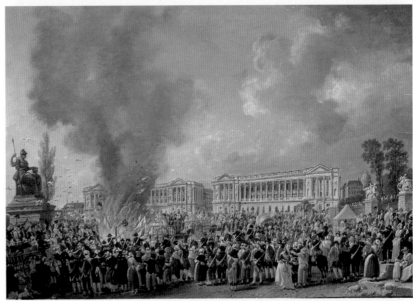

Fête of Brotherhood at the Arch of Triumph of the Etoile, April 20, 1848, in a painting by Jean-Jacques Champin (1796-1860).

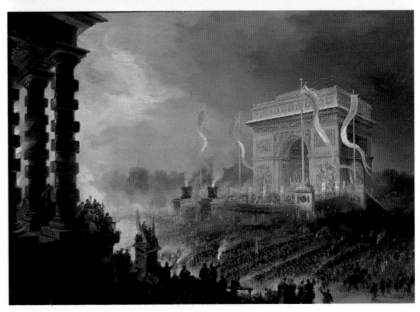

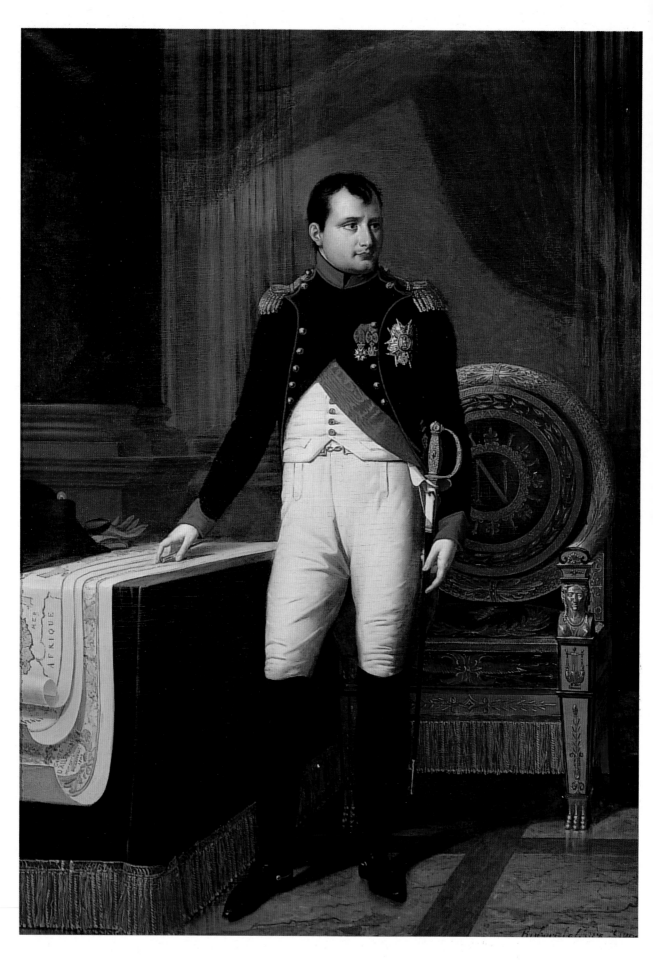

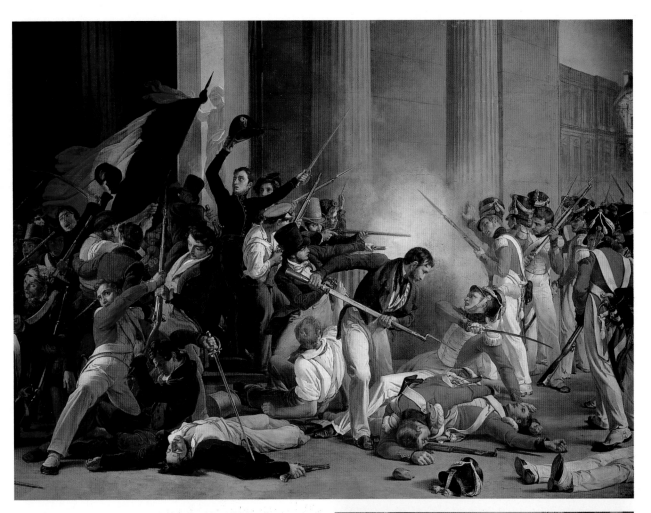

The Taking of the Louvre on July 29, 1830, oil on canvas by Jean-Louis Bézard (1799-1860). The painting illustrates one of the key moments in the July revolution which brought Charles X's reign to an end: the Swiss soldiers, entrusted with defending the palace, are overcome by the insurgents at the entrance to the Cour Carrée.

Portrait of Napoleon I, oil on canvas by Robert Lefèvre (1755-1830) painted in 1809.

Napoleon III Consigns the Decree of the Annexation of the Suburban Communes to Paris in 1859 to Baron Haussmann, oil on canvas by Adolphe Yvon (1817-1893). Baron Haussmann was the man behind the great town-planning program which turned Paris into a modern capital.

The Arrival of Queen Victoria and Prince Albert at the Gare de l'Est on August 18, 1885, by an unknown 19th-century painter.
Fête by Night at the Tuileries on June 10, 1867 during the Second Empire, by Testar van Elven.
The Soirée, painted around 1880 by Jean Béraud (1849-1935).

The Races at Longchamp, painted in 1866 by Jean Béraud (1849-1935), and by the same artist, **Backstage at the Opéra,** 1889. The Musée Carnavalet has about thirty paintings by Béraud who has left us a portrait of Paris of the Belle Epoque.

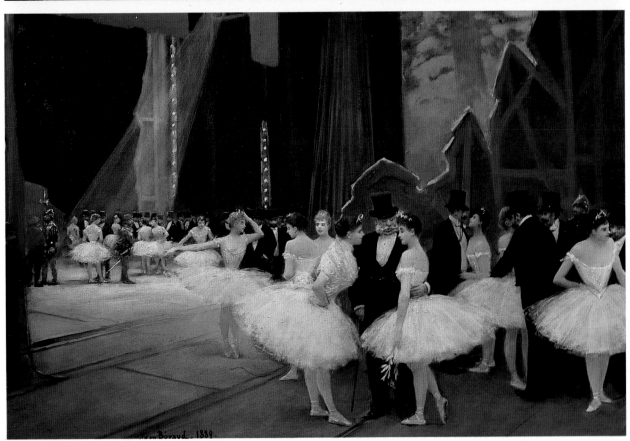

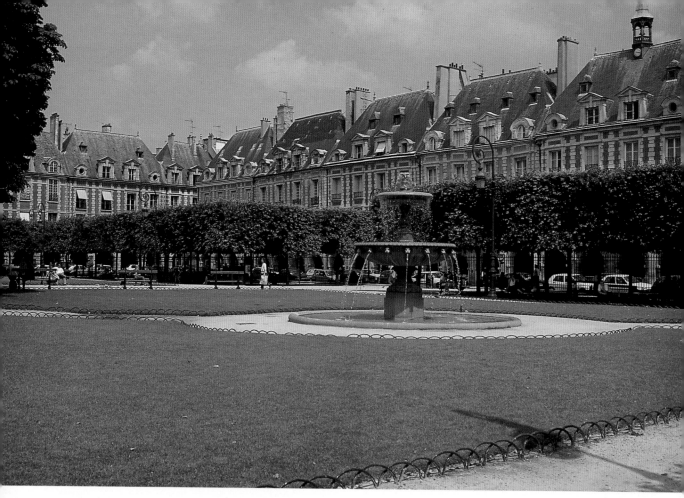

Place des Vosges, frequently considered one of the loveliest squares in the world, is located in the heart of Le Marais. It was originally called Place Royale, but in 1800 Napoleon gave it its present name. The luxurious Pavillon du Roi reserved for Henry IV is at the center of the south side, while opposite is the pavilion reserved for the queen.

The porticoes, a fountain, the equestrian statue of Louis XIII and one of the entrances to the 17th-century square. At number 6, where he lived for about fifteen years, is the Musée Victor Hugo which contains numerous relics, mementos and tokens of the great French poet and writer.

PLACE DES VOSGES

Looking at it from above, from one of the typical dormer-windows above the slate roofs, the square has the appearance of an enormous church cloister: perfectly square, 118 yards long on each side, it is completely closed in by thirty-six picturesque old buildings, with porticoes on the ground floor, surmounted by two orders of windows. In the square itself are green trees and flower gardens, while in the centre is a marble statue of Louis XIII on horseback, a copy of the original by P. Biard destroyed during the Revolution. The square occupies the site of the Hôtel des Tournelles, where Henry II died in a tournament in 1559. The square was designed by Henry IV in 1607 and completed in 1612. Because of its perfect form, because of the succession of porticoes which must have lent themselves to tranquil promenades and because of the gentle contrast between the green of the gardens and the severity of the surrounding buildings (buildings in which the pure white of the stone alternates with the warm red of the bricks), the square became another centre of fashionable life in the Paris which had not yet experienced the horror and violence of the Revolution. In the centre of the southern side is the Pavilion of the King, the most splendid of the buildings, reserved for Henry IV, while in front of it is the building occupied by the Queen. At number 6 is the Victor Hugo Museum, occupying the house where the great writer lived from 1832 until 1848. In it are souvenirs and objects recalling the most important moments in his life, as well as about 350 drawings which bear witness to his great and versatile genius.

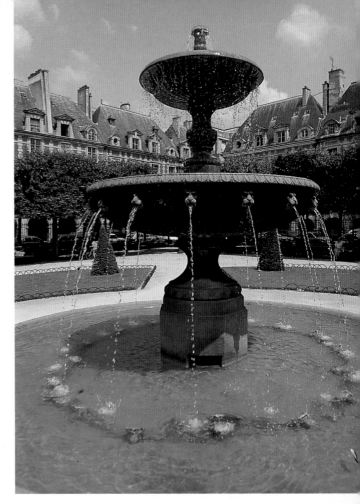

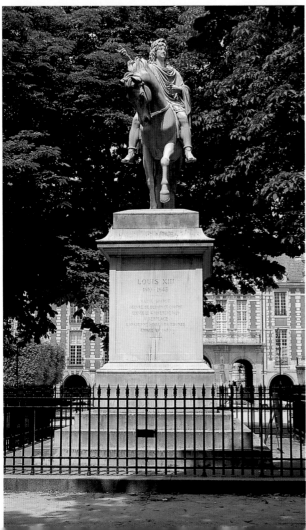

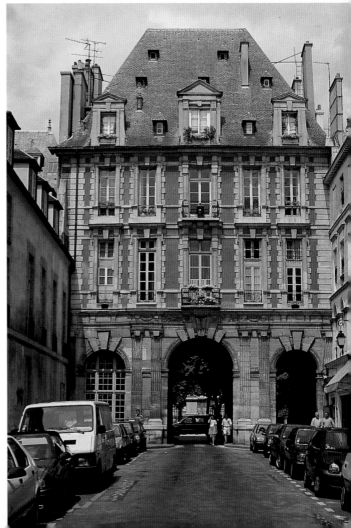

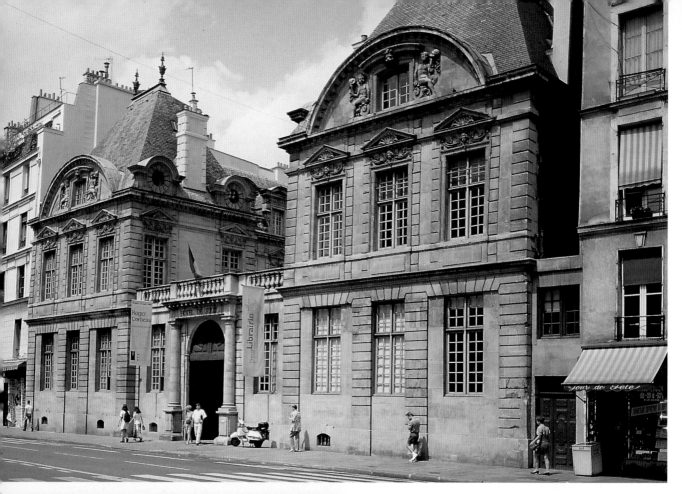

The fine facade of the Hôtel de Sully and the entrance to the Musée Picasso housed in the Hôtel Salé.

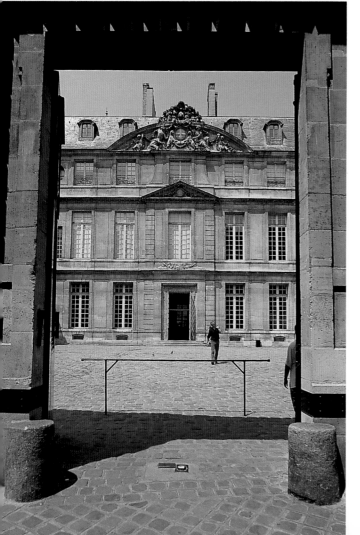

HÔTEL DE SULLY

Built in 1624 by Du Cerceau, it was bought in 1634 by Sully, former minister of Henry IV. Part of it today is the seat of the Department of Historical Monuments. The inner courtyard is one of the finest examples of the Louis XIII style: the pediments are decorated and the dormer windows carved and enriched by a series of statues.

MUSEE PICASSO

The museum is located in the Hôtel Salé, built in 1656 by J. Boullier for Aubert de Fontenay, a tax collector (hence the building's nickname). Here "Picasso's Picassos" are exhibited, sculptures and paintings from which the great Spanish artist, who died in 1973, never consented to part with: there are over 200 paintings, 158 sculptures, 88 ceramics, over three thousand prints and sketches and an incredible number of letters, objects, photographs and manuscripts. The many works on exhibit include his *Self-portrait in Blue*, 1901, the *Three Women under a Tree*, painted between 1907 and 1908, the *Great Nude in the Red Armchair*, the *Crucifixion*, 1930, and the *Composition with Butterfly*, 1932, until recently thought to have disappeared.

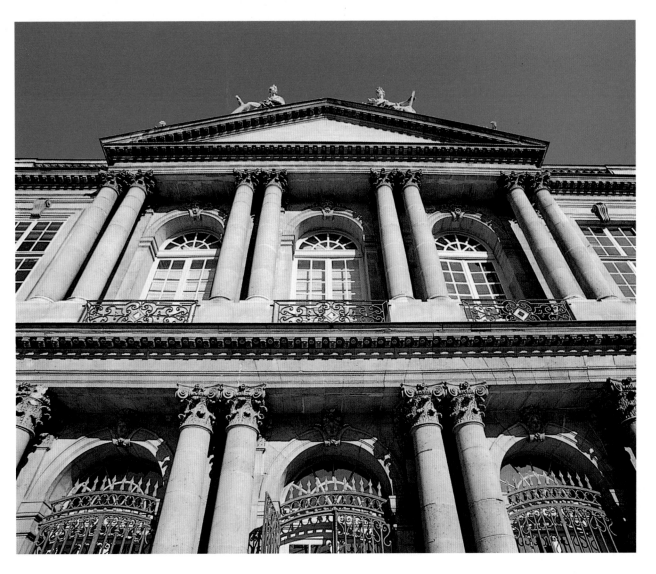

The central portion of the facade of the Hôtel de Soubise.

THE NATIONAL ARCHIVES

The National Archives were created in 1808 by Napoleon and occupy a spacious city block including six buildings; the most outstanding of these are the Hôtel de Soubise and the Hôtel de Rohan, which share the same garden. The wealth of documents regards the history of France from Merovingian times to the 19th century.

The **Hôtel de Soubise** stands on the site of the 14th-century Hôtel Clisson of which the fine ogival portal flanked by two projecting towers is still extant. Built in the early eighteenth century by the architect Delamair, it overlooks a majestic horseshoe-shaped court of honor; the facade, articulated on the ground floor and in the central section by coupled columns as are the wings of the court, is decorated with copies of allegorical statues of the Four Seasons by Robert Le Lorrain.

The first floor, decorated in the purest Louis XV style and considered a real masterpiece of rococo architecture, contrasts surprisingly with the calm beauty of the classical layout of the building. The apartments of the princes de Soubise are to be found here. Now seat of the **Musée de l'Histoire de France**, it contains the most important Archive documents, including one of Joan of Arc's letters, the Nantes edict and Napoleon's will. Of particular interest are the Chamber of the princess de Soubise and the oval Salon with their splendid frescoes and original decorations.

The **Hôtel de Rohan**, built by Delamair for one of the four children of the prince de Soubise, has a classic facade with columns and pilasters; in the court, above the door of the old stables, is a bas-relief of the Horses of the Sun, considered one of Robert Le Lorrain's masterpieces.

Bastille

Hôtel de Sens - Saint-Paul-Saint-Louis

One of the platforms in the Bastille station of the Métro: the painted tile composition on the wall shows, among other things, the invention of the Montgolfier brothers and the allegory of Liberty with the tricolor cockade on the Phrygian cap

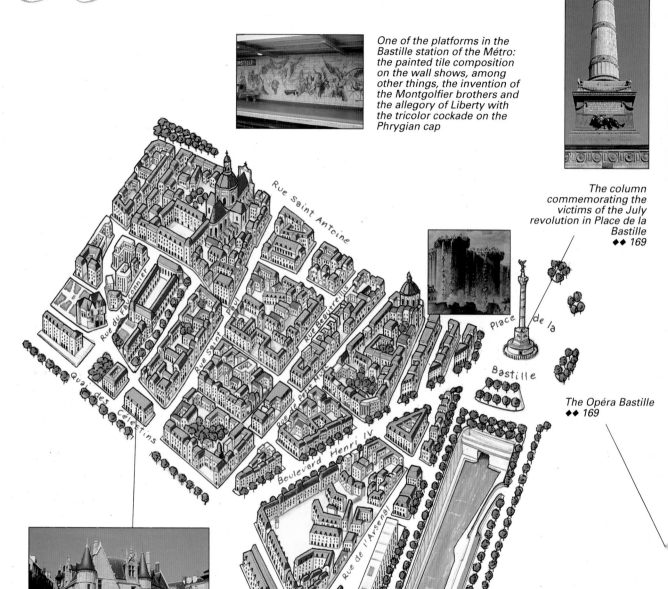

The column commemorating the victims of the July revolution in Place de la Bastille
◆◆ 169

The Opéra Bastille
◆◆ 169

The Hôtel de Sens is a splendid example of a large private dwelling in the Middle Ages. It was built between 1475 and 1507 as residence for the archbishops of Sens, from whom the bishopric of Paris depended. In 1605 Margaret of Valois was confined in this dwelling, where she led a life of pleasure, by her former husband, Henry IV. The building, most of which was rebuilt in 1940 and which now houses the Forney Library of Applied Arts, has a fine ogival portal, dormer windows in flamboyant Gothic style, projecting small turrets; a characteristic stair tower is in the courtyard

Construction of the Church of Saint-Paul-Saint-Louis, symbol of Jesuit power during the Counter-reformation, began in 1627. Inspired by the Church of the Gesù in Rome, the tall facade of this Baroque church with its three tiers of columns hides the tall cupola. To be seen inside is Christ in the Garden of Gethsemane by Delacroix

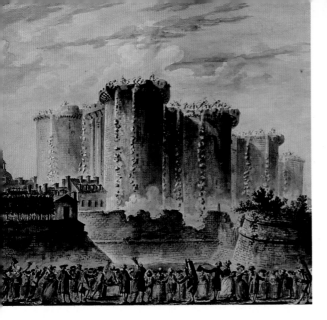

The Demolition of the Bastille in July 1789, in a water-color by Jean-Pierre Houel (1734-1813) in the Musée Carnavalet, the modern building of the Opéra-Bastille, inaugurated on July 14, 1989, on the bicentennial of the taking of the famous prison, and the July Column.

PLACE DE LA BASTILLE

A massive fortress, built in 1370 for Charles V and finished in 1382, stood to the west of the present square. It was used thereafter as the State Prisons: one of its prisoners was the mysterious figure who passed into history as the Iron Mask. This melancholy fortress thus became the first and most important objective of the popular uprising which broke out on July 14, 1789, when several hundred enraged Parisians marched against what was considered the symbol of monarchic absolutism. The day after, the fortress began to be dismantled, a job which was terminated the following year. At the center of the square is the July Column, built between 1831 and 1840 to commemorate the Parisians killed in the days of July 1830. Designed by Carlos Ott, the Opéra Bastille is characterized by the curved glass facade behind which is the main auditorium with a rotating stage.

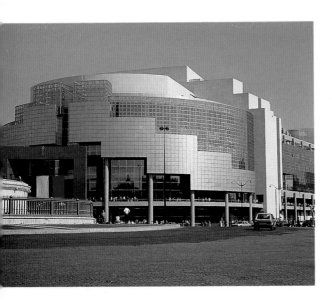

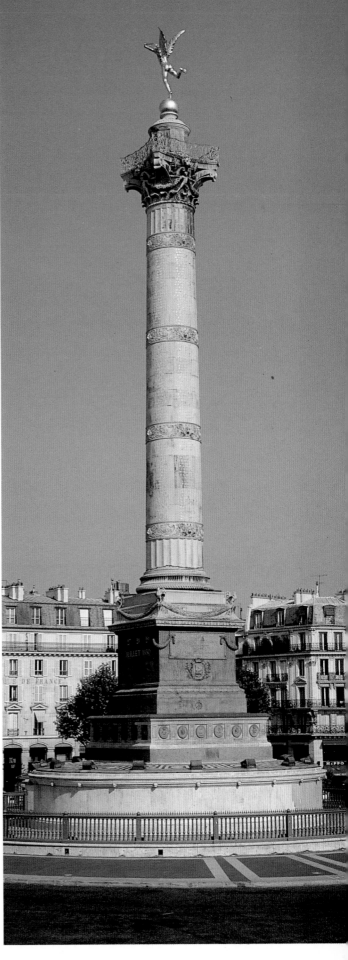

Grands-Boulevards - République
Sacré-Cœur - Montmartre

Villette - Défense - Disneyland® Paris

PLACE DE LA REPUBLIQUE

This vast rectangular plaza was created by Haussmann (1854) as an area for the maneuvers of the troops sent to put down the popular uprisings. At the center stands the monument with the statue of the Republic (1883), set on a pedestal decorated with bronze basreliefs by Dalou which depict events in the history of the Republic.

PLACE DE LA NATION

Originally Place du Trône, after the throne erected here on August 26, 1660, when Louis XIV and Maria Theresa made their entrance into the city. During the Revolution, when the guillotine was installed here, it was called Place du Trône Renversé and took on its present name in 1880. The bronze group of the Triumph of the Republic, by Dalou (1899), is set on the basin in the center of the square.

PORTE SAINT-MARTIN

A triumphal arch 17 meters high was erected by Bullet in 1674 to commemorate the taking of Besançon and the defeat of the Spanish, Dutch and German armies. It has three passageways, and a wealth of basreliefs by Le Hongre, Desjardins, Legros and Marsy.

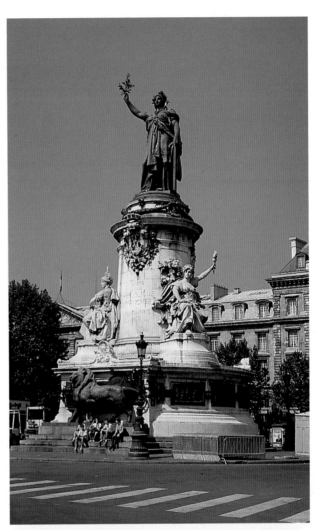

The statue of the Republic in Place de la République, the basin in the center of Place de la Nation and Porte Saint-Martin.

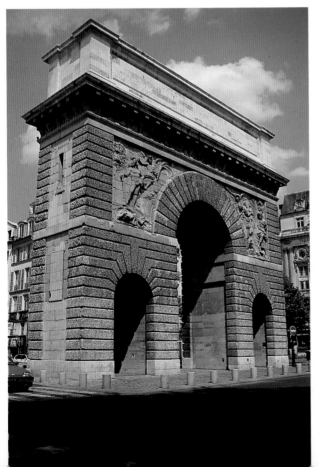

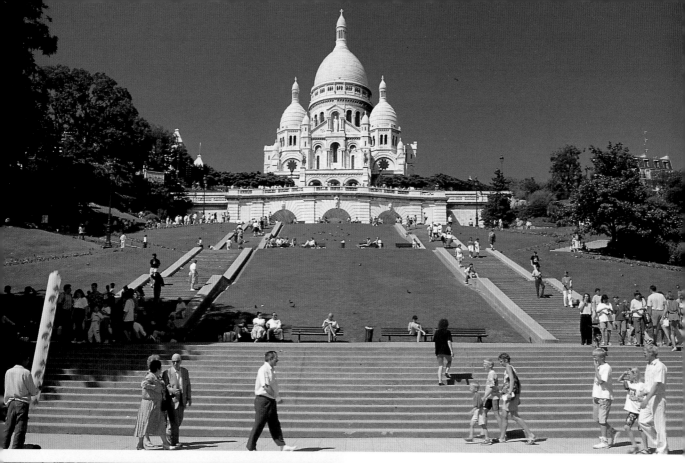

Two views of the Sacré-Coeur, a massive white structure, preceded by great flights of steps, standing at the top of the hill of Montmartre.

One of the two statues in front of the portico of the basilica, depicting Saint Louis, king of France, and Joan of Arc, the lantern of one of the four minor cupolas, and the great mosaic in the choir.

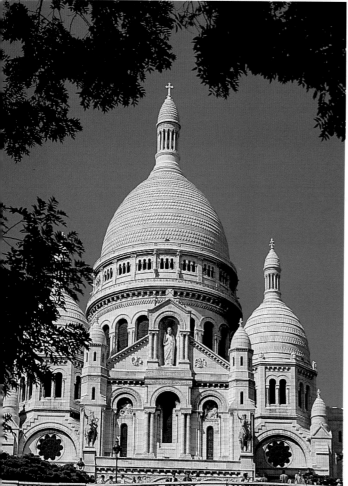

SACRE-COEUR

From whatever part of the city one surveys the panorama of Paris, one's eye finally comes to rest on the white domes of Sacré-Coeur. Standing majestically on the top of the hill of Montmartre, it was erected in 1876 by national subscription and consecrated in 1919. Its architects (among the most important were Abadie and Magno) designed it in a curious style which is a mixture of Romanesque and Byzantine. The four small domes and the large central dome, standing solidly on the high drum, are typically Oriental. On the back part, a square bell-tower 84 m. (275 ft.) high contains the famous "Savoyarde", a bell weighing no less than 19 tons and thus one of the biggest in the world. Dignified steps lead up to the facade of the church and the porch with three arches which stands in front of it; above are equestrian statues of what are per haps the two historical figures best loved by the French, King Louis the Blessed and Joan of Arc. The interior, because of its decorations of reliefs, paintings and mosaics which in places are incredibly elaborate, can almost be said to have lost its architectural consistency. From the inside of the church, one can descend into the vast underground crypt, or else climb up to the top of the cupola, from which there is a panoramic view of the city and its surrounding areas extending for miles. In order to see

the white mass of the church itself from an even better vantage point, one should descend into Place St. Pierre below, either by the convenient cable railway or down the ramps of stairs. One could perhaps object that the style of this church, its very colour and its brazenly monumental dimensions contrast too strongly with the city's other monuments and the patina of grey which they have acquired with the passing of time. But the integration of the church of Sacré-Coeur in the landscape of Paris, which is now accepted by all, may have been possible precisely because of this note of strident contrast, giving a value to the church itself and to the other monuments and throwing each one into relief within a valid historic and artistic context.

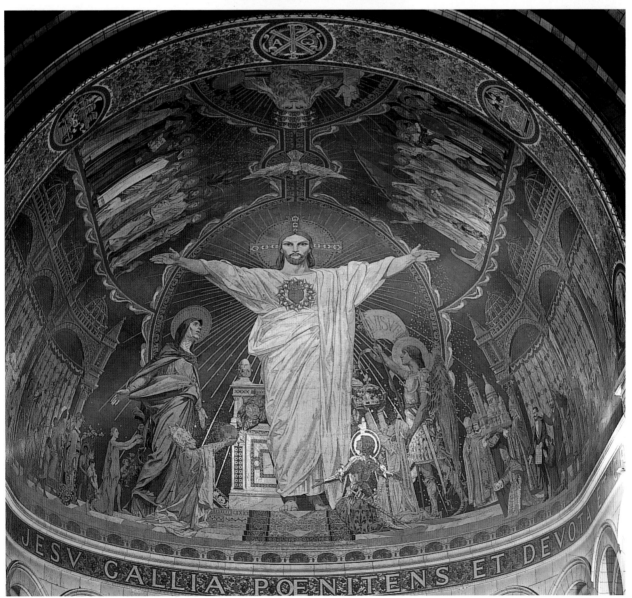

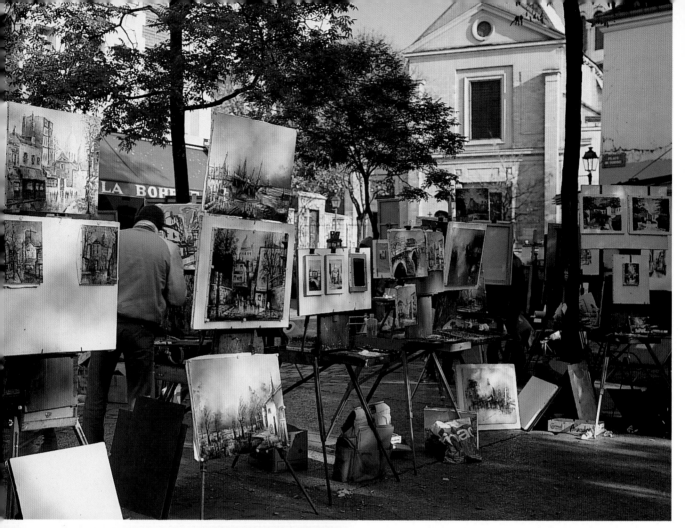

Place du Tertre, rendezvous and "atelier" for artists from all over the world, and the famous Moulin Rouge, the music hall where the can-can first saw the light.

PLACE DU TERTRE

The animation and color which lend life to this old square, once used as a meeting place and now lined with trees, make it the heart of Montmartre. It is frequented by painters and a cosmopolitan crowd and comes alive particularly at night, when its cafés and night clubs fill with people and the small space in the center of the square is taken over by the artists, who work a little for themselves and a great deal for the tourists.

PLACE BLANCHE

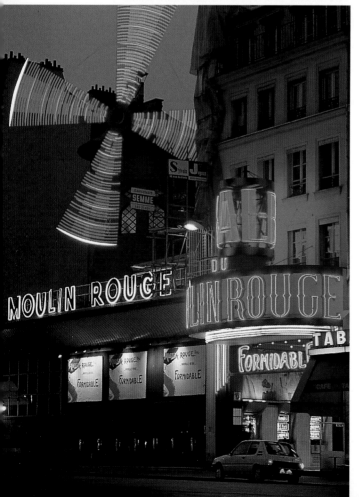

Lying at the foot of the hill of Montmartre, it owes its name, "White Square", to the chalk roads which once existed here. Looking out over the square are the long vanes of the **Moulin Rouge**, the music hall founded in 1889; among the artists who performed on its stage were Jane Avril, Valentin le Désossé, La Goulue, and it was here that the can-can was born, immortalized in Toulouse-Lautrec's paintings.. Not far away is **Place Pigalle**, a bustling scene, particularly at night, when the lights suddenly go on in the many night clubs.

A few pictures of the most famous and picturesque Flea Market in Paris.

MARCHE AUX PUCES

The most famous Flea Market in Paris is near the Porte de Clignancourt. Practically anything can be bought here: from period furniture to used clothing, from antique books to costume jewelery, from pottery to paintings to used records. Even if one has no intention of buying, it is well worth a visit just to enjoy the show.

LA VILLETTE

A market for livestock as far back as 1867, in 1979 the park of La Villette (35 hectares) was predisposed as the site of the largest museum ever dedicated to science and technology. Structures include the **Géode** (a vast hemispherical projection hall), the **Grande Halle** (one of the finest metal buildings of the 19th century), and the **Zénith**, a hall for spectacles.

LA DEFENSE

The Urban development of La Défense, conceived as a huge 130 hectare business area, commenced in 1955 in the area forming the extension of Neuilly bridge. Buildings are erected below a paved esplanade 120 meters long and 250 meters wide, with steps down to the Seine and under which all highways pass.

Of all the modern buildings characterized by pure, geometric shapes (Fiat, Manhattan, Gan, Elf-Aquitaine towers), the number one attraction is the **C.N.I.T. building**, where fairs are held every year. Built in coats of concrete by the architects Zehrfuss, Camelot and Mailly, it has the audacious shape of an overturned shell resting on only three points of support.

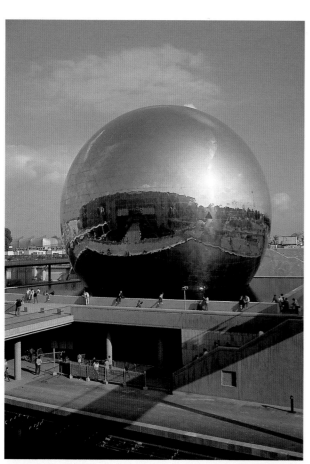

The steel sphere of the Géode which houses a cinema with a 180 degree screen and a few towers in the quarter of La Défense.

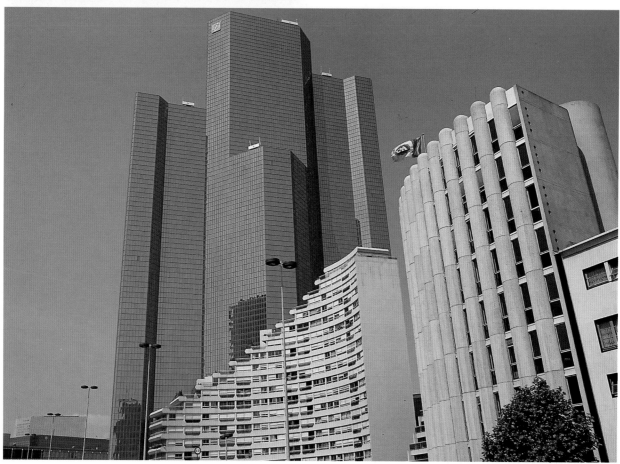

THE GRANDE ARCHE

Designed in 1982 by the Dane Johan Otto von Spreckelsen and inaugurated in July, 1989, the Grande Arche consists of two towers 105 meters high topped by a crosspiece. At the center of the structure faced in Carrara marble and glass hangs a sort of large awning, the so-called "Cloudi". Four elevators carry visitors to the evocative belvedere.

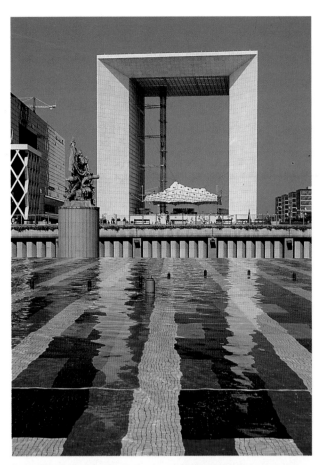

DISNEYLAND® PARIS

Easy to reach by the métro, Disneyland® Paris has become a must for all those, both grown ups and children, who visit the French capital.

With its fantastic sights, Disneyland® Paris takes you into the world of fairy tales as well as in that of adventures in space, lets you sail on a paddle steamer or be "shot" towards the moon from a gigantic cannon, pass from holograph images of ghosts which inhabit the haunted house to the tri-dimensional films in the Cinémagique. Or you can take a walk in the peaceful street of an early twentieth-century American town, take a ride in the cups of the Mad Hatter and cross, travelling at full speed, the ruins of a thousand-year old temple.

The geometric structure of the Grande Arche and two views of Disneyland® Paris.

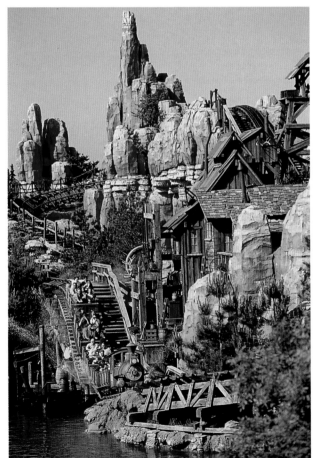

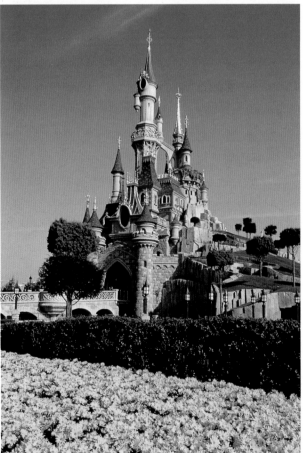

FIRST FLOOR

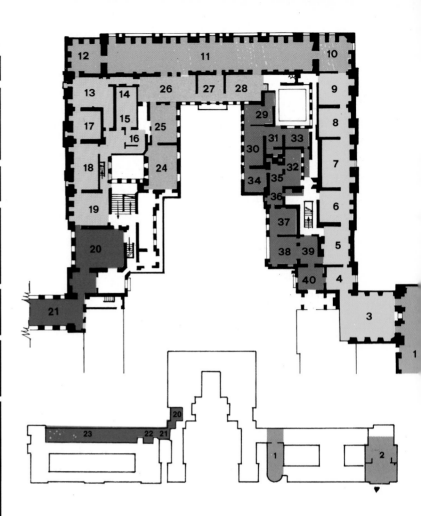

1	THE ROYAL CHAPEL
2	THE OPERA ROYAL

3	SALON D'HERCULE
4	SALON DE L'ABONDANCE
5	SALON DE VÉNUS
6	SALON DE DIANE
7	SALON DE MARS
8	SALON DE MERCURE
9	SALON D'APOLLON

10	SALON DE LA GUERRE
11	THE HALL OF MIRRORS
12	SALON DE LA PAIX

13	THE QUEEN'S BEDCHAMBER
14	LA MÉRIDIENNE
15	BIBLIOTHÈQUE
16	THE QUEEN'S PRIVATE ROOMS
17	SALON DES NOBLES
18	ANTICHAMBRE DE LA REINE
19	THE GUARD ROOM

20	SALLE DU SACRE
21	SALLE DE 1792
22	ESCALIER DES PRINCES
23	THE GALLERY OF THE BATTLES

*
24	THE GUARD ROOM
25	SALON DU GRAND COUVERT
26	SALON DE L'ŒIL-DE-BŒUF
27	THE KING'S CHAMBER
28	THE COUNCIL HALL

*
29	PETITE CHAMBRE DU ROI
30	CABINET DE LA PENDULE
31	CABINET DES CHIENS
32	DEGRÉ DU ROI
33	SALLE À MANGER DES RETOURS DE CHASSE
34	THE KING'S PRIVATE STUDY
35	ARRIÈRE CABINET
36	PIÈCE DE LA VAISSELLE D'OR
37	LOUIS XVI'S LIBRARY
38	THE PORCELAIN ROOM
39	BILLARD
40	THE KING'S GAMING ROOM

GROUND-FLOOR

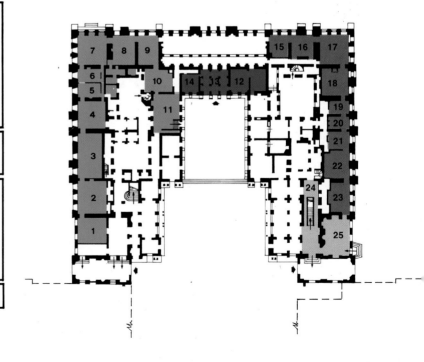

THE DAUPHIN'S APARTMENT
1	1ère ANTICHAMBRE DE LA DAUPHINE
2	2nde ANTICHAMBRE DE LA DAUPHINE
3	GRAND CABINET DE LA DAUPHINE
4	CHAMBRE DE LA DAUPHINE
5	CABINET INTÉRIEUR DE LA DAUPHINE
6	BIBLIOTHÈQUE DU DAUPHIN
7	GRAND CABINET DU DAUPHIN
8	CHAMBRE DU DAUPHIN
9	2nde ANTICHAMBRE DU DAUPHIN
10	1ère ANTICHAMBRE DU DAUPHIN
11	SALLE DES GARDES DU DAUPHIN

MARIE ANTOINETTE'S GROUND FLOOR APARTMENT
12	CHAMBRE DE LA REINE
13	VESTIBULE LOUIS XIII
14	SALLE DE BAIN DE LA REINE

THE ROOMS OF THE DAUGHTERS OF FRANCE
15	1ère ANTICHAMBRE DE MADAME VICTOIRE
16	SALON DES NOBLES DE MADAME VICTOIRE
17	GRAND CABINET DE MADAME VICTOIRE
18	CHAMBRE DE MADAME VICTOIRE
19	CABINET INTÉRIEUR DE MADAME VICTOIRE
20	BIBLIOTHÈQUE DE MADAME VICTOIRE
21	CABINET INTÉRIEUR DE MADAME ADELAÏDE
22	CHAMBRE DE MADAME ADELAÏDE
23	GRAND CABINET DE MADAME ADELAÏDE

24	THE STAIRCASE LOUIS PHILIPPE
25	THE ROOM HOQUETONS

* *Guided visit*

178

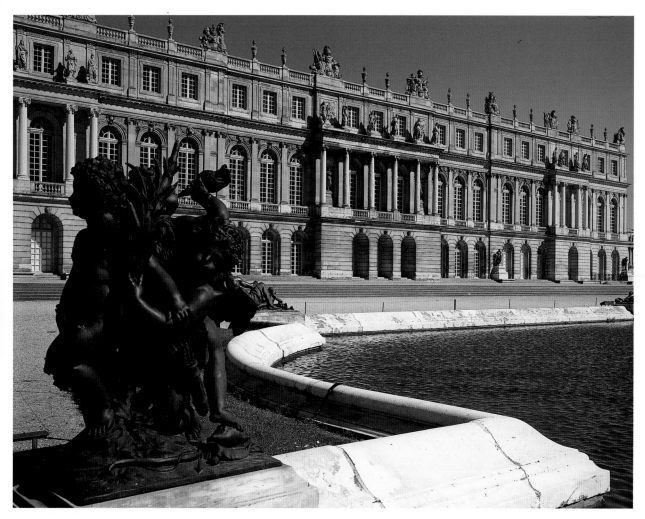

The central part of the front elevation of the palace overlooks the water parterre with pools decorated with bronze statues of putti and nymphs.

Versailles

Versailles. A name which evokes visions of a glittering court. Henry IV, who went hunting in these lands, and his son, Louis XIII, who had a hunting lodge built here, could never have imagined that this was the beginning of one of the most famous monuments in France.

A great hunter like all the Bourbons, Louis XIII gradually bought up the lands around the pavilion and then in 1631 he took over the entire estate of the Gondi family which had come from Florence with the retinue of Catherine de' Medici.

Later the king had the original building restructured into a small château in stone and brick surrounded by a moat.

The palace we now see developed around this nucleus. Louis XIII died in 1643 and for almost twenty years no thought was given to new buildings or remodeling Young Louis XIV occasionally went hunting here and brought along his mistress, Louise de la Vallière, with a small entourage of friends. Finally in

1661 construction work that was to continue for a good part of his long reign was begun. The internal transformations were followed by a general restructuration in 1666.

The minister Colbert had for some time been preparing the downfall of the superintendent of finance Fouquet, whose arrest after the extraordinary fête of Vaux, on August 17, 1661, was not at all a direct result of the envy of a king who had been humbled by such a show of luxury and ostentation. The greatest names of the time had been called in to make this mansion all the more resplendent: Le Vau, Le Brun, Le Nôtre, Molière, La Fontaine, Scarron... all artists who were thereafter also to be found in Versailles.

Some reprove Louis XIV for his megalomania and unlimited pride. We rather believe though that the young king had a political as well as economic end in mind as the idea of the château of Versailles shaped up.

He never forgot la Fronde who made him sleep on

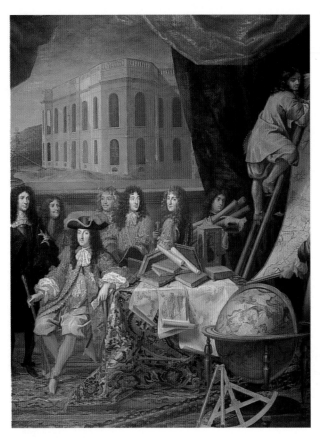

The Institution of the Academy of Sciences and the Founding of the Observatory in 1666-1667. *Detail of a painting by Henry Testelin (1616-1690).*

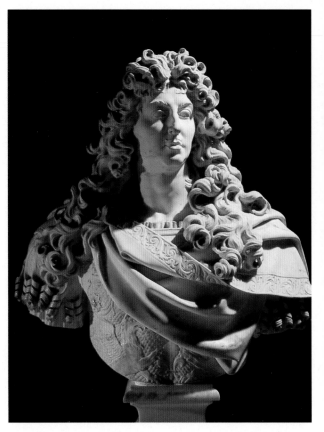

Louis XIV, *bust by Antoine Coysevox. In this youthful bust, the purity of the features is framed by the rich wig with flowing curls falling on the sovereign's shoulders.*

the straw in the cold and empty castle of Saint-Germain. He never forgot this final act of rebellion of the large landholders and he decided to keep these disturbing elements at bay. What he needed so as to attract and "keep watch" over them, was a fine château.

On the other hand he loved this land of Versailles. He was young and he took his métier de Roi seriously and considered his country the most beautiful of all.

The first thing to do in giving concrete form to this idea of greatness was to forego foreign commissions which did nothing but bleed the French treasury white. From Francis I to Mazarin, France had imported art works and artists, above all from Italy. Preference was now given to works of French origin and its diffusion was so widespread that for a long time France was synonymous with good taste.

All of France worked for Versailles. At the king's behest various Académies were created to stimulate a real true rebirth of French art. For example, the mirrors in the Grand Gallery were produced by the Royal Mirror Factory, founded by Colbert in 1665 and then installed in the factory of Saint-Gobain. In 1667 a royal edict for the reorganization of the Gobelins was promulgated and Louis XIV organized exhibitions of the products in the Appartement. The marble quarries of Saint-Béat in the Pyrrhenees, abandoned in Roman times, were reopened and are still producing. Louis XV on the other hand exhibited the production of the porcelain factories of Vincennes and Sèvres in his private rooms, personally promoting the sales. By making large orders for the queen he also relaunched the activity of the Lyon silk weaving establishments which were in difficulty.

But let's go back to the beginning. The number of workers employed at the château was considerable. In 1683 there were 30,000. Dangeau in his Diary, dated May 31,1685, mentions 36,000. But there were never enough and the king was forced to entrust some of the excavation and earth removal, including the Orangerie and the pool, to his troops.

Throughout Louis XIV's reign the construction yards multiplied and the king as well as his reluctant courtiers learned to live with dust and noise. Le Nôtre set to work. The king wanted a fine park - and in 1664 it was ready for the fête of the Plaisirs de l''île enchantée in honor of Mademoiselle de la Vallière. Le Vau enveloped Louis XVI's brick château and created two projecting bodies overlooking the garden and inserted an "Italian" terrace which was later to be the site of the Hall of Mirrors. Le Vau died

Louis XV, *by Pierre-Adrien Gois (1731-1823). "The most handsome man in France" poses.*

Louis XVI, *by Jean-Antoine Houdon (1741-1828). The principal features of the king's character are evident in this bust: goodheartedness, but also indolence, indecision and a certain bitterness. Qualities and defects of a simple man which offered the Revolution a pretext.*

in 1670 and work was continued by his pupil, François Dorbay. He in turn was succeeded in 1678 by Hardouin-Mansart who had become first architect to the king. Le Brun was charged with the interior decoration. Colbert, ever ready to have his say, protested but then laid out the money. The South Wing (1678-1682) and the North Wing (1685-1689) were built. Work began on the Salon de l'Opera only in 1768-1769.

The greatest obstacle to overcome was the supply of water for the fountains with their 1,400 jets which use 62, 000 hectoliters of water per hour. Water from the river Bièvre was brought in by an aqueduct but soon proved insufficient. Water from various ponds was then used and reservoirs were built. The water engineers invented a thousand contraptions and finally Marly's machine was created. Not even this was enough and the king had new projects which would use the waters of the Seine undertaken. This project was shelved and its place was taken by another one in which the waters of the Eure were to be used. But the enormous amount of work involved proved too much and the undertaking came to a halt. At the end of his reign Louis XIV could well be satisfied with what he had done: he had offered France the most beautiful palace in the world. His succes-

sors made no great changes, aside from the considerable remodelling done inside.

The Revolution was at the gates. On October 5, 1789, the people of Paris marched on Versailles, invaded the palace and took the royal family back to the capital. In 1793 after the fall of the monarchy the furnishings of the palace were sold at auction and the works of art were transferred to the Louvre.

Napoleon never liked Versailles. The palace gradually fell into ruin. The father of the painter Delacroix was of the opinion that it should be demolished and plowed under. Then Louis Philippe ordered it to be restored, paying in part out of his own pocket, and turning it over to the country as a historical museum. During the war of 1870 it was occupied by the Germans, after which it became the seat of the National Assembly until 1879.

After World War I the contributions of a wealthy American patron rescued the palace.

Since then the curators have in turn done all they could to restore part of its past to Versailles.

Versailles also represents the history of the French people. Every structure, every ornament, piece of furniture or tapestry tells us about the men who gave their all in building this palace dedicated "A toutes les Gloires de la France".

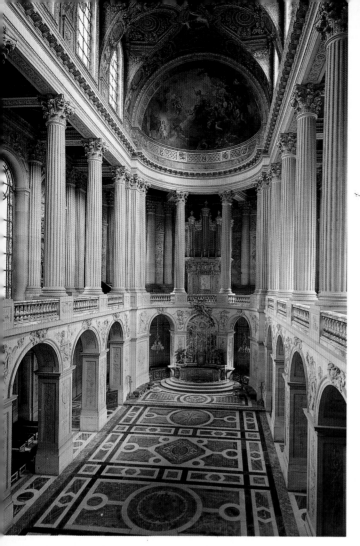

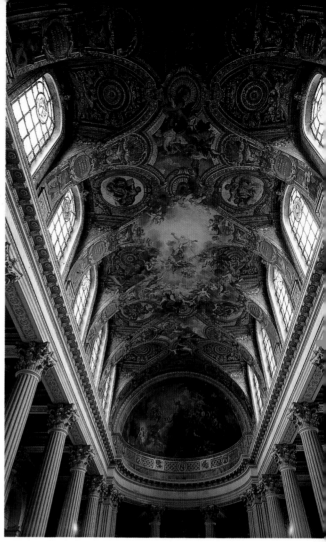

The Royal Chapel with the Corinthian columns which run along the first floor gallery.

The vault of the Chapel frescoed by Coypel.

THE ROYAL CHAPEL

From the Royal Court we enter the palace on the right and find ourselves in an ample vestibule decorated with Ionic columns. In front of us is the bas-relief by Nicolas and Guillaume Coustou representing Louis XIV crossing the Rhine. The large door on the right leads into the Royal Chapel.

This chapel, dedicated to Saint Louis, was begun in the year 1700 by Jules Hardouin-Mansart (1646-1708), one of the most brilliant architects of the time. He came from a family of builders and was the son of a painter. When he was 29 he was elected to the Académie and soon became First Architect and Superintendent of Building. Basically he was responsible for Versailles as we see it now. He built this chapel not far from the preceding chapel, in the upper part of which the Hall of Hercules had been installed. He recruited the best artists of the time as collaborators: the sculptors Nicolas and Guillaume Coustou, Laurent Magnier, René Frémin, François

Antoine Vassé, the painter François Lemoyne, all part of the art world which was then coming to the fore in France.

Although the architect proposed the use of polychrome marble, the king preferred a fine white stone from the quarries of Créteil. The large wide windows lend a marvelous almost surrealistic luminosity to the architectural complex. While the massive pillars of the ground floor are decorated with angels bearing the attributes of the Passion and cult objects, the first floor is cadenced by elegant grooved Corinthian columns which support the trabeation on which the vaulted ceiling rests. The frescoes of the vault representing *God the Father Announcing the Coming of the Messiah* are by Antoine Coypel (1661-1722) and in the painter's search for expression reveal the influence of Le Brun as well as of Italian art. The architecture of the vault is decorated with paintings by Philippe Meusnier, a specialist in this genre.

Above the altar, in the apse conch, is the *Resurrection of Christ* by Charles de Lafosse (1636-1716), a pupil of Le Brun, who spent some time in Italy and in particular Venice, where he acquired his taste for color and movement which safeguarded him from becoming too academic.

The ostentatious gilded bronze fixtures glowing on the altar are by Corneille Van Clève (1645-1732) while the organ case is by Robert Cliquot, one of the most notable of the French organ makers. The pavement is covered by polychrome marble in large designs. The royal coat of arms is at the center of the nave.

A spiral staircase leads to the first floor. The king and queen attended the service from projecting balconies in the tribune - the king on the left and the queen on the right. The ladies took their places in the gallery and the courtiers on the ground floor. All of them followed mass facing the king. Louis XIV, who was very devoted, demanded a serious demeanor and silence. The service must have seemed interminable to the ladies who came above all in the hopes of drawing the king's attention. One day Brissac, head of the Guards, announced that the king would not attend mass that day. Almost all the ladies present immediately left, but it was a joke and when the king arrived, he was surprised to find the chapel empty...

Hardouin-Mansart died in 1708 and his place was taken by his brother-in-law Robert de Cotte, who brought work on the chapel to its end and it was inaugurated on June 5, 1710. Shortly thereafter, on July 7th the first grand wedding was celebrated there with all the court present - that of the Duc de Berry, the king's nephew, with Mademoiselle, daughter of the Duc d'Orléans. Among the other royal weddings mention should be made of that of the Dauphin Louis, Louis XV's son, who never mounted the throne, and of his sons, the future king Louis XVI with Marie Antoinette of Austria on a lovely spring day, May 16, 1770; the Comte de Provence, the future Louis XVIII, with Louise of Savoy, in 1771, and in 1773, the wedding of the Comte d'Artois, the future Charles X, last king of France, with Maria Theresa of Savoy.

This chapel was also where the Knights of the Order of the Holy Ghost organized their great ceremonies and where the Te Deums were sung in thanks for victories. The Royal Chapel is therefore the site of the great religious events of the French monarchy.

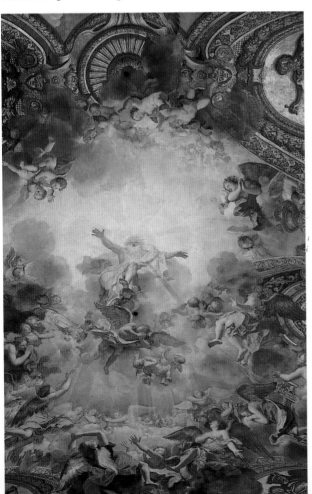

Detail of the frescoed vault with God the Father Announcing the Coming of the Messiah to the World.

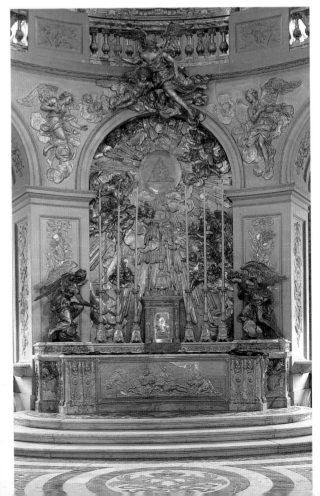

The high altar and the imposing bronze decoration by Van Clève.

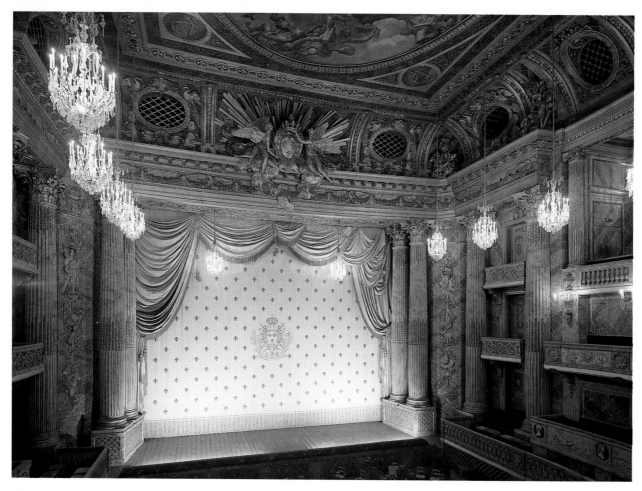

The stage of the sumptuous hall of the Opéra Royal.

THE OPERA ROYAL

Not until Louis XV were musical performances provided with a suitable setting. And what a setting it was! Commissioned from Ange Jacques Gabriel (1698-1782), the hall took only 21 months to build and it was ready to be inaugurated on the occasion of the wedding of the Dauphin Louis, the future Louis XVI.

The first opera theater in oval form, it was built entirely of wood, painted in faux marble, which gives it perfect acoustics, and with a capacity of 750 spectators who crowded in for concerts or operas. King Louis XV spurned a large royal box for three small boxes closed by a grate. Thanks to an exceptional device, the pit could be lifted to the level of the stage, after which the orchestra pit was covered and the room could be transformed into an elegant ballroom or banquet hall. The stage, the largest in France after that of the Paris Opéra which was built a century later, is 26 meters deep and 22 meters wide.

The wooden decoration was by the hand of the sculptor Augustin Pajou (1730-1809).

The canvas which still decorates the ceiling was painted by Louis-Jean-Jacques Durameau (1733-1798), painter to the king who had become curator of the paintings of the Crown in 1783. It represents

Apollo Offering a Laurel Crown to Men Who Have Distinguished Themselves in the Arts.

The last banquet was organized in this room on October 2, 1789, in honor of the regiment of Flanders which Louis XVI had called in to protect the palace and its inhabitants. But all to no avail, for the Revolution swept away the regiment, the guards, the carpets, mirrors, furniture... In 1871 the room was the seat of the National Assembly: the walls, already in a state of disrepair in the time of Louis Philippe, were whitewashed and Durameau's canvas was detached and placed at the back of the stage, so that a window might be put in its place. In 1952 an integral restoration was begun, bringing back to light the glitter of gold and the pink and blue tones of this unique room in which everything harmonizes perfectly, from the chandeliers to the curtain embroidered in gold with the king's coat of arms.

The cost of the spectacles was however prohibitive. As many as 3,000 candles were required just to illuminate the hall and it was therefore used as little as possible. It was sporadically opened on the occasion of visits by foreign royalty, for grand gala balls, and French lyric operas, particularly Glück and Rameau.

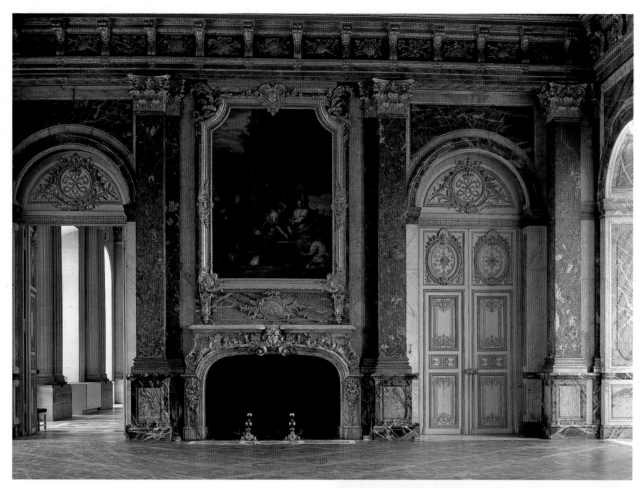

The Hall of Hercules, adjacent to the vestibule of the Chapel, leads to the Grand Apartments. The decoration is by Robert de Cotte (1656-1735); over the fireplace is a painting by Veronese, Eliezer and Rebecca, with a companion piece by the same Venetian painter, Feast in the House of the Pharisee, that covers the entire wall. The Apotheosis of Hercules by François Lemoyne is shown in the ceiling. The fresco, composed of over 140 figures, required three years to paint.

The Hall of Abundance is the first of the six rooms in the Grand Apartments. The walls, covered in green Genoa velvet, have works by Hyacinthe Rigaud (1659-1743), including the Portrait of the Grand Dauphin, Louis XIV's son. The Portrait of Louis XV, on the other hand, is by Van Loo. In the ceiling, decorated by René Antoine Houasse (1645-1710), the theme is that of Royal Magnificence.

THE GRAND APARTMENTS

A series of six consecutive rooms comprise the Grand Apartments adjacent to the Parterre on the north side. This part, built in 1688 by Le Vau with decorations by Le Brun, was given over to the State apartments, in which the king received the Court. The rooms, named after the mythological subjects depicted in the ceilings, are sumptuously ornamented with polychrome marbles, stuccoes, bronzes and tapestries.

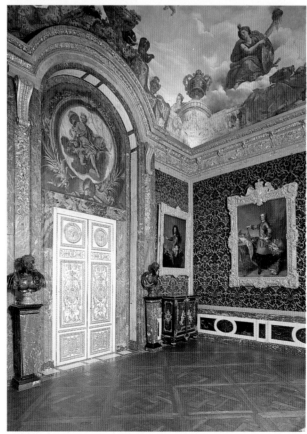

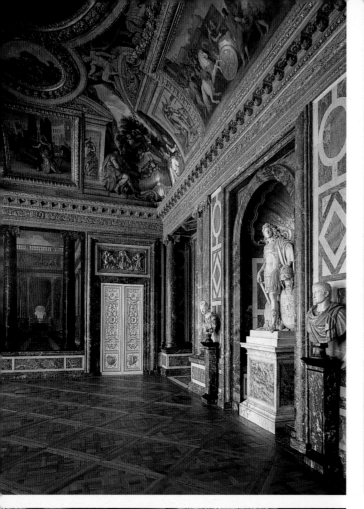

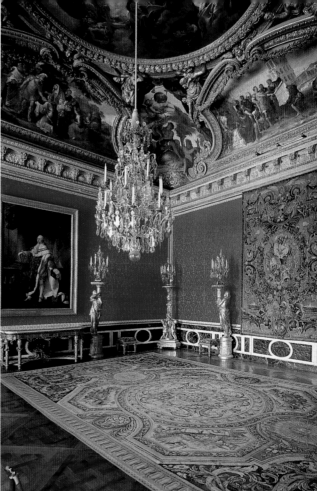

The Room of Venus is distinguished by a Venus Crowned by the Graces, by Houasse, in the oval in the ceiling. The side walls are decorated with two fine perspective views by Jacques Rousseau (1630-1693) who also made the two painted trompe-l'oeil statues in the space between the windows. In a niche in the back wall, a statue of Louis XIV by Jean Warin (1604-1672) showing the king dressed as an ancient Roman, with the attributes of war: shield, helmet and cuirass.

The Room of Apollo served as Throne Room and therefore the decoration was particularly fine. The ceiling has frescoes by Charles Lafosse showing the Chariot of the Sun, a direct allusion to royal authority. On one wall is the portrait of Louis XVI in his coronation dress. Above the fireplace, a copy of the famous portrait of Louis XIV by Rigaud now in the Louvre.

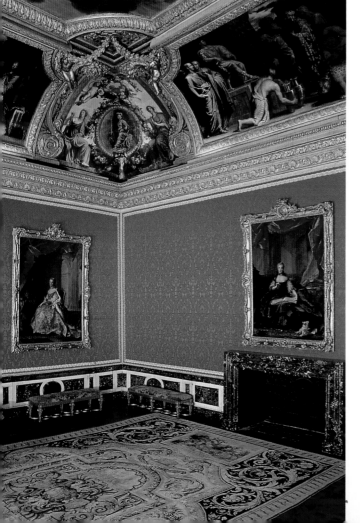

The Room of Mercury, on the ceiling of which Jean-Baptiste de Champaigne (1631-1681) painted Mercury on a Chariot Drawn by Roosters, houses various portraits of Louis XV and the queen Maria Leszczynska. The mortal remains of Louis XIV and Louis XV were on view for various days in this room.

The Room of Mars. Used as the Guard Room, in keeping with its name, evenings it was used as a Music Room. Audran painted Mars on his Chariot at the center of the ceiling, with around him Victory Supported by Hercules by J. Jouvenet (1644-1717) and Terror, Cruelty and Fear Taking Possession of the Powers of the Earth, by Houasse. Various outstanding paintings have been put on exhibit in the hall: above the mantelpiece, King David by Domenichino; on the left the Family of Darius by Le Brun, on the right Pilgrims of Emmaus after an original by Veronese. On the right wall, Louis XV in War by Carl Van Loo, opposite, again by Van Loo, Maria Leszczynska in her Court Gown with the Crown Jewels.

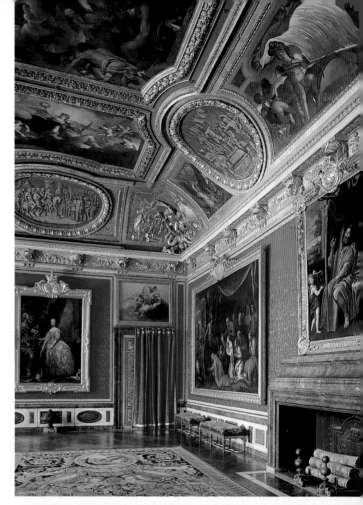

The Room of War is at the end of the Grand Apartments. An enormous stucco medallion, by Coysevox, is set on one wall: it shows Louis XIV dressed in "heroic style" with the flowing locks of his wig falling on his shoulders and holding the baton, symbol of command, in his right hand. Above the medallion are two winged female figures of Fame exalting the king, one with a trumpet, the other with a laurel wreath. Below, two chained "prisons". The bas-reliefs that cover the fake fireplace depict Clio, muse of History, as she writes the deeds of the sovereign. In the ceiling lunettes the countries defeated by Louis XIV and by Bellona, goddess of war, are shown painted under stormy skies. In the central cupola Le Brun depicted France Victorious.

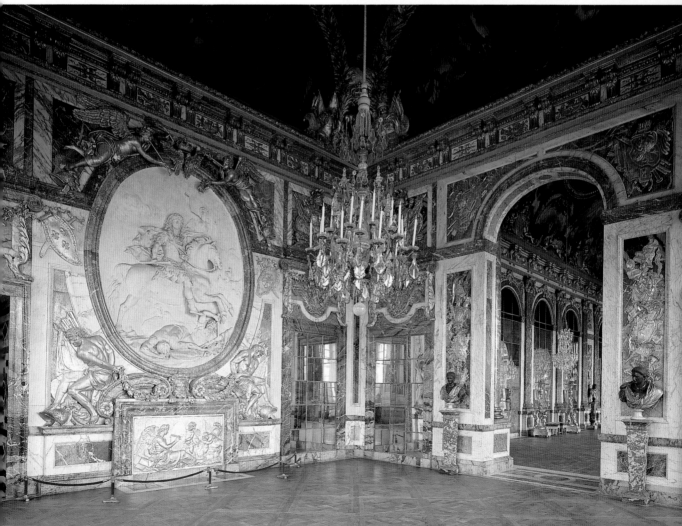

THE HALL OF MIRRORS

Louis XIV had it built in place of Le Vau's terrace, originally a means of communication between the north and south pavilions. Work was begun in 1689 and lasted ten years.

The Gallery is 73 meters long, 10.50 meters wide and 12.30 meters high. The seventeen arched windows overlooking the garden are matched by the same number of simulated windows decorated with panel mirrors with beveled sides and framed in chased gilt brass. Four of these doors communicate with the King's apartments. Particular attention has been given to the decoration of this world-famous gallery. The spaces between the windows are scanned by engaged pilasters in red-brown marble of Rance with bases in chased gilded bronze and capitals created expressly for this gallery by Caffieri. The frieze of the gilded stucco cornice is decorated with the emblems of the royal orders of Saint Michael and of the Holy Ghost. On the cornice are 24 groups of putti by the sculptor Coysevox and, everywhere, garlands, trophies and cascades of arms, by Coysevox, Tuby, Le Gros and Massou. In the time of the Sun King the furnishings in the gallery were of solid silver – the flower pots for the orange trees, the tables, the foot-stools, as well as the finest statues of the royal collections.

Access to this gallery, as well as to the whole apartment, was open to all and it swarmed with a motley crowd, from common people up to the grandest lords. Once it was even crossed daily by cows, asses and goats which were conducted to the apartments of Louis XV's daughters, who at the time were very small, so they could drink fresh milk every morning.

During the subsequent reigns, great receptions were organized for the arrival of various ambassadors, the visit of the Doge of Venice, princely weddings such as that of the duke of Burgundy in 1747 when a magnificent gala ball was held. On special occasions the king's throne was set up under a canopy at the back of the gallery, on the side of the Salon de la Paix.

Now the chandeliers in Bohemian crystal are still there to marvel at, the 24 torches from the time of Louis XV, the consoles in gilded wood with marble table tops, the porphyry vases, the antique busts... immersed in a fantastic world that transcends the man for whom it was made, Louis XIV, and the artists who worked there, a world to the glory and fame of all France.

The spectacular Hall of Mirrors with its marvelous gilded wood candelabra. This is where the great receptions and official ceremonies took place and was where the German Empire was officially proclaimed in 1871 and where the Peace conference which led to the signing of the Versailles Treaty was held in 1919.

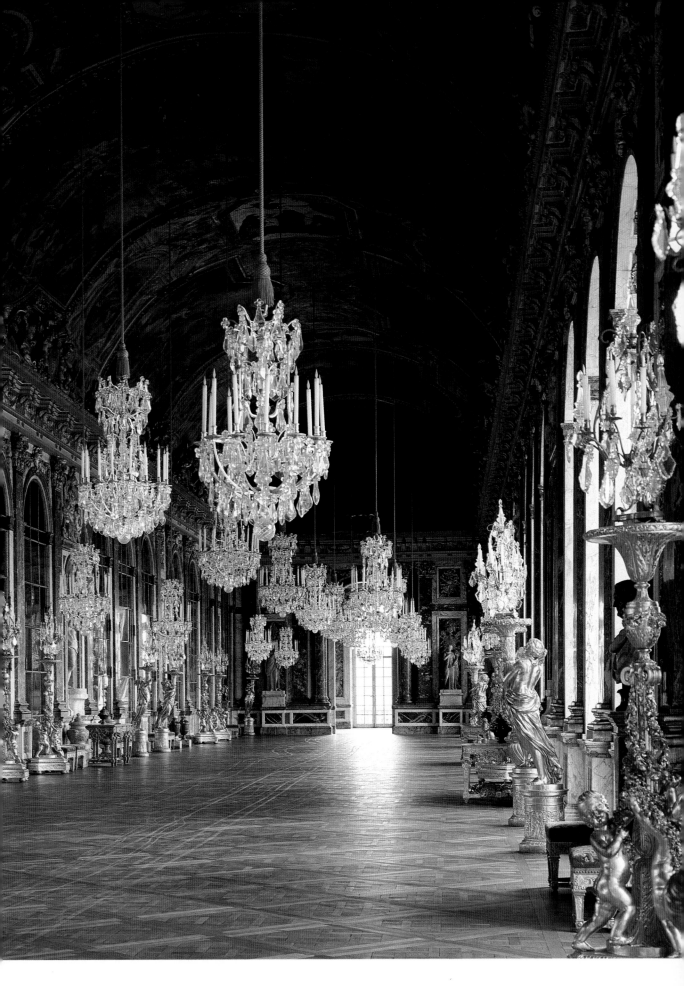

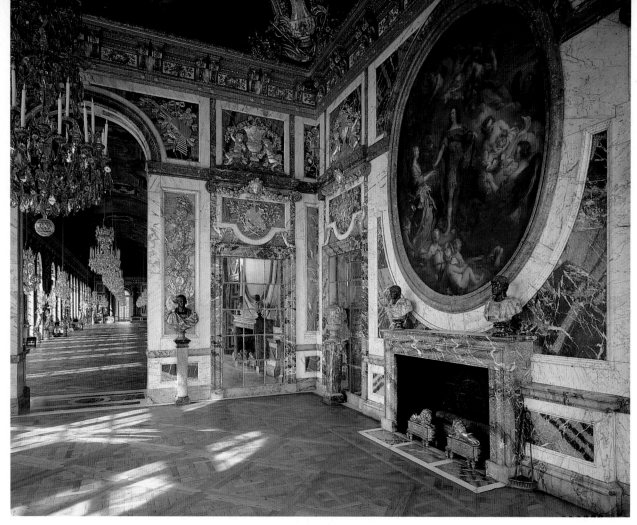

The Salon de la Paix, entrance to which is from the
Hall of Mirrors.

SALON DE LA PAIX

Situated at the southwest corner, the Salon de la Paix or Salon of Peace, flooded with light, overlooks the parterres to the south with their marvelous flowered arabesques. The decoration is similar to that of the Salon de la Guerre, at the other end of the Gallery. Most of the decoration dates to the time of Louis XIV, except the large medallion above the fireplace which represents *Louis XV as Peacemaker:* the king is represented at the age of 19 in the act of handing an olive twig, symbol of peace, to Europe in the guise of a maiden. This work by Lemoyne, of 1729, is above the green marble fireplace. On the mantelpiece, two small busts of Roman emperors; in the hearth, a fine plaque with the coat of arms of France and Navarre and a pair of fine firedogs with two facing lions, specifically commissioned for this room from the sculptor Boizot by Marie Antoniette. On the marble walls, cascades of arms and musical instruments. Attention should also be paid on the mirrored walls to the putti playing around vases of flowers as well as to the chandelier with the girandoles in amethyst-colored crystal. The door is flanked on either side by a bust with the head in porphyry, set on a pedestal, as well as a vase of grey marble. Busts of this kind abound in the palace. A cornice resting on gilded wood brackets runs around the ceiling while in the corners the lyres and caducei mean that the arts and commerce prosper in peace. This room was separated from the Hall of Mirrors by a movable partition in the time of the queen Maria Leszczynska, which was at times removed for grand fêtes. Depending on the occasion, it could be turned into a gaming room for the queen or a concert hall. On Sundays in winter the queen organized concerts of vocal and instrumental music which became famous. But, shy as she was, the queen made no effort to conceal her love for gambling, especially a game of chance called *cavagnole* at which she often lost. The nobles who lived a spendthrift life in Versailles tried to recuperate their fortunes gambling. In all the periods there was always a "game room" in the apartments of the king, the queen and the members of the royal household. The domed ceiling was frescoed by Le Brun At the center *France on a Chariot Drawn by Four Doves* surrounded by Peace, Glory and other peace-dispensing Virtues.

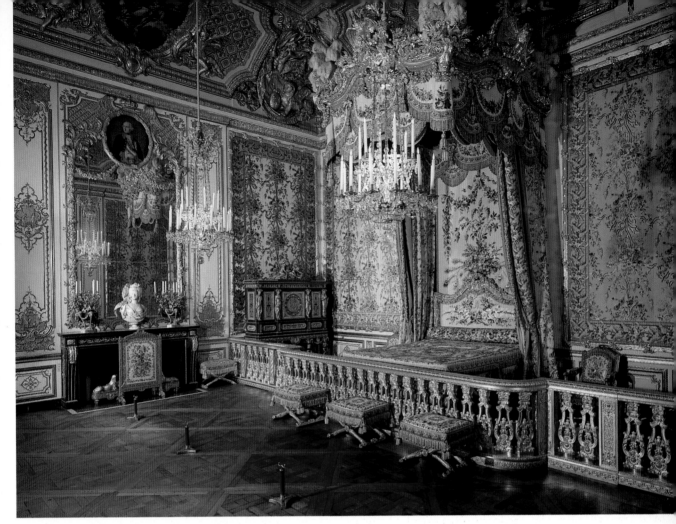

The Queen's Chamber, sumptuously decorated, with the ornate balustrade in front of the bed.

THE QUEEN'S APARTMENTS

The Apartments of the Queen overlook the *Southern Parterre* and consist of the *Guard Room*, with its ceiling frescoes by Coypel, the *Antechamber* which contains the portrait of Marie Antoinette with her children, the *Room of Nobles* and the **Queen's Chamber.** Louis XV had the queen's chamber, originally done by Le Brun, redecorated in honor of his consort. The portrait of the king and that of her father, the unfortunate king of Poland Stanislas Leszczynski, were hung on the walls which were decorated with gold and flowers against a white ground. Yielding to all the desires of a queen who had given him several daughters and finally in 1729 an heir to the throne, the king provided a life of luxury for the queen, paying her gambling debts and renewing her household linens every three years from top to bottom, with sheets and bedspreads decorated with lace... at a cost of 30,000 French pounds, which was an enormous sum for those times! The room was always overflowing with a flurry of retinue. Once the duke of Luynes counted as many as 65 ladies in front of the railing which no one, except the king and queen, were permitted to pass. The queen could find some peace and quiet in the small drawing rooms behind the Grand Appartement, but they all disappeared in the renovation the next queen carried out.

When she became Queen of France, Marie Antoinette used this room, but she had to leave it almost as it was due to the insistencies of the architect Gabriel. The decoration by Robert de Cotte, Verberckt, Jules Dugoulon and Le Goupil was finished by Gabriel father and son.

In 1770 Antoine Rousseau added the Imperial Eagles of Austria to the royal coats of arms of France and of Navarre. The portraits of the mother of the queen, the empress Maria Theresa, her brother Joseph II and her husband Louis XVI were hung here in 1773.

The silk on the walls, in the furnishing of the alcove and the upholstering of the armchairs was changed with the seasons. The one there now is the "summer" model and was donated by the Lyons silk manufacturers. The design is particularly airy with interlacing flowers – roses, lilacs, tulips - tied with ribbons.

The domed ceiling is decorated with four trompe-l'œil paintings by Boucher. The overdoor decorations are by Natoire and Jean-François de Troy. Note

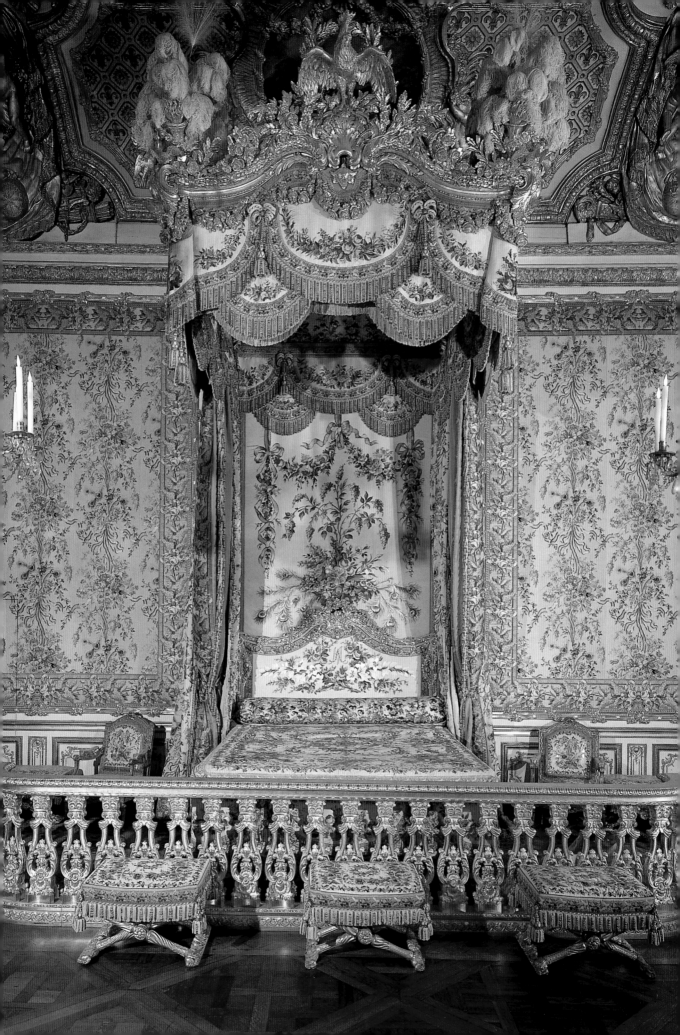

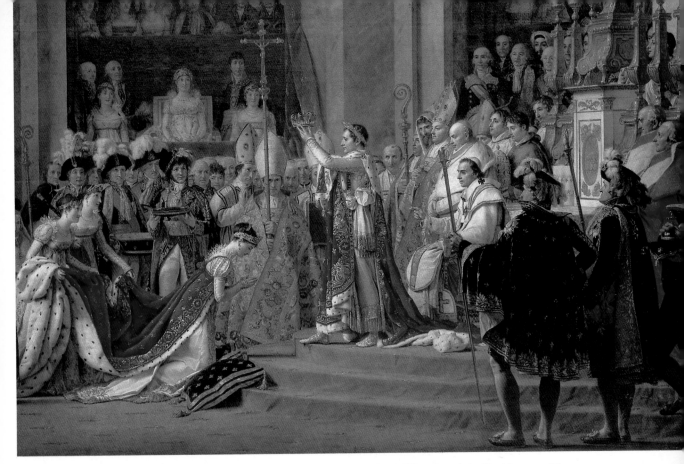

The bed with the curtains and baldaquin decorated with ostrich feathers and plumes.

Coronation of Napoleon I, by David, copy of the original in the Louvre.

should be taken of the fire screen by B.-Claude Séné (1748-1803), the foot-stools and the jewel-cabinet.

At dawn on October 5, 1789, the mob which had arrived the day before from Paris invaded the palace. Monsieur de Miomandre, on guard, cried "Save the queen" and fell, as did Monsieur de Varicourt. Marie Antoinette had barely time to flee with the king through the small door at the right of the bed. She was never again to sleep here and died on the guillotine on October 16, 1793.

Nineteen "children of France" were born in public in this room where three queens, Maria Theresa, Maria Leszczynska, and Marie Antoinette, and two dauphines lived. According to an ancient custom, the queen was required to give birth to her children in public. It must be kept in mind that Versailles was open to all and was even more crowded when time for a birth drew near. On December 19, 1778, when Madame Royale came into the world, the room was filled by such a throng of curiosity seekers, with two young Savoyards even perched on the furniture to get a better vantage point, that the queen felt ill and the king himself opened the window to let in a bit of air.

CORONATION ROOM

The Coronation Room was radically transformed by Louis Philippe so that two large canvases by David, the *Coronation,* which gives the room its name, and the *Distribution of the Eagles,* could be housed here.

On the wall facing the windows a painting by Baron Gros: the *Battle of Aboukir.* On the ceiling, the *Allegory of 18 Brumaire* by Callet.

Louis David (1748-1825), a pupil of Vien, accompanied his master to Italy where he became acquainted with Roman antiquity. He became the founder of neoclassicism and returned to Rome where he painted the famous *Oath of the Horatii.* Politically committed, he had voted in favor of the death of the king and had become Superintendent of Fine Arts. Napoleon's epic gave him a chance to make use of his interests in antiquity, drawing a parallel between the ancient Roman emperors and the "small Corsican" covered with imperial eagles and devoured by ambition who had dragged his legions throughout Europe.

The *Distribution of the Eagles* was painted in 1810, the same year as the *Coronation* of which we have a copy here, made by the painter himself; the original is in the Louvre.

The coronation ceremony took on place December 2, 1804 in the cathedral of Notre-Dame in Paris. We know that the celebration was carried out in absolute adherence to the ceremonial dictates but that jealousy and grudges smoldered underneath. The emperor's sisters balked at having to carry Josephine's train; Letitia Bonaparte, Madame Mère, shown in the tribune, was not present at the ceremony, for she refused to watch the coronation of her daughter-in-law, whom she referred to as "this woman". The painting, with its 150 portraits, is an authentic page of history.

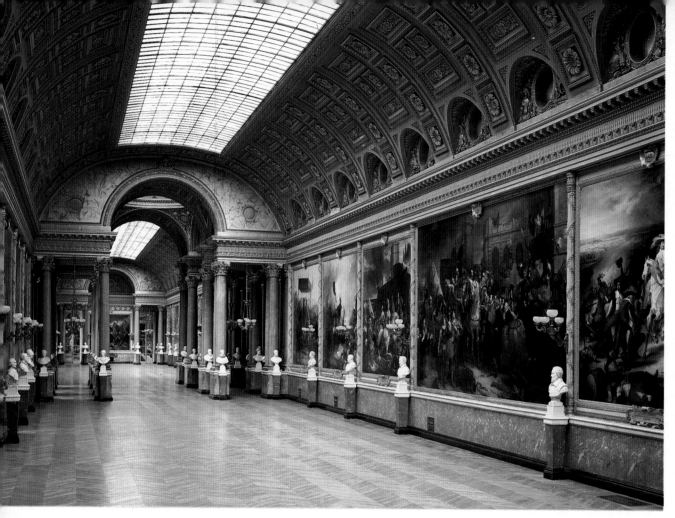

The Gallery of the Battles with pictures and busts of illustrious personages.

Some of the commemorative pictures exhibited in the Gallery. From left to right and from top to bottom: **Charlemagne Receives the Submission of Widukind in 785 in Padeborn** (Ary Scheffer, 1795-1858); **Battle of Taillebourg, July 21, 1242** (Eugène Delacroix, 1798-1863); **Battle of Rivoli, January 14, 1797**, (Félix Philippoteaux, 1815-1884); **Battle of Friedland, June 14, 1807** (Horace Vernet, 1789-1863); **Battle of Bouvines, July 27, 1214** (Horace Vernet); **Henry IV Enters Paris, March 22, 1594** (François Gérard, 1770-1837).

THE GALLERY OF THE BATTLES

After the 6th of October, 1789, the palace gradually went into lethargy. Without its king, it was no more than a body without a soul. The Revolution had gone its way, heads had fallen. Louis Philippe put on the robes of the king of France. Versailles was too grand for the *citizen king,* who set up court at Trianon. The palace became a museum.

As work went on to change it into the Grand Museum, walls disappeared and so did fine marble mantelpieces in various rooms, splendid wainscotting was painted over until finally in 1837 the Gallery of the Battles was inaugurated in the south wing which had once contained the apartments of the *Enfants de France* and the royal family's close relatives.

The architects Fontaine and Nepveu built this vast gallery, 120 meters long, to house the paintings which commemorated the glories of the French armies from the first tribes gathered around Clovis up to the Grenadiers of Napoleon's Guard. But there was also an inherent political objective: the need to muster a large ensemble around the person of the *roi des Français,* satisfying those who were nostalgic for the *Ancien Régime* and at the same time rekindling the spirits of the Bonapartists with the ghostly beat of the marching boots of the Old Guard.

White busts, with immobile expressions, of questionable make, rnark the stages of this history of France in pictures. But aside from the spirit, of a historian or an art lover, with which one proposes to visit the collection, an engraved plaque provides us with the true meaning of this gallery:

*"The busts in this gallery
are those of the princes of royal blood,
of the admirals, of the constables,
of the marshals of France
and of the famous warriors
who fell in battle for France".*

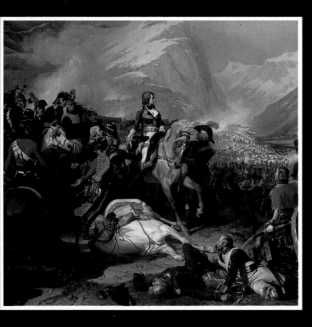

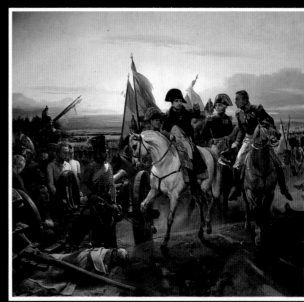

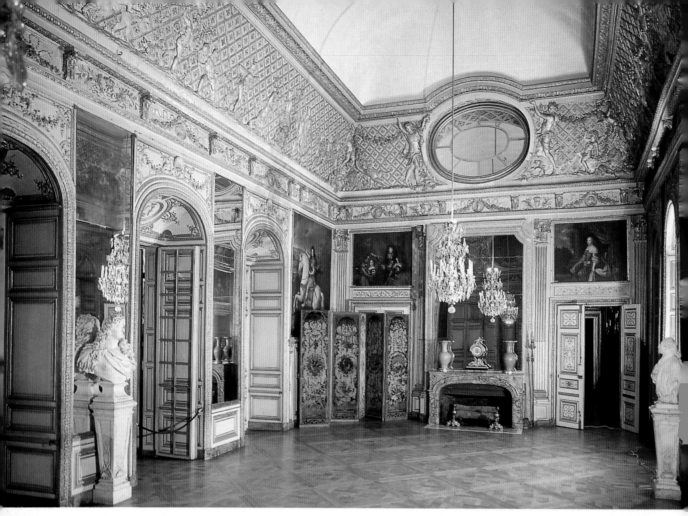

The Room of the Ox-eye is named after the oval opening in the frieze in the vault. It was in this antechamber that the courtesans gathered every morning waiting for the king to wake up.

Detail of the King's Chamber with the canopied bed topped by plumes and ostrich feathers and covered, as are the doors, furniture and walls, with luxurious upholstery.

The Council Hall with the table around which all the decisions of the Kingdom were taken up to the Revolution.

THE KING'S APARTMENTS

The King's Apartments, designed by Hardouin-Mansart, overlook the Marble Court and include the Room of the Ox-eye which served as antechamber, the King's Chamber and the Council Hall.

The Room of the Ox-eye. The hall, which is where the old king's chamber and the Room of the Bassans once was, is named after the large oval opening in the frieze of the vault decorated with gilded stuccoes showing children's games on a latticed ground with rosettes. Various artists were needed in the execution of this noteworthy frieze.

The walls are covered with wainscotting decorated with garlands, tall mirrors which enhance the light of the room and a few fine portraits such as *Louis XIV on Horseback* by Pierre Mignard (1612-1695), *Maria Theresa of Austria*, the king's consort, by Jean Nocret

(1617-1672), who also painted the famous picture of *Louis XIV and his Family*, in the same room, where the figures are shown in the guise of gods.

This room served as an antechamber and had little furniture. At eight on the dot every morning the first chamber valet woke the sovereign with the words "Sire, it is time", while in the hall and in the gallery everyone was waiting for the usher's announcement "Gentlemen, the king".

The King's Chamber. In the time of Louis XIII the room was used for receptions and overlooked the garden on one side and the Cour de Marbre on the other. When construction on the Hall of Mirrors began in 1679 the view over the gardens disappeared. In 1701 it became the King's chamber.

Great attention has been paid to the decoration with

196

its white and gold. The tall grooved gilt piers are the only elements of the original decoration that have survived. The king's bed is behind a gilded wooden railing. The gold and silver brocade of the two armchairs, the back of the alcove, the curtains, the baldachin and the bedspread were expressly made by the textile manufactories of Lyons in 1980 after the original.

Above the bed, on a hatched ground with rosettes, is a high relief by Nicolas Coustou, *France Watching Over the King's Sleep*. Originally there was only one fireplace in the room, the one on which the bust of Louis XIV by Coysevox is placed. Louis XV had the fireplace on the opposite wall built. The upper part of the mirror frame is a stylistic innovation. Five of the nine paintings by Valentin de Boulogne (1590-1632), a French painter of the school of Caravaggio, who worked in Rome, are inserted between the modillion frame and the ceiling. They represent the *Four Evangelists* and the *Tribute to Caesar*. There is also another painting, *Hagar in the Desert,* by Giovanni Lanfranco (1582-1647), a pupil of the Carracci.

Noteworthy the medallions above the doors, including a self-portrait by Van Dyck.

The Council Hall. The light for this room, which communicates with the king's chamber, comes from two windows and large mirrors. Louis XIV called his Council in this room which he had decorated with the finest pieces in his collections.

In the time of Louis XV the Council Hall was enlarged by Gabriel while the sculptor Jules Antoine Rousseau executed the marvelous wainscotting which can still be seen.

On the fine chimney piece with sumptuous decoration in bronze stands a lovely clock of the period of Louis XV.

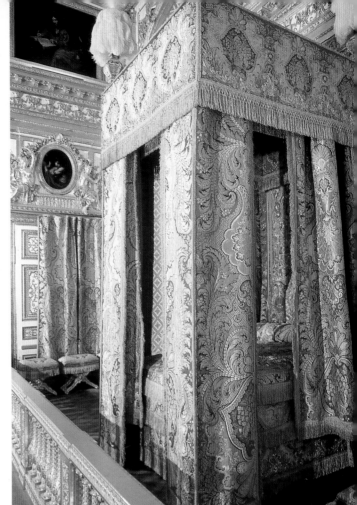

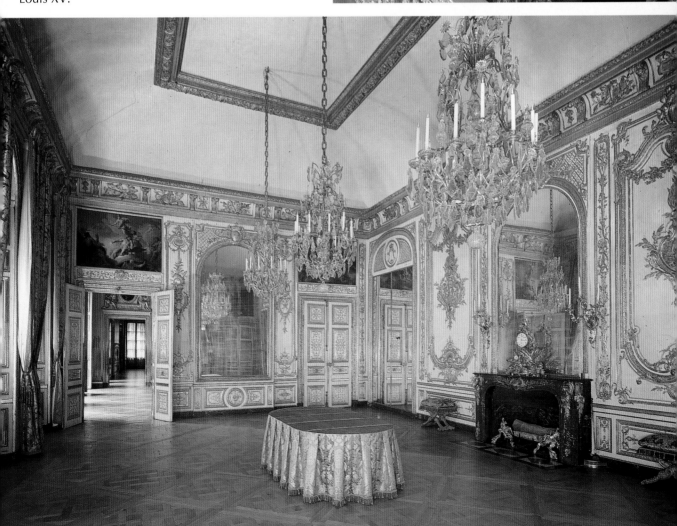

THE QUEEN'S
PRIVATE ROOMS

Louis XV had had these rooms installed for the queen behind her apartment. While the queen's apartment has a southern exposure and is flooded with light, these rooms behind overlook the Cour de Monseigneur, on the north. A wide balcony with a pergola and flowers was added to brighten the surroundings. When Marie Antoinette arrived, she had everything changed, regardless of cost, by the architect Richard Mique who put the finishing touches on the Cabinet Doré, the Library and the Bathroom.
All the rooms were filled with luxurious objects, in obeisance to the tastes of the queen.
Thanks to recent restoration, it once more looks as it did when Marie Antoinette left, with fine objects and furnishings which however did not belong to the queen, for hers were lost in the war.
The Méridienne. This exquisite little octagonal drawing room was expressly created by Mique for the queen's afternoon nap which was then known by the term "méridienne". The decoration is as refined as possible. The wainscotting was carved by the Rousseau brothers, painters and decorators, known for their ornamental motifs of Italian and specifically Pompeian inspiration.

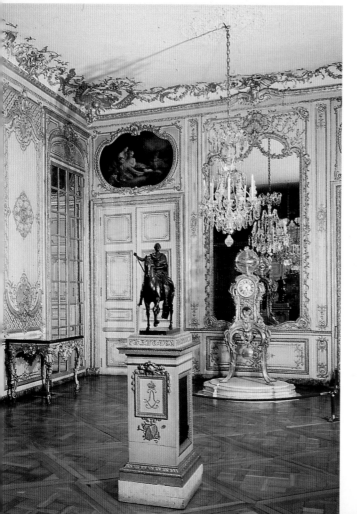

THE KING'S
PRIVATE APARTMENTS

The king's private apartments face south, on the Marble Court, and consist of various rooms including the Petite chambre du roi, the Dining room of the Return from the Hunt, the Cabinet de la Pendule, the king's private Study, in which the stupendous roll-top desk of king Louis XV, by the cabinet maker Jean-François Oeben is to be found. This desk is an authentic masterpiece not only of the art of intarsia and chasing but also in its mechanical perfection. In fact when the roll top was closed the drawers and writing surface were completely blocked.
Cabinet de la Pendule. The room takes its name from the astronomical clock invented by Claude Siméon Passemant (1702-1769), French clockmaker and optician, which was presented to the king in 1753 by the Académie des Sciences. The unusual mechanism made by Dauthiau is surmounted by a crystal globe with the moon and planets moving around the sun according to the Copernican theory. Jacques Caffieri made the marvelous decoration in gilded bronze.
In the center of the room is a reduced version by Vasse of the equestrian statue of Louis XV. The original by Bouchardon was on what is now Place de la Concorde formerly dedicated to Louis XV, and was demolished during the Revolution.

The elegant small drawing room known as the "Méridienne" and the Cabinet de la Pendule with the small equestrian statue of Louis XV and the precious astronomical clock.

Louis XVI's Library. Louis XVI had his personal library installed in the former bedroom of Madame Adélaïde, which had been transformed into a card room for Louis XV. The king's books have been ordered in the cases in this large lovely room with its purity of line. Gabriel designed the decoration which was carried out by Jules Antoine Rousseau.

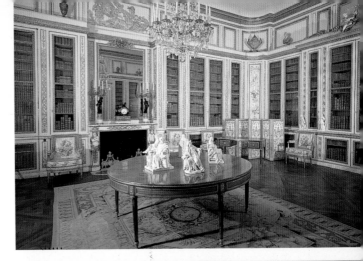

The Porcelain Room. The style of the fine French porcelains was inspired by the Marquise de Pompadour. Extraordinarily intelligent and with a decisive aesthetic sense, she succeeded in interesting the king in the manufactories of Vincennes and Sèvres. The two workshops produced such marvelous pieces that the king, in attempting to promote the sale, permitted an exhibition of Sèvres porcelain to be installed in the dining room of his private apartments.

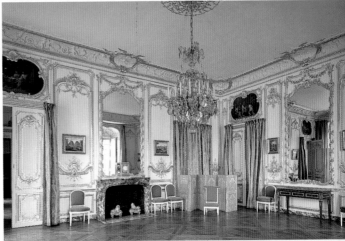

The King's Gaming Room. Formerly the "Cabinet of Curiosities" in the time of Louis XIV, it subsequently became the antechamber of the apartments of Madame Adélaïde. Despite the fact that it was redecorated more than once, the room is still pleasing. On the wall are ten water colors by Louis Nicolas Van Blarenberghe (1716-1794), painter of the Navy and of the War department.

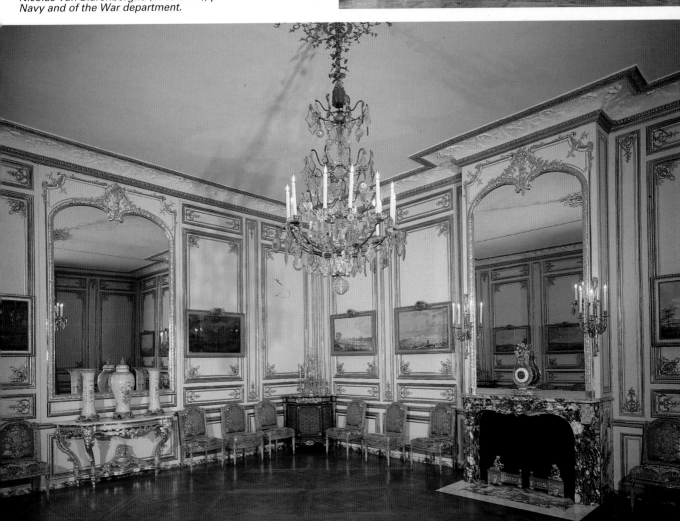

THE DAUPHIN'S APARTMENT

On March 30, 1349 the region called Dauphiné which stretches from the central area of the Alps up to the valley of the Rhône was assigned in appanage to the oldest son of the king of France. Actually, Humbert II (1333-1355), the king who at the time reigned over this region and who was without an heir and in deep waters financially, sold his possessions to the king of France after lengthy negotiations.

This eccentric figure later became a Dominican friar and the patriarch of Alexandria in Egypt. Dauphiné is indebted to him for the creation of important institutions such as parliament, the University of Grenoble and the State Audit court. Future King Charles V, son of John the Good, therefore became the first "Dauphin of France" in 1349. The last was the son of Charles X Louis Antoine (1775-1844) who never mounted the throne.

The Dauphin Louis, son of Louis XV, first married Marie Therese Raphaelle of Spain who died in 1746 and then Marie Josephe of Saxony who was to give him seven children.

When he left the apartments of the Enfants de France, in the south wing, the young prince settled in the corner apartment on the ground floor, south side, of the central body. At the time of his first marriage the young bridal pair – he was 15 and she was 16 – went to live on the first floor of the south wing in a magnificent lodging that had expressly been redecorated. Two years later the princess died and the unconsolable Dauphin received his new bride in the same apartment, slightly changed, until the apartment on the ground floor where he had lived in his youth had been redecorated.

The apartment consisted of a first anteroom, a second anteroom under the Hall of Mirrors with two windows on the Parterre d'eau. This was followed by the chamber and the corner salon, beautifully lighted by four windows, two on the Parterre d'eau and two on the south parterre. The last rooms were the library with small adjacent rooms, and the bedchamber.

Most of the rooms in this charming apartment, like so many others, were destroyed in the course of time.

Early in the 20th century, Pierre de Nolhac, historian and curator of the palace, restored them.

It is rather difficult to imagine these apartments without their woodwork and original furnishings. An attempt has therefore been made to recreate a certain harmony and a certain reflection of what they were or represented in the Dauphin's time.

The Chamber still contains all of Verberckt's (1704-1771) wainscotting. The fireplace of brownish red variegated marble is decorated with bronzes by Caffieri (1678-1775) representing *Flora* and *Zephyr*.

The overdoor decorations were painted in 1748 by Jean-Baptiste Pierre (1714-1789), a pupil of Natoire and last exponent of the rococo style.

The lovely portraits of the prince's sisters, Madame Adélaïde as *Diana* and Madame Henriette as *Flora*, painted by Nattier in 1742, can also be admired.

In the Grand Cabinet, paintings by Jean Baptiste Oudry (1686-1755) have replaced Nattier's overdoor decorations which represented the sisters the Dauphin was so fond of. There are exquisite paintings which are a joy to behold for by a skillful use of color the artist has infused his figures with infinite grace.

The large flat writing table, very elegant with its fine wrought bronze, was made by Bernard Van Riesen Burgh around 1745 for the Grand Cabinet. He was

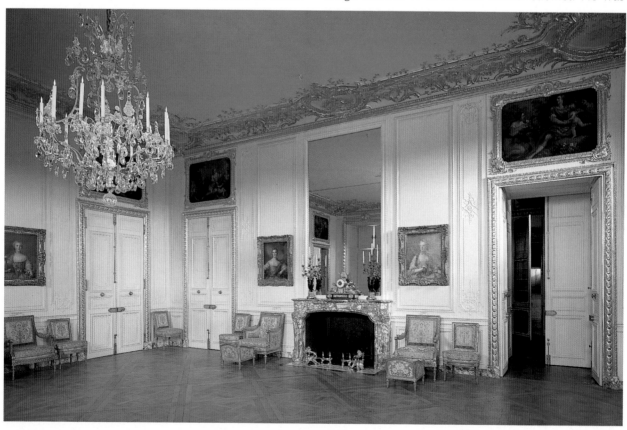

one of the three cabinet-makers of Dutch origin of the
same family and with the same name who signed
their furniture, which was typical of French 18th-cen-
tury taste, with the imprint B.V.R.B.
The library has overdoor decoration by Vernet and a
fine chest of drawers lacquered in vernis Martin, by
Gilles Joubert (1689-1775).
The Dauphin had only to cross a corridor, whether
from his library or from the corner drawing room, to
reach his wife's room. Notwithstanding, the first an-
techamber is situated at the other end of the four-
room apartment.
In the first antechamber is a portrait of the six-year
old Louis XV, by Rigaud, in coronation dress orna-
mented with ermine and the fleur-de-lys. In the sec-
ond antechamber is a painting of Louis XV by Van
Loo. The original decoration, here and in the adja-
cent Grand Cabinet, of wainscotting by Verberckt has
disappeared. The wood panelling of the chamber was
executed in the workshop of Verberckt. The last three
kings of France – Louis XVI in – 1754, Louis XVIII in
1755, and Charles X in 1757 – were born here.

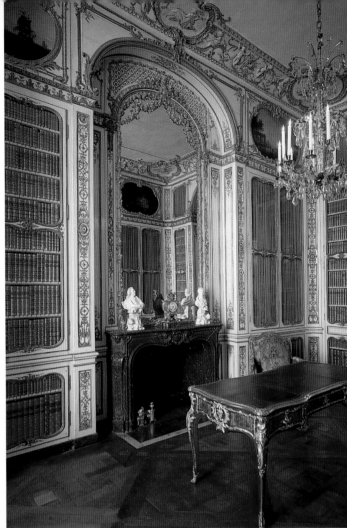

*A room in the Dauphin's apartment, on the ground
floor.*

*The exquisite library and the Dauphin's room with a
fine example of Chinese lacquer furniture.*

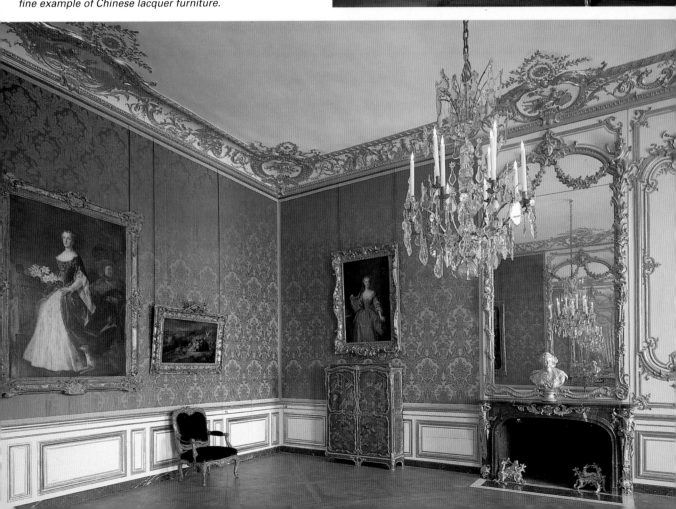

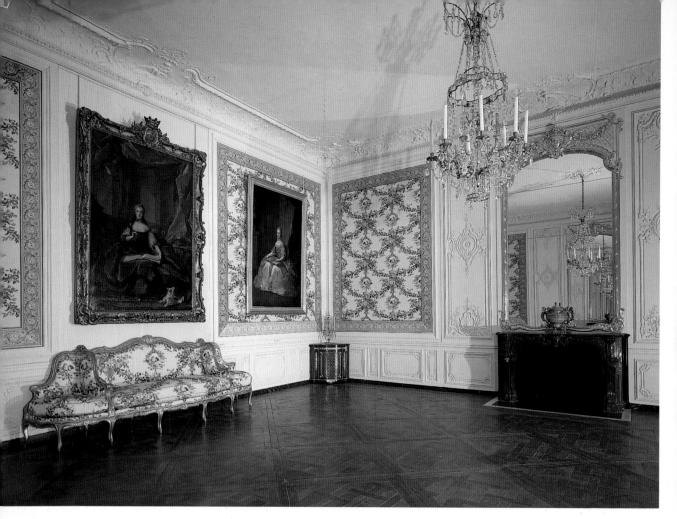

Madame Victoire's Large Drawing-room.

THE ROOMS OF THE DAUGHTERS OF FRANCE

Louis XV had ten children by his wife Maria Leszczynska, eight of which were girls. Living quarters for all these persons, including the servants and the small retinue that had grown up around the numerous family, had to be found. The first three daughters (Louise Elisabeth, Henriette and Adélaïde) remained in Versailles while the four younger daughters were sent to the Abbey of Fontevrault to receive an education. One of them, Madame Sixième, died there in 1744 at the age of eight. In 1793 Louise-Elisabeth married an Infant of Spain and left the castle where her two sisters Madame Henriette and Madame Adélaïde, remained. After having spent their childhood in the apartments known as those of the Enfants de France situated in the south wing, they settled in the Dauphin's apartment on the ground floor, in the central part of the palace, facing the south parterre (Parterre du Midi) where the king, who was very attached to his family, paid them visits.

In 1748 Madame Victoire returned from Fontevrault to be followed two years later by her sisters Sophie and Louise. Henriette died in 1752 and Madame Adélaïde moved from their apartment to some rooms adjacent to the parterre on the north.

After various moves, Louis XV's daughters gradually settled down in the central part of the ground floor where Louis XIV's old Appartement des Bains had been. Their apartments extended as far as the king's Small Court (Petite Cour du Roi) which was then called Cour de Mesdames, and as far as the Cour aux Cerfs, partially transformed into a garden with fountains and rocaille decoration.

At present the apartments of Madame Victoire and Madame Adélaïde have been carefully restored to bring them back to what they were before they were remodelled in Louis Philippe's time. Unfortunately the original furniture was lost during the Revolution.

In 1768 Louis XV wanted to offer his new mistress, Madame du Barry, a lovely apartment and asked his oldest daughter to give up hers on the first floor.

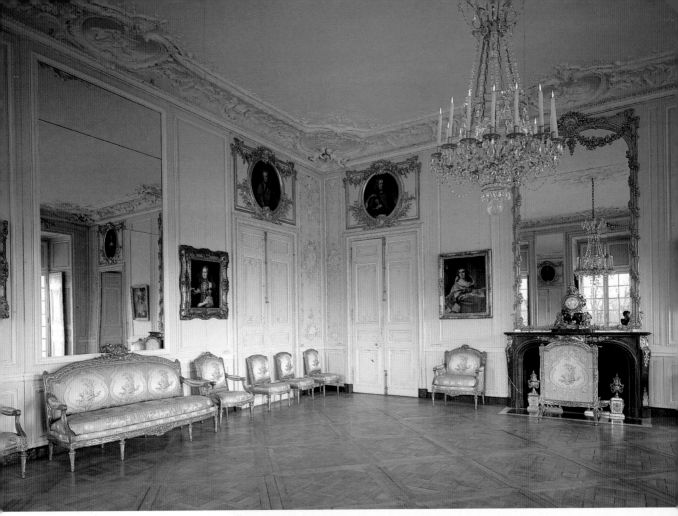

The corner room and the room known as that of the Hoquetons, originally the palace Guard Room. The name derives from the jacket, called hoqueton, worn by the palace guards.

Adélaïde then joined her sisters on the ground floor and being the oldest chose the best apartment, rather upsetting Madame Victoire who already lived there. A considerable amount of remodeling was needed so as to lodge the princesses Sophie and Louise "as their rank required". The Lower Gallery was used for this. These continuous changes, remodeling, transformation which must have required enormous sums of money now surprise us. At the time, Madame Adélaïde had two antechambers, a large drawing room, a bed chamber, an internal salon and a library. Now various mementos of this daughter of Louis XV, including a fine organ, are kept here.

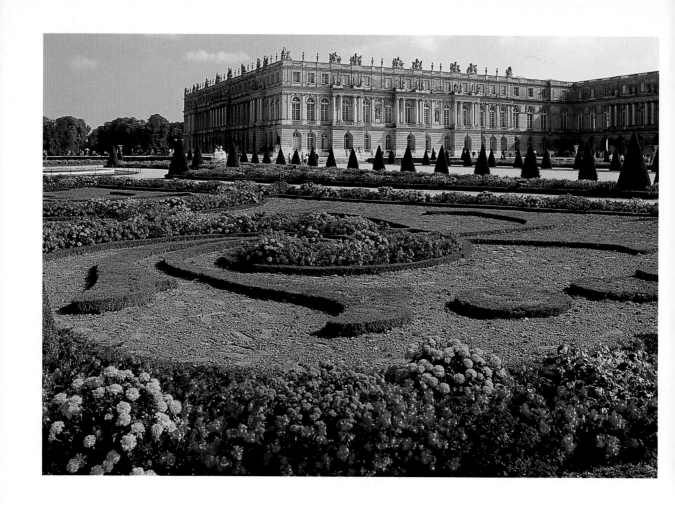

THE GARDENS

Even as work on the château was in progress, Louis XIV turned to the gardens. He entrusted the plans to Le Nôtre whose genius he had enviously admired in the gardens of Vaux-le-Vicomte.

To judge from the interest he showed in the plans, it seems likely that the park fascinated the king more than the castle.

Le Nôtre was a god as far as gardens were concerned and his was the secret of the art of perspective. He invented, created, recreated Nature, he strewed maples and beeches and elms over the grounds, modelled the hawthorne, planted the linden tree, planned a grove, created a labyrinth and fascinated the king with his creative fantasy.

Fouquet, the superintendent of finances who had fallen into disgrace, was in prison. In 1665 his property was put on auction in order to pay his debts and the king jumped at the chance to get hold of the objects that had aroused his envy during the famous fête of August 17, 1661, which had been fatal for the ambitious superintendent. In addition the king had various kinds of trees removed from the estate of Vaux and numbers of orange trees found their way to Versailles.

In 1683, Fouquet's son, short on money, sold the king the herms in white marble which now embellish the Quinconces to the north and south. Later seventy chestnut trees from the park of Vaux were transplanted to the gardens of Trianon.

In 1664 the gardens of Versailles served as setting for a memorable fête in honor of Mademoiselle de la Vallière which was to pass into history: the Plaisirs de l'Ile enchantée. With ballets, illumination, comedies and music, the fête was directed by two illustrious figures, Molière and Lulli. Equally famous fêtes were organized in 1668, 1674, 1689 and in 1699...

This was what the king intended the garden to be used for – fêtes as well as promenades. In the course of the numerous revisions, the cave of Thetis, which La Fontaine cites with his incomparable style in the *Loves of Psyche*, and other things as well, disappeared.

The problem of supplying water for the 1,400 fountains and pools also had to be solved. These gardens cover an area of 100 hectares, and they extend from the castle to the Etoile Royale for a total of three kilometers while the Grand Canal by itself measures 1.6 kilometers.

There are so many statues and groups of figures in bronze and marble that count has been lost. As in Charles Trenet's famous song, it can truly be said: "It's an extraordinary garden".

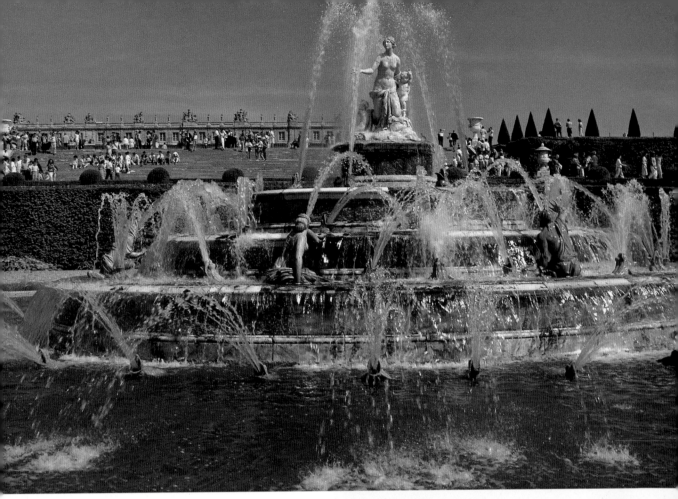

Delicate flower arabesques in the Parterre du Midi.

The jets of water rain down on Latona and her Children standing in the midst of this lovely fountain located in front of the staircase that leads to the palace.

Detail of the great circular colonnade, rhythmically echoed by the jets of water.

Detail of the Fountain of Apollo with the gilded bronze statues of tritons and the horses of Apollo's chariot.

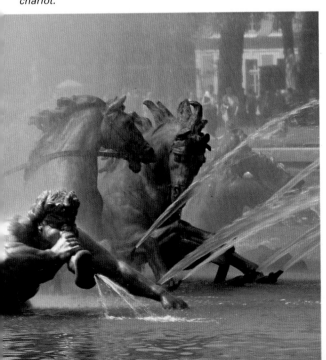

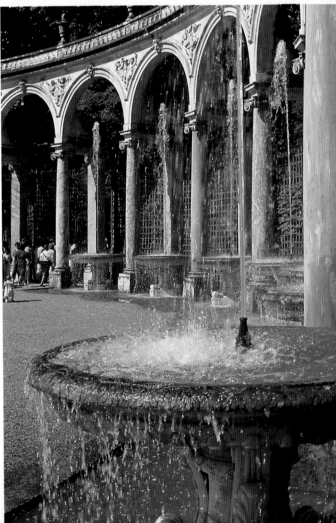

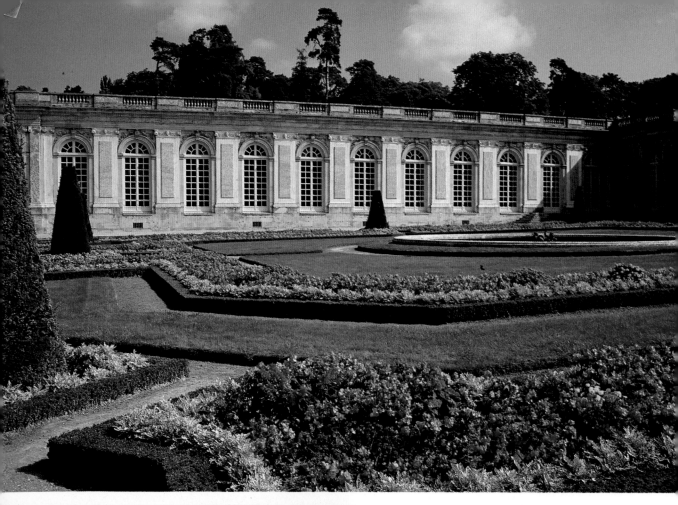

A view of the Grand Trianon and Napoleon's chamber with typical pieces of furniture of the time.

The Petit Trianon and the mill which is part of the farm.

THE GRAND TRIANON

In the back of the park, hidden by majestic tall trees, is the Grand Trianon whose name derives from the village and adjacent lands which Louis XIV acquired so as to enlarge his possessions. In 1670 Louis XIV requested Le Vau to build him a pavilion which was called Porcelain Trianon since it was externally faced with blue and white majolica tiles from Delft, Nevers, Rouen and Lisieux. But the pavilion was not built to withstand time and weather and the maintenance costs for such a small structure seemed excessive to the Sun King who was used to things done on a grand scale. It was decided to replace the building with a pavilion in marble and the works were commissioned from Hardouin-Mansart in 1687. Robert de Cotte also had a hand in the plans and built the peristyle which served the king as dining room during the summer. Little by little the building was enlarged It consisted of one floor crowned by an Italian-style balustrade, with the facade decorated with pilasters in pink marble from Languedoc and with Ionic capitals.

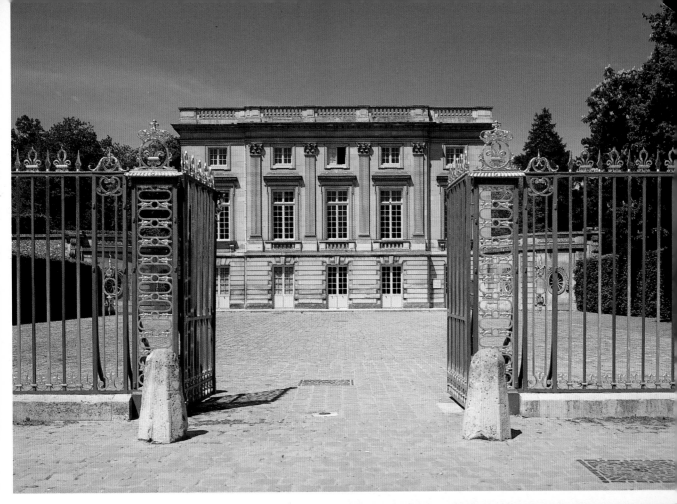

THE PETIT TRIANON

Louis XV detested the etiquette his great grandfather, the Sun King, had imposed on the court.

It was Madame de Pompadour who thought of building a smaller château near the Botanical Gardens of the Grand Trianon to give the king a place where he could relax away from Versailles.

The setting for a bucolic life was supplied by building a farm, with a new parterre, the French Garden and in 1750 Gabriel added a pavilion in fine white stone. The *French Pavilion* was a large oval room flanked by four small rooms.

Of a marvelously classic taste, the exterior has a facade in smooth ashlars and consists of a single story crowned by a balustrade supporting large vases and sculptures of putti.

This peaceful corner was not meant to be lived in but was used for picnics or to pass an hour of diversion. It was then that Jacques Ange Gabriel planned a new château, the Petit Trianon.

The architect had already designed buildings and city plans in Choisy, Fontainebleau, Marly, and was to demonstrate his talent once more with the building of the Petit Trianon, the Salon dell'Opéra in Versailles and the square dedicated to Louis XV, the future *Place de la Concorde*.

Surrounded by greenery, this elegant building with its pure lines was built in two years, between 1762 and 1764, and another four years were needed to complete the interior decoration.

Madame de Pompadour died in April 1764 and never lived in this "refuge" she had thought up for her royal lover.

INDEX